"You have to learn to be resilient. Resilience, persistence—they're the only things that matter." SIMON DOO[C]

"The only way I'm going to find confidence, the only way I'm going to find growth, is through failure." STEPHEN GATES

There are two things inside a company where you can invest a dollar and potentially get a hundred. One of them is brand— you can invest a dollar in your brand and get back a hundred or a thousand or a million. The other is culture." NOAH BRIER

"A magician knows that half of the trick happens after the trick is over." DERREN BROWN

"People matter. Meaning matters. A good life is not a place at which you arrive, it's a lens through which you see and create your world." JONATHAN FIELDS

You learn a lot from people by their magical thinking." BETH COMSTOCK

"The same way I trust in positive things, I had to trust in my sadness—that it was OK to be sad. And that at some point I was going to be ready to not grieve anymore." SHEILA BRIDGES

WHY

DESIGN

MATTERS

WHY

CONVERSATIONS WITH THE WORLD'S MOST CREATIVE PEOPLE

DESIGN

Debbie Millman

FOREWORD by ROXANE GAY
INTRODUCTION by TIM FERRISS

MATTERS

HARPER DESIGN

An Imprint of HarperCollinsPublishers

For my generous listeners around the world,

and to my wife, Roxane Gay,

who patiently—

and ceaselessly—

listens to me at home.

1 LEGENDS

2 TRUTH TELLERS

3 CULTURE MAKERS

4 TRENDSETTERS

5 VISIONARIES

FOREWORD

by

ROXANE GAY

Debbie Millman is one of the finest interviewers working today. She is, indeed, my wife, so you would expect me to believe in her unparalleled interviewing ability, but it also happens to be the truth. I married very well.

When you live with your partner, you learn a great deal about who they really are. I knew Debbie was passionate about her work and, especially, her longstanding podcast, *Design Matters*. And then we started living together. I saw just how ferociously committed she is to having genuine, probing conversations with some of the world's most creative people.

Debbie is voraciously curious and loves research. She spends hours a day in the weeks leading up to an interview learning everything she can about a guest. She studies their previous interviews. She unearths seemingly innocuous details about their early lives and careers. She reads everything they've written or that has been written about them, taking copious notes. And then she sifts through everything she has learned, drafting questions and determining the shape of the conversation she hopes to have. By the time she finally sits down with her guests in her studio at the School of Visual Arts in New York City, Debbie Millman is ready to guide anyone through one of the most engaging conversations of their lives. She settles in her seat, notes in hand. As she crosses her legs, her voice lowers to a huskier register, and for the next hour or two, she treats her

interview subject like the most interesting person in the world. And in that time, they are.

A good interview is much harder than it looks. When a notable person has achieved enough acclaim to be interviewed, they are asked a lot of the same questions about who they are and how they work and what they think. They develop a slate of standard responses because it is rare to be asked the unexpected question. It is that unexpected question Debbie most loves asking. There's a reason she prepares and then overprepares for her conversations. In every *Design Matters* interview, there is a moment where her subject expresses genuine surprise about some detail of their lives she has unearthed. Or they reveal a tender vulnerability she elicits from them with grace, care, and patience. It is always that moment when her interview evolves from good to great, from interesting to utterly compelling.

Design Matters has been in continuous production for more than sixteen years. Over that time Debbie has spoken with the world's foremost designers, public intellectuals, artists, writers, and creatives. She initially created the podcast to have a creative outlet divorced from her professional vocation as a brand expert and designer. She was interested in what it means to design a creative life, but over the past sixteen years the *Design Matters* project has expanded as her skill has sharpened. She has created a gloriously interesting and ongoing conversation about what it means to live well, overcome trauma, face rejection, learn to love and be loved, and thrive both personally and professionally. She has spoken to people about their crowning achievements and lowest moments. She has amassed more than four hundred and fifty interviews at this point, and each and every one is unique. From her first interview, with designer and creative director John Fulbrook, until now, Debbie Millman has become a singular voice in the world of intimate, enlightening conversations. She has demonstrated, time and again, why design matters.

INTRODUCTION

by

TIM FERRISS

Debbie Millman is my sister from another mister.

Then again, that's probably how a lot of her guests feel.

She first interviewed me on a crisp November night in 2016. The School of Visual Arts signage drew me off the streets of Manhattan, and as soon as I sat down in her recording studio, I knew things were going to be different.

First, the layout makes you feel like a child emperor, coveted zoo animal, or perhaps the first Martian to visit Earth. Her recording studio is a walled-off eight-by-twelve-foot sound booth within a larger classroom, and speakers pipe the audio outside. There is a huge window on one side so that students can look inside, and that early evening perhaps twenty-five students filled chairs in the room. That turns on all the lights of the mind.

Second, I noticed my books on a desk at her side, filled with more Post-it notes and bookmarks than I thought humanly possible. That made me excited to go deep.

Third, as I looked into Debbie's eyes, I felt an emotional phase shift: I was now inside the protective shell. This was her home and her safe place. The literal dark of winter had enveloped the building, but I felt like I'd been wrapped in a warm blanket. Everything seemed softer around the edges, and I let out tension I wasn't

even aware that I carried. Debbie smiled, and our breathing seemed to sync.

And that, ladies and gentlemen, is how Debbie works. She's very witchy with her setup.

Her prep and poise produce contagious calm around the mic. This zone extends out in a good thirty-foot radius, so interviewees and students alike fall under the spell. Once she hits "record," the prompts trickle out one by one like well-trained ballerinas. It has a powerful momentum but feels unrushed, and the stage and the story arc are only fully visible at the end. It's beautiful.

Sounds pretty nice, eh? It is, and I assure you: it ain't easy to make such a dance work when you're in Debbie's chair. It's fucking hard as hell.

Our session was in the middle of week one of my book launch, and I was in press junket purgatory. Doing twenty-five-plus interviews per day exposes you to the full spectrum of hosts, and 99 percent of them ask the same five to ten questions. To survive the monotony, every author develops an autopilot mode. It's like your head becomes a ventriloquist's monkey puppet, and you can recite all your polished sound bites while simultaneously thinking about chocolate or sleep or margaritas.

With Debbie, there was no autopilot. It was like driving the winding and hypnotic coastline of California on Highway 1. I was fully engaged and could not waver. Throughout the experience, the thought that popped into my head repeatedly was: I'm not here today to be interviewed. I'm here today to watch Debbie.

Yep, she's that good. Even the most jaded, world-weary traveler cannot help but feel that they are the only person in the world when Debbie is sitting across from them. And to her, for those 90 to 120 minutes, they truly are the only person in the world.

That singular, empathic attention is a rare gift to the world.

HOW AND WHY DESIGN MATTERS

by

DEBBIE MILLMAN

My first two decades working in design and branding are what I regularly refer to as my years of rejection and failure. Over and over again I attempted to find a way to bring together my love of the visual and the written word. I applied to the Columbia Graduate School of Journalism, but my application was soundly rejected. My father had attended Columbia University, and in that moment, my opportunity to follow in his academic footsteps vanished. I was rejected from the Whitney Museum of Art Independent Study Program. I was rejected for a job at *Vanity Fair* working for design director Charles Churchward. At the far-less-interesting jobs I did get, I dealt with all manner of messy workplace politics and the

kind of sexual harassment men rarely answered for. But I was also relentless in pursuing my ambition, working to become a better designer, and then a better brand strategist, and then a better leader. Twenty years into my career, I became more successful than I'd ever imagined: I was one of the few women in the United States running a global branding consultancy, Sterling Brands.

I was unaccustomed to the addictive feeling of real achievement, so when I first experienced it, all I wanted was more. My focus became singular. I abandoned everything I had once pursued to concentrate on accomplishing as much as I could as quickly as possible. After

a life of myriad, albeit inconsistent, creative endeavors, I stopped making art. I quit writing poetry and prose and stopped scribbling in my journals. I discarded sewing projects and craftwork. I even put my old guitar in its case and tucked it under the bed. I was so intoxicated by this new feeling of professional triumph that nothing but more of it mattered. I worked nonstop. I traveled constantly. I worked ridiculous hours. I abandoned my personal life. I was in perpetual motion for many years.

I had achieved a great deal, but there was an echoing vacuum of meaning and purpose in my life. I was consumed with the business of my work—shelf-presence and statistical significance, benefit violators, and back-of-pack romance copy (the information on the back of products designed to give consumers more information about any given brand). I worked on teams that created the illustrated bubbles on a new identity for 7UP and photographic droplets on the Tropicana Orange Juice carton. We added blue to the Burger King logo, and I created a hand-drawn typeface for Twizzlers.

We redesigned the branding and packaging for salty snacks, over-the-counter pharmaceuticals, canned soup, raw chicken, bottled salad dressing, Pepperidge Farm Goldfish, cat litter, deli meat, jarred tomato sauce, frozen meal kits, shelf-stable beverages, and a bevy of carbonated soft drinks. At one point I was sure I had worked on at least 25 percent of everything you could buy in a supermarket or a drugstore.

After nearly a decade at Sterling, I began to wonder if I had lost my creative soul or, at the very least, abandoned it to my professional ambition. Or, perhaps, it is more accurate to say I finally got to a place where I was willing to stare down a fear that had been hovering at the periphery for years.

In the midst of my struggle with creative ennui, I received a cold call from a salesperson of a fledgling online radio station asking if I'd be interested in hosting my own show. I had no experience hosting a radio show either online or off. But the salesperson tried to assuage my doubts by clarifying that I was only being

offered a thirteen-episode "try out," and the network—Voice America—was focusing on niche topics from creative people they were expecting to train. Voice America was one of the first online radio networks to emerge in the early aughts and, after an initial boom, extended the network to include Voice America Business and Voice America Country. The network was interested in my hosting a show on the business channel because of my position at Sterling.

I was skeptical, but I was also intrigued. The idea of hosting a program was outlandish, but it was different. I didn't want to do a show about branding, though. I wanted to do something completely uncommercial in an effort to try to resurrect my creative spirit. I countered the salesperson's proposal with the concept of developing a show about graphic design, which, if absolutely necessary, could also include a bit about branding.

My counterproposal came at a time when Donald Trump's reality television show, *The Apprentice*, was at the height of its popularity. The night before my final conversation to persuade the executives at Voice America that a show on graphic design could and would be gripping radio, the weekly exercise on *The Apprentice* featured a challenge with the Pepsi-Cola Company. The test for the young entrepreneurs included redesigning the Pepsi Edge can.

As fate would have it, I had worked on the design of the original packaging, and the client on the show was not only Sterling's client, she was also a good friend. The next day, when the executives at Voice America tried to stump me by asking what design topic I'd do a show on if I had to come up with an idea on the spot, I answered that I would interview the designer at Pepsi-Cola featured on *The Apprentice* the previous night. When they questioned how I could pull that off, I nonchalantly remarked that the designer was a client and a friend. The allure of a Pepsi connection was enough: they approved *Design Matters* immediately.

Sometimes a great opportunity is too good to be true. Shortly thereafter, I discovered that the salesperson and his team at Voice America were not really offering me a job as a radio host per se.

They were providing me with an "opportunity" to hire them as in-house producers of a radio show that would live on the Voice America network. At that moment, I realized it was a nothing more than a vanity project.

I weighed the shame of my hubris against my growing excitement about the potential of this new endeavor. I really had very little to lose. I was single and had no children. My mortgage was manageable. My current salary could more than comfortably fund the potential resurrection of my creativity. This is all to say, I absolutely leaned into my vanity. I signed on. I started planning. I figured the show would be a little bit of fun, a chance to experiment again, and a risk low enough to avoid public embarrassment.

On February 4, 2005, at 3:00 p.m. Eastern Standard Time, *Design Matters* launched on Voice America. The show aired live every Friday afternoon via a telephone modem in my office in the Empire State Building. I sat face to face with my guests, each of us holding a telephone handset. The sound quality was tinny and carried a wretched delayed echo.

The producers were also on the line from a remote location in Arizona. The result had all the craziness of a "Wayne's World" sketch from *Saturday Night Live*.

My first guests were friends. I asked John Fulbrook, then an art director at Simon & Schuster, to be my first interview. He was gregarious and a great storyteller. I figured that if I got too nervous, he could easily take over. My second guest was the visual strategist Cheryl Swanson. She ended up teaching me my first lesson in interviewing. When I asked Cheryl how I did, she gingerly recommended that I listen to future guests' answers before asking additional questions.

Over the next ten episodes, I asked more friends to join me, sometimes a few at a time. As my guests began to send the links of the show to their friends, word spread throughout the New York City design community that I was doing something cool. After my first thirteen episodes, Voice America renewed my contract and I wrote another check for the airtime. The show's reputation had grown such that I was able

to invite designers beyond my circle of friends, and, mercifully, most said "yes." By the end of the second season, legendary designers, including Milton Glaser, Paula Scher, Emily Oberman, Michael Bierut, and Stefan Sagmeister had joined me in conversation. I continued to run Sterling Brands, sold the company to Omnicom in 2008, and ultimately left in 2016. At the same time, in 2009, along with Steven Heller, I cofounded the first graduate program in branding at the School of Visual Arts, and I am chair of that program today.

I have spent sixteen years consumed by the question of how to conduct a good interview, how to get interesting people to reveal the depths of who they are, how to earn their trust so that our conversation can go to unexpected places. Since the inception of *Design Matters*, I have interviewed more than four hundred people. But I have a confession: at first, I was a terrible interviewer. I wasn't listening enough. I filled silences with unnecessary verbal tics. I had a plan for each interview and wasn't flexible enough to stray from that plan. Early on, critics said I

was too gushy about my guests and maybe I was, but I was talking to incredible people. I don't think that unabashed admiration was an unreasonable response. But still. I worked at developing *Design Matters* with the same relentlessness with which I approached my career. I learned to temper my fangirling, as the kids say. Perhaps most important, I became obsessed with research and still am today. In fact, I've grown to love preparing for episodes almost as much as sitting down with each of my guests. Now, I am lucky— when I am deep in my efforts, time goes to that elusive place where it almost doesn't exist. Hours go by without my even realizing it, and that is when I feel most creative. Once I've learned everything I can about my guests, I then start to shape the conversation. I want to help them articulate who they are in ways that honor their truest selves and their accomplishments. In my best interviews, I am asking my guests questions only they can answer. I'm not at all interested in asking open-ended cookie-cutter questions about creative processes or what they are inspired by or their favorite books. There is nothing wrong with these questions, but I want to give

my listeners a unique experience. When *Design Matters* is at its best, that's exactly what I do. In June of 2005, when the radio show became a podcast, it evolved from a show about designers talking about design, to designers, artists, writers, performers, musicians, and public intellectuals working in any discipline talking about how they have designed the arc of their creative lives. I've discovered that the arc of a creative life is a circuitous one, and I am endlessly fascinated by how people become who they are and how the decisions they make over the course of their lives impacts their work. *Design Matters* is now a show about how the most creative people in the world create their lives.

Back in 2005, if anyone had told me that this creative experiment would become one of the centerpieces of my life, I'd have rolled my eyes. If anyone had told me that more than forty million people (at last count) would download the show, that *Design Matters* would be one of the first and longest running podcasts in the world, that it would be designated one of the best shows on Apple Podcasts, that it would be featured on more than one hundred "best podcasts" lists, and that it would win

a Cooper Hewitt National Design Award, I'd have thought they were hallucinating. But here we are, a decade and a half into a grand experiment. This book represents a body of work, a love letter to creativity, a testament to the power of curiosity. In these pages, you will find conversations with the world's most renowned designers, artists, writers, and public thinkers. You will read about their most enviable successes, the devastating failures that almost derailed their careers, the joys and sorrows of their personal lives, and how they've given themselves over to the act of creation.

Sixteen years ago, *Design Matters* was something of a vanity project, albeit sincere and well intended. I am happiest when I am making something, and this show has provided me with moments of profound satisfaction. It has also shown me what is possible with an idea and some resilience and hard work coupled with the generosity of friends, a whole lot of hope, optimism, and a willingness to grow, to change, and to evolve. *Design Matters* has been the unexpected gift of a lifetime, an endlessly intriguing and ongoing conversation. With this book, I welcome you into that conversation, arms open wide.

PART 1

LEGENDS

MILTON GLASER

ALISON BECHDEL

EILEEN MYLES

CINDY GALLOP

SETH GODIN

ELIZABETH ALEXANDER

PAULA SCHER

ANNE LAMOTT

ALBERT WATSON

MARILYN MINTER

STEVEN HELLER

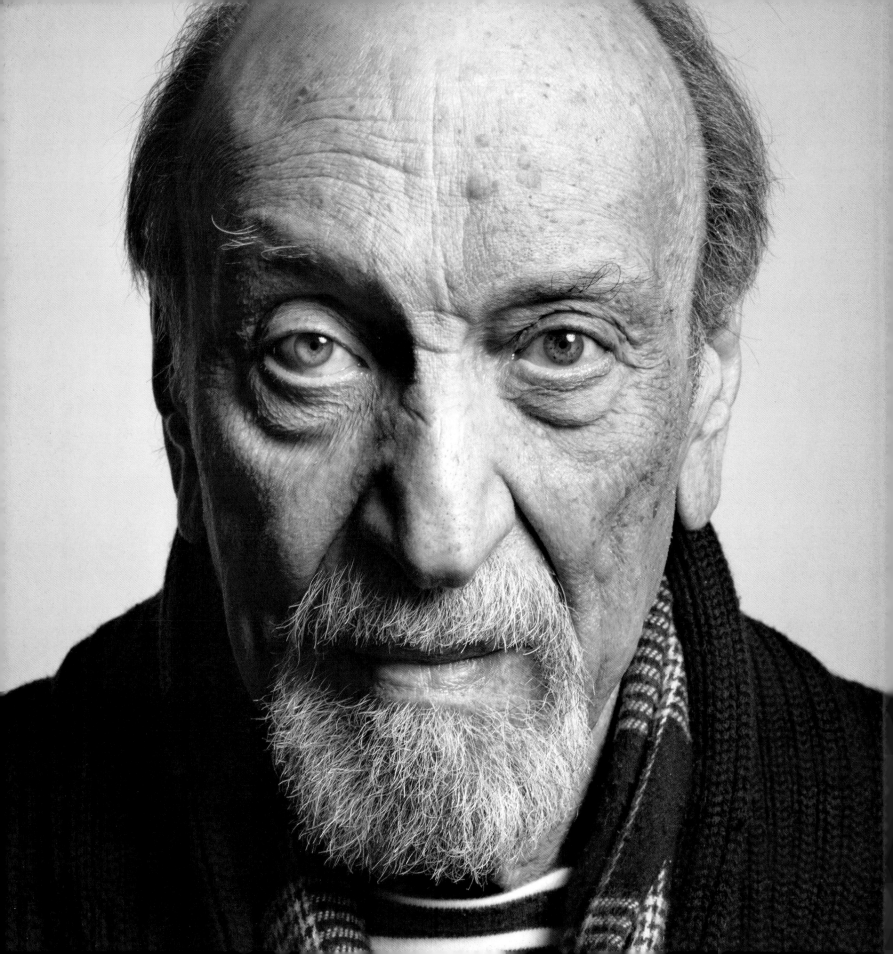

MILTON

Legendary, brilliant, intellectual, inventive, sweetly naive

These are just some of the words that have been used to describe Milton. I use Milton's first name intentionally but with no disrespect. Like John, Paul, Mick, or Keith, his name is instantly recognizable. Milton Glaser was very much the superstar of the graphic design business. He designed the iconic Bob Dylan poster and the I Love New York icon. Milton Glaser passed away in 2020, on his ninety-first birthday. During his long career, Glaser often talked about the confusion many people have about what it means when we use the word "art." He has suggested that we eliminate the word art and replace it with work. He then came up with the following descriptions: The sad and shoddy stuff of daily life can come under the heading of bad work. Work that meets its intended need honestly and without pretense, we call simply work. Work that is conceived and executed with elegance and rigor, we call good work. Work that goes beyond its functional intention and moves us in deep and mysterious ways, we call great work. Milton Glaser was a creator of great work.

GLASER

DM One of my favorite things you have authored is a piece titled *12 Steps on the Designer's Road to Hell.* In it, you sought to understand your own willingness to lie. You said that you created this when you were working on doing the illustrations for *Dante's Purgatory.* How did you come up with the steps?

MG I was doing the illustrations for the *Divine Comedy* specifically for the section called *Purgatorio,* which I was disappointed with. I thought that illustrating the conceptual hell would be more interesting, until I realized that purgatory is where we all are, somewhere between hell and heaven. The great distinction between purgatory and inferno, or hell, is that the people in purgatory know what they have done and the people in hell do not. The souls in hell haven't got the chance of getting up. The people in purgatory somehow can get out of it.

At any rate, I thought that everything that you do is either a step to going into hell or getting out of it. I thought that in our business—the communication business—the questions become most egregious. We are always in a situation of transmitting ideas to a public. If we apply the idea of doing no harm to what we do because we have some responsibility to that public, we have to look at the nature of the messages that we are sending out into the world. I started with benign things that are quite acceptable to most practicing professionals, such as making a package look larger on a shelf.

DM That's number one.

MG Number one. That comes under the general heading of professional practice, and while it is misrepresentation of a certain kind, that misrepresentation is an attribute of design because you are always dramatizing things. It is something that you could justify and causes little pain.

What I tried to do in the *Road to Hell* was to increase each problem so at a certain point you realize you're creating mischief. The question is personal: Where will I stop? What will I not do? I have to ask myself that question when I find myself going down the road a bit. I realized there was a certain point that I would go no farther. It's an interesting thing. It's very personal. People respond very differently to it in terms of what point they feel that their conscience or their sense of ethics will not permit them to go any deeper. You'd find that there is by age, there is by vocation, and certainly there is by individual.

DM Here is the full list:

1. Designing a package to look bigger on the shelf.

2. Doing an ad for a slow, boring film to make it seem like a lighthearted comedy.

3. Designing a crest for a new vineyard to suggest that it has been in the business for a long time.

4. Designing a jacket for a book whose sexual content you find personally repellent.

5. Designing a medal using steel from the World Trade Center to be sold as a profit-making souvenir of September 11.

6. Designing an advertising campaign for a company with a history of known discrimination in minority hiring.

7. Designing a package for children whose contents you know are low in nutrition value and high in sugar content.

8. Designing a line of T-shirts for a manufacturer that employs child labor.

9. Designing a promotion for a diet product that you know doesn't work.

10. Designing an ad for political candidates whose policies you believe would be harmful to the general public.

11. Designing a brochure for an SUV that turned over frequently in emergency conditions known to have killed 150 people.

12. Designing an ad for a product whose frequent use could result in the user's death.

Milton, where do you net out numbers-wise?

MG I hover around the top five before I find that I can't go further if I am really stringent about causing no harm. It's almost impossible if you have a firm conviction that you will do nothing to harm another creature. A lot of this is relative. A lot of ethics are relative. On the other hand, causing somebody's death doesn't seem to be complex at all. If you're willing to do it, it means you don't think of them as human.

DM At this stage in your career do you find that it's easier now to say "no" to projects, or have you always adhered to your principles?

MG I've always had principles and I've always tried to do no harm. I don't think it becomes easier as you get older or more successful. Quite the contrary. I'm a great believer in simply observing what is, and if you don't want to change your behavior, at least you know what your behavior is. From that point, I think it's necessary for designers to be aware of what they do when they are participating in misrepresentation or causing someone's death. They should simply know that's what they're doing and not pretend that they have no role. My problem with Ken Garland's *First Things First* manifesto is that it doesn't give people any place to go. It says, "Why don't you work for schools, universities, cultural institutions, and so on?" without the recognition that they form only 5 percent of the total economic opportunity for designers.

The real question is, "What are you going to do if you are in business, and you're participating in a capitalist enterprise which serves to maximize profits above all else?" What is your role in that? Certainly, going elsewhere is an alternative, but in most cases it is a nominal alternative. People don't have the opportunity to go elsewhere. The big question for most of us is staying within the system, understanding that we are in a profit-making capitalist economy. What do you do? That is a more complex issue than simply only working for universities and cultural institutions because most people simply don't have that option.

My problem with *First Things First* is that it doesn't provide real alternatives for people who have to survive and live, but, on the other hand, it does raise questions regarding the meaning of what you do. I feel ambivalent about the manifesto. I signed it and I would sign it again, but I think it has to present a deeper and more thoughtful idea of what people's alternatives are.

DM You have a book coming out in a few months called *The Design of Dissent*. You've stated that you feel that at this particular moment in time, the dissenting press is all but invisible. How did that happen?

MG What happened is that seven corporations now own the media. Corporations, business, and government are one, and you can't separate the interest of business from the interest of government. There is a collusion between business interests and what the government is interested in. In fact, there's no separation between those objectives by and large, and the people and journalists have been intimidated by the fact that if you want to pursue a career in journalism and you get labeled as a troublemaker, you're not going to have much of a career.

DM I find it interesting that being a troublemaker now can ruin your career when thirty years ago being a troublemaker made your career.

MG The terrible thing about it is that it's not as overt as one would hope. What people have done is they have voluntarily withdrawn from asking the questions because they realized it was dangerous. The government didn't have to tell them to shut up. Their business didn't even have to tell them to shut up, but they know what happened is, in fact, that they've created difficulty.

DM Is there anything that designers can do to change that?

MG I think designers can do only what good citizens do, which is to react, to respond, to publish, to complain, to get out on the streets, to publish manifestos, and to be visible. They can't do more than citizens can do except they have one great advantage: they know something about communication.

"I was really on a path to find out: What is art and what is being an artist?"

DEBORAH KASS

artist

August 2005

ALISON

For some artists, work and life are so intertwined that it's impossible to tease them apart.

Alison Bechdel is one such creator. Her cartoons and graphic novels lay out the complex intimacies of her life in all their heartbreaking splendor, upending long-held expectations in the process. Her long-running *Dykes to Watch Out For* is one of the major achievements in the comic-strip genre. Her graphic memoirs *Fun Home* and *Are You My Mother?* propelled her work to the mainstream, thanks to their thunderous emotional resonance. Our conversation took place a year after *Fun Home* was adapted into a Tony Award–winning Broadway musical.

BECHDEL

DM: You were born in Lock Haven, Pennsylvania. Your father was a high school English teacher, and he operated a funeral home. Your mother was an actress and a teacher. I believe you were about four years old when you saw your first butch lesbian. What happened?

AB: I was out with my dad on some funeral home–related errand in a larger city; we might've been in Philadelphia. He had taken me to lunch, and a woman came into the luncheonette who just blew the top of my head off. In seeing this big woman wearing men's clothes, I recognized a version of myself, and my father recognized that in her too. He said to me, "Is that what you want to look like?" Of course that was exactly what I wanted to look like, and I didn't know it was possible or that anyone else did it. Simultaneously, I was getting the message that it was not okay.

DM: When you were ten years old, you experienced an episode of obsessive-compulsive disorder. It would take you all night to write a simple diary entry. Your mother got involved, and you dictated entries that she would enter into your diary; you've written that you feel this activity became a kind of template for your life. In what way?

AB: When my mother took dictation for my diary, I became a memoirist because the thing I was most passionate about was the act of writing down the material of my life. In a more normal and relaxed family, love would have been transmitted through affectionate language or touch. We didn't have that, so it was all getting funneled into this one act of my mom's.

DM: Did your mother's dictation stop the obsessive-compulsive behavior?

AB: I haven't stopped it. I've learned to disguise it.

DM: In what way?

AB: Becoming a cartoonist was a productive way of harnessing it, but I still express it all the time through little ticks and gestures that I hope other people can't see. Like right now, I'm breathing out of one side of my mouth.

DM: Is it because you're uncomfortable?

AB: I do it all the time, but maybe I'm always uncomfortable. I wish I could get rid of it; I wish I could get this whole feeling kneaded out of my body. But then I don't know if I would still be myself.

DM: You've stated that drawing people has always been your passion, and that as a child you rarely bothered creating backgrounds for your figures because you were too eager to move onto your next subject—chefs, explorers, policemen, firemen, musicians, scientists, lumberjacks, farmers, spies, mountain climbers, lifeguards, astronauts, accountants, disc jockeys, coal miners, businessmen, and bartenders, among numerous other central-casting types. Why were they all male?

AB: As a kid, I didn't even notice that. I grew up in the 1960s, when the world was a man's world, so the guys were doing the stuff that interested me. Representations of women were just absurd. Housewives or secretaries didn't interest me. As I got older and had more of a political awareness, it occurred to me that to be a woman meant you were not human—you were something other than human. I would think of Mickey Mouse versus Minnie Mouse. Mickey was the regular generic human mouse, and Minnie was Mickey with all these impertinences and details added to her. I feel there was some element of gender dysphoria at work.

DM: *Dykes to Watch Out For* began in the margin of a letter you were writing to a friend, in a drawing you titled "Marianne, dissatisfied with the morning brew." It ran in the 1983 lesbian pride issue of a feminist newspaper. How did it get to the newspaper?

AB: I was a volunteer at this feminist monthly called *WomaNews*. I showed up because I wanted to meet people and do something interesting. I got involved in the production end of the paper. I was doing these cartoons for fun and showing them to my friends, and someone said, "You should show these to the collective and see if they want to put them in the paper."

DM: In your book *The Indelible Alison Bechdel*, you write, "The concept of a series, although initially a joke, begged for continuation." It was at this time you begin doing a cartoon for every issue of the newspaper.

AB: In the 1980s there was this gay and lesbian subculture happening that I found so exciting—this parallel world where gay people were making their own

art and newspapers and had their own bookstores and bars. I wanted to not just be part of that world but to show it. I started doing that with these comics. I wanted to see images of people like me which I didn't see anywhere in the culture at that point.

DM: When you first started to syndicate your comics, you expected no one was going to be interested in your bizarre subcultural experiences. Given the success you've now had, has it gotten any easier for you? Or are you still constantly doubting your own work and worth?

AB: That hasn't changed. Becoming a lesbian cartoonist was almost like seeking a form of expression that no one was going to notice or judge—specifically, my parents. My father was dead at that point, but psychically I was trying to express myself in a way that my parents couldn't see. Even later, when I would show my work to my mother, especially when I was writing *Fun Home*, I liked that she couldn't understand the comic's format. On some level, I didn't want her to see what I was doing.

DM: But that's because of the relationship you had with your mother, not necessarily the relationship you had with the world. Or would you say they were the same?

AB: I think they're similar. Both of my parents loved fine art and literature. They were always reading poetry. I had to rebel against that, so I found this art form that was anti-elitist and populist—and which was more like journalism. It was a way of being an artist without claiming to be an artist.

DM: You've said the challenge of autobiography is to transcend its inherent egocentrism enough so that someone else will be interested. I've read so many accounts of people who did not experience anything you experienced, yet who were completely able to relate to what you were writing about and who you were writing for. I'm wondering whether the cartoon narrative engages people in a way that is fundamentally different from a memoir narrative because of the graphics.

AB: I do think there's a way for people to see a scene that heavy-handed language doesn't allow. The drawings forge some kind of bond with the viewer.

DM: There were aspects of the characters, despite their sexual orientation or their politics, that were universal. People curled their feet under the chair in the same way, or held their cat in the same way, or drank their coffee in the same way. There's a humanity in these characters that transcends any type of life choice.

AB: If I had had it together enough to declare my mission, it would have been that I wanted to show that lesbians were humans. I had a very visceral sense of wanting to do that because in this day and age it's hard to convey how...

DM: ...marginalized lesbians were in the 1980s and before.

AB: Even marginalized is a weak word. Hated, despised, feared, mocked, ridiculed. It was the mocking and ridicule that I wanted to dismantle.

DM: As somebody who had struggled with my own sexuality for decades, marginalization is part of what kept me in the closet until later in life because I was so afraid of being judged and ridiculed. Because we're the same age, and because you've been so incredibly free with who you are and generous with your talent, I can't convey how brave it seems from the outside.

AB: It's not brave. It was circumstantial because my father died when he did. My closeted gay father killed himself right before my senior year of college, and so I didn't get into grad schools, I was a mess. I didn't know what I was doing, but there was something immensely freeing in not having a father.

DM: A judger.

AB: He had a whole plan for me, and he was very intrusive about it. He was constantly trying to get me to live out the life he wished he had had, to take the classes he wished he had taken. And it was very hard to fight that. I didn't want to live a secretive life like my father did—look how that worked out. I wanted to be out and open. But also I had nothing to lose. I had no stake in the system.

DM: Your mother wasn't all that into it.

AB: No, she wasn't, and that was hard, and that's part of my whole story with her. But there had been such a rupture with my father's death that I was beyond caring

about little things like that. All of this to say, it might look brave from the outside, but it really wasn't. I didn't have any alternative.

DM: In 2006 you published *Fun Home*, which centers on you coming out during your freshman year of college and your closeted gay father's suicide a short time later. *Time* magazine crowned the book number one of its 10 Best Books of the year, stating, "Forget genre and sexual orientation: this is a masterpiece about two people who live in the same house but different worlds, and their mysterious debts to each other."

I wanted to see images of people like me which I didn't see anywhere in the culture at that point.

AB: I wanted to tell this story about me and my father almost as soon as it happened. He died when I was nineteen. But these were big secrets. No one knew my dad was gay. No one knew his death was a suicide. He was hit by a truck. All of a sudden, I found out my family was nothing like I had thought. My entire childhood was upended.

DM: You had no suspicion at all? Even when he brought you into the city and went out while you were sleeping?

AB: No, no. I began to have this need to reconcile the past with what I now knew was a different version of that past.

DM: How do you make sense of it?

AB: Well, you go to therapy for a long time.

DM: Fair enough. When you were writing *Fun Home*, you had the realization that the book was you learning from your father to be an artist. And you ended the story with James Joyce's incantation at the end of *A Portrait of the Artist as a Young Man:* "Old father, old artificer, stand me now and ever in good stead." The musical doesn't include the Joyce references or many of your drawings, but it does capture their spirit, and Alison the character gets launched by her father to do something he wasn't able to do. Can you talk about how your father taught you to be an artist?

AB: *Fun Home* had started as the story of me and my dad. Along the way, these literary references gradually crept in as I needed to find out more about who my father was. I started looking at the books and authors that my father had loved so passionately and that he was always trying to get me to read when I was growing up. So the Joyce reference organically came together. Our lives are chaotic. There's no meaning or order to the things that happen to us day after day. But to try and find a story, to try and find some kind of meaning or narrative in those random events—that is a very pleasing activity.

DM: After *Fun Home* won the Tony Award for Best Musical, you told *Rolling Stone* that you were not used to such good things happening. You struggled financially, you struggled emotionally in years past. How do you make sense of all this incredibly well-deserved good fortune?

AB: I'm still trying to do that. I know it's important to let it in and accept it and not be afraid that it's going to disappear. But it is not my natural state. I'm very pleased about how things have turned out, but it can be just as traumatic to have positive things happen to you, sometimes, as negative things. It's change.

DM: What is it like seeing characters that were once real and then drawn as cartoons come alive in other bodies?

AB: It's weird and also strangely wonderful and healing to see people acting out my family's story on the stage night after night.

DM: What does it feel like seeing people having visceral reactions to your work?

AB: It's all unbearable, in a good way. It's very intense to see the show. It's a painful show to watch, and it's especially painful if it's actually your own story. I've become shut down to it, in a way.

DM: Your mother died just before *Fun Home* opened at the Public. Had she read any of it or heard any of the music?

AB: I gave her the script along with a CD of all the songs, and I told her, "Here it is. If you want to listen to it and read it, just prepare yourself—it could be intense." I have no idea if she ever read or listened to it.

DM: She didn't give you any feedback? Did she give you feedback on the graphic novel?

AB: I showed that to her in draft form. Part of the seven-year process was getting her to be okay with all of that. She was very minimal in the feedback she would give, I think because she didn't want to implicate herself. She did have a few things she asked me to change or correct, and I mostly did those things.

DM: You refer to a lot of this in *Are You My Mother?*

AB: Yes, my memoir about my mother ended up being a memoir about writing the memoir about my father and how she and I navigated that.

DM: What made you decide to write that book?

AB: It wasn't clearly conceptualized as a memoir about my mother. For many years, I thought I was writing a book about crazy relationships I'd been in. It was about the idea of relationships, about the self and the other, and it was very abstract and constipated. Finally, my agent said, "This doesn't make any sense at all." It was a great relief to hear someone tell me that. At that moment, I realized the problem was that I was trying to avoid directly writing about my relationship with my mother, and then I was able to tell the story.

DM: At the beginning of the book, you state, "You can't live and write at the same time." Do you still feel that way?

AB: I do. Once you're writing, you're not present in your life. But that's not so terrible. I think that's just my lot that writing is more comfortable than living.

DM: Like your mother, you've kept a log of your daily external life, but unlike her, you also recorded a great deal of information about your internal life. Has the demarcation between the two become any clearer to you?

AB: The personal is political. It was a useful slogan when I was growing up. It explained my life perfectly: I was the result of a father who was gay before the gay liberation movement and a mother who was thwarted in her desire to be a writer or a professor because she came of age before the women's movement. They were a little too before their time. But if they had never met, if she had gone on to be a feminist or my dad had come out, I wouldn't have been born. As a younger person, I felt very clearly that there was no demarcation between the external and the internal. I felt that everything was an open book. As I've gotten older and as I've lived with the fallout, good and bad, of writing these stories about my family, I feel less adamant about that. I think there is place for privacy. Especially as I feel so overexposed—like I've put so much of myself out in the world.

DM: You write that the notion of a true self that had to be kept hidden at all costs resonated with you. I find that so interesting—the notion of the true self needing to be hidden while writing about the self. As I was reading *Are You My Mother?* I was overwhelmed again and again by how much we choose to reveal, even though you are revealing all of these experiences, thoughts, and feelings. Do you feel you're revealing your true self in a different way in writing *Are You My Mother*?

AB: I hope I am. The funny thing about *Are You My Mother?* is that it's a very cerebral book, and I feel like it somehow fails to break out of the very thing it's describing, which is the mind as its own object.

DM: You've speculated that being a lesbian actually saved you from some aspects of your childhood—that if it weren't for the unconventionality of your desires, your mind might have never been forced to reckon with your body. You state, "It was only my lesbianism and my determination not to hide it that saved me from being compliant to the core." That blew my mind.

AB: For me, thinking is a defense against just being. In my case, my body spoke up. I knew I was attracted to women, and that felt like something that was inherently true and that I had to go with. I say it saved me because I became an outlaw at a young age and was very freed up to do whatever I wanted. I was writing this crazy marginal comic strip for free. It was not a great career path, and bizarrely it has worked out. So, I thank my body for that.

EILEEN

"I am always hungry
and wanting to have sex.
This is a fact."

That's the opening of Eileen Myles's poem "Peanut Butter." If you haven't read Eileen Myles's writing, please start. It's blunt, it's open, it's funny, it's moving, and there's a lot of it: more than twenty volumes. She started off in the East Village poetry scene in the 1970s, and for decades she's been famous in the poetry world. Very recently, she vaulted to a new level of renown, when the Amazon show *Transparent* modeled a character on her and read her poems on air. It's a rare and wonderful thing when a poet makes waves in popular culture, and Eileen Myles has done just that and so much more.

MYLES

DM Eileen, you've written about how you walked into the Veselka café in October 1975 and met the late New York poet Paul Violi, who invited you to a workshop at St. Mark's Church. What do you think your life would have been like if you hadn't met Paul?

EM I wrote my novel *Inferno* to say what it was like to be a female coming into New York as a poet in the 1970s because every dude had some book you should read. And that's how the poetry world always was. It was just a question of what other pile I could have wound up in. But Paul was my guide into all the other schools of poetry at the time. It was everything that was not in the mainstream American canon of literature. So that was the right place, and hopefully I would have found it some other way, but Paul was the guide.

DM In an interview in the *Paris Review*, you stated, "I've made myself homeless. I've cut myself off from anything I knew prior to living in New York. I did this to myself, so I know exactly how it happened." Do you think this was necessary to you becoming the writer you are now?

EM Yes. We're always translating. I think any of us who come from another class can't stay home and do or make. You have to take what you have someplace else. Even in the poetry world I've done that, importing male avant-garde styles into a queer or a lesbian world.

DM In 2009 you wrote a book of essays titled *The Importance of Being Iceland*. You wrote this book after becoming sober; you began performing instead of reading your poems and tried improvising after being moved by performers like Spalding Gray. Talking led you to running for political office. In 1992 you conducted an openly female write-in candidacy for president against George Bush. What made you do this?

EM I was a little unhappy. My girlfriend at the time decided to go to grad school and I was disappointed.

DM So you needed something to do? Okay! Let's run for president!

EM I needed a new project. I had seen Pat Paulsen running for president. Jello Biafra running for office. Mostly men, actually. I had been really interested in figuring out how to be political in my work—authentically political in a way that still felt like my work. So with all that, and the timing of George Bush and the new language of political correctness, I was interested. I was doing improvisational performance work, and I thought, "My God, a campaign would be exactly that."

DM You mentioned the words "politically correct," and I know that the appropriation of that term in culture has pissed you off. Tell me why.

EM It's really funny because it's specifically lesbian language. In a lesbian community, politically correct meant that would be the person who would stand up at the reading and say, "Would that person with the perfume on their body or other animal products, please…" It was so ludicrous and shocking to see our Republican president suddenly using this lesbian language against us.

DM Your campaign originated in the East Village and exploded into an effort of national interest. You had a flyer for your presidency. I found it online. It's titled, "8 Reasons Why You Should Write in Eileen Myles for President in '92." Would you read it?

EM "8 Reasons Why You Should Write in Eileen Myles for President in '92." These are all bullet points. "She will abolish income tax. It's invasive. Tax assets instead. She will reduce defense spending by 75 percent. Twist our priorities back toward domestic spending." And in the graphic it was like a bow tie. Under Myles, "we will pay our UN dues and stop vetoing peacekeeping initiatives around the world. She refuses to live in the White House while there are homeless in America. Her vision for America is inclusive. Everyone can come. All classes, races, sexes, and sexualities count. As an openly female and queer candidate, she has primary reasons for promoting these groups. A poet, Myles writes her own speeches. Once elected, she will continue to communicate with the American people. She will create a department of culture. She guarantees health care for all Americans, within 90 days of her election. She needs it, too. Veto the mainstream. Stay outside. Vote for Eileen Myles.

DM Do you know how many votes you got?

EM No. We did go to the board of elections and they said something really paltry, and it wasn't until Al Gore had his own counting episode that we realized they just don't count. I think that when these handwritten votes get to all the precincts, they just throw them out.

DM You and your former partner, Joey Soloway, authored "The Thanksgiving Paris Manifesto," which was hosted on your site, *Topple the Patriarchy*. From what I understand, you and Joey were feeling revolutionary after seeing the Broadway show *Hamilton* and visiting the White House. You've said that writing the manifesto together was an act of passion. Can you share some of the themes of what you wrote and why you wrote it?

EM We were enjoying the extreme act of creating new requirements for art-making. Like, inviting men to stop making art for fifty or one hundred years. Inviting men to stop making pornography for one hundred years. It was to go out there and create a whole new space in which female work would flourish and expand, and men would think twice about going forward into that space. The nature of a manifesto is hyperbolic because what you're trying to do is level the playing field and even create the playing field. There's never been justice for women. There's never been a place where men actually aren't making work. Why don't we start there?

CINDY

Cindy Gallop has said of herself,
"I like to blow shit up," but that doesn't
describe all of the things she has built.

The former advertising executive now runs her own business innovation consultancy. She started *Make Love Not Porn*, a video-sharing site that counters the clichés of hardcore porn by showing how real people have sex. She is a fierce feminist warrior. In this interview we discuss her beliefs about the advertising world, what it means to be a leader, and why she likes to date younger men.

GALLOP

DM: You studied English literature at Somerville College at Oxford University and received two master's degrees, one from Oxford University and another from Warwick University. I understand you were in love with the theater and you started your career as a theater publicist. What were your ambitions at that time?

CG: I fell madly in love with theater at Oxford, which has a very thriving student drama scene. I wrote, acted, directed, and stage managed. I used to draw a lot, so I got pulled into designing theater posters for friends at Oxford. From there I got pulled into promoting their shows. I enjoyed that. I thought, "I bet it's a lot easier to get a job in theater doing this than it is to act or direct." I was absolutely right because I never had any problems finding a job marketing theater. That's what I did.

DM: At the time, a woman approached you and said, "Young lady, you could sell a fridge to an Eskimo." Wherein you decided the universe was telling you to try something new. Why was advertising that something new?

CG: That comment crystallized that my skills marketing theater were transferable into advertising. Getting my first job in advertising was extremely difficult, though. First of all, I tried applying for jobs based on my experience in theater. I found myself in that state where you can't get a job because you have no experience in advertising, but you can't get experience in advertising unless you get a job. I went back to the very beginning. I applied for graduate trainee, which a lot of advertising agencies offer students fresh out of university. The very first graduate trainee entry-level job I got offered was for an agency called Ted Bates in London 1985. I just grabbed it.

DM: Your first assignment at Ted Bates was to work on the DHL Courier and Mars Confectionary accounts. You said you had a whale of a time during your first two years in advertising.

CG: There was something enormously liberating about going right back to the beginning, running around making coffee with very low expectations. That was fantastic. It was like a second childhood. There was also the fact that back in London in the 1980s, advertising was an enormously glamorous industry. Everyone wanted to work in it. The social life was fantastic.

DM: You stayed at Ted Bates for several years. The firm was ultimately acquired by Saatchi and you ended up at J. Walter Thompson. But within six months, Gold Greenlees Trott invited you to join and you did. I read that the first day you joined the agency, you felt like you had been sleepwalking at JWT. What was so different about GGT?

CG: GGT was one of the hottest agencies in town. It was started by Mike Gold, Mike Greenlees, and Dave Trott. It was the wild boy agency. It was a very gritty agency, it prided itself on its macho culture. Jim Kelly, the managing director, used to like to say, "At GGT we stab you in the front." One day, they suddenly realized that they were all guys. In a pretty typical fashion they instantly hired three female account managers, of whom I was one. Obviously, I agonized over leaving a job I had after only six months. Then a friend said to me, "Cindy, this is GGT, you'd be mad not to." I joined GGT. They had the energy, the dynamism, the commitment to great work. It was fantastic.

DM: Let's talk about Bartle Bogle Hegarty, where you won the Advertising Woman of the Year award from Advertising Women of New York in 2003. You went on this incredible run. You got there and exploded. How did that happen?

CG: Quite honestly, Debbie, I haven't the faintest idea. I just had my head down working really, really hard. I mean, that's all I was doing.

DM: After sixteen years, you resigned from the chief marketing officer role. Why?

CG: I turned forty-five back in 2005. I had a midlife crisis in the sense that I always thought of forty-five as a midlife point in which you should pause, take stock, reflect, and review. The problem was, I hadn't the faintest idea what to do next. Vast amounts of thought and angst-ing ensued. Eventually, I thought the best thing to do was to put myself in the market and say, "Okay, guys, here I am. What have you got?" I took a massive leap into the unknown. From there, everything I've done has been a complete and total accident.

DM: In your 2009 TED Talk, you launched your *Make Love Not Porn* website. You stated that the goal of *Make Love Not Porn* is to provide more realistic information about human sexuality than what hardcore pornography depicts. Tell me about what made you decide to do this, how you're doing it now, and what the response has been.

CG: *Make Love Not Porn* was a total accident. It came out of direct personal experience. I date younger men who tend to be in their twenties. About nine or ten years ago, I began encountering what happens when

our society's total access to hardcore porn meets the equally total reluctance to talk openly and honestly about sex. Porn becomes sex education today by default—not in a good way.

Eight years ago, with no money, I put up makelovenotporn.tv, which I had the opportunity to launch at TED. The talk went viral instantly. It drove an extraordinary response to my tiny clunky website that I never anticipated. I realized I'd uncovered a global social issue. I saw an opportunity to do something that I believe in very strongly—the future of business is doing good and making money simultaneously. I saw the opportunity for a big-business solution to this huge, untapped social issue. I always emphasized that Make Love Not Porn is not anti-porn because the issue isn't porn. The issue is that we don't talk about sex in the real world.

DM: Why don't we?

I took a massive leap into the unkown. From there, everything I've done has been a complete and total accident.

CG: Three reasons, actually. The first is centuries of repression, religion, and sociocultural dynamics in every country. This issue is the same everywhere. The second is the patriarchy because historically every institution has been male dominated and women have not had the opportunity to apply their lens to sex and sexuality. Third, there aren't enough people like me; society makes it extraordinarily difficult to disrupt cultural narratives around sex. Many people have tried and given up because of the huge barriers you face. You need people like me who don't stop no matter what.

DM: What type of porn is more conducive to real life?

CG: I'm doing something that is not porn. At makelovenotporn.tv, we are building the world's only social sex platform. We are socializing sex to make it socially acceptable and socially shareable. Our tagline is "Pro-sex, pro-porn, pro-knowing the difference." Our mission is one thing only, which is to help make it easier for the world to talk about sex—by which I mean parents to kids, teachers to schools, everyone to everyone—and therefore as socially shareable as anything else we share on Facebook, Tumblr, Twitter, Instagram.

Makelovenotporn.tv is an entirely user-generated crowdsourced video-sharing platform that celebrates real-world sex. We're very clear what we mean by this. We're not porn. We're not amateur. We're building a whole new category of social sex. Our competition isn't porn. It's Facebook and YouTube, if Facebook and YouTube allowed sexual self-expression and self-identification. Social sex videos at Make Love Not Porn are not about performing for the camera. They're just about doing what you do on every other social platform, which is capturing what goes on in the real world as it happens in all of its funny, messy, wonderful, beautiful, ridiculous, spontaneous, glorious humanness. We curate to make sure of that. And we have a revenue-sharing business model, so that half of the income from renting and streaming videos goes to our contributors.

DM: How do you think watching porn of any sort changes or influences intimacy?

CG: Again, the issue isn't porn. The issue is that we don't talk about sex. Many things are laid at porn's door that should be laid instead at society's. It is not porn's job to educate about sex. Porn is entertainment. It is society's job to open up to talking openly and honestly about sex in order to encourage and facilitate better human sexual relationships.

Because we don't talk about sex, it is an area of rampant insecurity for every single one of us. We all get very vulnerable when we get naked. Sexual egos are very fragile. People therefore find it bizarrely difficult to talk about sex with the people they're actually having it with while they're actually having it. Because you are terrified in that situation that if you say anything about what is going on, you will potentially hurt the other person's feelings, you'll put them off, you'll derail the encounter and the entire relationship—but at the same time you want to please your partner. Everybody wants to be good in bed. Nobody knows exactly what that means. You will seize your cues on how to do that from anywhere you can. If the only cues you've ever been given are from porn because your parents never talked to you, your school didn't speak to you, your friends aren't honest, then those are the cues you will take. Porn in the abstract is a very useful concept to help you explore your sexuality and discover there are other people like you, but it is no substitute for open, honest dialogue around sex.

What we do at *Make Love Not Porn* in socializing sex is more important now than ever before because in a world where grabbing women by the pussy is presidentially endorsed, opening up around sex encourages good sexual values. Many of us are born into environments where our families bring us up to have good manners, a work ethic, a sense of responsibility. Nobody ever brings us up to behave well in bed. They should, because empathy, sensitivity, generosity, kindness, and honesty are as important there as they are in every other area of our lives. When we are open enough to teach children good sexual values from day one and that there is a standard of behavior everyone should be adhering to, we cease to bring up Brock Turners. We end rape culture. When we take the shame and embarrassment out of sex, when we normalize sex, we end sexual harassment, sexual abuse, sexual violence—all things where perpetrators rely on the shame and embarrassment that we've imbued to sex to make sure their victims never speak up.

DM: You're very public about the fact that you date younger men. That you never wanted to be married. Never wanted to have children. Why do you want everybody to know?

CG: I'm very public about all of those things because we don't have enough role models, for both women and men, who demonstrate you can diverge from society's expectations and still be extraordinarily happy. I want to demonstrate that it is absolutely possible to pause and question whether marriage is for you, whether children are for you, whether even relationships are for you.

DM: With *Forbes*, you recently hosted a series of webinars giving women actionable advice on how to ask for raises, how to position themselves for promotions, and how to be seen as leaders within their agencies and creative departments. You said, "Never give away anything for free." Why do women do that?

CG: We are taught to undervalue ourselves from the moment we're born. A lot of my coaching is about getting women to realize that people value you at the value you seem to put on yourself. The more highly you value something, the more highly everybody else will value it as well. Nobody values anything they get for free.

DM: You also say, "Be totally unashamed about wanting to make a shit ton of money." What is the difference in the way men and women are conditioned to think about money?

CG: Boys are brought up to work and earn money. You want to make as much money as possible. Women are brought up to think that a man is a financial strategy. You get married and that's it. That is fatal. Fortunately, there are many female entrepreneurs out there now building platforms and businesses that are absolutely eradicating that. We don't get taken seriously until we get taken seriously financially.

Women, you owe it to the rest of us to be determined to make an absolute, goddamn, fucking shit ton of money. My advice is to ask for the highest amount you can utter out loud without actually bursting out laughing. Separate to the obvious benefit to you, there is importance to this: when the senior management of your company looks at that Excel spreadsheet of company salaries, seeing that women are paid less than men translates to being lesser than men. Putting up with lower salaries is saying to management and business that we are less good than men. Also, you've got to make a huge amount of money so you can invest it in the rest of us female founders and help women get to where we all want to be, together.

DM: You alluded before to the fear of what other people think. I know that I am often paralyzed by that very thought, "What will somebody think?" I feel ashamed about something that I want to do or something that I wish I could achieve. What advice can you give anyone listening to this podcast about how to move forward in life without that obstacle standing in the way?

CG: I encourage people to think about this in a different way. Everything in life starts with you and your values. Look into yourself and identify who you are, what you stand for, what you believe in, what you value. Decide what your values are and then operate according to them. It makes life so much easier. Life still throws you all the shit it always will, but you know exactly how to respond to any given situation in a way that is true to you. You are only ever doing things that are true to you. That is what matters, not what other people think of you. Many people are living lives that they don't really want to be living. They are doing things they don't want to be doing. They are in relationships they don't want to be in because of what other people think. You will never live the life that you really want to live if you care what other people think. You will never be truly happy if you care what other people think. Know who you are. Know what you want to do. Live accordingly, and do not give a damn what anybody else thinks.

"**If** a piece of art can really move you, then it can move many, many, many people.

We're all different, but we are—at our core—quite similar."

BRIAN KOPPELMAN

writer, director, producer, and showrunner

January 23, 2017

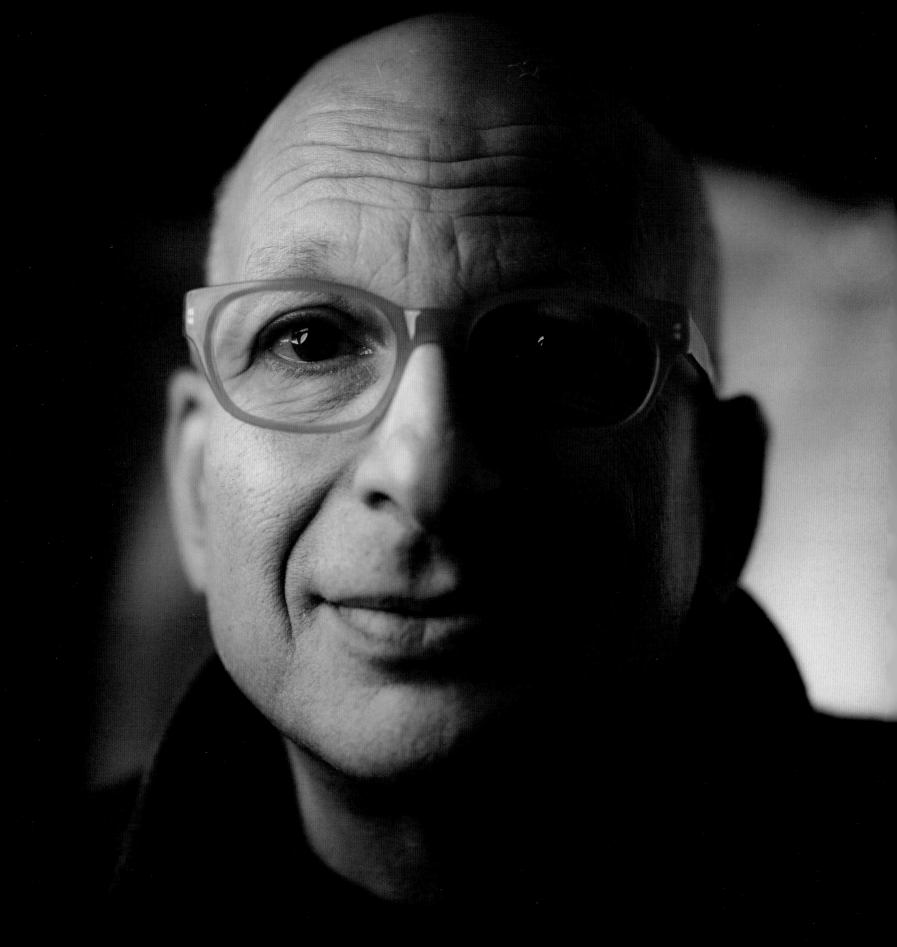

February 6, 2017

S E T H

In the world of marketing, Seth Godin is an established and savvy master.

Search his name in Google and you'll find the top result is his blog, though if you search on Amazon you'll find his now twenty books, all of which have been bestsellers, including the seminal how-to business book *Purple Cow: Transform Your Business by Being Remarkable.* But he's much more than a marketer. His range of professional experience is dizzying—from early jobs at the vanguard of the tech world in the 1980s and 1990s to six and a half years convincing test prep pioneer Stanley Kaplan to produce a course of SAT books. He writes trenchantly about work and personal growth in titles like *Tribes: We Need You to Lead Us* and *Linchpin: Are You Indispensable?* In this interview, we talked about his career, making things that transform people, his book *What Does It Sound Like When You Change Your Mind?*, overcoming fears, inventing professions, and how to live in a difficult political moment.

G O D I N

DM: I understand that when you were fourteen you started your first business. What kind of business was it?

SG: There was an auction on public television to raise money for the station, and I had access to a mainframe computer that could print out biorhythm charts. The idea was that I would auction off customized biorhythm charts to raise money for the public TV station. I raised a few hundred dollars, but then it turned out people wanted more of the charts so I started selling them. Then someone sent me a note saying that something horrible had happened on their triple zero day—their dog had died—and could I do one for everyone in their family? I thought, wow, people believe this. I decided at that point that I was done. When I was seventeen and I started working at a summer camp in Canada, I was able to help ten-year-olds and twelve-year-olds see the world differently, deal with their fear, sit up straight, breathe, and paddle a canoe. I think I've been trying to do the same thing ever since.

DM: You taught style canoeing at this camp in Canada for thirty years off and on.

SG: It was an extraordinary privilege. The sport was invented by a guy who taught my teacher how to do it. And understanding what that lineage means—understanding that you can invent a new way of being out of whole cloth. To say, "Let me invent the profession, let me teach other people how to do the profession, let me find people who need a light turned on or someone to point them in a different direction." It's about showing up and doing the work and sitting with people who need you to help them become the people who will teach the next people.

DM: I read that when you were teaching style canoeing, you discovered that the best way to attract people was to help them connect with their dreams. How did you even recognize that was something you could do?

SG: Why would anyone have trouble articulating and reaching their dream? It's a four-letter word.

DM: Fear.

SG: If you find the fear, you can see it, you can acknowledge it, you can learn to dance with it. You cannot make it go away. It turns out that adults are really good at hiding fear. Kids haven't had as much practice, so starting with twelve-year-olds was useful because they gave themselves away. No twelve-year-old actually dreams of paddling a canoe all the way across the lake and back by themselves. What they dream of is agency. What they dream of is being seen. And those are the

We're bad at experiencing the future and we're excellent at experiencing the present. And something that might be good in the future feels bad today, so we get stuck.

two things they're also afraid of. So if you can figure out how to get in early in the arc of your engagement with someone, and figure out where the fear is, and figure out how to help someone learn to dance with it, then you've got a shot at teaching them design thinking. Then you've got a shot at teaching them a practice that will enable them to chop wood and carry water on their way to doing the work that they seek to do.

DM: I think if we felt intrinsically that we could rely on ourselves, we wouldn't have as much fear of uncertainty or of the unknown.

SG: Let me add one level around that: it's not that we can't rely on ourselves, it's that we don't believe we can rely on ourselves. All of this is about narrative. When you're four, you're not really sure you can run across the street before a car would hit you. Now we are, right? We can rely on ourselves to do that.

DM: After studying computer science and philosophy at Tufts University, you got an MBA from Stanford. I understand that one of your first jobs out of business school was working at software startup Spinnaker Software, which helped invent educational computer games in the early 1980s. Later, in one week in 1986, you married your now-wife, Helene, quit your job, moved to New York City, and started your own company. What was going on in your life to inspire so much change in a seven-day period?

SG: I'm very uncomfortable talking about this journey of mine because I don't think it's that interesting. But I do think all of us have stories like this. What we say we want is a regular step-wise progression from here to exactly where we want to go. But the stories we tell ourselves about our pasts are never that. It's not what we actually want in a life well lived. It's all the things that were nutty, that happened too fast or with little foresight, or just by the skin of the teeth—those are the things that we add up. In the moment you say, "Oh, my goodness, I wish

things were calmer." But, in fact, when we look back and ask, "How did this happen?" it happened because of the things that were chaotic.

DM: I think that what makes those stories fascinating is when you're honest about the chaos, as you have been. You've been very transparent about all the rejection letters and all the failure and fear.

SG: Here's the story that happened after that dramatic seven days. I'm unemployed, I have a lovely bride, and I'm living in a law school dorm in New York City. Then I read an article about Faith Popcorn and BrainReserve. For most marketers in those days, twenty-five or thirty years ago, she was a rock star because she got to work on interesting projects. I said, "That'll solve my problem. I'll just work four weeks a year for Faith Popcorn." I got on my bike and rode to Macy's, where I had my resume gift-wrapped. I took a $20 bill and ripped it in half, and I put it in a gift card and wrote, "I'll give you the other half when we meet." I rode my bike over to the office of Faith Popcorn's BrainReserve and dropped it off. When I got back to the dorm on Mercer Street, the phone's ringing. It's Faith. She says, "This is great, how soon can you be here?" I take a cab and race back up to her offices, and she and her partner are sitting there. She says, "How much time do you have? We have nine, maybe ten, projects for you to work on. We'll call you tomorrow." They don't call me tomorrow. They don't call me for a week. They don't call me for months.

So as I'm living my life, everywhere I go I buy the ugliest postcard I can find and mail it to Faith. "Hi, I'm in Cleveland working on this project, wish you were here." Two years go by, I'm struggling with business and I need a Christmas gift because it's how you build a brand. I'm out of money, so I buy a $19 laminating machine and use FileMaker Pro to turn my address book into nicely typeset cards with the address and name of each person on them—I make luggage tags for all the people in my database. A week later, the phone rings. It's Faith Popcorn. She says, "Seth, BrainReserve doesn't have a space in it, you did it wrong. Could you make me a new set of luggage tags, please?" Fast forward five, ten years, and I get a call from her former partner, who has a book and wants my help. He says, "Can I meet with you?" I tell him, "You can meet with me, but you're going to have to answer a couple questions." He says, "I have no idea what happened but I can tell you this: there was a special bulletin board in the office just for your postcards."

DM: You've written that the people who turn you down usually have a reason, but they're almost certainly not telling you why.

SG: One of the most important things that anyone who sells ideas needs to learn is Zig Ziglar's concept of the obligating question. Zig was the greatest sales trainer who ever lived, and he was a friend of mine. Zig said after the third objection, you stop answering objections. If the person says it's too expensive, it's the wrong color, you answer those. But if they're still saying no, then you ask the obligating question. "So you're saying this is wrong. If we could fix that problem, are you okay to go ahead today?" The answer to the obligating question is rarely "yes." If the person says, "Well, then I'd have to blah-blah-blah," then you understand that their objection isn't actually the objection. It's just a good way to get you to go away. Buying anything is really frightening. It involves change, change involves risk, risk involves death. So saying "yes" and dying are only an inch apart from each other.

DM: You've talked a lot about risk and you've talked about how for many years you were two weeks away from bankruptcy and you would do whatever it took to make payroll. What kept you going?

SG: I told myself at the time that I could get a job as a bank teller. And I realized how horrible my life would become if I was going to be a bank teller for the next thirty years. I'm pretty much unmanageable as a human, and I knew that. I think telling myself I could get a job helped me go forward because I realized I had a choice. It's when we're stuck with what feels like no choice that it's super easy to give up. Since the biorhythm days, I've always believed that the thing I'm offering is worth more than it costs. That's very important. I never felt like anyone was doing me a favor by buying from me. I felt like I was doing them a favor by making something for them at a discount.

DM: Where does that self-esteem come from? You experienced nine hundred rejection letters before you got your first non-rejection letter.

SG: I think it wasn't about me, it was about my product. My ideas were separate from me. I didn't feel like I was selling me. It's about deciding to raise myself, after I left the house, in a culture and an environment of generous persistence. No one who wants to compete athletically skips the gym or doesn't consider their diet. You train. I was listening for one hour, two hours, three hours a day to these audiotapes that were training me.

DM: You've been putting quite a lot of material online for people to read and learn from. And you've written many books. You've been blogging every day since January 15, 2002.

SG: First it was an email newsletter that I started in 1991, and then it evolved into something else. I started it for a very simple reason. I thought I had something to say, but I also believed that by frequently and generously showing up in front of people who wanted to hear from me, I would earn their trust. And if I earned their trust, it would be easier for me to solve their problems.

DM: Your blog is followed by hundreds of thousands of people. And as you put it, back when the algorithm was interesting, the blog was ranked by *Technorati* as the number one blog in the world written by a single individual. But you've stated that while we are hooked on data, there's one group that doesn't need more data. How do you assess the impact of your work without statistics? Is the anecdotal enough?

SG: The scholar Michael Schrage coined this great concept—that what every great artist does and what every great market does is make someone change. Who are you trying to change? How have you changed them? That's what we do. Harley-Davidson is a great brand. Why? Because they turned disconnected outsiders into respected insiders. Apple Computer turned people with bad taste about digital goods into people with good taste about digital goods. And once you have good taste, then you are hooked on the whole thing. If no one's being changed, then you're instantly replaceable.

DM: Your latest book is a collection of your last four years of writing. It's eighteen pounds and eight hundred pages long, and it's a wonderful journey through ideas, art, and provocation. The title of the book, *What Does It Sound Like When You Change Your Mind?* was taken from a post of the same name that you wrote on March 4, 2014, wherein you recall a mistake that you had made.

SG: It was a small mistake, but it cost me $40 billion. Starting an Internet company in 1989 or 1990, as we were doing, was insane. There was no World Wide Web, it was just Archie and Veronica and email. When we eventually raised money from Fred Wilson, we had to persuade the VCs that email was going to be a thing. That's how early we were. And then the web came along. I looked at it and concluded: this is just like Prodigy, except it's slower and uglier and there's no business model. We're not interested. So we didn't start Yahoo!

and we didn't start Altavista or Google. We didn't start Groupon or Facebook. We ignored it. It took me months of not seeing it, even when people who worked for me and who I trusted were beginning to see it. And then one day a noise went off in my head and then we shifted gears. What would it mean to my self-esteem and to my short-term life for me to admit that I was wrong and start doing something else?

DM: Why are people so afraid of doing that?

SG: We're bad at experiencing the future and we're excellent at experiencing the present. And something that might be good in the future feels bad today, so we get stuck.

DM: In a piece titled "Contempt is contagious," you declare that the only emotion that spreads more reliably than contempt is panic. You also talk in your book and on your blog about what kind of energy you bring into any situation. Are you generating enthusiasm and generosity and kindness? Or are you draining the oxygen out of a room? When you're draining the oxygen out of the room, you are somehow igniting contempt and panic.

SG: Reciprocity is very deep within us and within our culture. Someone opens a door for you, and you feel like it's your turn to open the next door. It works positively, but it also works negatively. If someone treats you with contempt and dehumanizes you, that breaks the connection between the two of you. It's very difficult to respond rather than react. That contempt cycle spirals.

Great teachers throughout history have taught us that the braver, stronger, kinder person breaks the cycle. Now the problem with mass culture is it's different than two people standing at a revolving door because it's lots and lots of people. And then when you add to it the fact that the media makes a living by spreading panic and escalating contempt, we have a real problem. We have to figure out as humans how to choose not to consume that. And as marketers, I think we have to make the choice not to pay for it. It's not easy. As James Murphy said, "The best way to complain is to make things." And what we have to figure out is how to disconnect ourselves from the circle of fear and the circle of contempt and settle down and make something that matters instead.

"**A**rt

has that incredibly envious position

of not having to do anything.

It can just be.

It doesn't have to function

in any way or form.

But every piece of design does."

STEFAN SAGMEISTER

graphic designer

November 22, 2009

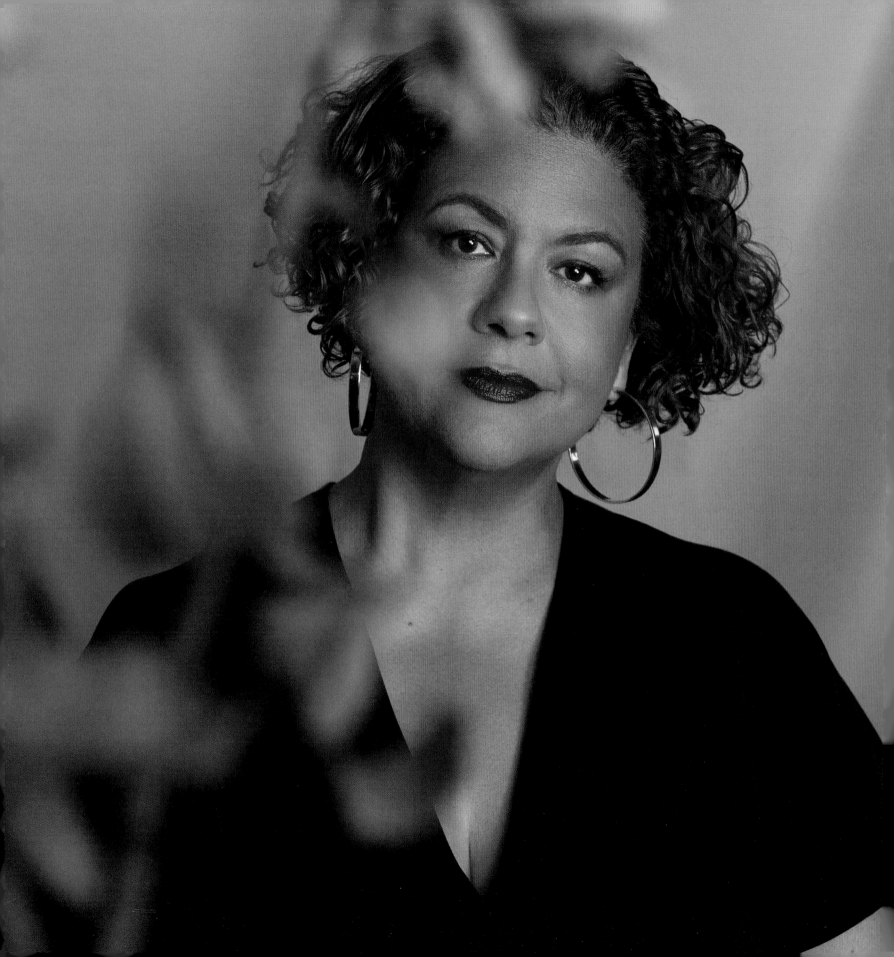

ELIZABETH

In 2009, at President Barack Obama's first inauguration, Elizabeth Alexander read a poem she wrote for the occasion,

"Praise Song for the Day." It was a high point in her celebrated and prolific career as a poet, essayist, playwright, and academic. She taught at Yale for many years, and now she's teaching at Columbia in New York City, where she was born. In 2012 her husband, the painter Ficre Ghebreyesus, suddenly and unexpectedly died, and her memoir, *The Light of the World*, is a moving portrayal of open-hearted love. She joined me to talk about art, love, how death makes us think about what we truly value, and to share the stories and craft behind her poems.

ALEXANDER

DM: Elizabeth, you were born in Harlem but grew up in Washington, D.C. I understand you had so little greenery in your early life that the first time you were placed on the grass to crawl around, you started weeping.

EA: It's true, or so my mother tells that story. I lived in Harlem for not even two years before we moved to Washington, but that's where my parents came from, and it was close to their sense of self. What it meant to be from that storied and extraordinary place, and what it meant to be a city person, was always a point of pride that was central to who I think of myself to be.

DM: Your mother was a teacher of African American women's history at George Washington University, and your father was the U.S. Secretary of the Army. When you were twelve years old, your father ran for mayor in what was the first-ever mayoral election held in D.C., in 1974. What was it like being out in the street campaigning with your dad at that time?

EA: Back then, Washington, D.C., was almost 80 percent African American. It was a city with a lot of Black history, a lot of Black empowerment, a lot of global Black ideology. "Chocolate City," that's what it was called. It was an international city because of the embassies, and also Black international because of Howard University. There was a way that we understood ourselves as mighty, in that regard, and yet Washington, D.C. is sometimes called "The Last Colony" since there is still taxation without federal representation. So imagine, that mayoral election was the first time the city got to say who their mayor is. There were a lot of big ideas associated with my father's run, and I liked being out in the street. I loved having all of these beautiful, idealistic people in our home. During the campaign there was always a pot of chili on the stove and people thinking about what electoral politics could mean for folks.

DM: You studied ballet as a child?

EA: I did. So we must speak of Adele, my mother. She insisted that I take ballet, and every time I wanted to quit she had this amazing way of keeping me going. You repeat and repeat and repeat, and eventually you can put it together and make something beautiful and understand it as an expressive art. It was what I loved, and I was very good at it, but being very good at it did not mean being good enough to do it. You can devote yourself so thoroughly to something, and love something so thoroughly, but what does it mean to really be an artist? It's serious business.

DM: Do you think that discipline that you were able to cultivate as a ballet dancer is something that has impacted your writing?

EA: It has impacted how I approach every single thing I do. It's about finding a discipline and understanding that you don't get immediate payback, and also that just because you've got a little flare with a certain shape of poem or turn of phrase, you have to resist defaulting to that. You have to become well rounded in your discipline. You can be a kicker and not a good jumper, but then you've got to learn to be a better jumper.

DM: You went to Yale University for your undergraduate degree, and I understand that in your senior year you studied with the writer John Hersey, who you credited with helping you find your fictive voice. But when you got to Boston University as a postgrad, the poet Derek Walcott looked at your diary and saw your potential in poetry. How did he see your diary?

EA: Because I showed it to him. I was admitted into the fiction track, but I knew that the great poet Derek Walcott, whose work I read, was why I was there. So I went to his office, and I knew I couldn't show him stories. I had a diary, and in it I had what I called at the time "word clouds"—it's a phrase that the poet Garrett Hongo uses. But I had to show him something. He thumbed through the diary and said, "Well, here's this." On a legal pad he had, he wrote one of them out with line breaks and said, "See, you're writing poems, but you don't know how to break lines, and that's what makes it a poem."

DM: You said that he gave you a huge gift: he took that cluster of words and he lineated it. How do you think he saw that?

EA: One of the things he used to say was, "The poem will find its shape, the line will find itself." He would say, "Start writing and you will see what the natural shape of this poem is." It was very mystifying to me when I first heard it, but I find it to be absolutely true.

DM: In 1991 you began teaching at the University of Chicago, and it was there that you first met Barack Obama, who was a senior lecturer at the school's law school. What was it like first meeting him?

EA: I remember experiencing him as the smartest person I'd ever met. Just the quality of the machine—his swiftness, connectivity, the way he put things together. He was a great person, but it was certainly outside of the imagination to think of the U.S. presidency.

DM: In 1996 you met and courted your late husband, Ficre, over a period of six weeks. At the end of your first

week together, you were certain you were going to get married. How could you be so certain?

EA: I'd been around the block and so had he, and sometimes to know what's not right—that's a way of knowing what is right. My father had said something profound to me at a bad moment. He said, "Never forget that that man is not the only person who loves you, that you are loved, that love is love, so don't think that the romantic object is the only source." It was a very useful thing to come into a relationship already knowing that I was loved.

DM: Ficre's mother once described him as "a man who has drunk his water, which is the best kind of man to marry, one who's experienced in the world but who is sated, one who has had enough, who needs no more than his wife and children and work and home." Yet he had come to this country when he was sixteen years old to escape the chaos in East Africa. How was he able to be this man who has "drunk his water"?

EA: Sometimes I look at siblings, and one is broken and one is resilient. Why? One is light and beautiful and non-conflictual, and the other one makes trouble everywhere. Some of it is mysterious. Ficre came from Eritrea; he left a civil war that had characterized his whole life. His brother died in the war. He left on foot for Sudan, then Italy, then Germany, then for the United States. He was resilient, and he was always a very creative person—he had that ability to see beauty or to make beauty from what you live through.

DM: On January 20, 2009, you recited your poem "Praise Song for the Day" at the presidential inauguration of Barack Obama. How did you find out you had been chosen?

EA: There had only been three poets ever to do this, so I wasn't sure if there was going to be a poet, but one morning I got a call from someone on the Transition Committee. It was released to the press at the same moment, so my computer just started rattling and shaking and the emails started. It was on December 18 that I found out, so then began the very intensive task of writing the poem.

DM: When did you know it was ready?

EA: Ficre is the only person to whom I've ever shown my work regularly, and he was this mystical, Ouija board-y kind of person with the poems. We had a ritual where I would read it to him and then he would read it to me, which was always very useful because when someone reads your poems back you can hear things in them.

Then I would give it to him again and he would take his finger and land somewhere and say, "That's the problem." I like to be perfect and fabulous, so I'd be pissed off every time that it wasn't done. He was always right in a very intuitive way. With this poem, we did our method five hundred times. Then one day he was sitting on the steps and he gave the thumbs up—which was very funny because he's not American, and it's very out of character to see an East African man giving the thumbs up. That was the greatest thing that he could have said, and he was right, he was right.

You can devote yourself so thoroughly to something, and love something so thoroughly, but what does it mean to really be an artist? It's serious business.

DM: You wrote about your experience of reading at the inauguration in *The New Yorker.* You brought your family, but your husband insisted that your father should be sitting with you on the stage with the president—not because he had spent his life advocating for racial justice, but because he felt that people needed to look up on that stage and see his white hair. Why was that important to him?

EA: My father has fought for racial justice and human equality his whole life. He was a very close advisor to President Johnson during the Civil Rights years, and he was just a man of thirty, thirty-one at the time. All of the work that he's done has been about knowing that people go to work every day, about what it means to give people more egalitarian work opportunities. He's a fighter of a generation that has kicked down doors everywhere they've gone. So it was about his life experiences as being emblematic of a generation of warriors and also about understanding that this moment in American history was not just about the generation in the middle, but about all of those people who would never have had the chance to be president of the United States but helped get us to that place.

DM: In April 2012, just a few days after his fiftieth birthday, Ficre unexpectedly and tragically passed away. In 2015 you published a stunning memoir titled *The Light of the World,* which was a finalist for the 2016 Pulitzer Prize. What made you decide to share your story in this way?

EA: I never understood this about my writing before, but it was how I knew what I was living through. It was how I knew I was alive. It was how I knew I was somehow sentient. I did not know what fugue state I was in, and I wrote without looking at it. I was writing and writing and writing and my beloved book agent, Faith Childs, told me that an editor approached her who knew what happened and asked if I might be writing. I said I am, but I'm not writing a book. It felt almost shameful to think about this as anything that would be a product in any way because there was the question of my children—what does it mean to my children to share this? At the end of a very intensive not even one-year period, there was a book that is as much my children's as it is Ficre's gift to me because he believed in me as an artist more than anybody. It's unfortunate that there was the occasion to write it, but it pulled out of me something that I never would have dreamed I could do.

DM: In the years that you and Ficre were together, you wrote four books of poems, two books of essays, two edited collections, and countless essays and talks. You taught hundreds of young people African American literature and poetry and directed a poetry center. Ficre made over eight hundred paintings and countless photographs and collages. He ran two restaurants, and you also had two sons. Suddenly you're now writing and taking care of your children on your own. How did you even approach the notion of having to do this alone?

EA: I guess I've always believed in what I expressed in "Praise Song for the Day"—this love beyond marital, filial, national. Love that casts a widening pool of light. So while I am a great believer in intimacy between two people, between lovers and spouses, with your children, I also believe—and I came to understand this fulsomely—that we cannot only belong to our romantic units. I've always given out lots of Valentines on Valentine's Day. If people in heterosexual nuclear families think that it's all about them and their shimmering perfection in their homes and that their love can stay there, they are mistaken. You have to belong to more, and then hopefully—this is not why you do it—the village will have your back when you need the village, which we all will at some point.

DM: You said that you didn't want the book to be stuck in memory. What did you mean by that?

EA: Ficre was an extraordinary person, a beautiful person, a rare person, but I would like to think that a good writer could write a compelling portrait of anybody. I felt it could get flattened easily, so what I focused on was telling very precise stories and doing miniature portraits of this person, so that memory itself and rose-colored glasses would not be involved in any way. I tell you first about the terrible thing that happens, but then I quickly tell you this is who these people were and this is how they fell in love, so that if you're going to stay with the book, it's because of the story.

DM: After Ficre died, you stated, "Now I know for sure the soul is an evanescent thing and the body is its temporary container because I saw it. I saw the body with the soul in it, I saw the body with the soul leaving, and I saw the body with the soul gone." How was each stage different?

EA: He had catastrophic heart failure. His heart burst, so he died before he hit the ground. He really was gone, but people worked on him, I worked on him, so he was not pronounced dead until after he'd gone to the hospital. What I can tell you, even knowing that, is that when he was in our home, he was there, he was really in there. And then later, the same body, still warm—he simply wasn't. It is that simple and there's no more detail except for that.

DM: In the book you describe being on the verge of tears for seven months straight all day, every day.

EA: It did feel like crying without end sometimes, but I would wait until the kids left the house. Eventually, it stops and sometimes it comes back. That's the enormity of another human being with whom you make a life and make other human beings, and I think it's also the enormity of what it means if we're lucky to give ourselves to somebody and take in someone a hundred percent. A hundred percent of him is in me, so that is wonderful but that also means that it's never completely over. As my children reach new stages of life, I think, "Where is he?" But then I think, in some way he is still available to us.

DM: One of the things that I love about this book is how you are able, just with words, to create a world that soothes us even while confronting the deepest sadness. You've done this in such a graceful, generous, and soulful way.

EA: Thank you. I realized after having written it that I was also writing about the life we had, which was a life in art. We made stuff every day; we had a house that was filled with food and music and poems and paintings. That was how we lived, that was what we did, and in the book, as in my life, that was where I found meaning, not just comfort.

"In any piece of art—a dance, a manuscript, a book, a piece of fiction, a poem—if you're depicting someone other than your own people, whether it'd be race, or economic status, or nationality, gender, sexuality—when you're an outsider looking in—you might have the tendency to romanticize those others. I think it's important for us to speak from the inside. You speak up. You tell the world who you are, and what you are."

BISA BUTLER

artist

September 7, 2020

PAULA

July 23, 2018

**In the design world,
Paula Scher is
a titan of craft,
a working legend,
a creative guru.**

The Pentagram partner Paula Scher has produced so much iconic work in her career that the abbreviated version of her 2017 monograph, *Paula Scher: Works,* still weighs in at 326 pages. In this interview, Paula pulls back the curtain of her superlative career to reveal that even legends must negotiate social pressure, difficult personalities, and insecurity on the road to success.

SCHER

PS: I grew up in a fairly oppressive period. It was the 1950s, it was the suburbs. That time and place was all about conformity. At the point when I was miserable, I didn't even know I wasn't conforming—I was too young. But I felt like there was something off about me compared to the milieu that I lived in. Drawing was a way of hiding.

DM: You went to college at the Tyler School of Art and Architecture thinking you were going to be a painter, but because you felt that you couldn't really draw, you tried other things. You couldn't throw pots, you knocked your finger out of joint taking a metals class, and you rolled your finger through a printing press. In your junior year, you discovered graphic design.

PS: I actually entered the class to be an illustrator because it was illustration and graphic design in the same class, and I was very frustrated by typography. But the class itself was about ideas. If you could express something, then it was very praiseworthy, so that gave me tremendous confidence. I was terrible at typography then, though.

DM: Until one of your professors told you to illustrate with type.

PS: I couldn't marry illustration and typography, it didn't make any sense to me. You used to buy a hunk of press type and rub the typography down on the paper. There was a common face we all used called Helvetica and it never went with anything I was using. It looked terrible. My professor then said, "Illustrate with type," and I began drawing the type. That's when I started to realize that type had character.

DM: After graduating from Tyler in 1970, you moved to New York City with your portfolio and $50. Your mother said, "Paula, don't do anything like that. That sounds like it takes talent." And your dad thought an art career was nonsense and hated your 1960s lifestyle. How did you survive this?

PS: That stuff makes you strong, actually, and I didn't see any good alternatives. I still feel that if something is difficult but it's what you want to do, then you have to confront it and try to do it because the rest of your life you'll regret not having done it.

DM: Your very first job was working in children's books, followed by a job in the CBS Records promotion department, which I read was like working in the cootie department.

PS: It was the lowest form of graphic designer. People in the cover department didn't talk to you; you were beneath their contempt.

DM: How did you end up getting promoted to record covers, then?

PS: Actually, I was designing ads and I got good at them, and the art director of Atlantic Records, a guy named Bob Defrin, called me up and asked if I wanted to work there. The advertising and cover departments at Atlantic were the same, so I designed twenty-five record covers that year, and then I was hired back to CBS to be the East Coast art director of covers. To not be a cootie, you have to walk around the block, and when you come back you're not a cootie anymore.

DM: For the next ten years you worked at CBS, and you created 150 covers a year. You said that one of the most important things you learned while working in the music industry was how to explain your work to others and get people to appreciate what you were doing. But you also said that famous people at the time mostly treated you like a hairdresser. How were you able to persuade them to choose the work you wanted even while they were perceiving you as a figurative hairdresser?

PS: It depended upon who the recording artist was. The pop stars were rough, and I used to be very accommodating because that's what I did for the company. But then there'd be a jazz artist or somebody who was dropped from the label, and I would have control over the work and I did good work. Of the 150 covers I did every year, maybe five were really good. I was playing the numbers, but I figured out how I could make what I wanted to make and how I could also be effective in my job.

DM: What advice would you give to young people about developing the ability to explain, defend, and promote their work?

PS: I fear that young people don't have that opportunity very often because they're working for somebody else. But if they're working for somebody who explains their work very well, they can pick up a lot. And maybe when they have direct interactions with their clients, they can begin to defend and explain why something is terrific and why it shouldn't be changed.

DM: In 1982 you took a very big risk—you left this amazing job at CBS to go out on your own with Terry Koppel. What made you decide to do that?

PS: First of all, the record industry was going down. CDs had entered the fray, and this plastic jewel box with a slip-in piece of paper was not great as a canvas for design. Another thing was mass layoffs. But the real reason I left was I wanted to make something that wasn't square. I wanted to be a magazine art director. I wanted to make something that had pages that turned. But I couldn't get a job as a magazine art director because I didn't have any magazine experience. I didn't want to be somebody's assistant art director after making all this work and running a department, so I thought to go on my own.

When we started our business, we were hot. And the opposite of being hot is being cold. I think that, when you're young, if you soar too fast, you also crash land, because I began getting criticized for my work. It was called "retro" or "bad postmodernism." I was criticized for the Swatch Watch poster.

DM: The Swatch Watch work that you did is articulated beautifully in this extraordinary new book by Unit Editions called *Paula Scher: Works*. Despite getting permission from Herbert Matter's estate to use an image that he had created, you were maligned in the press for what people thought was theft or plagiarism, when in fact it wasn't. It was an homage.

PS: It was also credited.

DM: Why do you think that you were so bullied at that time?

PS: I think that it was an easy target. What was odd about the situation was that the poster generating all the brouhaha was designed in 1984. The attacks started in about 1989. That's five years later. It seemed like there was a real delay in it. And some of it was calculated.

DM: When you started at Pentagram, working there had some difficulties. You had to contend with a lot of male egotism and you were isolated. You were in your early forties, you had no children, and most of your women friends were juggling careers and babies while you were trying to compete and exist with fifteen men. What made you stay?

PS: Three projects. In 1993 I got a call to work on a big identity project for the American Museum of Natural History. Then, almost directly after that, Janet Froelich asked me to redesign the *New York Times Magazine,* and then I got a call from the Public Theater. And they all happened in the same year.

The calls were all for me; they weren't for the Pentagram partners. I don't think I would have gotten the jobs as a single woman alone in my own business because they were too big. But they gave me a lot of confidence and they were visible, and it got much easier after that.

DM: Do you think that your male partners perceived you differently after you got those three jobs in a row?

PS: Well, a few of them were pissed off.

DM: Good. So nowadays you balance three major roles at Pentagram: getting business, doing business, and educating. Can you talk a little bit about getting business and doing business? I would imagine that calls come in all day long asking for Paula Scher to design work for numerous organizations.

PS: Sometimes, but not always. Because we don't have a new businessperson who goes out and finds work for us, we essentially get work by being visible. Being visible means doing things like this. It means becoming active in certain parts of the profession, or joining a board, or donating something as a service. Then there's the doing of the work, which takes up time.

DM: You have been celebrated for a long time as the world's greatest female graphic designer.

PS: Isn't that insulting? My partners don't put up with that. I've never heard anybody refer to...

DM: ...the greatest white male graphic designer?

PS: What is that?

DM: So, this new book: I got it, I tore it open, I started reading it. I couldn't stop. And when it came to the end, I wrote an email to you and I said, "Forget this female graphic designer thing, Paula. This book shows that you are the most accomplished graphic designer working today." And it does.

PS: I don't even know how you would rate who's the most accomplished designer. But the idea that you took the sex off of it is great.

DM: You absolutely are somebody who always tells the truth. So how do you do that in a way that your clients almost always find acceptable?

PS: When I'm working with somebody, my expectation of the relationship is that they hired me to help them do the best possible job for them. If they believe that I'm capable of doing that, then we can have an open dialogue. If the politics or the finances of the situation are going south, I will push them and challenge them to get it right.

What do you do when you feel the design is being compromised and they're unwilling to make a change? How do you persuade them to do the right thing?

PS: Well, there isn't really right and wrong in anything. There's only better and worse, and in most cases the client will have looked at a lot of our experiments before we're even selected for an identity. They'll see four to six things sometimes, and they understand the logic and the pros and cons of each one. I would never show anybody something that wasn't viable because that would be terrible for me.

If you've already established that relationship, then there's no point in being indirect about it. When that isn't the relationship, the project fails. And then there's no point in continuing because I'll be frustrated and they'll be frustrated. So sometimes we quit after the first phase because we can tell we just can't stand each other and they should go away and be well someplace else.

There isn't really right and wrong in anything.

DM: Adrian Shaughnessy goes on to say, "Paula Scher's critics look at some of her work, Shake Shack's identity, her long-lived Citibank logo, or her apparently neutral Microsoft work, and see only mainstream commercial design. It's a charge that Scher, ever the contrarian, accepts but with qualifications." My question is: What are the qualifications?

PS: There are groups of designers who think that design has to be in the service of some nobler purpose and not for corporate America. I don't agree with that because most people confront corporate America all day long, and I think that a designer's responsibility is to elevate the expectation of what something should be. I'm very proud of my work for Shake Shack because it elevated a whole area of fast food and it forces McDonald's to do a better job. If you're not doing that work as a designer and you have disdain for that work, then somebody worse will do it and that's what we'll all live with.

DM: One thing that I've quoted you on many, many times, is the notion that people don't hire very expensive or accomplished brand designers because of how accomplished they are. It's because they know how to navigate through the politics. And you do that brilliantly.

PS: If I go to the dentist, I don't tell the dentist how to fix my tooth. That would be presumptuous. But I don't mean I'm just the client's dentist. I mean my job is to help them make themselves understandable and recognizable to audiences, and I know how to do that. And if they've hired me, I can help them and we can work very well together. If they can do it better than me, then they should hire somebody else.

DM: In addition to your prolific work as a designer, you're also a painter and you have gallery exhibits and commissions all over the world. And you said that time and financial structure are the main differences between your practices as a designer and as a painter. So what about the time part?

PS: It doesn't take very long to design something, and the way I make my paintings, they're very laborious and they take a very long time. And design is done quickly, running around with other assistants and help and it's highly social, whereas I paint by myself in a room. So they're very opposite things.

Designers have a hard time with this. They'll say, "My work is art," meaning "My work is fine art." And they use it as a value judgment. I don't see it that way. I think that the difference between fine art and design is financial.

There's only better and worse.

If you're a fine artist, you go wherever you go and you make whatever you're going to make, you determine what you're going to make, and if you're lucky you stick it in a gallery someplace or you just look at it by yourself. If you're a designer, you more or less engage with a client and there is a criteria for the work. There's a size for it. There's a materiality that's an expectation. There's a series of set parameters. Design and fine art are not the same act and they're not approached the same way, but they don't require different value judgments. There are terrific pieces of graphic design and there are crappy pieces of fine art and vice versa, and it's a measure of nothing. It's just a different structure of how you're making and performing and acting as a person who makes things.

DM: In one extremely heartfelt section of *Works,* Adrian describes a characteristic of yours that he suspects is rarely seen by the people you work with. He shares that you had revealed doubts and uncertainties about your work. Do you still experience insecurity?

PS: Of course.

DM: Why?

PS: Why not?

DM: Do you approach insecurity differently in light of your accomplishments? What do you tell yourself when you're feeling insecure?

PS: It's time to reinvent—to find another way to do something.

DM: Do you see insecurity as sort of a trigger to start doing something else?

PS: Well, it's usually indicating to me that I'm getting sloppy and lazy and I feel bad about something. I think that careers are this surrealist staircase. When you're in your twenties and you're starting out, the risers are very tall but the treads are very shallow, because you don't know anything yet. You make a lot of discoveries.

Then you get into your thirties, and you become a bit of a professional: the treads are a little deeper and the risers a little more shallow; you're still making discoveries but not to the degree you were in your twenties. By your forties, you're not only a pro, you're an aging pro. The treads get a lot longer, and you find that you're competing for work against people younger than you, and that's scary.

You have to make another jump in your fifties, where the risers are very low and the treads are very, very deep. It doesn't matter that you're not growing because the thing about your fifties is you have power. And the reason you have power in your fifties is that all your clients are always your age. So all those people you grew up with, they've got power too, and they can give you some decent work. You may not have the innovation sensibilities or arrogance that you had when you were young, but you have a lot of knowledge. Your sixties is just the fifties extended until the end, when you don't know what the hell's going on anyway.

DM: You state in the monograph that you felt so much of what has happened to you has been happenstance. Why is that?

PS: There's your character, there's your fortitude, there's your stick-to-itiveness. Those are part of me, I admit that. But I moved to New York and got a job in the record industry, and that was incredibly lucky. The idea that Woody Pirtle would ask me to join Pentagram. It's not luck that they were already talking about me, but the fact that I was available and was ready to do that at that time was incredibly lucky. I was ready for the Public Theater, I wanted that job. But that job happening at that particular time in my career was amazing.

DM: What do you attribute to the longevity of the work, then? What you've been doing for the Public Theater is still as good as it was, if not better than, when you first started.

PS: I stayed with it. That I'll take credit for. In retrospect, I realize how much we all get to contribute to the culture, though we don't really think about it. It's more about the joy of pushing something or making something that might be new, but once you've made it, you're onto the next thing. That that thing hung around is magic.

ANNE

Anne Lamott covers some big topics in her writing.

Alcoholism and drug addiction, single motherhood, faith and depression, just to name a few. Yet she does it with grace and humor, and book by book she has built a large audience of dedicated fans, including me. In this interview we discussed her origins, her road to sobriety, and her many beloved books.

LAMOTT

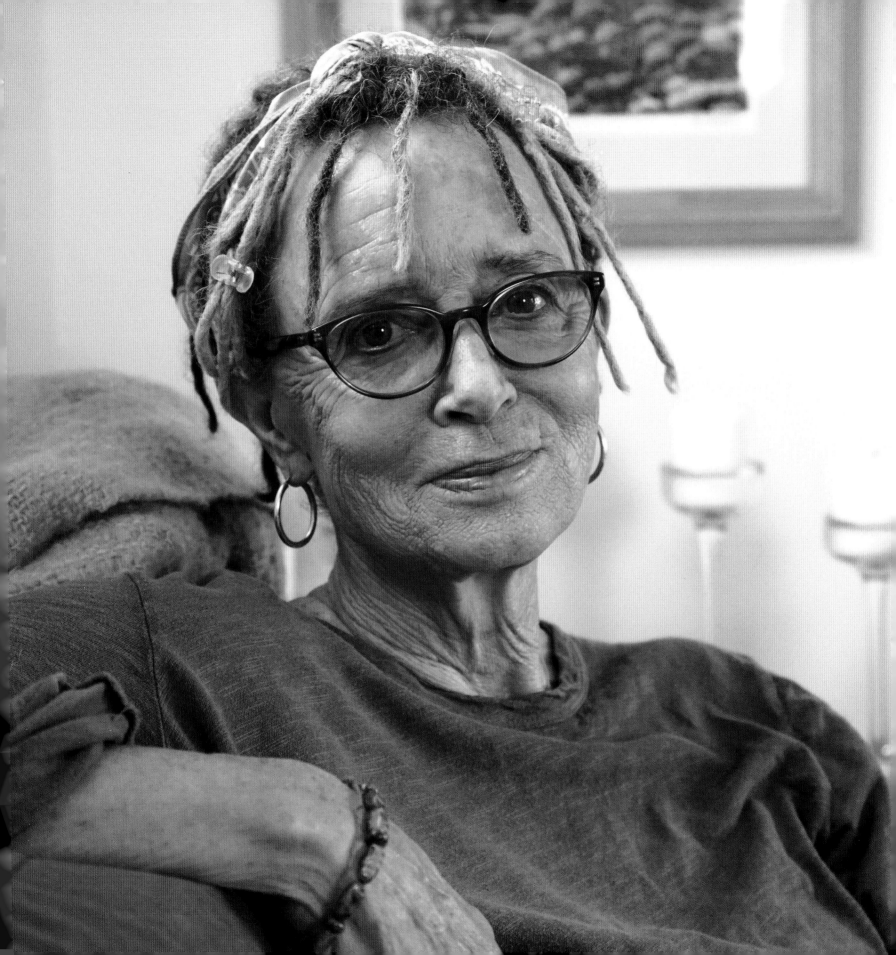

DM: You were born in San Francisco, the daughter of nonfiction writer and novelist Kenneth Lamott, and your mother, Dorothy, a journalist and lawyer. In *Stitches: A Handbook on Meaning, Hope, and Repair,* you write, "If you were raised in the 1950s or 1960s, and grasped how scary the world could be, in Birmingham, Vietnam and the house on the corner where the daddy drank, you were diagnosed as being the overly sensitive child. There were entire books written on the subject of the overly sensitive child. What the term meant was that you noticed how unhappy or crazy your parents were. Also, you worried about global starvation, animals at the pound who didn't get adopted, and smog." You've described yourself as a sensitive child. What did you make of the world around you at that time?

AL: Well, I held my breath. I came into the world a certain way, and that was pretty tightly wired. Grown-ups were always helpfully saying that I should get thicker skin—i.e., be a completely different child than the one I was. I had a big open heart, and no one thought to say that's a beautiful way to be. We were intellectuals and atheists, so I was encouraged to figure things out and scoff at anybody with any religious faith or paths. Over time, I became a super-achiever and that seemed to help everybody; it kept me from feeling too panicky most of the time because I studied and I achieved. I learned a lot of tools for surviving the stress that you encounter in a very unhappy family. You make them happy. You become mommy's big-girl helper and daddy's wife. So I was dancing as fast as I could, which I think brought on the migraines. I had to unlearn all of these survival tools in order to have a vibrant, vital sense of any immediacy at all in the world because I was always trying to stay one step ahead of the abyss.

DM: You've said that your parents were cold and remote and they spoke in clipped phrases of contempt for each other. What motivated you to become the overachiever as opposed to the self-destructor?

AL: Well, I was both. I was an overachiever and everything I did was self-destructive. I didn't know how to eat. I lived on sugar when I was small and tiny. When I became a teenager and a fleshy, sturdy person, I started trying to diet. And then I became bulimic. It was a double life because I was a tennis star and I made sure that everyone loved me, and inside I felt that I was insane or defective. But you can get addicted to that people-pleasing. I had a lot of growing up to do and a lot of

healing to do. I got sober when I was thirty-two, which was thirty-two years ago. And that was when I began to look at how hard I was on myself and how I was still holding my breath.

DM: I know when you were about age six, you wanted to be Pippi Longstocking. How come?

AL: She had such a joy for living and adventure—everything I wanted to be. She loved life. She was free and she was silly and she was adventurous and she was on top of her game.

DM: You mentioned that your parents were atheists and yet today you write often about your strong faith, which you said would horrify your father if he were still alive. And I understand that as a kid you would pray in secret. How did you find faith while growing up in the absence of it?

AL: Well, one of the reasons my father hated Christians so much was that he'd been raised by Presbyterian missionaries in Tokyo, right after World War I. He found them so cold and so without love; they didn't hold him and love him and tell him they loved him. So, of course, I ended up being a Presbyterian, but way after he died. In the meantime, I always found religious friends. My first best friend was the daughter of a Christian Science healer. I was so hungry for talk of love and God and that I was a precious and perfect child of God. No one at our house thought that, apparently. We were close to a family that was Jewish. It was okay to be Jewish because you're born that way, so you weren't judged harshly by my parents. And you could be Buddhist because so many of the great avant-garde writers in the late 1950s and early 1960s were Buddhists. And I tried to be a Buddhist and to find my niche in the Eastern traditions, but I accidentally ended up being a Christian.

DM: What are your spiritual beliefs now?

AL: I'm a Christian, though I'll just take truth wherever I can find it. I was changed and blessed by Ram Dass when I was about twenty through his very early books like *Be Here Now*. I was in San Francisco for the 1960s, and *Be Here Now* had a huge impact on me. He was so funny and honest and neurotic. His position was and is that he never got over a single neurosis. But he learned to be a man of love and a man of awareness. His whole pitch was that we are loving awareness—whoever you are, wherever you come from. Many years ago, he said, "When all is said and done, we're really just walking each other home." And I live by that. It's in *Almost Everything*

and probably the last five books because it helps me so much. I remember going to see him—everybody was on the floor and it felt like coming home. It blew my mind in the best possible way, where it made truth a lot more spacious than I'd known it to be. I thought I was raised to believe that we were right and to study more so that you could be even more right. And that you could impress even cooler people and more educated people with how right and how brilliant you were. And he gave me permission to breathe, to pay attention and breathe and love and serve.

DM: Had you had other experiences like that?

AL: I'd had a couple of profound experiences at Goucher College with spirituality and religion, but more than anything, more than even being a writer when I grew up, I wanted to not be a Christian. That was the most important thing because of my parents and my love for my father. And then, a few years after he died, I think I was thirty-one—I found this church at thirty-one and converted drunk. It was a funky little church with buckled linoleum, and I started going over because I was just lost. I'd get greasy food at the flea market then I'd wander over. But they didn't hassle me. They didn't try to get me to take classes or to sign on. Little by little I came to feel this love and affinity of Jesus, and I finally got worn down by my own insanity and damage and self-destruction—and I loved these people and they loved me. They loved me and they let me sit there and be there with them. They asked nothing of me and I caved.

DM: Do you think that that's ultimately what helped you become sober?

AL: I'm not sure because church didn't help me get sober—Jesus I don't think helped me get sober. I think what helped was hitting a catastrophic bottom and being so sick and tired of being sick and tired. Every morning I would have a little bit of speed or something. Take a hot shower and go for a run. And I was young enough that I could, and then I'd have a lot of coffee and smoke the marijuana that I smoked from the time I was about fourteen. I could pull it off, and, all of a sudden, I couldn't pull it off anymore. So I did what you do when you've run out of good ideas and you just can't bear it one more day. I called a friend who was sober and I said, "I think I need help."

DM: You said that when you were drinking, "No matter how conceited I got, I'd still have the self-esteem of a pig."

How did you come out of that? What was the sense of hope you had at that time that you could be different?

AL: Well, I still live in the same county where I was born, so all my relatives were all there. I was loved out of all sense of proportion. I'd had three books out. I had done really well for my age. I was young and I was funny and I was adorable and everyone loved me. And then on the inside I was Swiss cheese. In the Christian tradition, they'd call it sin sick. I had these two different worlds I was inhabiting, but the world where I was loved and appreciated and esteemed and publishing and running and playing tennis, that was working.

When you're an alcoholic or a drug addict, you're always explaining to yourself how things got away from you. But then I was telling myself I had this faith and this path of seeking spiritual truth wherever I could find it. So I had God and I had goodness and I had the beginnings of believing that I was loved even though my life was so crazy, even though I was having tiny boundary issues with men and other people's men. I was in public a lot really drunk.

DM: I read that you didn't want to get sober.

AL: Of course I didn't want to get sober. I loved being drunk. I loved drinking. I loved smoking weed. I loved speed. I did a ton of meth. I weighed no pounds, which I liked. I weighed twenty-five pounds less than I do now. And I loved being stoned. I've had the feeling that I was really connecting with God. When you're drunk or stoned and you're embarrassing yourself or your family, it's like you sit down with the disease and you chat with the disease about the disease and you neck with the disease and you realize that other people are trying to control you and then you become bitter and resentful and then you drink because they're stupid and they're not free, they're not artists.

But finally you wake up some morning and nothing is different than it was three days ago or three weeks ago. And you're just done. And you say, "This has got to stop." It was very painful, and I was afraid that I wouldn't be able to write anymore because the tradition of American writers and probably all writers is that you should be an alcoholic. I didn't write for eight or nine months, and then I wrote the best book of my life, which was *All New People.* It turned out that getting sober was like getting my windows washed. I was thirty-two and I had to learn very basic stuff about how to be a grown-up.

DM: In 1994 you released what is considered one of the greatest writing manuals of all time, *Bird by Bird: Some Instructions on Writing and Life.* The title is a reference to advice that your father gave your brother when he was working on an overwhelming book report about birds. Your dad advised him to simply take it bird by bird.

AL: "Bird by bird" meant my dad had told my fourth-grade brother, "Read about pelicans and then write a paragraph about them in your own words and then illustrate it. And then we're going to do chickadees. Just read about them and then write me a paragraph in your own words." That had always been helpful to people. It's funny, because the publisher didn't want it; they thought a novel made more sense because I'd made my name as a novelist. But I'd been giving these talks for years called "Every Single Thing I Know About Writing," mostly at writing conferences. Almost no one at writing conferences sells their book or gets an agent, then makes a lot of money and then has really good self-esteem for the rest of their life. I wanted to tell people who wanted to be writers that the writing could give them everything they wanted. Publication wouldn't. I had seven months to write it because they didn't want it. And this book just poured out of me because I'd been giving these talks forever.

DM: Anne, of your own artistic journey and how you found yourself, you've said, "I had to stop living unconsciously, as if I had all the time in the world. The love and good in the wild and the peace and creation that are you will reveal themselves, but it's harder when they have to catch up to you in roadrunner mode." That scared me because I'm always running and I don't want to lose that. So, you stopped, and you wasted more time "as a radical act," and you stared off into space. How did you create this new mode of living?

AL: It's natural that you live as if you have all the time in the world, but when you get a little bit older, like when my dad died, boy, did that pop my balloon. I started to realize you have no idea how long you're going to live and you have to get serious about not squandering this one precious life—as far as we know—that you're going to have.

I realized there were all these lessons that I'd learned as a child. Say you were sitting at the table in the kitchen and you were just thinking about something that had gone on at school or at a friend's family. You'd be sitting there working at clay trying to figure out what it all meant, and a grownup would come along and they'd say, "Don't you have anything to do? Is your homework done?" You were discouraged from spacing out and thinking. But if you're going to be a writer, you have to space out—you have to stare off into the middle distance like a cat. There were so, so many rules that I had to unlearn if I wanted to be okay.

DM: In the preludes to your book *Almost Everything: Notes on Hope,* you write, "Love and goodness and the world's beauty and humanity are the reasons we have hope. Yet no matter how much we recycle, believe in our Priuses, and abide by our local laws, we see that our beauty is being destroyed, crushed by greed and cruel stupidity. And we also see love and tender hearts carry the day. Fear, against all odds, leads to community, to bravery and right action, and these give us hope." Are you feeling any optimism in these times, or how can you feel optimism in these times?

AL: I always feel optimism, and I also am absolutely stunned and horrified by the Trump administration. There, I said it. I wasn't going to name names, but I'm horrified. I'm angry. I march. I send money to organizations that I hope will bring it all down. And I feel just like everybody does about it. And I also remember, as a radical act, how much is really beautiful and touching and precious. I'm getting married and I'll be sixty-five. I have an unbelievably fabulous grandchild who lives with us half-time. I love that I just got a shingles vaccine. The people who love me are great people. On down days, I can believe what I secretly think about myself or I can believe how my friends see me, which is as a magical, brilliant, tenderhearted person. It's a choice to have hope.

DM: You've written, "You have to make mistakes to find out who you aren't. You take the action, and the insight follows. You don't think your way into becoming yourself." Does hope help?

AL: I think one of the reasons I have so much hope is I see that, against all odds, we can change. We do change. Our hearts soften. We start to be much, much more affectionate with ourselves and forgiving. We learn radical self-care. And we change. How far I have come—from the most anxious and terrified people-pleasing person to now, where I really don't care—gives me hope. And I forgive myself. I still might get very cross with myself or frustrated or whatever, but it might last an hour now instead of entire decades.

"Please

don't think you have to have any of it figured out or that you have to be any certain place at any certain age.

It's such a lie.

And it will rob you of the ability to be present in the moment, and that this is the only place where the good stuff is, where the juice is, where the creative energy is, where the healing is, and where the possibility is."

CHANI NICHOLAS

astrologer and writer

January 28, 2020

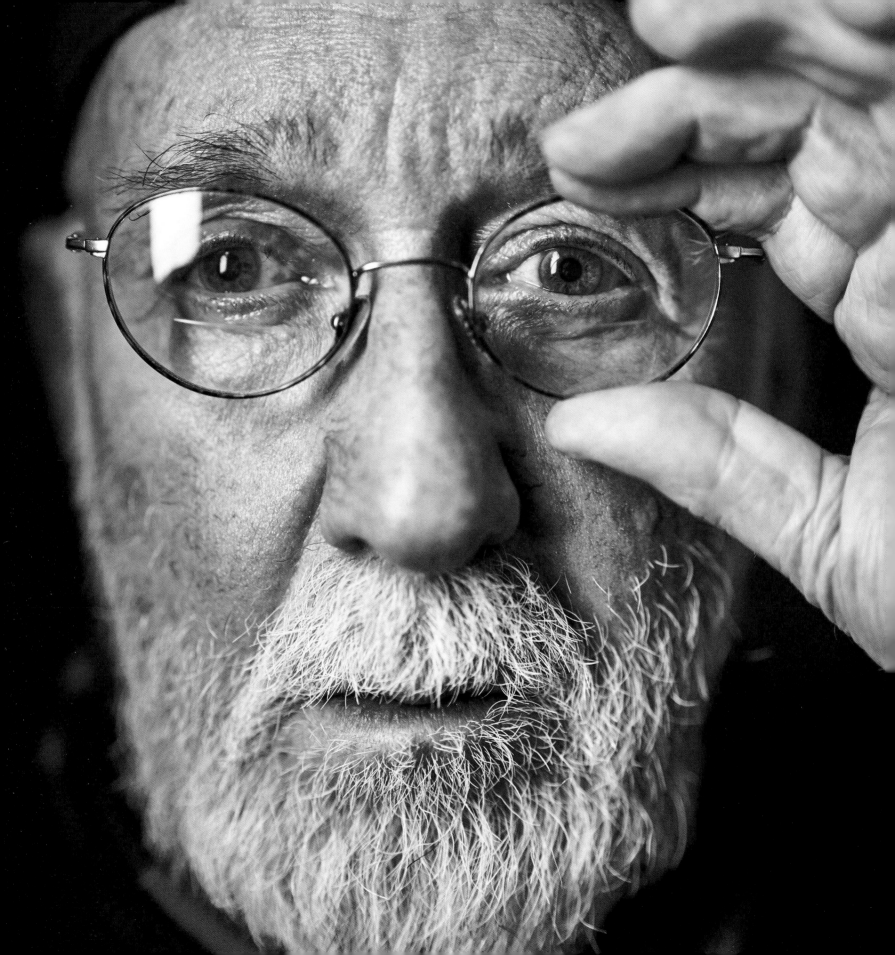

ALBERT

Albert Watson first came to fame in 1970 and has become one of the world's most successful and prolific photographers.

He has photographed every supermodel of the past three decades, Orkney's standing stones, Chairman Mao's limo, the most iconic photograph of Steve Jobs ever taken, the first monkey in space, death-row convicts in Louisiana, a dominatrix in Las Vegas, the astronauts of Apollo 14, Elvis Presley's gold lamé suit, and hundreds of artists, celebrities, royalty, and cultural leaders.

WATSON

DM As one of the most accomplished photographers alive today, it might surprise some to learn you were born without vision in your right eye.

AW A lot of photographers, when they look through the camera, they only use one eye. If I don't think about my vision it seems normal. If I concentrate on my vision, I'm very aware I don't have sight on the right side.

DM You talked about the revelation you felt when you took that first picture and that sense of wanting to do it over and over again. I believe that that came when your wife bought you a Fuji automatic fixed-lens camera for your twenty-first birthday.

AW We didn't have two pennies. She bought this little camera that was like $30, but I used it. I learned to use and maximize what it was capable of. It was great to have my own camera.

DM When it came to picking up the art of photography, you've said you were old school and felt a responsibility to learn the technical side of the craft, which was painful for you, and your advice to young photographers today is get the technical thing out of the way and become so fluent in it that there is no stress. Why was it painful at first?

AW Because I'm not really a technical person. The thing that didn't work for me, that a lot of photographers still do, is they send their work out to a digital house, and the digital house does some work on it, sends it back. It was very important to be on the equipment with these very good technicians. Working with them is a great way to control the image because I'm primarily interested in printing. Obviously, in the early years, I was interested in darkroom, what you would call silver gelatin printing, and so I was used to traditional darkroom, and it gave me a great advantage moving into digital. I was able to apply a lot of the philosophy of printmaking into the digital world, then into Photoshop.

DM How long did it take to feel like you'd mastered each phase of the technical skills of your craft?

AW It took ten, twelve, fourteen years before I became really fluent, where I saw a vision of something, I had a creative idea, then I had the skills to carry out that idea. I'm always learning. Even to this day, I'm always ready for a surprise, something that doesn't work

DM Do you like the act of learning?

AW Of course. There's always something new that comes along that you want to try. I had an interesting exchange with Steve Jobs, where I had one thing prepared for him. I thought it was something he would respond to and it would be easy for him to do. I said, "I would like you to give fairly strong eye contact, and I want you to imagine you are across a table from a lot of people that disagree with you, but you know you are right." He just...of course, he smiled and he said, "Oh, that's easy. That's every day for me." Then I did that shot of Steve Jobs, and it was just really coming from the preparation of that one line. Sometimes it can be that simple.

> DM But you have to know an awful lot to come up with that one line.

> > AW I did on Steve Jobs. The Steve Jobs book wasn't out, but every single damn thing that I could get on Steve Jobs, I read.

> DM When you were with Steve Jobs, you had thirty minutes. With other artists or other subjects, do you have multiple scenes where you ask them to think about something specific or is it just that one?

> > AW Think of the movie poster for *Kill Bill,* with Uma Thurman, when she's in the yellow jumpsuit. She was wearing all these costumes, but they were pretty sure the one that they wanted was the yellow jumpsuit. Someone said you have to do action, and I was fine with that because that was the nature of *Kill Bill,* but I thought in a simple portrait of her I would be able to get something quite cool, maybe even a tiny bit sinister.

> > DM There does seem to be layers of emotionality to your greatest photos, where you see different aspects all at the same time.

> > AW A lot of it is timing. You have to be really watching what they're doing.

> DM You've said that the photographer's best weapon is not his lighting and not the camera, it's his communication skills. How are you able to get a subject to open up and to feel comfortable and to trust you?

> AW I try to be, whenever possible, completely honest with the person and very natural. I'm never tricking a person into something. I'm always very direct of what I'm hoping to get and what I get. I'm also, often when the person goes into hair and makeup, in there watching them have their hair and makeup done. Sometimes they are communicating with the hairdresser or the makeup artist, and I can feel something, see something in their openness. From the minute they enter the studio, I try to have them in front of me.

DM When you were shooting Renée Zellweger, you asked her to concentrate on two different emotions, on being both angry and also in love. How do you get somebody to do that?

AW This is where actors are invaluable. It doesn't take a lot of planning, you just have to have a plan.

DM What do you think the audience sees when they see that Renée Zellweger photograph?

AW I hope they manage to see some weight in the picture because I did that.

DM You have photographed more than just celebrities. You did a remarkable series on Las Vegas where you featured a professional dominatrix. You shot her for fourteen hours straight in a Budget Suites hotel and emerged with an incredible photo of a leg in a high heel, atop a stove. Discussing that photo, you've said that you've been asked, "Did you plan to do that in the shoot?" And your response was, "No, I was in an environment that allowed it to happen. When you see something like that, you have to latch onto it right away." Do you know in the moment, or do you ultimately discover that after, when you look at all the film?

AW In a project like that, you're not advertising a bottle of water, you're not advertising a car. Nobody's saying, "Make sure you see my Cartier watch. Make sure that I see the earrings." You're in a free fall of creativity. You can do anything.

DM Discussing the craft of photography and aging, you said, "With photographers, you're relying sometimes on techniques that you've learned and then later on in life you're using those techniques to make pictures, and that's what transforms them sometimes. That's what makes them richer, because you have that experience."

AW Photographers are lucky or unlucky because people are always saying, "Will you ever retire?" And of course, you don't retire. You just keep on trucking along. You like to fantasize a photographer is like a wine—the longer you leave it in the bottle, the better it gets. I like the new work particularly, and I'm glad I did the old work. We're going up a ladder, onward and upward. You always want to get up that ladder and see what you can do.

"Our

ability to create

is what separates us."

CHASE JARVIS

entrepreneur, photographer,
and writer

February 4, 2019

MARILYN

Marilyn Minter straddles the line between commercial and fine art as skillfully as anyone since Andy Warhol.

Her photorealistic depictions of the female body are simultaneously beautiful, erotic, and disturbing. Minter has also applied her talent and distinctive point of view to the political arena. In this interview we talk about living, working, and making art through a pandemic, the impacts of trauma, and working with Pamela Anderson and Miley Cyrus.

MINTER

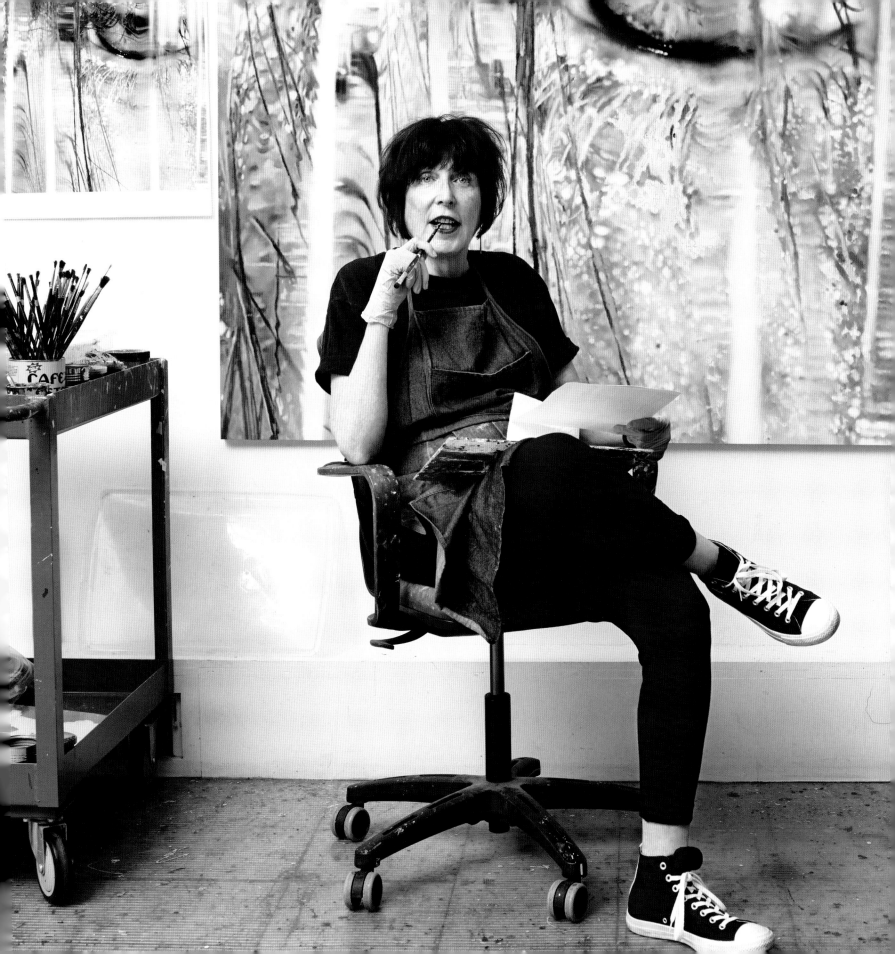

DM: You've described the Florida of your childhood as the land of no parents. What do you mean by that?

MM: A lot of people went to Florida to escape, especially in south Florida—everyone came from someplace else. It was a real party scene. I had a drug-addict mother and an alcoholic father who was also a compulsive gambler. I think we moved to Miami so he could go to Havana and gamble.

DM: Your parents split up when you were about eight years old, and your dad left your mother for a friend of hers. Same thing happened to me at about the same time in my life. My father left my mother for my mom's best friend, who lived down the block.

MM: Wow, so you know the trauma is pretty extreme.

DM: It is extreme.

MM: All the family members are split, but also all the friends take sides, and my mother was ostracized.

DM: It sounds like you were raising yourself even before that.

MM: If you went into my house, you knew there was something wrong with this picture immediately, even when I was a little girl.

DM: By the time you got to high school, you were what you've described as a really bad girl. You got into trouble for confronting your teachers about their racism.

MM: I was appalled. We were raised by very racist, anti-Semitic, anti-Arab, anti-everything people who were a disgrace to their families, and it felt so wrong to me. I got sent to the dean of students' office once a week, and I skipped school all the time and went to the beach. There were bad kids that were poor, and then there were the middle-class bad kids, and I was essentially the leader of middle-class bad kids.

DM: Given your upbringing, where did your moral compass come from?

MM: My brothers and I wonder why we were such liberals in this really backward environment, and I don't know. I've always been crazed by injustice, and I was called names growing up all the time. I was a bad kid. I mean to say I was a bad kid because I had a drug-addict mother, but I was the worst kind of kid you could have if you were a drug addict because I was uncontrollable. I would stay out all night and make her frantic.

DM: Did you have a sense then that you could be successful?

MM: I knew I had a vision and I knew I was smarter than other people, but I was born on drugs, my mother never breastfed, and I still don't know arithmetic to this day. I could memorize anything because that was my way to survive. But I always knew I had something to say, even though I didn't have any encouragement whatsoever. I made art anyway because it gave me too much pleasure, whether anyone was going to look at it or not.

DM: You attended the University of Florida, Gainesville, where you created a series of black-and-white photographs you had taken of your mother smoking and grooming herself at home in her nightgown. The legendary photographer Diane Arbus visited your school and hated everything she saw by the other students, which consisted of romantic pictures of seashells and the sky and so forth. When one of your teachers showed Arbus a contact sheet of your photos of your mother, she loved them. What was that like for you?

MM: My school was in very conservative Gainesville, and when I first brought the proof sheet to class, everybody was going, "Oh, my god, that's your mother?" And waves of shame came over me, and I thought, "I'm not going to show these anymore." The teacher didn't think they were terrible, but my peers were shocked by them. I didn't print them until 1995. In 1971, when I was in grad school, Diane died, and that's when I found out who she was. She was in *Life*. I didn't know she was an important artist before that.

DM: You hid the photos for twenty-five years in a drawer.

MM: Yes.

DM: After you graduated from Gainesville, you went to Syracuse University for an MFA. While you were in school, I understand you called the Factory to learn how to make silkscreens.

MM: The phone number of the Factory was printed in the back pages of this radical magazine *Evergreen Review*. And they told me how, yes. I was always ambitious.

DM: Yet you've said that at that point in your life you had no confidence.

MM: No, none.

DM: That's such an interesting combination of attributes. No confidence but ambitious.

MM: I didn't have any problem at all asking for help. I had to build my resume, so to speak. It was that moment in feminism where I decided there was no difference between males and females. I was determined to be able to do anything a guy could do. I guess it was the late 1980s. I was always concerned why male artists got so much more attention than female artists. I know the work of Joan Mitchell, and I thought, "Damn, she kicks ass. She's so good. Why isn't she getting the same

amount of attention as somebody like de Kooning?" So, with that background I went to see this great show of Mike Kelley at Metro Pictures. The paintings were sewed onto stuffed animals; he made banners out of felt and a decoupage chest of drawers of lips and mouths. He was mining a thirteen-year-old girl's brain: mall culture and glitters and rainbows. I thought, "Wow, this is this intellectual man. If a woman artist had made any of this work, she would get no attention whatsoever."

I always knew I had something to say, even though I didn't have any encouragement whatsoever. I made art anyway because it gave me too much pleasure, whether anyone was going to look at it or not.

DM: She would have been ostracized.

MM: Ostracized or considered a sensualist. And I thought, "This is so brilliant. He's making a picture of a thing that we all know exists." People were enraptured by it. So I considered, "What is the one subject that women have never touched because if a woman made this, she'd be totally dismissed—but if a man made it, it changed the meaning?" My response: "What happens if a woman takes sexual imagery and owns it and makes reproductions from it?" And that's how I got into working with porn. I only knew about two other artists, Judy Bernstein and Carolee Schneemann—I thought of them as working with soft-core porn. So I thought, "It'll only work if I do cum shots, really hardcore things." At that point, cum shots were hardcore, so I made this one series

called *Porn Grid.* What I was doing was repurposing imagery from an abusive history and trying to make the case that nobody has politically correct fantasies and that it's time for women to make images for their own amusement and their own pleasure. They should own the production of sexual imagery.

It frightened the hell out of everybody, and it still does. I was asking these questions, and since I didn't have any answers—which I still don't, by the way—that was my downfall because it was so easy to categorize me as a traitor to feminism. I basically got kicked out of the art world. My show closed a week early. I couldn't sell anything. I had excoriating reviews in the *Times* and the *Village Voice.* I was devastated because I wasn't trying to be titillating.

DM: What do you think people were actually upset about?

MM: I think they were upset that women tried to own this power because women have always known they have this power over men. Men are frightened by it and other women are frightened by it. Owning the production of it is still so scary to everyone, but I'm an old lady so I can get away with it. If young girls work with sexual imagery, they still experience terrible slut-shaming in the art world today.

DM: You think it's more acceptable that you do it now because of your age?

MM: I always use this as an example: there's this very famous Robert Mapplethorpe photograph of Louise Bourgeois holding this giant dildo and she's grinning and everyone thinks she's adorable. But if a young beautiful artist had that…you can see both men and women get terrified of that.

DM: Do you think it has more to do with these slightly more tolerant times in terms of sexuality, marriage equality, and so forth?

MM: The beauty of today is that we're finally looking at everybody who's been ignored, who's been written out. The language didn't exist for women to work with sexual imagery either. We were unladylike if we even knew about it. I'm not an intellectual, but this was very wrong somehow. The art world is a bunch of clichés, and when I showed the pictures of my mother in 1995, all of a sudden I was taken seriously because, "She comes from dysfunction, so she must be a good artist." A friend of mine at the Drawing Center asked me for installations, so I made giant photos. I made them in a blueprint press and pinned them to the wall, and the response was amazing. And that's when I was let back

in. This is how I feel about the creative process: that if you listen to your inner vision, you make art from that place, then sooner or later the zeitgeist hits you. I'm one of the lucky ones because it hit me when I was alive.

DM: Marilyn, you've said that when a work of art upsets you, it's probably good. Why is that?

MM: Most artists make art that looks like art, and when you see something that's another language, it's a fresh vision. It's threatening somehow too. I want to run away from it because it's taking up space that I could have had. And I know that that's absolutely the worst attitude you could possibly have with new art. I want to grow and change, and I don't think that happens without difficult conversations and embracing what looks strange to me or what's going to disrupt my world or leave me behind somehow. But I work through all of that, and I think, "Okay, the best thing I can do is go embrace that artist and tell them how great he or she is." And then the envy disappears. I get rid of the poison that way.

DM: How do you think women can own the production of sexual imagery?

MM: When I was first doing this work, there were very few sex workers who were intellectualizing it. There were so many more porn stars who were being exploited or were porn addicts. But Pamela Anderson owned the production. She said, "I'm not a dancer, I'm not a singer, I'm not an actress. I'm a pinup." And she did very well.

DM: The work you've done in the last decade includes a series of portraits with Pamela Anderson, Lady Gaga, and Miley Cyrus. For all of the photographs, you asked them to cut their hair into bangs. How come?

MM: Pam was forty, and I wanted to make her look innocent because she is such a hardcore animal-rights activist. I thought it was so interesting that she took on that cause while she was a pinup. I wanted to show that empathy. I thought if I cut her bangs and took all her makeup off, I could create that kind of innocence that identifies with animal cruelty and suffering. And with Gaga, it was right before *A Star Is Born* came out, and she had no makeup on. She was reinventing herself, and I was working with her at a moment when she wasn't paying attention. She didn't think I could see her and she let her guard down, and that's the picture I used for the *New York Times.*

DM: You've written about how you always get stressed before you start a new project and feel like you're going to fail. Do you know anybody who thinks everything that they do is great?

MM: I do know people that work from arrogance, but every good artist has self-doubt. I think failure's part of the creative process, and I also think you have to face your fears and make the work.

DM: You've said, "Pleasure is transitory, and you have to find pleasure in being of service or doing activism or helping other individuals. That lasts longer than great sex because even when you have all the things you thought would satisfy you, they never do."

MM: That's been my experience. You get true, real joy out of helping someone, helping others, and fighting injustice. And if I didn't do it, I'd be going crazy right now. It makes me feel that I can make my work.

DM: How are you feeling about our future?

MM: I don't think there's any way, shape, or form we're going to come out of this being the same culture we knew going into it. And hopefully the best-case scenario is that we start to come together as a nation that wants to stay healthy, with clean air and oceans, and mitigate the cruelty that's in the world now. But that's never happened before, so I don't know why it would this time. I don't know what's going to happen.

DM: You are living with your husband and still working. How are you managing your work during this experience of the pandemic?

MM: I'm pretty lucky. We have a house we built upstate, so I can walk around. I'm immunocompromised a little bit, and my husband is too, so we're very careful. But I can work remotely all the time. I'm making art every day. That's a relief. That's where I get true pleasure. I also make art to keep my team alive because those are the people I feel responsible for.

DM: Has your work changed at all in this period?

MM: I'm making some really nasty things. I can't help it.

DM: What kind of nasty things are you making?

MM: Well, I don't think they're that nasty, but what they are is how I'm feeling. Metaphorically, I'm out of breath. It's devastating when you think about what's going to happen in the next while, but I'm not an illustrator. I'm trying to make metaphorical images that mirror what I'm feeling. I don't know what I'm going to do with them, but I'm still making them.

"We

propose using the word
'pussy' instead of vagina.
Vagina comes from the
Latin word for 'sword holder.'
So we basically call our
pussies a thing you put a
penis in. I don't believe
a body exists as an object
of service to the penis."

ZOE MENDELSON

writer and journalist

July 29, 2019

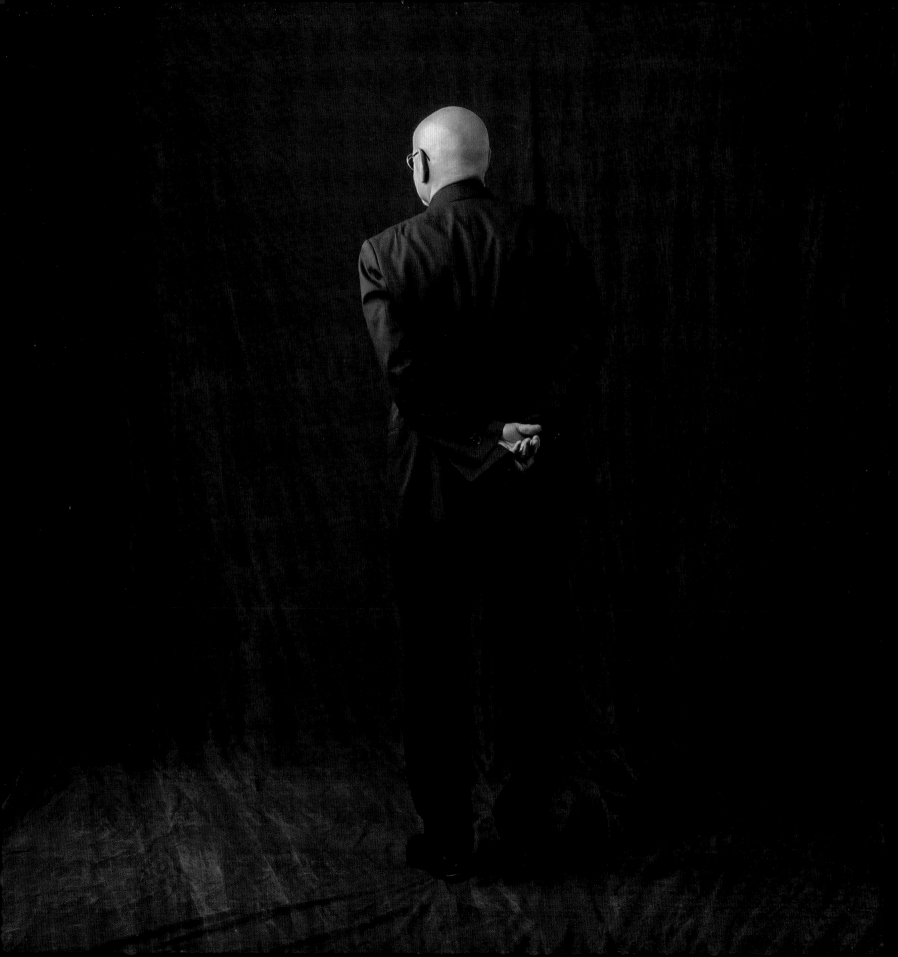

STEVEN

Fourteen Interviews
in Fifteen Years

HELLER

By Zachary Petit

"I actually worked on the very last hot metal page of the *New York Times*," he said, "and it was one of those moments that I wish I had on film because it was a darkened room, one light hanging over the printer's bench...."

Cue the music.

It was 2005 and Debbie Millman was halfway through the very first season of *Design Matters*. Steven Heller was her guest, and time and again, just as the conversation seemed to tip toward catharsis, the music broke in, indicating a commercial break.

"We have so much going on," Millman said, "I might have to do another episode with you, Steve."

Prescient words.

To begin to breach the world of Steven Heller is to be dwarfed by a tower of words—millions of them, piled high. And this could take form quite literally. If you took the more than two hundred books Heller has written, co-written, or edited about design, they would indeed cast a hulking, profound shadow.

To date, with fourteen *Design Matters* interviews, amounting to some 76,000 words—the length of Thomas Pynchon's *Gravity's Rainbow*—Heller is by far the person who has appeared on the show the most since its inception.

When Millman first interviewed Heller, he had banked thirty years as an art director at the *New York Times* and had a mere ninety books under his belt. As he would note in a later episode, "I was cleaning out a closet for a sale and found three books that I forgot I had written."

Why, season after season, all the Heller after Heller? Well, you have to start at the beginning.

Cue the music.

Year after year, the books would continue to pour forth from Heller, and Millman would have him on to talk about them. But it wasn't until 2018, during a live taping at an AIGA Atlanta event—Heller's thirteenth appearance on the show—that Millman held the quintessential biographical *Design Matters* interview with him, tracing his roots all the way back to the kid who grew up in a housing project in New York City, making publications about the state of the world and selling them for a few pennies.

The inspiration for the first edition?

"I had written to Eisenhower to invite him to my house for dinner, and he responded," he said. "But he said he couldn't come. So I got really pissed off, and that was the first takedown [piece]."

Engagement with politics—a through line in all of Heller's work, his thoughts,

and his conversations, not to mention his *Design Matters* interviews—came early. At ten he marched down to volunteer at the Kennedy campaign headquarters, where he stuffed envelopes, among other tasks. (Meanwhile, "I'd go to Nixon headquarters, which was a block away in the Roosevelt Hotel, and I'd get their leaflets, say I'm going to hand them out, take them, and throw them away.")

Heller would encounter Kennedy twice in his budding activist days—perhaps a fitting preface to 2011, when he was awarded the Cooper Hewitt, Smithsonian Design Museum's Design Mind Award at the White House, where he met Michelle Obama. ("We were simpatico for about two-and-a-half minutes.")

He began doing cartoons for underground newspapers and eventually found his way to the *New York Free Press* at seventeen. He also met illustrator Brad Holland.

"He got me interested in making magazines happen and got me interested in illustration and what illustration could say, rather than what it did. What it did was illuminate something that was written. His belief was that illustration had its own life and that it should complement, not supplement."

He worked at *Rock* magazine alongside Patti Smith. He redesigned Warhol's *Interview* and did time at the city's first sex tabloid, *Screw*. He learned design on the streets, in real time.

As Millman pointed out in the interview, Heller had built this resume while still in his late teens to early twenties, which, given the world of publishing, is perhaps not entirely dissimilar from a Horatio Alger novel. ("What I will say," Heller said, "is that I am so damn lucky. There's hardly a thing that I wanted to do that I haven't been able to do except be a British actor.")

Heller enrolled at New York University but was thrown out after he put his philosophy professor in a *Screw* cartoon and refused the school's subsequently mandated therapy sessions. After being reclassified as 1-A—available for military service—during the Vietnam War draft, Heller enrolled at School of Visual Arts, but the legendary illustrator Marshall Arisman threw him out (though two years later, he'd hire Heller to teach at the school, and the two would go on to co-author books together).

It's safe to say he landed on his feet. At twenty-three, the *New York Times* hired him to work on the Op-Ed page. It was to the relief of his family.

"For my parents, oy vey, it's like being a doctor. I mean—the *New York Times*, my son. None of the *Screw* stuff."

And at the *Times*, that's when the books began.

*

The striking thing about reading Millman and Heller's *Gravity's Rainbow* is the sheer amount of joy between the principal characters. They butt heads, delightfully, over Heller's occasional barbs at the craft of branding (though Heller would help Millman develop the School of Visual Arts Masters in Branding program). They geek out over design history, of which Heller is an absolute master (one cannot walk the halls of design history without tripping over his words, his symposiums, his famous articles, his infamous articles—invariably, in the maze of the profession's past, he is ever around every corner). They hit cerebral highs and pop-culture lows, bobbing and weaving with topics branching off and flowing at will, perhaps unlike any other *Design Matters* interview over which Millman masterfully exerts narrative control. As Millman said in 2015, "Steve, one of the things I love most about having you on the show is how many pathways our conversations take."

Interviews over the years have oscillated between the history of teen magazines, the evolution of the swastika as a graphic symbol, Heller's love of velvet lettering, and such anecdotes as when Heller would prank the late design legend Paul Rand on every Jewish Orthodox holiday by calling him up and getting him to answer the phone—a technological malfeasance the religion expressly forbids. "Got you," Heller would say.

As Millman said during the introduction to a 2015 episode, "Each time [Heller has appeared on the show], he's taught me something new and utterly fascinating about the history, practice, and culture of graphic design. Now," she continued, "this won't surprise anyone who knows anything about Steven Heller, but he currently has several new books out, and it's still only spring."

The books.

His first? *Artists' Christmas Cards* (1979), being a collection of exactly that. As Millman noted, there is a joke that Heller has an idea, and by the time his wife, the lettering maestro Louise Fili, awakens, he has a contract for a new book.

As Heller put it, "If I have an idea, I'll wake up, I'll go to the computer, I'll write somebody with the idea, and then bug them until they tell me 'yes.'"

He estimates that he produces ten times as many ideas as there are books. And, as Millman revealed in an episode of *Design Matters*, Heller is the key to how she landed her first book deal. He had passed on an idea that a publisher approached him about, but he recommended Millman in his stead, and thus Millman's *How to Think Like a Great Graphic Designer* was born. ("Which I still maintain is the worst book title of any book ever written," she said.)

If I have an idea, I'll wake up, I'll go to the computer, I'll write somebody with the idea, and then bug them until they tell me "yes."

"There are stories like this, probably a million-fold, of people that Steve has influenced, of people that Steve has helped, of people that Steve has mentored," Millman said in the 2018 *Design Matters* episode. "The way in which you've lived your life, and the generosity in which you've shared your opportunities, is something that I've never witnessed before."

In 2011—perhaps my favorite of the Heller *Design Matters* interviews for its insight into his process and the flow of the conversation—Heller tells Millman he works on ten different books at any given time. They are legion. There are so many, they are arranged in alphabetical chunks on his website. *The Art of Satire. Becoming a Graphic & Digital Designer. Borrowed Design: Use and Abuse of Historical Form. British Modern: Graphic Design between the Wars. Covering PRINT: 75 Covers, 75 Years. Design Cult. The Design Entrepreneur. Design Humor. Edward Gorey. Graphic Style Lab. The Moderns. Stencil Type. The Swastika. Typology.* And on and on.

And all of that is in addition to the *Daily Heller*, his blog on *PRINT* magazine (disclosure: which I edit) that he indeed produces every single weekday, prodigiously, alongside a bevy of articles for media outlets galore.

Heller's 2019 interview drew to a close this way: "Steve, my last question for you is about some of your other upcoming books. You are at 200 now, right? How many books is it?"

"I've stopped counting," Heller deadpanned. Whether his tongue was in his cheek or not is up to the listener.

*

So, why fourteen interviews? It's not like chipping away at some unseen form within a sculpture to reveal the truth, nor is it akin to piecing together a jigsaw puzzle or mosaic. Rather, it's two brilliant minds delightfully at play. It's jazz.

To witness them interacting in person is pure creative alchemy. On the show, as in person, Millman has a knack for drawing out the best of what I dub Hellerisms (and which I discreetly jot down in a notebook when I meet with the pair to kvetch or brainstorm various writing and editing ventures).

What some writers can only produce on the page arrives in real time for Heller. To wit, and utterly devoid of context, from a series of *Design Matters* interviews:

"Design is about what we put into our world, into our culture. Everything we have, everything we do, is designed."

"I think Paul Rand said it because in the world of graphic design or commercial art, being original is not the quintessential virtue. Being good at something, which includes this idea of originality but a very subversive idea of originality, is what's key. Don't go out of your way to be original because you won't be if you go out of your way to do it. It requires a lot more fusion and meshing up of ideas. Be good and maybe out of that goodness will come something that's innovative."

"My idea about design was always that it had to serve a social purpose. The reason I didn't go into advertising was I didn't want to sell something to somebody that they didn't want. The reason I never went into branding was because I didn't want to create a story that was a fictional story about something that had no history."

"History, as we all know, is written by the survivors, and there are certain historical facts that never get covered. And in graphic design, it's fascinating how many things don't get covered until somebody uncovers them.… Some of the things that might go into a history book are ignored because they are so ephemeral. We remember the heroes, and somebody has told us who the heroes are or the heroes themselves have told us who they are."

Heller retired from the *New York Times* after some three decades and has long been associated with School of Visual Arts, where he co-chairs the MFA Design Department, and co-founded the MFA Design Criticism, MPS Branding, MFA Interaction Design and MFA Products of Design programs.

What keeps this design school dropout in design school, plodding on?

In an episode of the show, Heller mentioned one of his program's resounding success stories: Deborah Adler's innovative prescription drug packaging for Target, and later, CVS.

In 2010 during Millman and Heller's fourth interview, during which the pair discussed Heller's new book *POP: How Graphic Design Shapes Popular Culture*, he had this to say:

Heller: "I just love seeing what students come up with, and I really take a great deal of joy, as do you, in them becoming successful, and their lives being changed. And if I could have a little part of that life-changing experience, that makes my life a little more valuable to me. So, it's a schmaltzy way of explaining it, but it's a great thing, and it's not unlike being an art director."

Millman: "In *POP*, you say that teaching is when you are able to make the most insignificant thing viewed as significant. And I think that one of the great, great talents that you've brought to everything that you do is showing the world how both significant and insignificant things can be viewed in the most powerful and significant way. And thank you for doing that for us, Steve."

Heller: "It's always a joy. Are we going to do interview number five?"

Millman: "Oh, absolutely. Are you kidding?"

Cue the music.

uage Lang

Mat ters

By Steven Heller

For a long time after it was peeled away from commercial printing as an affiliated yet independent profession, graphic design was, like a well-behaved child, largely seen but not heard (about) other than among professional circles and in trade publications. It was not viewed as art or cultural phenomenon; and if it was spoken or written about as a serious subject, it probably focused on the business or technique of what was long called commercial art. During the late nineteenth century, type and layout of books, posters, advertisements, newspapers and magazines were the means to make mass communications, they were not artistic ends in themselves.

Eventually, however, interest in what was later dubbed graphic design spilled over onto a larger intellectual stage. Graphic design became a recognized discipline, with a pantheon of innovators and maestros whose views about form and content were illuminating (even entertaining) to hear and read about. Since the early twentieth century, graphic design has generated lots more popular interest and discussion. These days, we who practice it love listening, talking, arguing and nattering about it at lectures, panels, and in books, magazines, blogs and audio/visual media.

When Debbie Millman launched her Internet radio show *Design Matters* sixteen years ago, the period when the web was aggressively taking off as a vast broadcasting platform, she opened a forum for conversing with and listening to designers speak about their work, influences, clients, old techniques, new technologies and eccentric methods; not to mention their professional, social and personal lives. Millman reckoned that if the design community would voluntarily pay conference fees to attend a lecture or workshop where designers would inspire audiences with their show-and-tells, this same audience (and possibly many other interested folks) would be happy to spend an hour a week for free to hear even more about design directly in the comfort of their homes and studios on their computers or iPods.

Her pioneering podcast cleverly titled *Design Matters* has never been a fishing expedition to catch sound bites, and as the show continually evolves Millman has waded ever deeper into the minds, motivations and, of course, work of her subjects.

But what most distinguishes *Design Matters* is its host who lovingly delves into all aspects of design culture. Her style centers on posing questions designed to elicit revelatory and surprising responses from her guests. As with all interviews, Millman discusses recent work as hooks on which to routinely hang juicy themes. She draws out her interviewees in candid ways that neither they nor the audience expect to hear. Each guest is subjected to a fair share of challenging questions, and Millman refuses to feed them flack queries to get predictable responses.

Millman's initial years (now more than 450 episodes) dwelled in the demimonde of graphic, product and industrial designers, photographers, illustrators, typographers and other visual artists, so one might logically assume the title *Design Matters* would limit her scope. You would be wrong. In recent years she has interviewed a range of fiction and nonfiction authors, musicians and composers, scientists and innovators, performers and entertainers of all stripe and backgrounds. It makes sense: *Design Matters* has always been at root about language in general, not just design languages. Maybe Millman's next incarnation could be called *Language Matters*. What do you think?

PART

TRUTH
TELLERS

2

CHRIS WARE

BRENÉ BROWN

ESTHER PEREL

TIM FERRISS

ANAND GIRIDHARADAS

EDEL RODRIGUEZ

CARMEN MARIA MACHADO

LYNDA BARRY

CHANEL MILLER

CHERYL STRAYED

GABRIELLE HAMILTON

CHRIS

**Chris Ware's book *Building Stories*
is really a box.**

It opens up to reveal fourteen beautiful little objects—the future relics of the printing industry. There are broadsheet newspapers, a comic strip, a pamphlet, a magazine, a hardcover, a board game, even a Little Golden Book with that shiny binding. Each object contains a story about the inhabitants of the same three-story Chicago brownstone, from an amputee on the third floor to a bee in the window box. There's no real chronological order to the series, no beginning and no end. It's an ambitious book, more than a decade's worth of work. In this interview, we took a deep dive into the making of this masterpiece.

WARE

CW: That is true. Yes, I did. I just felt really bad that he'd never got any Valentines. I made him one and gave it to my mother to send to him. And she put it in the place where all the letters that are addressed to fictional characters go, which I'm not exactly sure where that is, but clearly he never received it. It's a testament to Charles Schulz's power as a cartoonist, an artist that I think is able to and was able to instill that feeling in readers. I've said this before, but I think he's the first cartoonist to ever create a sense of empathy in his readers for his characters.

DM: When did you first realize that you wanted to be a cartoonist?

CW: When I was a kid, I remember when I was around eleven years old, I submitted some pages to a Charlton comic book that I for some reason thought was soliciting submissions, but I'm pretty sure that wasn't the case. Early on, I was already deluding myself, but I can distinctly recall thinking if I could only have my own comic book, then I would be happy.

DM: You first started publishing comics every week for the Daily Texan when you were in college. It was the country's largest university newspaper. It was there that you began developing Quimby the Mouse and an early version of Jimmy Corrigan, the Smartest Kid on Earth. How did you come up with these characters?

CW: I was specifically trying to create something that was more human and hopefully meaningful and potent. And at the same time I was in art school and trying to do big arty paintings, and I was making sculptures, etc. I was almost leading a double life of making things for my art classes and then doing comics at the same time. I was taking five classes, so frequently I'd have an exam that I'd have to study for or a paper to write and then I'd have to draw my comic strip at the same time. Frequently, it was just whatever I could think of. In a way it was really an effective mental boot camp, trying to create something publishable. Frequently it was not. But fortunately, the editors of the paper didn't really mind.

DM: When you were at school, your work came to the attention of Raw editor Art Spiegelman, most famously known for the graphic novel series Maus. Is it true he just called you one day out of the blue and asked to see some of your work? Did you think it was a prank?

CW: I did. I've been reading his stuff for years. I first found Raw magazine in the back room of the Dragon's Lair, which is the comic shop in Omaha, Nebraska. My grandmother used to drive me there and wait in the car. I would go and look for superhero comics, then the owner started letting me into the back room, where there was the pornography and underground comics. One day, there was a magazine sticking up with the word Raw, and I thought, "Oh boy, I've found it." I pulled it up and it was drawings by Joost Swarte and Ever Meulen. It was not pornography, much to my disappointment, but I bought it anyway. And that's when I first started reading Art's work. He was the editor, along with Françoise Mouly, and that's where he was serializing Maus.

I brought it all with me to college. Art was the single example of someone trying to do something in comics that was genuinely serious and human and powerful. I even remember in my freshman dorm room, folding up pieces of paper to make a Maus-sized pamphlet and thinking, "Okay, now I'm going to start on my graphic novel." I drew maybe a page and a half. I can't even remember what it was about. It was horribly embarrassing. By the time he actually called me, I was living in a $195 a month apartment, in a crappy 1950s building. I don't remember the content of the conversation at all, other than I was stupefied. From that point on, Art and I have been great friends. He's one of my very best friends in the world and I owe him my life. He's a wonderfully generous man.

DM: Let's talk about Building Stories. It's hard to refer to it as a book because it feels it's so much more than a book. It's fourteen individual pieces that tell the remarkable interlocking stories of the residents in a Chicago apartment building. Was there a strategy for how you decided how you were going to organize it? What piece was going to be a book or what was going to be a board game?

CW: Somewhat, but not really. Mostly it was just what felt right to me as I was working on it. Originally, I thought that the book would be fragmented along the lines of the characters within the building itself. But as it became clear that the book was seen entirely through the consciousness of one character, I decided the individual pieces would objectively be told through her. In some cases the stories are actually writing projects that she creates for a creative writing class.

DM: What made you decide to create her as an amputee?

CW: When I was in school, I saw a woman waiting for the bus who was an amputee. I started thinking about what her life was like, what person would she be. I found myself thinking about her a lot. And I thought, well, maybe she'd be an interesting character. On top of that, when I was in school too, some of my teachers told me you can't write about this or that, you can't write about women because then you're colonizing them with your eyes. And that seemed ridiculous to me. That's what writing is about. It's about trying to understand other people. Really, that's what it comes from, is trying to understand other people but also trying to do it in a way that's empathetic. I didn't want to make a big deal about it either.

DM: She's such a rich character; her perspective felt real and authentic. I was recently talking to designer Emily Oberman about you and asked her, "If you had to ask Chris one question, what would it be?" And she wrote back, "Why so sad?"

I just try to capture a feeling of life as I've experienced it. I don't intend it to be sad, but life has generally long stretches of waiting or doubt or anxiety or nervousness. And in my own case, sadness is a part of life.

CW: I just try to capture a feeling of life as I've experienced it. I don't intend it to be sad, but life has generally long stretches of waiting or doubt or anxiety or nervousness. And in my own case, sadness is a part of life. I'm not trying to shy away from it, but I'm not trying to make it exciting either. I just want it to feel real. I really, really admire the movie *Tokyo Story*; I think it's my favorite movie. The second time I watched it, I realized that the director captured this feeling of…life, that we spend so much of our time trying to tamp down and repress, that suddenly I was feeling this sort of heartache or profound sense of empathy or wanting to be good in some way that I remember feeling as a child all the time. And then as I became an adult, I figured out ways of repressing it or setting it aside and somehow making it through life without having that be at the forefront, just because it became too difficult to deal with. If I could even just get one thousandth of a percent of that into what I'm doing, I'd feel that I somehow succeeded at what I was aiming for.

DM: I think that one of the most remarkable characters in *Building Stories* is the building. It has its own soul. The building loves the pitter-patter of pink feet and keeps track of how many people live there, how many pregnancies, removed radiators, squashed bugs, telephone calls, orgasms, punches, screams, breakfasts, and so on. What made you decide to give the character of the building such humanity?

CW: On one hand, it is the self-conscious creative construction on the part of the main character to write for her creative writing class. It's one of those big ideas you try when you're a beginning writer that can sometimes go horribly wrong. Then, there are other times it can somehow open up possibilities of feeling that you might not otherwise have expected. On the other hand, it's just something I am interested in and think about a lot. I think about the history of the building and the things that have happened within it. It sounds crazy, but if you start thinking about a building through time, it can almost start to seem like a living organism. My friend Tim Samuelson, the cultural historian of the city of Chicago, genuinely feels empathy for buildings and for what they've experienced through various generations. He's been a big influence in my life in that way. It all comes down to empathy. If you feel sorry for a building,

you're going to be less likely to knock it down. If you feel sorry for a person or try to understand how they're feeling, you're going to be less likely to be combative or suspicious when you meet them. If you feel empathy for a group of people or a nation, you're less likely to attack them. I just feel it's what being human is. That's the most important thing you can learn. It's the most important thing you can impart to a child. That's what I've learned from my mom and my grandmother.

DM: You state this in the book, "Who hasn't tried, when passing by a building or a home at night, to peer past half-closed shades and blinds hoping to catch a glimpse into the private lives of its inhabitants? Anything... the briefest blossom of a movement...maybe a head, bobbing up...a bit of hair...a mysterious shadow...or a flash of flesh seems somehow more revealing than any generous greeting or a calculated cordiality.... The disappointing diffusion of a sheer curtain can suggest the most colorful bouquet of unspeakable secrets." And you then go on and you give the amputee character a statement. And she says, "I know it's dumb, but I can't help it. Ever since I was a kid, I felt sorry for things...no matter how inanimate...I would get so carried away, I'd hug a table leg, or kiss a chair goodbye. I compulsively dare myself to grant a personality to anything and everything." Do you do that in real life?

CW: I used to kiss the television at Christmastime when there were those holiday specials on because I knew I wouldn't see them again for a year.

DM: I kissed Mr. Rogers.

CW: That's wonderful. He's one of my great heroes. Fred Rogers was one of the greatest Americans who lived in the twentieth century. I'm sure he would appreciate that. There's a wonderful interview with him, a documentary about him, where he's being asked about what he was trying to do, and he says, "There is a sacred space between the television and the children's eyes that cannot be violated." And he says it with such dead seriousness and conviction that you realized that is his whole life.

DM: You don't shy away from some very provocative experiences. There's an abortion that haunts the main character through much of the book. And there is her profound loneliness, and her hatred of her body. I think all of the women in *Building Stories* have issues with their body. They aren't happy with who they are. They mostly aren't happy with the way they look. There's also quite a lot of wonderfully evocative sexuality in the books. There's some great scenes of people having sex and people doing fun things to their own bodies. Do you go into different modes of feeling when you're creating these different scenarios?

CW: It's about feeling through a character and caring about a character. What do we read fiction for? It's for finding out—I think Art said to me once—that all our secrets are the same.

DM: One of the common denominators in many of the characters is that they have a profound sense of self-hatred.

CW: That's probably my problem. The book all comes through my consciousness.

DM: What's that about?

CW: I don't know. I'll look at my pages when I'm done with them, and I'll think, "Oh, my God, that looks terrible. How could I have drawn that? Why did I do this stupid story?" Or it fell flat or it didn't work. That's just the way I feel. It would be nice to occasionally feel slightly confident about what I do, and there might be moments where I feel something came out not as bad as I thought it did. But for the most part, it doesn't. I just hope for the best. I try my hardest, that's about the best I can say. I do very much envy writers who don't feel that way.

DM: Do you like the characters in *Building Stories*?

CW: I do. I definitely like them. For better, for worse, I fall in love with all my characters, which sounds crazy.

DM: No, it doesn't. You put so much empathy in them, even when they're nasty and bitter and cruel. You can't help but root for them.

CW: Well, there's a reason why people are nasty and bitter and cruel. I think sometimes they're not even sure themselves why they are. It's up to the writer or the reader to figure that out.

DM: In one passage in *Building Stories,* your main character says, "I stood there for a second or two in the bathroom that was, for all intents and purposes, identical to mine, and wondered exactly what it was that made lives turn out the way they do." I'm wondering, do you know the answer to that?

CW: No, I don't. I have no idea. That's why I write stories, I guess. It's somehow a combination of luck and accident—what we think of as will and impulse and sympathy and empathy—and all these things somehow mixed up together. It's trying to be good. Trying to be a good person.

"As an illustrator, someone's calling on you to create a universe, to create a whole new world for readers or viewers to experience. And I think if I was just going to recreate the same story, I might as well just take a photograph and I'm not a great photographer."

BRIAN REA

illustrator, designer, and writer

September 23, 2019

BRENÉ

Vulnerability

Shame

Failure

These aren't things we like to think about in ourselves, but for Brené Brown they are the focus of her attention. As a research professor and business leader, she has studied how being vulnerable can make us more courageous and empathetic, more true to our humanity. In our interview, we talked about her book *Braving the Wilderness*, belonging, courage, the TED Talk that changed her life, and vulnerability in a time of political division.

BROWN

DM: You left New Orleans for Houston, Texas, when you were in the fourth grade, and then you left Houston for Washington, D.C., when you were in the sixth grade. In eighth grade, you moved back to Houston. That must have been really hard for you.

BB: It was terrible. I was always the new girl. That's why writing a book on belonging seemed so natural to me, because I could mark the calendar of my life by not belonging. The hard thing about the Houston move is I went back into the same school I was in during sixth grade, but I had been gone for two years. My friend group had nothing to do with me.

DM: After the final move back to Houston, your parents' marriage began to seriously disintegrate as well. It was also at this time, the very end of eighth grade, after eight years of ballet, you tried out to be a cheerleader on the drill team.

BB: I want you to picture white leather cowboy boots, a blue short little satin skirt with white fringe, a white cowboy hat, and everyone wearing a short wig with flipped-out Doris Day hair but in their natural hair color. You had to wear a standard-issue "Cherries in the Snow" Revlon lipstick.

DM: In *Braving the Wilderness*, you write that, to this day, you're not sure that you ever wanted anything in your life more than you wanted a place on the drill team. Being on this team was about belonging personified. What happened in that experience?

BB: I think we moved back two days before tryouts—tryouts were starting at the end of eighth grade. Here my parents feel on the cusp of disaster, but here are the bear cadets and they're so bright and shiny. Tryout day came. I got to the gym to tryout. I looked around. I was getting out of the car by myself and all of the other girls had spent the night before together. They were running in, holding hands, giggling and laughing. All of these girls wore full makeup, huge hair, golden blue silver outfits. I had on a black leotard, gray sweatshirt, and dancing shoes. I did the routine. It was easy. It was great. I could kick harder than anyone in my group. It was fine. You went home. You had to wait three or four hours until they posted the numbers. You wore a little number on your thing. My parents drove me back to the high school because we were going to San Antonio to visit my grandma. I remember walking up to the poster board. I was number sixty-two. I remember a girl named Chris, who was the shiniest of all the girls in eighth

grade, running up, looking at her number, clearly seeing it, screaming; her dad jumping up out of his car, running, and grabbing her and twirling around. I thought, "Oh, my God, this is not happening." I got back in the car and I was crying, and my parents did not say a word. We just drove for three hours to San Antonio.

This is the hard thing about parenting. The story I made up at the time was my dad was captain of the football team, and my mom was the head of her drill team. I thought they were ashamed of me and for me. They did not know what to say. My parents had no idea what to say in that moment. For me it was a defining moment because it was the moment I no longer belonged to my family. It's funny because when I talk to my parents about it today, they just say, "We didn't know what to do."

I always tell parents, "You cannot control for the stories your kids will make up. The only thing you can do is provide a culture where they can go to you and say, 'The story I'm making up right now is this: are you ashamed of me or for me?' or 'Everyone's cool here but me.'" It was the last thing I ever tried out for in my life. Fitting in is imperative in high school, so I took to Miller Lite and smoking weed. I found another crew that did not dance on the drill team. Being defined by that experience was not great. It was hard. It continued through my early twenties.

DM: You write about how there are only three ways we respond to this type of pain: living in constant pain, denying pain, or finding the courage to own the way we move forward. Can you talk about those three ways?

BB: I thought this is a book that takes on the political culture right now, that takes on white supremacy and Black Lives Matter, so why am I starting with a story about the drill team and not belonging? There are absolutely bigger issues to take on, but there is no bigger issue, I think, for those who feel like they don't belong in their families.

DM: Or don't belong on the planet.

BB: Or don't belong on the planet, because then it's hard for us to be a part of the resistance, it's hard for us to speak up. I've observed in the data that one reaction to pain is, I pretend like it doesn't happen until it absolutely cripples me. The body keeps score, and it will always win. The second response is people who take that pain—and this is what we see today in the world—and inflict it on others. It's easier to cause pain than it is to acknowledge and feel your way through it. The last one is people who acknowledge pain, who

work their way through, and who in response have a very keen eye for seeing pain in the world and in other people. That was my choice. The little miracle for me is that my parents grew with me.

DM: How do you get over those initial life-defining wounds? How do you go from feeling like you don't belong in your family to a place where you're willing to look at why and then feel that you do belong in the world?

BB: The key is owning the story. As long as you deny the story, the story owns you. The story is not going anywhere, so your choices are to pretend like it's not happening or to own the story and walk into it. When I look at Charlottesville and those guys with torches, I see people living a wound and thereby inflicting pain on other people. I think you either own the story and you heal from that story or you become dangerous to other people.

DM: It seems so obvious that anybody that has to exert their power over someone else doesn't feel powerful enough.

BB: You just hit on one of the biggest controversies in my field. I'm a social worker. I started very early in the worlds of domestic violence and sexual assault. There was a lot of controversy around perpetrators of domestic violence. Is that an action of power and control? What I found in my work is that it is a response to powerlessness, not power. People who feel a sense of power don't respond like that. There is no greater and more profound danger in the human experience than powerlessness.

DM: Why is that?

BB: How do you respond when you feel powerless? We're desperate. Powerlessness is incredibly dangerous. Now, are the white supremacists in Charlottesville really powerless? They're a member of a majority culture, they're men, I hypothesize they're mostly straight and Judeo-Christian. What their narrative of powerlessness is, I don't know, but that's when people become dangerous. I think what we're seeing right now in the culture is a refusal to go to a model of shared power.

DM: What made you decide to write this book?

BB: I was going through my own metamorphosis around belonging. I was trying to finally understand what it meant to carry belonging in my heart and not to negotiate it externally with other people. I was in it for five minutes before I realized, "Shit, you can't write about connection and belonging without talking about the real political world today." It was not my intention to wade into politics and what's happening, but you have to follow the data when you're a scientist, and that's where it went.

DM: When you began studying vulnerability, your own conflict with it became apparent. You recognized you were not only no play and no rest, but you had a disregard for play and rest and the people who thought it was important.

BB: I was trying to figure out the anatomy of connection: what do men and women who are connected share in common? I ended up with lists in which wholehearted men and women do this and they don't do this. I looked at the "don't" list, and that described me to a T. Don't try to be cool, try to be perfect, try to derive your status from how exhausted you are and how hard you work. All these things described me and I thought, "Oh, my God."

DM: Why do we do that? Why do we use these outside badges to buoy ourselves in the eyes of others?

BB: It's a status thing. Exhaustion is a status symbol because we desperately want to be seen, we desperately want to belong. We want to believe we're lovable. In the absence of connection, there is always suffering, so we want to feel connected.

DM: Why is social cache, this external validation, the opposite of vulnerability?

BB: Because vulnerability at its heart is the willingness to show up and be seen when you can't control perception. No armor.

DM: For decades, I tried to hide not only how much shame I felt about living but also my failures and my rejections, as though if I revealed that, it would mark me, it would damage me, and I would never be loved again. I think it ultimately came from not feeling loved to begin with.

BB: The one thing that we all have in common is the fear that you just named. It is the paradox of vulnerability: that when I meet you, the very first thing I look for in you is vulnerability, and the very last thing I want to show you is my vulnerability. I'm desperately seeking yours while hiding mine.

DM: What are we so afraid of people seeing?

BB: Unlovability.

DM: It's rare to meet someone that you can see immediately has had good parenting. Ultimately, I think good parenting is what makes you feel lovable in the world.

BB: It is key. I think the mistake that we make is 99.9 percent of the parents were doing the very best they could and probably ten orders of magnitude better than what their parents did. The belief that we have to change is that because someone didn't or couldn't love me, that makes me unlovable. Someone's ability or willingness to love you, whether it's a partner or a parent, has no bearing on your lovability whatsoever. That's what changes the trajectory of people's lives.

DM: A Maya Angelou quote figures prominently in the narrative of *Braving the Wilderness* and it comes from an interview she did with Bill Moyers. She says, "You are only free when you realize you belong no place. You belong every place. No place at all. The price is high. The reward is great." This line bugged you for a long time.

BB: It did, so I Googled the interview with Bill Moyers because I had never seen the whole thing. The next question he asks is, "Really? You don't belong anywhere?" She pauses for a second and says, "No, actually, I belong to Maya. And I like Maya very much." My response was, "Oh, my God. I want to belong to Brené." That's when I started the research on belonging.

DM: Leaning into that quote motivated you to start developing this book and the theory of true belonging. Would you share with us the theory of true belonging?

BB: True belonging is the spiritual practice of believing in, and belonging to, yourself so deeply that you can share your most authentic self with the world and find sacredness in both being a part of something and standing alone in the wilderness. True belonging doesn't require that you change who you are. It requires that you be who you are.

DM: Why are so many people so afraid of being alone?

BB: I think people are afraid to be alone because they don't belong to themselves. True belonging is not just about being a part of something but also having the courage to stand alone when you're called to stand alone: when the joke's not funny; when you don't believe in something; when you have a different opinion; when you're at family dinner and people are saying things that you actually find hurtful. When you're called to stand alone and you can't, then true belonging is very elusive. Your level of belonging will never exceed the level of courage you have to stand alone. That was a new thing for me.

I'm at a place in my life right now where I'm not afraid to be alone. I so fully belong to me now. I call what we're in right now a spiritual crisis of disconnection. I define spirituality as the belief that we're inextricably connected to each other by something bigger than us. Some people call that bigger thing God. Some people call it fishing. Some people call it art. Spirituality is no more, no less, than the belief that we're connected to each other in a way that's unbreakable. You cannot break the connection between human beings, but you can forget it. We have forgotten that inextricable connection between human beings.

When I am alone and standing up for something I believe in, I know you can't do anything to permanently break the connection between me and everyone else in the world. I know I'm called to stand alone. I think people who forget that we're inextricably connected feel not just alone but lonely, and I think that's the difference.

DM: Your TED Talk catapulted you to fame, but you had been speaking and publishing for quite some time before that. Your first book, *I Thought It Was Just Me,* had been published in 2007. You self-published it first as *Women and Shame* back in 2004. You'd written about how you could wallpaper a building with your many rejection letters. You even borrowed money from your parents and sold copies of the book out of your trunk.

BB: No one was talking about shame. Publishers told me, "A book on shame? No thanks. Sexy as that sounds, we're not interested."

DM: What gave you the power to persevere?

BB: I felt otherworldly about it. There were a lot of tears, a lot of frustration, a lot of crying, a lot of rejection. I sold enough books out of my trunk that it got Penguin's attention, then Penguin bought it. I experienced so much shame, especially at the hands of my academic colleagues, for self-publishing. When Penguin bought it my position was, "I will absolutely sever myself from the vulgar commerce of book sales. I will not do any kind of promoting of this book. I will sit back and wait for it to hit the charts." It failed. Two months later, they called me and said, "You're being remaindered, pulped. It's over. It's done. You failed."

DM: What did you do?

BB: I lost my shit at first. I have a very high tolerance for risk and failure as long as I can learn something. I asked myself, "What is the learning here? What is the learning here?" The learning for me was, if you're not going to get excited and put value on your work, then don't expect anyone else to get excited or put value on your work. I got a chance to redo it with a paperback. So, this is the learning from *I Thought It Was Just Me.* If I fail wholeheartedly, I can live with that. If I fail and I've been half-assed or half-hearted in my effort, that I cannot live with.

DM: One of the things that I ask the students is, "What are you afraid of? What is keeping you from trying this or doing this?" One of my students said something that I've never forgotten. He said, "I'm afraid if I do this and I fail, I will die of a broken heart."

BB: The only people who don't have heartbreak in their careers are people who have no love or passion for their career. Heartbreak is, while miserable when you're in it, a small price to pay for doing work that you're profoundly in love with. I find hearts that are stretch-marked and scarred to be far more profound than clean shiny new hearts. That's daring greatly. If you live a brave life, the only guarantee is you're going to get your ass handed to you. Just know that is part of the process. ∎

"Survival

of the species has as much to do with cooperation over resources as competition. In fact, you can't actually compete for resources unless a group of people are cooperating."

DORI TUNSTALL

design anthropologist, writer, and educator

October 7, 2011

ESTHER

**Ten years ago,
Esther Perel was a psychotherapist
known for her clinical work with
intercultural and interfaith couples.**

Then she turned her attention to relationships and sex, writing *Mating in Captivity: Unlocking Erotic Intelligence*. Her 2013 TED Talk about desire in long-term relationships has been viewed more than ten million times, and a more recent TED Talk led to a new book called *The State of Affairs: Rethinking Infidelity*. In this interview we talk about why we get disillusioned in relationships, the real reasons people have affairs, and how to recover from breaches of trust.

PEREL

DM: Esther, your parents were survivors of the Nazi concentration camps, and you've said that trauma was woven into the fabric of your family history. How did that influence your childhood?

EP: On some level, you couldn't see it. On the other, you saw numbers tattooed on people or a mother getting up in the middle of the night and checking doors. On the surface, my house was very, very normal, but underneath there was a real sense of dread. At the same time, we didn't survive for nothing. We were going to live life to the fullest. We're going to capture it with a vengeance. That energy was very much woven into me, combined with the sense that I was a symbol of life and a symbol of revival. Many of us who were born then had a responsibility to all those who didn't have a chance to live.

DM: In my research, I found a line that stayed with me. You thought there was a world of difference between not being dead and being alive.

EP: This is a line that I came up with for *Mating in Captivity*. I was speaking with my husband, Jack, who had co-created the Bellevue Program for Survivors of Torture. We would talk about how you come back to life when you're once again able to be playful because you're not watching for the next disaster to hit you. You come back when you're able to take risks. That's when I began to shift my interest from sexuality to eroticism because eroticism is that life force. Then I began to apply it to my community. I grew up in Antwerp, where there were two groups of people: the people who did not die, and the people who came back to life. I remember those children, I remember their parents. I would go play at their houses, and it was morbid. Then I looked at this other group of survivors, and they were like my parents. They were going to live life. They were going to experience the erotic as an antidote to death.

DM: When did you decide that you wanted to be a therapist?

EP: As a teenager I was a therapist to my friends. I had a knack for this stuff. I also was interested in psychology because I didn't feel good in myself. I dreamt a lot of trauma as if I was in the camps. That's very common to a lot of children of survivors.

DM: You said that being a couples' therapist is probably the hardest type of therapy to be in and to practice.

EP: It's the best theater in town.

DM: Why is it so difficult?

EP: Because a relationship can get so invested with expectations and dreams, and often it starts out at an Olympian level and then just collapses. This disillusionment is generally blamed on the other. What they're doing wrong. How they've let you down. How they're not there for you. How they are responsible for how you feel. That level of intensity that triggers the feelings you have with your partner, you have only experienced one other time. That's with the people who raised you.

DM: Why do we imitate those patterns?

EP: The foundation of our emotional life, the language we have for it, and the meaning that we ascribe to it comes from the people who raised us. You choose a partner and you hope that they will fix the holes of the past.

DM: Are we choosing a partner unconsciously, specifically to repair that pattern?

EP: Or repeat that pattern. Some say you choose a person with whom you're going to repeat the pattern so that you can finally transcend it. What is clear is that what is initially attractive for being different becomes the source of conflict later because it is different.

DM: What do you tell people when you are trying to get them to see their own contribution to a relationship dynamic?

EP: I use the vulnerability cycle, which was created by a very dear colleague of mine. It shows that when you are triggered, it touches a vulnerability; you then respond from a place that defends against this vulnerability. It is called a survival strategy, and it triggers the other person's survival strategy. You developed your survival strategy as a child. So, after I ask someone about the triggers in her relationship, of course I instantly ask, "Tell me, this thing you feel disrespected about, did you have that ever before?" You didn't just devise a vulnerability cycle when you got married.

DM: We've never expected more from our intimate relationships. Being part of a couple is an essential social construct all over the planet. But being in love while also being married is a relatively new construct in the same way that being happy or finding purpose in a job are also relatively new constructs.

EP: Marriage is an institution that has always changed. If you asked my parents what makes for a good relationship, my mother always said, "It's hard work. It's compromises, concessions. You need to want it to work." They didn't talk about love. That didn't mean there was no love, but it was a byproduct. It wasn't the organizing concept. Relationships were organized around duty and obligation. They were organized around fixed gender roles. Everybody knew what was expected of them and they could feel good about having fulfilled those roles. Romanticism is the greatest energetic engine of the Western psyche. That's it. It has captivated us like no other.

DM: Is it a myth? It doesn't last in the way that it starts, so what is happening when we're experiencing romantic love?

EP: You've asked three questions. The first question is, "What is the difference between a love story and a life story?" There are a lot of people you can love, but you can't necessarily make a life with all of them. What has happened is that we try to merge the love story and the life story. We want marriage and love to become one part. And we've gone a lot further. For most of history, marriage was an economic enterprise around duty and obligation. The marriage was between two families, not between two individuals. It didn't matter how good you felt; the marriage continued because there was no exit, primarily for women. At the end of the nineteenth century, the rise of romanticism, urbanization, individualism, and industrialization began to bring love to marriage. Passion had existed somewhere else that marriage had nothing to do with. For quite a long time, in fact, adultery was the space for love since marriage wasn't supposed to provide that.

DM: Equally for men and women?

EP: Yes. Men acted on it much more than women because they had the license to do so. But the idea was that love stories took place on the fringe of the marriage, not inside the marriage. Now we're not only delivering love to marriage, but now we bring sex to love, linking sexual satisfaction with marital happiness for the first time. We had to have contraception to liberate sexuality from procreation, so sex for connection and pleasure is a whole new definition of sex inside relationships. It never existed before. Whereas women in my mother's generation did their marital duty, now we want to be happy in our marriage. We also introduce intimacy as a new concept, as a matter of validation. Then we're starting to look for the soulmate. When have we looked for a soulmate in marriage? It was a religious pursuit, not a relational pursuit.

DM: Do you believe there is a one and only?

EP: Absolutely not, never. I think there are many people with whom you can make a life, and there are many people with whom you will have unique experiences. I do not hold the notion of the one and only. Today, that one and only has to give you everything that the traditional village had to give you. You have to have the person who inspires you in your career and is your intellectual equal, trusted confidant, and passionate lover. This one person for everything model collapses from the sheer weight of the expectations. Never was one person responsible for all those things, and this is what has fundamentally altered modern romance. Yet we are very, very wedded to it. A lot of this has to do with the dissolution of traditional institutions. People once turned to religion for wholeness, for meaning, for transcendence, for ecstasy. Today we turn to romantic love for all those needs.

DM: Quite a number of people in our culture believe that if you work hard enough, you will be able to achieve this with your partner.

EP: Absolutely. Love will be enduring, intimacy enthralling, and sex exciting. There is this unit called the couple that has an enormous amount of pressure put upon it to do well, to be happy, and to be perfect. On top of it, the unit is rather isolated. Single people talk. Couples don't talk.

EP: I wrote this book because I believe that the quality of relationships determines the quality of our lives. I wrote this book because I think we learn our best lessons from studying when the worst happens. If you're going to look at trust, you want to look at the violation of trust. Big shit shows can take place in a couple. If you read what happens in those moments, then you get a very good idea of what to actually do to have a strong or a thriving relationship.

To understand modern infidelity, you have to understand modern marriage. If I have been chosen as the one and only, then betrayal is a shattering of the grand ambition of love and a crisis of identity. This is unique to our current love model. The devastation is different from what it used to be in traditional relationships.

I also use a lens that I call the dual perspective. Affairs are about hurt and betrayal, but they are also about longing and loss and exploration and self-seeking. The majority of the people I see are not chronic philanderers. I see a lot of people who have been faithful and monogamous and loyal for a long time, and then one day they cross the line that they themselves erected.

DM: For what?

EP: "Aliveness" is the essential word you hear.

DM: Why does aliveness dissipate over the course of a relationship? Do we metabolize our passion?

EP: Aliveness wanes because we get constrained by roles. The role of the wife, caretaker, husband, provider— roles that are about being responsible, settling down, being accountable, building, protecting. Those are the antidotes to the erotic. The erotic thrives on the unknown, the mystery, and the playfulness that family life defends against. Family life needs consistency, routine, rituals, repetition. We find it difficult to do both in the same

place. What makes you feel stable is not the same as what makes you feel adventurous; what gives you a sense of belonging is not the same as what gives you the sense of freedom; what gives you comfort isn't the same as what gives you edge.

When people describe aliveness, they're not talking about sex. It's that sense of ownership, freedom, and agency you feel when you do something that doesn't exercise responsibility toward everyone else in your life. It's less about infidelity and more about the power of transgression.

DM: Earlier in our interview, you described your clients as blaming one another for their feelings. How do we go from feeling alive to feeling dead in the interaction with the same person?

EP: The aliveness doesn't come from the other person. The aliveness comes from the action that you just took. The aliveness comes from the transgression you just committed. The aliveness comes from the risk that you just took. But we don't always want to take risks in the same place where we seek security. The reason we transgress is because we have a model where risk and security are confined to separate places. I always say the experience of love is not what the other person is—it's how you experience yourself in the presence of the other.

DM: Sometimes when we see the gaze of another, we aren't so much turning away from our partner but turning toward the person we have become. We're not looking for another lover so much as another version of ourselves. Are you saying that it's possible that the most intoxicating "other" that people discover in an affair is not a new partner, it's in yourself?

EP: Sometimes you don't fall in love with the other person as much as you fall in love with that other version of yourself because when you choose a partner, you choose a story. That story becomes the story that you're going to enact. That's the character you're going to play. Relationships that thrive are the relationships that know how to reinvent and resuscitate themselves so that you can have different versions of yourself. If I can't be

another me with the same person, I go look for it with another person—either by ending my relationship with you or stepping outside my relationship with you. This doesn't justify it, this just tries to explain it. If affairs were not discovered, many would die a natural death.

DM: Because the mystery was solved?

EP: That's right, because they were not meant to be anything besides an affair. It was meant to be a love story, and love stories run their course.

DM: I want to talk to you about polyamory, which seems to be the new "it" word in sexual dynamics. Why are people taking this major new step in relationships and in life?

EP: For most of history, monogamy was one person for life. Today, monogamy is one person at a time, with premarital sex as a norm. That required a major change in sexual boundaries. We don't just want procreative sex, sex as regular service, or pity sex. We want a connection. We want pleasure. Polyamory is just a natural progression of those sexual boundaries.

DM: Are ethical non-monogamy and polyamory the same?

EP: Monogamy often emphasizes sexual boundaries, and polyamory looks at the coexistence of different love relationships. It's less about sexuality and more about attachment. People who are negotiating monogamy are trying to bring together different value systems: the value system of commitment and the value system of personal fulfillment and personal expression. We've never seen this bridging of independence and belonging in one relationship.

Another thing is that the conversation of polyamory takes place among entrepreneurial spirits, people who are dismantling the old economy and culture of marriage. They dismantle the traditional norms, and they are trying to create new norms. In that sense, polyamory enters. Unfortunately, it gets co-opted by people who don't know about commitment. It gets co-opted by people who commodify others.

DM: Tell me about what you mean by the commodification of others.

EP: What is my return on investment? Is this the deal I signed up for? The consumer economy is an economy of service. It's an economy of experience. We want marriage today to be an experience, and we want that experience to be inspiring and transformative.

We have a generation of people who don't tolerate frustration. When things don't work, they throw them away and they get new things. They don't know how to reinvent the location, to keep things interesting, to stoke things. The commodification of people is when you can ghost them like they never existed.

DM: You've been happily married for over thirty years to Jack Saul, a professor at Columbia University as well as a therapist and an activist. What is the secret of a happy marriage? Is there?

EP: I think we both often will talk about how even when I hate his guts, I'm not bored, and he would probably say the same thing. We remain interested in each other as people, not just as spouses and parents and all the other things. I think its admiration, which is different from respect.

I also think that a system stays alive and fresh because it has new experiences, new challenges, new thresholds. We don't just do the things we've enjoyed before. We set ourselves up for various new adventures, especially now that the kids are gone. The kids are no longer the adventures, so we create new ones for ourselves. That includes allowing the other person to tend completely to themselves separately, which is a gift. We each have very good friends of our own. Some we share, some are our own, so we're not reliant on each other for everything by far. On some fundamental level, I think he's a good person for me to go through life with and vice versa.

T I M

It may take a village to raise a child, but when the child is grown up, what then?

Tim Ferriss says we all need mentors, and he brings many to his brand-new book, *Tribe of Mentors: Short Life Advice from the Best in the World.* Tim Ferriss is a five-time *New York Times* bestselling author, tech investor, and host of the wildly popular podcast *The Tim Ferriss Show*, which has been downloaded more than four hundred million times. In this conversation, Tim gets deeply personal about depression, perseverance, and the support of others.

FERRISS

DM: Let's talk about your most recent main-stage TED Talk, where you reveal how you have suffered from fifty-plus depressive episodes in your life. What have you learned from those episodes?

TF: I've learned a lot from my experiments in resolving those episodes. I've become better at coping. Mitigating the onset of an episode—that's one piece. It's almost like treating the flu. You can spot the indicators of onset.

DM: What are those?

TF: Feeling tired is one, then I end up over-caffeinating, which feeds into anxiety and agitation. Or if I feel unfairly attacked or victimized by someone on the Internet, I get so righteously indignant and upset about that, but I simultaneously recognize the futility of it.

DM: It makes you feel helpless.

TF: It's not going to be a productive use of time. I have a lot of history, past trauma, that gets triggered by too much exposure to divisive aggression online. You're seeing that hair-trigger response a lot now in people who might normally view themselves as fairly put together. If I feel like people are feeding the dangerous tendencies of my lesser self, then I've been proactive about curating the people around me purely for psychological health.

DM: When you're experiencing a depressive episode, how do you calibrate your internal life and your external life? I went through a particularly difficult time from September 2015 to February 2016. I met somebody on the street whom I hadn't seen in a long time, and I think I started crying. She said, "Oh, my God, you seem fine on Facebook." I told her, "Everybody's fine on Facebook."

TF: Everybody's Tom Brady and Gisele on Facebook.

DM: It became clear to me at that point that I was living this internal life that maybe my friends and closest comrades knew about, in contrast to a life in which the rest of the world thought everything was fine.

TF: If I think I'm slipping into a depressive period, one of the most important things to do is to schedule group activities with friends because I have a self-defeating tendency to go into isolation. In general, I've tried to have at least one group dinner with friends per week because then the present-state awareness distracts from whatever silly loop happens to be replaying in my head. As a preventative measure, I also think that daily morning meditation is helpful. Meditation needs a rebrand. The word is so repellent to so many people—it was to me. The way I view it now is that you are practicing observing your thoughts without being tumbled by them.

Instead of reacting immediately to whatever that thought is, you act like a viewer in a movie theater. You think, "Huh, interesting choice, director." Then you watch the snarky email or somebody being rude at Starbucks or whatever and, like a cloud, it slowly morphs into something else and you don't have to push it away. You don't have to hate yourself because of it. You don't have to get angry. Instead of immediately reacting, you have some gap where you say, "Pause. Now I choose my response." That helps to catch a lot of the downward spirals before they become a spiral.

DM: One thing that's helped in getting older is recognizing that downward spirals are episodic. I no longer feel that I'm going to have one that lasts for the rest of my life.

TF: I recently did a ten-day silent meditation retreat, which I do not recommend for everybody. It was one of the harder things I've done.

DM: What did you learn about yourself?

TF: That whatever you think you have locked away and compartmentalized, whatever damage you feel you have safely exiled to a place where it will never return—surprise, it's right there waiting for you. You become very unlayered in a process like that. You end up dealing with everything. The reason I mention it is the selective posturing that we all do. It's easy to look at Facebook or to see people you perceive to be superheroes and think they've got it all figured out and that you're just a broken toy never to be fixed. But the vast majority have battled incredible demons and have suffered horrible things in various ways. It's par for the course. If you think you're uniquely fucked up and flawed, you're not. The most dangerous mental frame I get into is when I'm saying something to myself like, "Wow, you're really fucked." At that point, not only are you depressed, but you're getting angry that you're depressed.

DM: We should start a new website called *ShameBook*. Everybody posts when they're scared and nervous and angry at themselves. The whole world could join in on the shame spiral together.

TF: "Here's a photo of me in my tighty-whities after eating an entire box of Ho Hos."

DM: Your TED Talk focuses on a tool that completely changed your life in 2004. At that time, a very close friend, a young man your age, unexpectedly died of pancreatic cancer, and your then-girlfriend left you. You said that the tool found you. I wanted to know: do you believe in fate?

Whatever you think you have locked away and compartmentalized, whatever damage you feel you have safely exiled to a place where it will never return—surprise, it's right there waiting for you.

TF: I'm going to redirect and just talk about the exercise, which is "fear setting."

DM: What is fear setting and how do we do it?

TF: We've all heard that you can't accomplish your goals unless they are specific. You need a very clear target. If you want to overcome your fears, then they also have to be very specific. That's the point of this exercise, and it's real simple. You take a piece of paper and turn it lengthwise, and you create three columns. At the very top of the paper, you write whatever you're considering doing that you've been pushing off or that's causing you anxiety. What if I quit my job? What if I started this company? What if I ended this five-year relationship? What if I took my first vacation in ten years?

DM: That's one of your fears?

TF: That was one of mine. I'll use that again for illustration. I wanted to take a four-week break because, as you mentioned, my long-term girlfriend had left me. I was melting down physically. I was using stimulants to keep going during the day. I was using sedatives and alcohol to go to sleep at night. I had planned to take a four-week trip to London to get out of my routine and either shut the business down or figure out a way to redo all the systems and extricate myself as a bottleneck. But I didn't take the trip. Instead, I thought about all the things that could go wrong.

So, in the first column on your page, you have "Define." You're going to write down at least fifteen very specific bad things that could happen. I'll miss some type of notification from the IRS, and they'll audit my business, and it'll be some type of legal complication, and I'll get sued, and game over. That's one specific bad thing that could happen from going to London.

DM: So, one of the items could be, "End up homeless in the street"?

TF: It's a column of fifteen of those, at least. Take some time. This is worth at least an hour, believe me. Every time I've done this at critical junctures in my life, it has fundamentally changed my life and helped me to choose the right fork.

The next column is "Prevent." For each of those bullets you've come up with in the first column, what could you do to prevent them or decrease the likelihood of them happening? For the IRS stuff, I could change my mailing address to a UPS store, and then I could pay them to scan all the mail and email it to me. You progressively can see how ludicrous your fears are when you start to put them under this microscope. "Ludicrous" is a strong word, but defeatable, reversible is what I mean.

In the last column, you're considering, "You do all your fancy preemptive work and this shit happens regardless." What do you do? What could you do to either get back on your feet temporarily or reverse the damage? Now you don't feel hopeless and helpless. You actually have an option. So on and so forth down the list.

DM: That's the define-prevent-repair page.

TF: The second page is, "What would be the benefits of an attempt or a partial win?" It's very easy to view failure and success in binary terms, but the results are seldom binary. As James Cameron would say, and I'm paraphrasing, if you aim high enough, you will fail above everyone else's success. For instance, the vacation, the starting of a business: what are the benefits of an attempt or a partial win? What are the skills or relationships you might develop that could transcend that project or decision and apply to other things in your life later? Those snowball in a very beneficial way. Even if it failed, how does that experience change your conception of what is possible? You learn a bunch, you develop a bunch of new relationships, and then you have to take a temporary bartending job to get back on your feet. Well, hey, you're alive. You can get back at bat.

DM: I think it's important to test yourself, to know that you can rely on yourself.

TF: It's a progressive conditioning. Maybe you become more comfortable with uncertainty. That is a huge gift that you can give yourself. The fact of the matter is, my first few business ventures failed abysmally, but the skills and relationships still serve me to this day. The question, "What are the benefits of an attempt or

a partial win?" is really important so that your bar for worthwhileness isn't, "I'm Babe Ruth." Setting the bar so high only rationalizes staying the course.

DM: You talk about how important it is to consider the atrocious cost of the status quo.

TF: Yes, and that's page three. This is something I've certainly borrowed and adapted from other people, specifically Tony Robbins. Last page: "What is the cost of inaction?" because we very often look at the potential benefits of winning, and then the things that could go wrong if we try to change something. We don't consider the sometimes atrocious costs of just continuing to do what you're doing. What are the costs—physical, emotional, financial, psychological—to you and the people you love? What does that look like? In many cases it's a fucking disaster, but unless you put it on paper, it's this phantasm that floats around in your head in a very unproductive way. Once you put it on paper and you can see it, you realize, "Wow, the cost of an inaction is almost guaranteed to be ten times worse than doing anything else."

DM: Let's talk about your new book, *Tribe of Mentors.* What made you decide to write it?

TF: The genesis stories of these books have some commonalities. The first is that I almost always write books that I can't find myself. I'm too impatient at this point to not reach out to experts and try to put it together myself.

DM: *Tribe of Mentors* features 130 people that you reached out to, all of whom help other people in a vast array of topics.

TF: The advice that I perhaps have found most valuable is, you are the average of the five people you associate with most. I wanted to give people a choose-your-own-adventure buffet of people they could associate with. All of them are incredible and range from Kelly Slater, the most decorated surfer of all time, to David Lynch and Ben Stiller.

DM: You start your book with the revelation that you were about to become forty and you had no plans for the future.

TF: It struck me that forty, symbolically, could serve as a good excuse to hit pause, reassess, and ask a lot of big questions—to refine what I want to say "no" to, get better at saying "no," and get better at saying "yes" to the few things that I would have to define as most important to me. Rather than try to figure it all out on my own, which had been my labor-intensive habit in the

past, I said, "Well, after doing the podcast and meeting all these people, why don't I just reach out to the people I thought were demigods when I was in high school or college and ask them questions that I'm struggling with?" That's what I did.

DM: In one question, you asked whether your goals were your own or simply what you thought you should want. What did you discover in that investigation?

TF: I'm still realizing that many of the goals I pursued so intensely were not my own. I was unclear on what I wanted, so I looked at how people were competing and tried to find games where I could win.

I don't think this will surprise you, given our background and our conversations. I spent most of my life, until very recently, having a very low regard for myself. I did not care for myself. I would say I hated myself and felt anger toward myself as my primary state.

DM: That breaks my heart.

TF: But that's what it was. The way that I spoke to myself in my head for thirty-plus years is so belligerent, harmful, and hurtful that I would never use that tone with any other human being. Suffice to say, what I decided to do in lieu of loving myself, which seemed self-indulgent and ridiculous, was to develop myself into a sharp instrument of competition. It's something like, "Okay, now my pride will come from developing an ungodly capacity for pain and outworking everyone and winning." I chose many goals and arbitrary financial targets because I thought I could go harder than anyone else, take more than anyone else, and win. That's how I was programmed.

DM: What have you discovered in the process?

TF: That you take a lot of bullets and sustain a lot of damage. That I never did it for the joy of winning but for the relief of not losing. And that when you put that much armor on, you're not guaranteeing that you won't be hurt. The armor doesn't just keep stuff out; it keeps stuff in.

DM: It sounds like you're exploring and embracing a whole new way of thinking about yourself.

TF: There are a lot of things I've learned, and number one is to seek goals and paths that excite and energize you, not just paths that give you some type of temporary relief. Number two is, if everyone is competing for something or claims to be striving for something, it's probably very poorly defined. Last, as it relates to the goal selection, I would say before you idolize someone or emulate their path, look at their life as holistically as possible.

"Our

number one addiction is to our thoughts. Meditation is not about getting rid of those thoughts—it's about focusing, and acknowledging them. That gives you a moment to release yourself from the bondage, even if it's just for a moment."

SUKEY NOVOGRATZ

activist and philanthropist

March 12, 2018

April 30, 2018

ANAND

Over a decade ago, Anand Giridharadas was working for McKinsey & Company in Mumbai, India.

He moved out of business consulting into writing and journalism and hasn't looked back since. He started writing for the *International Herald Tribune* and the *New York Times* and became a columnist for both. He's also written two books, including *The True American: Murder and Mercy in Texas*, about a Muslim immigrant's efforts to keep the state from executing the white supremacist who tried to kill him. His most recent book, *Winners Take All: The Elite Charade of Changing the World* is a scathing look at plutocracy and corporate greed. In this interview, we talk about what it means to be an American and the disparity of privilege.

GIRIDHARADAS

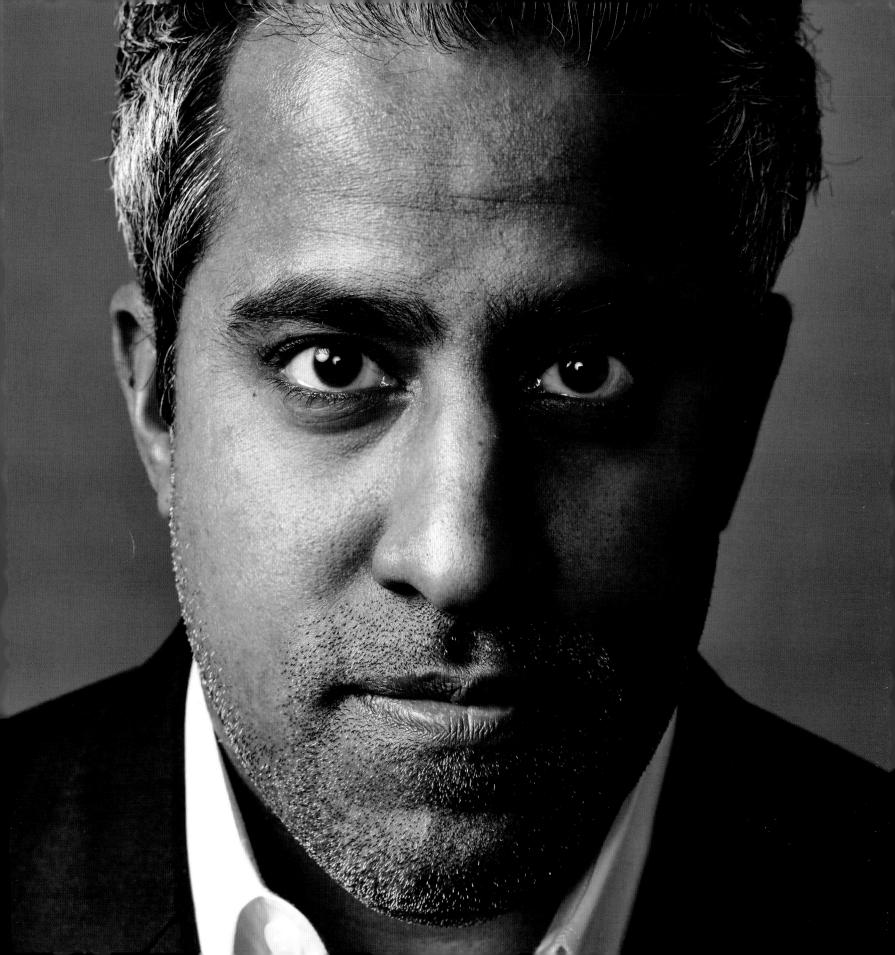

AG: India was a place that my parents left and where my father particularly felt that his potential couldn't be developed. So the honest account of my "founding story" with India is it's a story of exit. A lot of second-generation people like me don't talk openly about this reality: that the founding story of the other place is that the people you love the most—the people to whom you're most attached in childhood—voted to get out of that place with their feet. When I would visit India as a child, I had a good time but there were a lot of things that confirmed and built on this storyline that this is a place worth leaving.

DM: At some point in your childhood, your family moved to Paris. What was the genesis of that decision?

AG: We moved to Paris when my parents decided they wanted to become immigrants again and try it out. Then we moved back from Paris once they realized it's not easy to become French but it is pretty easy to become American. There's a difference.

DM: Was it really more difficult to acclimate in France than it was in the United States?

AG: This gets to an essential question in a moment when it's easy to be down on America. There's something extraordinarily special in the DNA of this country that says that anybody can become American. Does America leave people out of that? Yes. Does it fail to live up to that? Yes. Is there an entire Black exception to that story that's a four-hundred-year story? Yes. To only talk of those things and not talk about the remarkable way in which so many have become American is to miss part of the story.

When I go to Europe and people ask me where I'm from and I say, "the United States," people don't believe me. Here, the people who don't believe me are racist, fringy people. It does not blow anybody's mind that I'm American in America. In India, it blows people's mind. It's easy to be down on the United States, but at its best, this country actually believes in a post-identity concept of an American. And in theory, this country believes anybody can be this thing. There's a lot of work to do to live up to that, but I've been to a lot of places in the world that don't even have that as an ideal. It's an extraordinary ideal.

DM: Shortly after college, you left the United States to work at McKinsey in India. How did your views of India change when you began living there?

AG: The relationship that began with that negative storyline was the reason for going there, and then going there transformed the story. The India that I carried in my mind was not a monolith. It was this collage of all these little stories and the meanings that either I attributed to the stories or that my parents had squeezed from them. In going back to India, I got a chance to test these stories against the reality of my own perception of this place that I had made from the collage.

DM: How did your parents react to your move back to India?

AG: They understood my story as a continuation of their story, which is they were chasing the frontier of their future. I was chasing the frontier of my future, and that happened to be their past.

DM: You left McKinsey and got a job as an international correspondent when the *New York Times* took over the *International Herald Tribune*. You wrote this in the *Times*: "My parents watch me from their perch outside Washington, D.C., and marvel at history's sense of irony: a son who ended up inventing himself in the country they left, who has written of the self-inventing swagger of a rising generation of Indians, in a country where 'self' was once a vulgar word." Do you think that "self" is still a vulgar word in India?

AG: India is so big and in such transition. There is a vast, largely unchanged territory of Indian society where it's still very much a vulgar word. If you are a woman in India, frankly, "self" continues to be a vulgar word. Self is still very much perceived as a very hostile notion because self is the enemy of community. It's the enemy of caring for others, of putting your children or elders ahead of you. In a system where social security is nonexistent, where health insurance is not a thing, self threatens the entire social infrastructure. That said, what I described in *India Calling* was a profound revolution in India in which that idea of self was breaking in.

DM: You've been very outspoken with your opinions about Facebook and have this Tweet pinned to your Twitter profile: "Mark Zuckerberg will go down in history as a tragic figure, and one befitting an age of billionaire savior delusions. He claimed to change the world even as he maimed his country. He pledged to rid the world of diseases while ignoring the disease he was spreading." Tell me more about why you feel this way.

AG: I have spent the last couple of years working on a new book called *Winners Take All*. It's trying to understand the following paradox: we live in this extraordinary age of rich and powerful people trying to "make a difference," change the world, and give back. By raw numbers, we live in the most philanthropic time in human history. If you are a rich person and you're not regularly talking about giving back, you're an outlier today.

America is more unequal than it's been in a hundred years.

That said, America's more unequal than it's been in a hundred years. Half of Americans have, on average, not gotten a raise since 1979. One percent of the planet now owns 50 percent of the wealth, and 10 percent owns 90 percent of the wealth. We have this paradox of an enormous amount of elite concern and the reality of a system that is as cruel as we've seen in a long time and that siphons almost all of the gains of progress up to a very few.

What I tried to understand is, what is the connection? If all these people are helping, why is the system so bad? What I started to understand was that this claim of changing the world—and sometimes even the well-meaning intention and activity of attempting to change the world done by winners—is a critical part of keeping the world the same.

DM: What's your sense of how this is happening?

AG: These billionaire saviors—those who insist that they must not only try to help but lead the effort to promote greater equality from their perches atop the distribution of power—often insist on changing the world in ways that protect their own privileges. They do not disturb the social order. They do not risk anything that they hold dear. They will create charter schools, but they won't equalize how public schools are funded in this country. They will do "lean in" feminism, but they won't do the universal daycare that has shown across Europe to actually be the program that allows women to go back to work. They will support Goldman Sachs empowering ten thousand women through some CSR project, but they won't talk about Goldman Sachs costing many more women their homes through what it did in the financial crisis.

Mark Zuckerberg is this embodiment of the man who wears a hoodie who never calls his company a company. He always calls it "a community" and always claims to be emancipating someone somewhere, whether beaming the Internet across Africa or emancipating the people of India with free Internet that was actually an assault on net neutrality. He uses his power to claim that he's this liberator of mankind while, in fact, he does business like Genghis Khan—while, in fact, he is wiping out much of the American media industry.

DM: You started to talk about some of these ideas publicly at the Obama Foundation Summit last year. Your speech revealed some of the faux change-making for what it is, yet there was significant optimism in it. You said, "When times grow dark, the eyes adjust. What I see stirring in the shadows is people realizing that they have neglected their communities in an age of magic and loss. All around I see people awakening to citizenship. For decades, we imagined democracy to be a supermarket where you popped in whenever you needed something. Now we remember that democracy is a farm where you reap what you sow." The idea of democracy as a farm is a beautiful notion.

AG: It's happening, whether it's the kids at Parkland, or the Women's March, or the surprising health of our civic life in the Trump era, with the record number of women running for office—the record number of people running for office at all levels. Yet I'm not sure that we will survive the Trump era intact.

DM: What do you mean?

AG: There's a small but significant chance that he could so degrade our institutions and standing in the world and foreign policy that in a real way the run could be over in a meaningful way by the time he's gone. He could have shattered the norms.

The possibility is not trivial that this is a fall from which we won't ever quite recover. That said, I think there's a bigger chance that we will limp through the Trump era and come out stronger than we've ever been because people learned something that he taught us, which is that you are only as good as the country you fight for. You can't just make money in the private sector and hope you have a great country. You can't just start a social enterprise doing some little program here and not worry about the fundamental systems at work in your country. All around this country I think there's an awakening where we're taking stock of the real story of this country, what it is and what it's been. We're realizing that you get what you pay for in a democracy. You pay in your effort and your civic love.

If you're unwilling to talk to people across divides, you get a country in which people are unwilling to talk across divides. We have collectively allowed our society to degrade, in part because we have individually become complicit in that degradation. What is so exciting about what's happening now is that people are waking up to the utter obligation of citizenship.

DM: You state that "as wokeness has percolated from Black resistance into the cultural mainstream, it seems at times to have become a test you must pass to engage with the enlightened, not a gospel the enlightened aspire to spread. Either you buy our whole program, use all the right terms, and expertly check your privilege or you're irredeemable." Then you go on to ask, "Is there a space among the woke for the still-waking?" How would you answer that question?

AG: I think the loving way to look at this country is to say, "It's always had high ideals. It's always failed to live up to them. It's always tried to narrow the gap." Sometimes doing a better job at narrowing the gap than at others. Still, America is a remarkable country that is going through an extraordinary shift in who and what it is. For the most powerful country in the history of human civilization to be majority minority—to be a majority of people from, literally, all parts of the world—is an extraordinary fact. We are trying something that is very hard, and by the way, no European country had its Barack Obama.

We are, in many ways, at the very forefront of an experiment about whether you can create a country in which people's heritage is secondary to their character. As right and righteous a goal as that is, I have no illusions about how hard that is going to be, simply because it is

hard for people to lose their certainties, their routines, and their spot in line.

When I said, "Is there space among the woke for the still-waking?" I meant that those of us who want the new America to come need to understand that if we are a closed circle expecting people to show up woke, show up ready, it's going to be a small party. For those of us who want that day to come as fast as possible, it's essential that we figure out how we can tell the story in a way that brings people in—the people who are a little scared of it, the people who don't know what cis means, or what white privilege is; the people who don't feel comfortable talking about race or who don't think that they are in any way complicit in white supremacy because they don't understand what it means when people say they are complicit.

I think we can do a better job of making space for the people who are limping their way into this new America. In politics, small numbers matter a lot. If 5 percent of the people who voted for Donald Trump come to the conclusion "Actually, no, no," that's a landslide the other way.

DM: What about those who say that we shouldn't be caretaking these people?

AG: Even if you may feel that they've been fussed over too long and don't deserve to be fussed over as equality finally comes, we need to tend to those people who do not understand who they will be on the other side of the mountain. If we don't, the next forty years are going to be brutal. You're going to have a lot more Mark Stromans. You're going to have a lot more Donald Trumps, and you're going to have a lot more rage. You're going to have a lot more Fox News.

All of these things are symptoms of a disease that I think we sometimes don't see, which is that this country is changing so fast, so quickly, so precipitously and fundamentally that it terrifies people. Toni Morrison has this great line, "What difference does it make if the thing you're afraid of is real or not?" What matters is that we have an unsustainably high number of people who don't know who they're supposed to be in the country that's coming. I think it is our collective problem to fix this and figure it out.

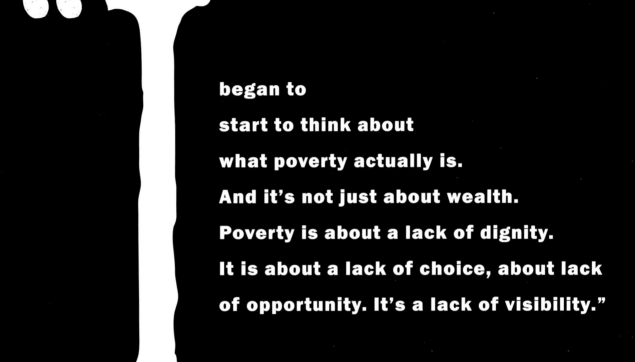

"I began to
start to think about
what poverty actually is.
And it's not just about wealth.
Poverty is about a lack of dignity.
It is about a lack of choice, about lack
of opportunity. It's a lack of visibility."

JACQUELINE NOVOGRATZ

entrepreneur and author

September 22, 2020

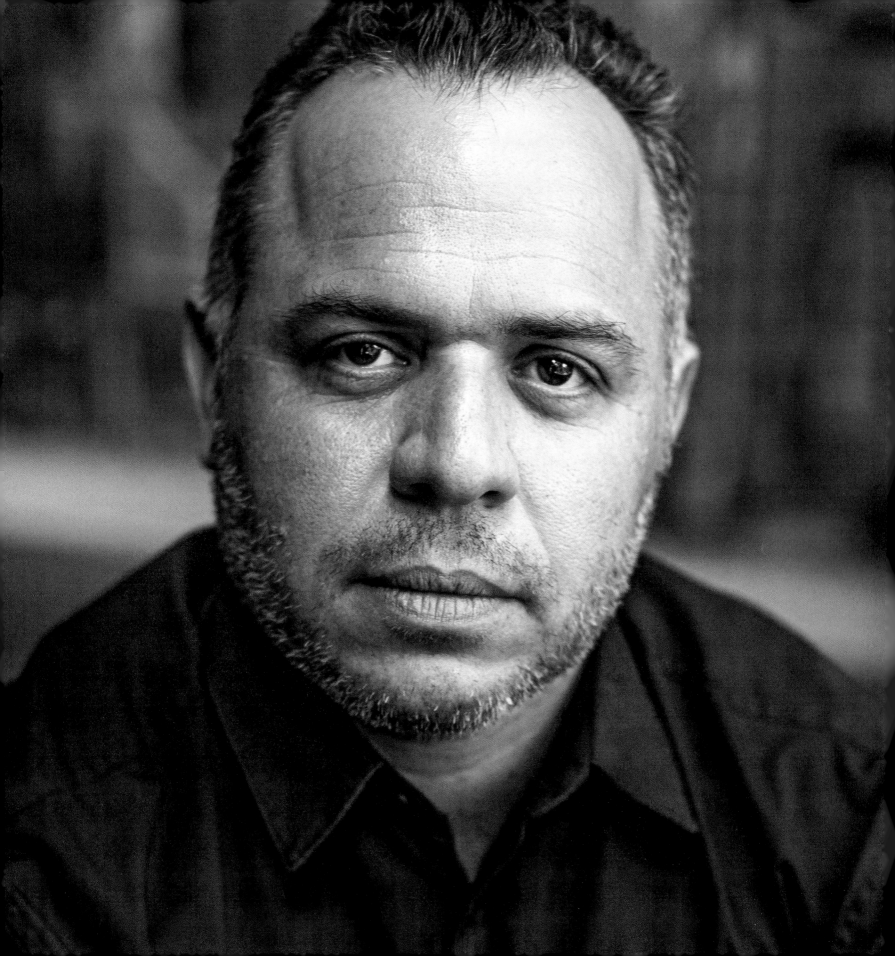

E D E L

**In April 1980 several hundred Cubans,
fed up with the bleak economy,
stormed the Peruvian Embassy in Havana,
demanding asylum.**

Over the next few days, their numbers grew to more than ten thousand. In response, Fidel Castro opened the port of Mariel to anyone wishing to leave Cuba as long as they could arrange to be picked up by boat. Family and friends in the United States quickly sent hundreds of boats from Florida, and of the 120,000 people who made it out of Cuba, a nine-year-old boy named Edel Rodriguez went on to become one of the most celebrated illustrators in the United States. In our interview, he recounts illustration's role in his childhood and explains how he leverages social media to create politically charged imagery.

R O D R I G U E Z

DM: You grew up in a small, rural town outside Havana, and your family had to work to find food and basic supplies every day. You even made your own toys to play with. What was that experience like for you?

ER: It was just life. We never thought we were poor. It was just life. You woke up and you made your toys. You went out into the countryside, cut down some sugarcane, and ate it for lunch. It was actually a lot of fun. I didn't really think much of it, but my parents were aware of what was going on because they had lived before the revolution, when there was a lot more food and there wasn't that much spying by the government. They're the ones who got concerned and wanted to get us out, but to me it was a lot of fun. I loved my time in Cuba.

DM: What kind of toys were you making?

ER: We would make guns out of wood. The bullets were bottle caps. I was working with my hands all the time. My entire life, I've been making things with my hands.

DM: You began to show a talent for drawing, sketching, at your aunt's pharmacy in Cuba. What motivated you to draw there?

ER: She had paper and she had pencils. That's the one place where I found them. I guess she wanted to keep me busy at the desk in the back of the pharmacy, so she'd give me paper and pencils and I would start drawing. I remember mostly drawing tanks. I was fascinated by military tanks at the time.

DM: What did your family think of your drawing back then?

ER: You're a kid doing whatever kid thing you're doing. It's different living than in the United States, where immediately you see potential in your child and send him into art classes or whatever. No one really took that seriously except for my father. My father was always very encouraging, taking me to art shows and things like that.

DM: When you learned you were going to move to the United States, how did you feel?

ER: I didn't know I was going to move to the United States. I was told we were going to go visit my family in the United States. One of the things that was happening was that teachers would go snitch on students at the Communist Party headquarters. The headquarters would go arrest the parents, so they didn't tell me.

DM: When you first arrived in Florida, you didn't speak any English. You've said that your art was your way of communicating. At that point, what kinds of things were you drawing?

ER: There were times when I would get picked on at lunch. I remember kids would steal my lunch. I didn't know what to say. If I needed help from another kid, I would sketch out, "The boy hit me." It was basic communication done through drawing cartoons to try to explain to the teacher, to the kids, what happened. That was a summer school. The next fall, this entire population of Cuban kids arrived in Miami and we were all put together in two classes.

DM: In Cuba your father was a photographer in addition to a restaurant manager and a taxi driver. He had a lot of jobs. Early on in the United States, he had a trucking company. He'd tell you that you had to study or you'd end up like him, which influenced your passion and your drive. Did it bother you that he didn't want you to be like him?

ER: No, no. He would say that every day. He usually would say it when it was the worst time of the day, so that it made a strong impact. He'd say, "Go to school so you don't have to do this garbage." It stayed with me. He's always looking for something better. He's the crazy one that would just go on a limb to do something. It was his idea to leave Cuba because as bad as things were, things were okay. My mom was very comfortable. We left because my father was constantly going after her and saying, "We have to leave. We have to leave." Later, when I wanted to leave Miami to come to New York, he's the one who took me to the airport.

DM: Your mom wouldn't even go, right?

ER: My mom would not go to the airport.

DM: She didn't want you to leave?

ER: No. He took me to the airport. He gave me cash when I got on the plane. He's always like that, a bit of a dreamer. I was eighteen. I took a plane ride to New York City for the first time. Once I had been here for a weekend, I decided, "I have to figure out a way to get up there." It became a big problem at my house, arguing with my mother. They didn't want me to leave. They felt like we had left Cuba and that was a big deal. To have

me leave the family again was not what my mom wanted. I told her, "I will be back in three years. I'll do it quickly."

DM: How many years ago was that?

ER: Twenty-eight?

DM: You now teach at the School of Visual Arts, and I know you take quite an interest in young illustrators today. Do you feel like the diversity of the field is beginning to change?

ER: Maybe ten or fifteen years ago it started changing quite a bit for a lot of different reasons. I think the Internet changed that because all of a sudden, artists and illustrators from other countries could start working in the American market. The names and the diversity started becoming a lot more pronounced.

We never thought we were poor. It was just life. You woke up and you made your toys.

DM: You started working at *Time* magazine as a temp, then you worked your way up to becoming the magazine's youngest art director for the Canada and Latin America editions. You said, "I come from a family of very hard-working peasants and farmers, so I don't think of office work or drawing as hard labor. I laugh at it sometimes. It's nothing compared to what my parents or grandparents have done, so this keeps it all in perspective." What does it mean now, to your parents, to see you reach this kind of success?

ER: I think they're very happy, and proud, and occasionally confused.

DM: What are they confused by?

ER: The things that I do, the graphics and the visuals.

DM: Let's talk about some of the covers you have designed for various magazines. Your cover for *Newsweek*, "What Silicon Valley Thinks of Women," won a National Magazine Award and also stirred up a fair amount of controversy. Your amazing Trump covers for *Time* landed you on Ad Age's "50 Most Creative People of the Year" in 2016 alongside Frank Ocean, Prince, Tom Ford, David Bowie, and Beyoncé. I believe those covers ushered in a new phase of illustration work on magazine covers—much stronger, much more direct, much more brutal.

ER: That's the right word, brutal. The danger that we were facing and that we are still facing in this country is this neutrality. This "Oh, both sides have their own point of view. We need to listen to both sides." That kind of thing, which liberals practice very well. It got to a point where I felt you needed to confront this. It was basically fascism in the United States, and you don't appease fascists. You really do confront it as strongly as possible, and that's what I wanted to do with that cover. Making him orange is a very strong visual. It's taking what he looks like and then tweaking it even more. I wanted that strength. It was affirming to have the backing of the magazine because once *Time* magazine does that, then everybody else decides, "We can confront this in the same way."

DM: I read that you'd much rather not be creating work about Trump. How do you manage to look at that face as much as you have to look at it?

ER: I don't really look at him. I don't really look at pictures of him. I'm working with symbols and graphics in my head. I usually spend ten minutes, fifteen minutes on something.

DM: Ten or fifteen minutes?

ER: Something I might put on the Internet is very fast, actually. If it's a cover, then definitely I'll spend more time tweaking it. I can maybe do something in three or four hours. Part of the thing is, I don't want to draw his eyes, and his nose, and getting involved in all this stuff. For me, it's more of an object and a brand. I've created this branding and this brand of him, and I can

now tweak it and change it. It's not even him that I'm doing, it's more about anti-branding. It's creating a brand and then doing everything to destroy it, basically.

DM: Your *Der Spiegel* cover went even further. You created an image of Trump beheading the Statue of Liberty. It went viral, and you said that it was pretty hilarious that a drawing was making the world go nuts.

ER: It's definitely been the one image that has created the most controversy and the most coverage. It's still happening about a year later.

DM: That's a heart-stopping illustration.

ER: Good. It's what I wanted. The backstory is that I had created a series of illustrations, probably about ten, taking ISIS to the max. I felt that they were doing so many awful things that they were in fact killing themselves. I created this image of an ISIS terrorist with his arms up. He has a knife in one hand and his own head in the other, and he has no head. He had cut off his own head. I did that in 2014.

Then I was watching the news and the Muslim ban happened overnight as planes were still in the air. You had planes trying to land; there were kids that were sent by themselves; they were at the airport and they couldn't get out because they didn't have the permit to come into the country. I was thrown back to when I came to the country when I was nine years old, a kid trying to come in. At that time, I was welcomed with open arms. Now I was asking, "What's happened to my country?" The Statue of Liberty was like a saint in my family. All of these things were popping into my head as I was watching TV. I was disgusted by it. That's something that Castro would do.

DM: You compared Trump to Castro.

ER: That's how Castro and the Communists in Cuba treated us when we wanted to leave the country. We were put in this pen for a week. We were held and anything could happen. The idea of toying with people's lives and emotions angered me.

Out of pure anger, I took the ISIS terrorist, the same exact image, and I put Trump's head on it and put a Statue of Liberty on his arm and it was the same knife that the terrorist was holding. I was making a direct correlation that the real terrorist was Donald Trump. The person that's affecting lives at that time was Donald Trump. Since it was related to the Muslim ban, "Yes, he is an ISIS terrorist" was the concept. I posted it on Twitter, on Facebook, and all my media channels, and it went nuts.

Then, about a day or two later, *Der Spiegel* called me and said, "Hey, we are doing a cover on the Muslim ban. Can you send us some ideas?" Before the cover was even out, it was at protests at the airports. People had printed it off the Internet.

DM: You give people the permission to do that, right, with printed comments on it?

ER: At that time, I hadn't even thought of that. At that time, people downloaded it off Twitter and created huge posters to bring to airports and all this stuff. It started a lot of direct messages, a lot of emails, insults, and all sorts of things—calling me a Communist. Every insult that you can think of, basically.

I think it's very important to not normalize a lot of this stuff. It's like an entire country that's being gaslighted all the time. That's happened in Venezuela, in Cuba, in Russia, in many other countries. We can't let it happen here, and it can. I think what I do with my work is make people react, "Wow, I'm not crazy. Someone else sees what I saw."

DM: *Fast Company* has dubbed you the "preeminent illustrator of the Trump era." Do you look forward to the day you can stop illustrating him when this is all over?

ER: Yes, there are a bunch of other things that I want to be painting. My favorite thing is to be in my studio painting and making things that make no sense. But as I wake up every day, I'm thinking, "I've got to say something about this."

"Corporations

and politicians
don't make changes
unless we—
as consumers
and citizens—
demand them."

TATIANA SCHLOSSBERG

journalist and author

January 13, 2020

June 11, 2018

CARMEN

Author Carmen Maria Machado's short story collection
***Her Body and Other Parties* was nominated for**
the National Book Award for fiction.

M A R I A

If you like fairytales and myths, this book is for you. If you like horror and science fiction, ditto—the same book has got you covered. If you like experiments or fiction, queer theory and luminous storytelling, you're also in luck. In our interview, we talked about her career as a writer, why she's a ruthless pragmatist, and why she needs to believe in magic.

MACHADO

DM Carmen, growing up in Allentown, Pennsylvania, you've said that there was a lot of storytelling going on in your home, particularly from your Cuban granddad. What kind of stories were being told, and how did they influence you?

CMM He would tell stories about Cuba and his life after he left Cuba that were really strange and very dark. I don't think I fully appreciated or understood their darkness. There was a story he would tell about how he had this pet rooster, and then one day they were having dinner and he asked, "Where's the rooster?" They were like, "You're eating him." There's this way of speaking about his life that was funny, and rueful, and structured in this really interesting way. The humor and the darkness were always very close to each other and playing off of each other, which I have since learned is a very distinctly Cuban way of speaking.

DM I understand you were a big reader when you were a kid, but you got so freaked out by R. L. Stine's *Night of the Living Dummy* that your mom banned *Goosebumps* books from your house. I read that you liked how it made you feel afraid, and you've observed that it was really marvelous to learn that a book can reach out and do that.

CMM Yeah, it's funny, I just, I literally just bought an enamel pen that is the dummy's head from that book that I found at a store, and that felt right that I owned it. It just seemed like a thing I should wear on my lapel whenever possible. I did an interview a while ago where I was discussing this with the interviewer, and he described it as something that changes your temperature. I was like, "Yeah, the work that I like is work that changes your temperature." It makes you feel something.

I do it and I'm like, okay, that was the thing I did, but there's no sense of anything. There's no, like, I'm not happy, or sad, or angry, or afraid, or anything. I just feel nothing, I'm just okay and that's my worst nightmare. As a reader and as a writer, if someone was like, "I felt nothing when I read your book," I'd rather someone be "I hated your book." I'd be like "Good, I'm glad it evoked a feeling in you that way." So yeah, those books, I couldn't tell you why, I don't know why that book in particular, but for some reason that was a book that so affected how I felt. I couldn't sleep, the lights were on for a week, my mother was just, she was beside herself. She's like, "This is ridiculous, why are you doing this?'

DM In your short stories, there's this underlying sense of tension and you tease us with it. There's this building sense of intensity I've never read before.

CMM I think of short stories as laboratories. You're able to play around in a way where if the experiment fails, you can cast the story aside and move on. That's a very contained space I can play around in and experiment, and also you can pull things off in the short story that a reader would not necessarily want to sustain. For some reason, the short story just really works for me.

DM Me too. They feel somehow easier to manage emotionally.

CMM I always tell my students a novel is like being beat up over the course of a day, and a short story is like one punch to the nose. They're a different experience of reading, and I prefer the punch to the nose. I don't know why.

DM

Do you believe in magic?

CMM I want to believe in magic. I exist in this very weird space. I'm a ruthless pragmatist and yet I want to believe in magic more than anything. If I could change anything about the world, I'd want to know that supernatural things could be true.

DM

You went to American University in Washington, D.C., and initially studied journalism. Why?

CMM I wanted to be a writer, and my dad told me the only people who had full-time jobs were writers that had health insurance—journalists. I took one semester of journalism writing classes, and I had this poor beleaguered teacher who was this lovely brilliant human, this really talented journalist Amy Iseman. She was trying to get me to take adjectives out, and I said, "No, I won't relinquish another adjective." She was like, "I don't know if this is for you." Eventually I changed majors because that was not how I wanted to write.

DM After you graduated from AU, you applied to and got into the Iowa Writers' Workshop, widely regarded as one of the best writing programs in the world. What inspired that decision?

CMM Well, there was a gap in between, so I moved to Berkeley, California, and it was the beginning of the recession. That's the worst decision I could have possibly made. I had a degree that was totally non-functional and student-loan debt. I moved to the most expensive area in the country and I struggled. I was really sad and so I started applying to MFA programs. I was so desperate. I applied to a ridiculous number of them, I think twenty-five, twenty-six. I got into Iowa and did not look back.

DM Is this when you finally accepted that you wanted to be, and were going to be, a writer?

CMM It was the first time I'd taken a professional step. Before that, I was writing, but I never really thought about "What if I wrote a book?" I was experimenting and trying new things, and then everything clicked into place. Most of that happened after I graduated, but when I was at Iowa I made decisions about actively trying to push into certain areas I was interested in trying out.

DM Your path to publication wasn't easy. You'd gotten a literary agent, but during your first round of submissions, no publisher would take the book. How did you eventually land with Graywolf Press?

CMM The process of trying to sell a book is really terrible. It's very stressful if you're coming at it as a debut author, where you're outside of the system. Even finding an agent was really strange because back when I was looking for an agent, I would write query letters, and agents would say, "This is interesting but it's not quite for me. When you have a novel, let me know." No one wants to buy short stories.

DM Why?

CMM They don't sell a lot. My book is an exception, and there are exceptions like George Saunders. A lot of people will say to me, "I normally don't like short stories, but I like your short stories." Graywolf was the only place that made an offer.

DM It's been released to rave reviews. You won the Bard Fiction Prize and the National Book Critics Circle John Leonard Prize, you were a finalist for the National Book Award, the Shirley Jackson Award, the Kirkus Prize, the *Los Angeles Times* Book Prize for fiction, the Dylan Thomas Prize, and the PEN/Robert Bingham W. Prize for Debut Fiction. Well fucking done.

CMM Yes, thank you. That was the funny thing—obviously it's a good book. I love it, I feel very proud of it, but I think the timing of the book—if Donald Trump was not president, I think the book would not be selling nearly as well.

DM Why?

CMM We are in this crisis about gender. The crisis is manifesting as #MeToo, it's manifesting in the way that the election played out with Hillary Clinton, regardless of how you think about her as a candidate, the way in which women saw sexism on this massive, boorish scale. The way that played out, it was really traumatic for a lot of women. We didn't fully acknowledge or deal with that trauma because then the election happened and everyone panicked. A lot of people are trying to reckon with these questions and this feeling. The book feels really relevant. The way in which we treat women and talk about women and grapple with their bodies has always been really terrible. I think it always will be. I'm a pessimist about that.

"I

am definitely
an aggressive woman,
without a doubt—and I'm not
going to make any apologies for it.
I'm grateful to be an aggressive woman.
It's served me very well."

SHIRLEY MANSON

musician and performer

December 3, 2018

LYNDA

For nearly three decades, Ernie Pook's *Comeek* could be found in alternative weekly newspapers across the country.

With clear block lettering and hairy pimply drawings, Lynda Barry chronicled the everyday adventures of a boy, Ernie Pook, and a girl, Marlys Mullen. Comics have never been the same. Her books have also been extraordinarily influential. Her first illustrated novel, *The Good Times Are Killing Me*, came out in 1988, and her latest, *Making Comics*, was just released. She's a professor of Interdisciplinary Creativity at the University of Wisconsin in Madison, and she recently won a MacArthur Fellowship, so it's official: Lynda Barry is a genius. We spoke about collaborating with four-year-olds, drawing as a superpower, the alphabet as a doorway into the image world, and the damaging effects of one's own opinion.

BARRY

LB: I hung up on them seven times because I thought it was a robocall. This number kept calling, and I started doing that obnoxious thing, answering and hanging up, to discourage whoever it was. Then I turned my phone off. And then, through other means, I heard somebody needed me to call them, so I called them. The person who wanted me to call them was named Marlys, so I thought it was about my comic strip character, Marlys. Often somebody wants to tell me, "I'm named that too." And I tell them, "Oh, yay." I thought it was going to be an "Oh, yay," and it was an "Oh, yay" of a different sort.

DM: How do you think it's going to change your life?

LB: The first thing I considered was taking out all the stuff that was stressing me out about teaching and keeping the parts that I love—working with students and doing research. The research that I'm most interested in is working with human beings for whom writing and drawing haven't split yet, and they happen to be four-year-olds. I believe that drawing with people that age has a mutual benefit that's profound. I've seen it with my older students. I started a program because I was confused as to why grad students were so miserable and why that's acceptable to the academy. We should be doing everything we can to make their lives comfortable because they're the people that are discovering things. So I told my grad students that I was going to find co-researchers for them to work on their dissertations, and I didn't tell them that the co-researchers were four years old. In grad school, your focus becomes laser sharp and anything that isn't getting you toward your goal seems to be extraneous, but discovery doesn't work that way. I wanted them to be with human beings who had this super open frame of mind, and after that I started to realize that this applied to me too. My time with them always resulted in some discovery in my own work.

DM: In your new book, *Making Comics,* you note that if drawing, singing, or dancing are absent in children, we worry about them. Not so for adults. I found that astounding. You also talk about the separation of writing and drawing that happens as children grow older, which you've just mentioned. How do we encourage that connection to continue longer than the age of four or five years?

LB: It stays with us naturally if the environment around us takes part in it. I work with kids as much as I can, and oftentimes there are parents around. What's amazing to me is how I can rarely get a parent to draw with us.

DM: Is it because they're afraid they're not going to do a good job?

LB: They're so afraid. When you ask them, "Do you want to draw?" the first thing they do is cross their arms and hide their hands. It's as if their hands might accidentally start drawing, so they have to tuck them away because the hands want to. Their fear of drawing is so profound that it's like when somebody suddenly has a bodily fluid that escapes that they can't control, and then they are horrified, like if your nose started bleeding or something. I'm curious about why that horror exists. I've done a whole lot of work with adults to get them to draw and to find drawing exercises that aren't intimidating or that happen too fast for that fear to step in. I feel like I'm working with kids when I'm working with adults because I'm working with the part of them that gave up on drawing at about the age of eight, when they realized they couldn't draw a nose. And for most people, nose or hands, age eight, it's over.

DM: We're afraid of doing anything that we don't think we're good at, but you can't get good at something until you start doing it. I think many of us live in this paralysis of wanting to do something but also being ashamed of not being able to do it well and being humiliated in the process of doing it.

LB: You don't even have to be able to do it well. It's like thinking that unless you can ride a bike like Lance Armstrong, you shouldn't ride a bike. Not even Lance Armstrong could ride a bike like Lance Armstrong. Drawing is an experience, but then they treat the drawing like it's a thing and a thing to be judged. That's what I love about comics because comics leap right over that problem of representation. You wouldn't want Charlie Brown with a hyper-realistic nose or hands. It'd be pretty horrifying. All those shapes that are preserved by our ability to write the alphabet and our beautiful numerals— they're the most beautiful shapes, ones that allow us to make comics.

DM: I will never forget the first time the graphic designer Chip Kidd showed me the cover of the *Peanuts* book that he edited because it was just a close-up of Charlie Brown's eyes. It looked like a C, a period, a period, and a C. I didn't understand what I was looking at, and then as soon as I realized it, it became clear. It was genius.

LB: You just did it. You said a C, a period, a period, and a C, which is the way my four-year-olds articulate things. I often talk to them about difficulties that my older students have. I go to them with my problems. I say, for instance, "They're scared of drawing hands." And this kid says, "Hands are easy. It's a snowball, thumb, thumb, thumb, thumb, thumb." Or ears, that's another thing. They'll say an ear is the letter C with a 5 in it.

DM: That's perfect.

LB: A kid's drawing is gesture. It's natural human movement. Another place where we see that is in the sciences. At the university, I get to watch how scientists move their hands on the white board when they're thinking. It's astonishing. The parallels between how their hands look and how their drawings look and a four-year-old's. The thing that I've come to realize is, "What if a line is not just when you're getting an idea, but the line itself is giving you an idea?" Drawing can go not just from your head to the page, but from the page, up your hand, and into your head. That's the kind of drawing that kids are doing. They're drawing and then seeing what it is they're drawing.

DM: What is your first creative memory?

LB: The letter O. We were studying the alphabet in first grade and we were on the letter O. I grew up in the Pacific Northwest, but I drew an orange grove. I had never seen one, but I drew an orange grove with a stream going down the middle of it. I was a strange kid. I had a lot of emotional problems, but that drawing made a couple girls in the class, who were normally not very nice to me, very interested. They wanted me to draw them each a version of that drawing. It was the first time I saw a drawing as some kind of communication—a communication that was much different than just looking at somebody and talking to them.

DM: You've said that comics were the reason you learned to read and that when you were very young, you picked the five comic strips you decided you were going to read for the rest of your life.

LB: I had just been introduced to this idea of "the rest of my life." When I was thinking about it, we were passing a fence and I looked at this fence and thought, "I'm going to remember that fence for the rest of my life." And I have. I remember picking out those comics. I grew up in a difficult family, and we happened to have little scissors around the house, teeny tiny cuticle scissors. I didn't have a lot of toys, so I used to cut out black-and-white characters from the comics, and those were my toys. My mom had a lot of disturbances and would take stuff away from me. What I loved about them is you could hide them. I became very attached to comics. Not in the nerd way that people do, where you know everything about the author. I was attached to the characters themselves.

DM: You've written about how you didn't have books in the house, but you had the daily paper, and you picked out the comic *Family Circus* before you could read. The images in *Family Circus* appear in circles, and there was something about life on the other side of that circle that looked pretty good.

LB: It still looks good to me.

DM: For kids like you, there was a map and a compass hidden in *Family Circus*. The parents in that comic strip loved their children; their home was stable. It was your wished-for family.

LB: Yes, you know what's amazing about comics in general and also the world? It's amazing that human beings may be born into a family where it's not the right place or there isn't a lot of love, but you're also born into this world that is jam-packed with characters. It's astonishing that no one teaches little kids how to become attached to the characters they need. Just like no one taught us how to turn a piece of cloth into a blankie that will allow us to sleep at night. We have a natural ability to love characters and to be able to use them.

DM: They're transitional objects.

LB: I was born into a family of characters, and *Family Circus* was that for me. I loved being able to look through that little circle and see this happy life. Then one day I got to meet Jeff Keane, who draws the strip, and I burst into tears. Even now when I'm talking about it, I tear up. I think it's because when I touched his hand, I was on the other side of that circle. I realized that happened because I drew a picture. Life is so much better than I thought it would be.

DM: How did you feel when he drew you into *Family Circus* as Jeff's little friend?

LB: It was so great. It was such a beautiful thing to have happen. Unbelievable.

DM: On your own family, your parents got divorced when you were twelve. You dropped acid for the first time when you were twelve. You changed your name from Linda with an i to Lynda with a y.

LB: I also saw *Hair* when I was twelve, which was life changing. I found out the production was coming to Seattle. I remember skipping school. I remember buying a ticket, and I had this feeling. I said to myself when I left the house, "You are not going to be the same person when you come back." And that's exactly what happened. It filled me with this feeling that there's this other place to go where these people are waiting. It let me know that there was an Age of Aquarius and there was another way of being in the world.

DM: Let the sunshine in.

LB: Let the sunshine in. It was the opposite of depression. The image world has always been the place where I've found everybody. It's a slow start, I think, for artists. You can have a slow start in life and have difficulty in the beginning, and then something happens and it gets better.

DM: Another defining moment when you were twelve was the discovery of the work of cartoonist R. Crumb. How did you come upon his work?

LB: I was in row three in math class. I think I was in seventh grade, and this kid had *Zap #0* next to me and I asked if I could see it. I remember looking at a few pages and then convincing the guy to loan it to me overnight. There was something about the way he was drawing ordinary people in this extraordinary way. He'd have a scene that was in a store—just normal people on the street or in a store—but the way he drew the people was extraordinary, the way they are shaped, the way they are dressed. I started copying him right away, which is another way that cartoonists learn. His work made an impression on me—the way he saw the world and saw the ordinary parts of the world. He'd draw a room and include cracks in the ceiling or the string pull from the light. The sex stuff, the other stuff that he's known for, was so pale to me compared to the ordinary world that he portrayed.

DM: You worked as a janitor in a hospital from when you were sixteen to twenty. Your mother also worked as a janitor. And you studied as an undergrad at Evergreen State College in Olympia, Washington.

LB: I had such a good teacher at Evergreen—Marilyn Frasca. She had us working like we were in grad school. We worked relentlessly. By the time I graduated, I knew how to work and I knew how to sustain a practice. I knew that that's what I wanted to do, and all I needed was to find a way to support that desire. So any little job I

could have helped me do that. That's how I looked at it versus people trying to find a job doing the thing they love right away. That's difficult and it's also not necessarily a good idea because you're usually under somebody who's starting to tell you how to do it. And that can jam your signal in a way that can almost maim you. I think it can be irreversible.

DM: I know that Marilyn Frasca taught you about the idea of the Image, with a capital I.

LB: When I was nineteen, she asked me to think about this question, "What is an image?" I thought it was a picture. I thought that's what she meant—it's just a picture. But now I see it as this other world entirely. For example, coming here on the subway, there was a fellow sitting right across from me. He was a tall, gangly fellow who was out of it. He was in this pose that looked exactly like a Picasso painting that I had seen. He looked like a junked-out dude sitting across from me, and at the same time he was in this pose that was so arresting that I couldn't keep my eyes from him. There's the reality of him sitting there, and then there's the image part of him. It's this idea that in any situation that you're in, that other view is available to you—and also that it doubles your amount of time on Earth. The idea that there's something that can accordion out time for you and also make you able to fly and turn invisible. I think that's exactly what's happening when you're reading a book. You're somewhere, but you're also invisible. And then when you're looking at a scene, it's almost like you can fly. So all those little superpowers that we imagined having when we were a little kid are there for us in the image world.

DM: I've read two accounts about how your comics first got published, both involving Matt Groening, creator of *The Simpsons,* who you went to college with.

LB: What happened was Matt became the editor of the school paper, and he said that he would print any comics that somebody submitted. I thought, "Oh, right, really?" I was making the most horrific comics, and those were the ones that I was slipping under the door of the newspaper office.

DM: What does horrific mean?

LB: A picture of a father reading the newspaper and a little girl trying to show him what she learned at school during the day. He's not paying attention, but she has learned how to sever her own arms and legs. There was a lot of limb severing. Or an argument between a guy

who had no legs and a guy who was a jackass about whose life was worse. Sometimes it would be a very crudely drawn picture of a person—you could barely tell it was a person—and then underneath the caption would say, "What is wrong with this picture?" No matter what I submitted, Matt printed it. It went under the door, and then it would show up in the paper. We ended up becoming really good friends.

DM: How did you create Ernie Pook?

LB: That title came from my little brother, who's eight years younger than me. When he was little, he named everything "Ernie Pook"—his socks, the food he was eating—but he would differentiate by calling them Ernie Pook the 32nd, Ernie Pook the 422nd. When I decided to do a comic and it was going to be in our little weekly paper in Seattle, I wanted to name it something, so I called it *Ernie Pook's* just for him. I thought he would crack up, but when it was printed and I showed it to him, I said, "Look." And he replies, "Who's Ernie Pook?" He had no memory at all of naming every little thing.

DM: And how would you define *Comeek*?

LB: This was at a time when there was superhero stuff, there was stuff in the daily newspapers, there was some underground work—the R. Crumb stuff—and so the comics that I was doing and Matt was doing didn't have a place. It was called "punk art" for a while. I wanted to call it something different, and again, the title was for my brother to make him laugh. It's also a play on how my relatives say things. The first panel was just about some kids who got sick after going to a parade—who ate something and got sick. That was it. I drew that, and I had no idea that I was going to spend about thirty years with those characters—Marlys, Arnold, and Freddie. I remember drawing that panel and not particularly liking the drawing.

DM: How come?

LB: I don't know. What terrifies me is how easy it would have been to just throw that away. My teacher, Marilyn, taught me this amazing thing. We were looking at a drawing I did, and I said, "I don't really like this drawing. I don't know how I feel about it. I don't think I like it." And she paused, and she told me, "It's none of your business." It was the most mind-bending thing anybody had said to me because I thought: "You mean there's another way to look at this besides do I like it or not?" That was the fulcrum. That's the crucial moment of my entire career as an artist, that one little sentence. "It's none of your business."

DM: You've said that in the same way you don't have to like the way your liver looks for it to be able to function, you don't have to like the way your drawings look for them to start to work.

LB: Absolutely. This idea that liking, or not liking, is the essential part of making something. When I had that taken away, I was finally able to look at the work and see it as something that had the same right to exist that I did and something that might have a function that I can't even suspect. It's the idea of learning to look at something without like or not like, without judging. It's allowing the thing to come forward, allowing the thing to be present.

DM: We're living in a day and age where everything is judged by being liked.

LB: I know.

DM: In *Making Comics* you detail how you hesitated before agreeing to teach a comics class. What made you finally agree?

LB: I knew I could teach writing, and I'd been slowly sneaking drawing into the writing classes, and I started to see what a benefit it was, and how excited people got, and how it was definitely a more crazy, unknown terrain. But I never did develop a super-fast comic style or a very accomplished style. If there's a stranger who doesn't know my work at all and they ask me to draw something, when I draw something for them, you can see this little look of pity they have. As though they're thinking, "That's your dream, you just keep on it." Because my drawing style is a little bit funky.

DM: But you can draw. You can draw Renaissance style if you want to.

LB: If I want to, I can. It's always a little stiff, but I can do it. I can draw draw, but that's not the drawing I'm interested in. I'm interested in the wild, wild—I don't know if it's west or east or north or south, but something wild.

DM: You end your new book this way: "Everything good in my life came because I drew a picture. I hope you will draw a picture soon. I will always want to see it."

LB: Yes, it's true. I will always want to see it.

CHANEL

It was a case that started a
national conversation about
rape on college campuses.

On January 17, 2015, nineteen-year-old Stanford student Brock Turner raped Emily Doe. When the judge in the case sentenced Turner to a mere six months in prison, a media firestorm began, and two years later voters recalled the judge. The day after the sentencing, Emily Doe's victim impact statement was published and it went viral. We now know that Emily Doe is Chanel Miller. Her memoir, *Know My Name*, according to *The New Yorker*, "may have been precipitated by her assault, but the final work devitalizes its horrific beginnings. No narrative is as persuasive as Miller's. There is no more self-effacing sobriety, no more conclusions plastering confusion and fury. Know her name, know her voice."

MILLER

DM: You were born in Palo Alto. You've described your house as one where everything grows and all spills are forgiven, where anyone is welcome at any time of the day, where darkness could not get in. Chanel, what is it like to grow up in a family like that?

CM: I never for a second questioned that love. And I think that's what has allowed me now to go to the darker places to speak very openly about difficult things I've experienced because I still have this foundation to go back to.

DM: You were well parented. In your book, you write how your grandma Ann stated that you were born with a pencil in your hand and you still draw all the time. You draw when you're upset, when you're bored, when you're sad. And you've shared that depression has been an on-and-off companion in your life. How did you manage through your early experiences of depression?

CM: I draw to remind myself that there's so much that I contain that I cannot see, and I always feel like I can't give up on myself because it's not fair to all the little creatures that are inhabiting me; if they would never be able to make it onto the page, that's not fair to them. Drawing reminds me that even when my mind is cloudy, thinking about serious court stuff, I still have that very strong desire to create silly things.

DM: You referred to depression and non-depression as riding with slugs or horses. Can you elaborate on what you mean by that?

CM: I go in and out of these phases where I'm productive or not, where I enjoy waking up in the morning or not. I've tried really hard to not think of depression as failing, as if happiness is the default. Really, it's an equal state as happiness, and I'm okay with fluctuating through both.

DM: You received your Bachelor of Arts Degree in Literature from the College of Creative Studies at the University of California, Santa Barbara. You stacked your bookshelves with writers, and when you wrote or drew the world slowed and you forgot everything that existed outside. At that point in your life, what did you want to do professionally?

CM: I wanted to write children's books. I remember Remy Charlip had this book, *Arm in Arm,* and the first page shows two octopuses. He had this page of little kids playing, and they said, "Isn't it better to be out in the snow rather than in a warm bed?" And then it cut to a bedroom of these little people under a quilt, and they're saying, "Isn't it better to be in a warm bed than out in the snow?" I thought, "Oh—perspective!" And the

snow on the page, he had drawn each snowball as one-fourth the size of a lentil and they filled the entire page. I remember thinking, "Adults are usually so busy, and this man cares so much about drawing these tiny, tiny snowballs. I want to spend my time doing that."

DM: After graduation, you moved back home and went to work at an Internet startup. What kind of work were you doing there?

CM: I did a lot of office management, but they also allowed me to create content. I drew all kinds of things for the app, like weird birds and sumo wrestlers, a little portrait of John Muir, and illustrations about Kwanzaa and Peru. I appreciated that environment.

DM: How did you envision your life unfolding at that time?

CM: I think I would have grown up in that office with those people, and I still visit them and they welcome me back—and it's so nice to feel like I didn't lose them. That was important to me and helped me accept that I don't have to accumulate so many losses as I set off in my own direction.

DM: The evening of January 17, 2015, that changed everything. For those who might not be aware of the story, can you share a top line that isn't too difficult for you to share?

CM: I had gone to a fraternity party on the Stanford campus. I had already graduated. I was with my younger sister and some of her friends. We were dancing silly, having a good time. Then I was out on the patio with her, I was drinking lukewarm beer, it tasted awful. And that's where my memory ends. I didn't know anyone at the party. I hadn't been talking to anyone except my sister and her friends. And next thing I know I'm in a hospital and I have blood on my hands. I realize I am not wearing any underwear and my hair is completely embedded with pine needles that were scratching my neck and falling out into the gurney that I was in. And then I underwent a multi-hour, extremely invasive forensic exam where all evidence was collected and bruises and scratches on my body were photographed that would later be exhibited in court.

DM: So, you were raped?

CM: I was raped.

DM: In the introduction to *Know My Name,* you state that the book is not a personal indictment or a blacklist or a rehashing. What would be wrong if it were any of those things, Chanel?

CM: To me, a revenge narrative suggests that it's about him or going after him or my pursuit of him rather than centering it back on me. I wanted the story to revolve around me. I wanted to be selfish in that way and to redirect all that attention—and to also say that there are thousands of him. This narrative repeats endlessly. I wanted to focus on a greater picture rather than the me-versus-him battle.

DM: You were assaulted while you were in a blackout state. How have you responded to people that somehow felt the blackout was to blame?

CM: I just continue to say, "You will never convince me that it's okay to violate me." There's no justification that exists. I don't care what context it's under. You cannot make excuses for penetration without consent.

DM: You describe how people seemed angrier that you'd made yourself vulnerable than that he acted on your vulnerability. You write, "Drinking is not inherently immoral. A night of heavy drinking calls for Advil and water. But being drunk and raped seemed to call for condemnation." People were confounded that you had failed to protect yourself, which incensed me. How did you handle it?

CM: I was astounded by how people seem to treat rape as the given, saying, "We know this exists, it happens so often, you have a high chance of it happening to you if you go to a fraternity party. So why didn't you protect yourself better?" And I'm here asking, "Why do you expect that to be the common experience that we should constantly have to guard ourselves from?" In the beginning, I was internalizing all of the negativity and critique, but at the same time, my body was hurting, my body was upset, and later on my body was exposed in photos. It's not fair to go after my body like this; it needs me to take care of it, it needs me to nourish it and be better and ask more for it. And that's what I learned to do, to take care of myself.

DM: When women drink to excess, they're blamed for what happens to them, but when men drink to excess and harm women, the women are blamed. I still can't wrap my brain around why.

CM: I don't know why it's so hard for us to expect better or envision a world in which this doesn't happen. As I've said before, I know men who drink and don't violate women—that is a possibility. It's not like drinking automatically makes you forget how to treat a person.

DM: Initially after the assault, you didn't tell your parents. How come?

CM: Protection. Always protection. I also didn't know what had happened to me, so I didn't have a narrative to provide for them. I wanted concrete facts before I told them anything. Otherwise, I attempted to protect them from as much as I could for as long as I could until I realized I could not do it alone. If there's something that I learned, it's that I should have asked for help sooner.

DM: You found out a lot about the details of the assault while reading the newspaper online as opposed to being contacted by the authorities, the hospital, and so forth. Do you know how the details got out to the press so quickly?

CM: Because the police report was filed, which was then available to the public, but I didn't even think it would be a story—I didn't know what the story was. So, all of this was new to me and it was very out-of-body to read it online. It took a very long time to fully inhabit my body again.

DM: People were terribly cruel to you online. You grew deaf to the warm-hearted comments and the harsh ones became louder. How did your family respond to all the cruelty?

CM: I think it hurt them too, and it hurt me watching it hurt them. But also it strengthened my resolve to be all right in spite of everything. I still have a lot of negative memories and triggers as I move through the world, but I can reframe how I see them. I can see them through a more loving lens and remember that there are so many people who are trying their best to take care of me.

DM: You write heartbreakingly about what you referred to as the eventual rotation of selves: "You can't fawn over your coworker's photos of Maui by morning, slip away to battle your rapist by noon. It required two entirely different modes of being." Initially, you were unwilling to give up working but ultimately had to, yet at that point no one other than your immediate family and your boyfriend knew what had happened to you. You spent four years in that rotation of selves with no one knowing. How lonely was it for you?

CM: It was astonishingly lonely, especially in contrast to now. Now that I am being nourished by people and able to converse face-to-face, I realize how much I was missing. It's insane to me. Also, when I think of it now, when I was getting the rape kit done at the hospital, you're lying back and there was a picture of a sailboat

on the ceiling: that was the single image of comfort throughout the next year and a half. There's no art, no music, no emotions that are allowed to be expressed—no plants, even—in all of these spaces. It's so essential to let more people in when you look around these spaces, which have no signals to revive yourself. You just feel like you're being punished when you're in spaces like that.

DM: You were told that you couldn't discuss the case even with your sister, and, reflecting on the legal process, you write about what it felt like to always be trying to keep up, not to mess up, to learn court jargon, to pay attention, to follow the rules.

CM: We need to be able to find a way to achieve justice without completely dehumanizing and debasing the victim. I feel like a lot of the reason I lived in isolation was because you're in a realm you don't understand, and the only way to keep it contained is to not speak about it. And it's not okay to not be able to even speak to your own family. My sister wasn't treated as my sister in the courtroom; she was a fellow witness. Same with my boyfriend. I can't discuss the case with them.

DM: You weren't even allowed to be in the room when they testified.

CM: No, I was not. So I couldn't support her. You're treated like consultants—come in here when we need you, answer any question asked of you, and then you're dismissed. But it broke my family down for a long time. We didn't have our bearings, we would always be disoriented. We wouldn't want to speak. It's so terrible, and I don't expect anyone to go through that.

DM: As a way to cope and get back to yourself, you went to the Rhode Island School of Design and took a summer printmaking course. What was it like getting back to working with your hands and making art?

CM: Even just walking into the room and smelling the ink again felt like home. I loved that I was capable of output rather than just feeling like things were being taken all the time. I put up all my prints on the walls to say, "See, you are capable of so much, of infusing spaces that don't have color with insane amounts of color and imagery. Even if you're in places that are devoid of all of those things, you carry the ability to infuse them with the light they need. So, don't ever be tricked into thinking you will be without those things because you have them, and when you are given the privacy and comfort to express yourself, they'll come out again."

DM: After the assault, you began therapy. How did therapy help you?

CM: Well, first of all, it was the first time in eight months that I had fully disclosed my story. Even if you choose to tell a few people, you will still be telling filtered versions. When it's fully out, you can finally look at it and see it more objectively, like, "How do we tackle this thing that landed on my life?" Rather than, "Why am I so messed up inside? Why is everything distorted? Why can't I function?"

DM: You stated that your therapist told you to hold your wounded self. How hard was that for you to do?

CM: It was extremely hard, and I don't think I fully understood what she meant until the verdict was read. When the jury finally said yes and yes again and yes again, I thought, "Why did I ever question myself?" I felt like the self that was in the hospital, I had just fully abandoned her, I had neglected her over the year and a half. Why didn't I just hold her from the very beginning? Because that's what she needed, and I should have cared for her earlier on.

DM: That's really hard to do, Chanel.

CM: It is and I made a promise to myself then that I would, I would.

DM: There seemed to be some confusion of your ethnicity in the court paperwork, so much so that at one point you slammed a table with your fist, threw back your chair, and screamed, "I'm Chinese." How much do you think your ethnicity factored into the way you were treated?

CM: I genuinely believe that I was underestimated. I also believe that even if people don't openly admit it, they might've thought that as an Asian person, I would have been more easily dismissed. They might've thought that even if the judge knew I wouldn't be happy with the sentencing, I wouldn't cause an uproar, I would just slowly disappear. I hear a lot about tiger-mom stereotypes, which my mom never fit into. It's because of her that I'm not afraid to fight. She grew up under a Communist regime and fought for her right to speak freely and came here because she wanted to do that. And if she can fight forces much greater than her, then I can fight for myself in this stale little courtroom.

DM: It was very clear that Brock's ethnicity favored into the way he was treated, and you appropriately state the following: "Instead of a nineteen-year-old Stanford athlete, let's imagine that a Hispanic nineteen-year-old working in the kitchen of the fraternity commits the

same crime. Does this story end differently?" I don't think there's any doubt the story would end differently.

CM: It was astonishing how quickly they humanized him, how they treated the assault as an isolated incident—like he simply needed to be guided back with the right nourishment and instruction. There was never a single moment of reprimand, there was never seeing him as a criminal. He was just someone who had lost his way. And he was young and had so much promise, but he wasn't a threat. He wasn't capable of hurt. He was only capable of being confused and being drunk.

DM: If he had owned up to what he had done right at the very, very start of this process, if he had apologized, do you think the outcome would have been different?

CM: Yes, and I actually was expecting an apology at the very beginning. I never thought I'd have to testify, and I was ready for that apology and to accept it. Instead, he pushed back harder and harder, and when things weren't going his way, they found more artillery.

DM: They found lies.

CM: Or whatever they needed to get where they wanted to go, at whatever the cost. I was never visible, and I felt that and I knew that. It still stuns me that I was able to cry in front of them and be naked on a screen and to sit feet from them but to never have my presence acknowledged.

DM: You write very powerfully how a friend of yours who had also been assaulted told you that this was an opportunity to make a difference for all assault victims.

CM: Even though I hated being inside the courtroom, I felt, "I need to continue down this path to see where it goes because there is an idea that justice will be attained. I need to see if that's true." If they're promising that with enough evidence, victims get justice, then now I have the evidence. Are you going to give me justice? And the answer in the end was "no."

DM: Brock Turner was ultimately found guilty of three felonies, yet he got one month of jail for each of them. The judge in the case, Aaron Persky, stated that he didn't give Brock a longer sentence because it would've had a severe impact on him. Did you ever get the sense that the judge understood the severe impact the assault had on you?

CM: No, and I think he also failed to calculate all that had been happening since the assault, all of the damage that was being accumulated in the aftermath, and that's what I think we tend to overlook. We're so fixated on the dimensions of this bruise because we don't know how to measure internal damage, psychological damage, emotional damage. It didn't stay frozen in that night; it has leaked into all the nights after, and not only onto me—it has rippled out to my family, it has changed their lives in ways I still can't fully comprehend. All of that was being unaccounted for.

DM: Chanel, your work ultimately changed the law in California about what is considered rape. Can you share what that new law is?

CM: It eliminates probation as an option when a victim is assaulted while unconscious.

DM: Thank you. Thank you for doing that. You've written how trauma provides a special way of moving through time. Years fall away in an instant. We can summon terrorizing feelings as if they are happening in the present. Are you still experiencing that?

CM: Yes, absolutely. The difference is I'm far more in tune with how I'm doing, and I always check in with myself. That self-monitoring is really different from before, when I would hold things in for a really long time and they would explode when they hit a breaking point. And I accept that this is as fast as I can go, this is as much as I can do, and if I hit a point where I feel like I can't do any more, it's not because I'm inadequate; it's because my body is asking for more nourishment from me and I'm going to respect that.

DM: How is your art making part of your recovery?

CM: It always felt like the art world and the court world were completely separate, and I want to continue to integrate them. I'm interested in adding art into those waiting rooms or on those pamphlets. Images can be very nourishing and humanizing, and I want to be able to express that with my little characters—to treat them as little companions that people can find in those darker places. So, I will continue to create little armies of images that I hope will help people get more in touch with their emotional truths.

DM: Do you have other art projects brewing?

CM: I do. I thought I would be confined to speaking about one topic forever. And even the simple act of someone inquiring, "Tell us more about your drawing" has meant so much to me. It makes me understand that there's a lot of future I'm excited to grow into and that people will allow me to grow into.

C H E R Y L

You could say that Cheryl Strayed
is very adaptable.

Her memoir, *Wild*, was adapted into a movie starring Reese Witherspoon. Another book, *Tiny Beautiful Things*, was adapted for the stage by Nia Vardalos and Thomas Kail. *Tiny Beautiful Things* itself was adapted from an advice column she once wrote called "Dear Sugar." And that advice column has ultimately been adapted into a *New York Times* podcast, "Sugar Calling." To talk about it all, I was joined by Cheryl from her home in Portland, Oregon, where she was isolating with her husband and two teenagers during the Covid-19 pandemic. We spoke about healing our parents' wounds, going on long difficult journeys, and how to write "like a motherfucker."

S T R A Y E

D

You recently said that the pandemic has made it clear to you that you are a writer first and foremost. Was that ever really in doubt?

CS: No, but one of the things that happened after *Wild* became a bestseller is I suddenly had so many opportunities that were not writing. I now have a very active career as a paid public speaker. Much to my surprise, I'm good at it and I enjoy it, so it got really easy to say "yes" to talks. I say "no" to a lot, too, but it became this thing I could do to earn money and to feel I was doing interesting and important work in the world. It's not a replacement for my writing, but sometimes it's a little easier, like, "Oops, I can't write today because I have to fly to Dallas to give a talk." Now, all of my public engagements have been canceled. So, it's, "Okay, back to my origins. I'm going to write my way out of this." At first I was in denial about the pandemic; I decided it would last about eight weeks. Then, as the weeks passed, I realized I had to do the thing I have advised others to do many times when they feel powerless: to surrender and to accept. Accept what's true. I'm trying to accept it and let go of the future.

DM: Let's go into the past a little bit. You were born Cheryl Nyland in Spangler, Pennsylvania, and moved to Chaska, Minnesota, when you were six years old. Shortly thereafter, your parents got divorced. In addition to the time after your mother died, it seems as if those years were some of the darkest of your life. Did you realize it at the time?

CS: That's such a great question. I did realize it to the extent that a child can. I was born into a house of extremes. On one hand, I had this mother who was very loving and warm and optimistic. I have a sister who's three years older and a brother who's three years younger. My mother always communicated to us a sense of wonder and love and light. The beautiful things. But we were living in a house that was, frankly, terrifying. My father was violent and abusive. He was emotionally abusive to all of us. He was physically violent to my mother. My brother and sister and I all witnessed horrifying things, things that I never witnessed beyond

that as an adult. As a little child I saw my mother being beaten by my father, my mother almost killed by my father before my eyes, my mother being raped by my father. So my perception of those years is definitely one of fear and sorrow and darkness. But because that was my life, it wasn't until my mother finally escaped my dad that I realized, "Oh, this is what happiness is. This is how it should be." We were very poor and lived with a lot of chaos and disarray but also a lot of light and joy and fun—and no longer being under the weight of that fear you have when you live with somebody who's abusive.

DM: You've written, "The father's job is to teach his children how to be warriors. To give them the confidence to get on the horse, to ride into battle when it's necessary to do so. If you don't get that from your father, you have to teach yourself." What is the biggest thing you had to teach yourself?

CS: The biggest thing is that I'm okay in this world. There will be times in your life when you need to ride into battle, and you need to teach yourself how to do that. If we didn't get that essential sense of self-worth from both parents, we need to reckon with that in our adult lives. I had to heal many things, but the biggest one was that, at the deepest place within me, I had to learn to believe in the power of my own resilience and my ability to survive and persist. I think that's what parents give us, if they love us well. And if we don't get that, we have to find it ourselves in the world.

DM: As I was rereading *Wild* and watching the movie again, I got the sense that your journey was one of finding out if you could rely on yourself.

CS: I think that we all need to do that. Obviously, somebody like me, who had a father who was abusive and a mother who died—I was really an orphan. But I think that's part of the human journey. Even my own kids, who are loved and secure and living in a very happy home—part of their journey is going to be finding their way and finding their strength and courage. It wasn't until after I wrote *Wild* that I understood that with that hike, I'd given myself my own rite of passage. Those rituals are what we've done as humans throughout time,

across every culture and continent. We don't do that so much anymore, and it's a loss. Most of us would benefit from being asked to find out who we really are by being put in uncomfortable or challenging circumstances.

DM: I came across a couple facts about you that were wonderfully surprising. When you were thirteen, you moved to Aitkin County, in northern Minnesota, which was very rural. You lived in a house with your mom and your stepfather. They built the house, and for many years the house didn't have electricity or running water or indoor plumbing. But despite all of this, you were a high school cheerleader and the homecoming queen. You were an overachiever from day one.

CS: We lived in a one-room tar-paper shack for the first six months while we built a house for ourselves. It was a lot of work, and it was incredibly difficult, and I was a teenager. I wanted to be pretty and popular and not associated with going to the bathroom in an outhouse or taking a bath in a pond, which is what I did. My rebellion in my teen years was to be a version of myself that I wanted to be—to project a sense of success, and grace, and togetherness. I wanted to be popular because to be popular is to be loved.

DM: You went to the University of St. Thomas in St. Paul, and for your sophomore year you transferred to the University of Minnesota in Minneapolis, where you studied English and women's studies. What did you want to do professionally at that point?

CS: When I was a freshman, I majored in journalism. I thought that I could funnel my desire to write into journalism because it's the job where you can actually get paid to write. When I transferred to the University of Minnesota, I majored in journalism, but I took a class with the poet Michael Dennis Browne and everything absolutely exploded. I thought, "I have to trust this." So I switched majors and became an English major. I thought I'd become a great American writer. I was ruthlessly committed to following through and doing it until I succeeded. As I say these words, the female in me is thinking, "Don't say you want to be a great American writer because that seems cocky or that you're bragging."

But I'll tell you, that's the thing that got me through—the intention, the plan, the ambition. I had to be an absolute relentless warrior and a motherfucker on behalf of my own self as a writer.

DM: Write like a motherfucker, right?

CS: That's right.

DM: That reminds me of that little mantra you had while you were on your hike, "I'm not afraid. I'm not afraid. I will not be afraid."

CS: And when did I say, "I'm not afraid?" When I was afraid. Even to this day, writing is so hard for me. I still have to be a warrior and a motherfucker. I still have to say, "Cheryl, you can do this. You're going to do this, and you are not going to give up. You're not going to be second. You're going to go all the way to the finish line."

DM: In March 1991, when she was forty-five and you were twenty-two, your mom died of cancer. You've said that your mother's death was in many ways your genesis story and the start of what you called your wild years. Using drugs or having a lot of sex or any sort of reckless behavior was about trying to find love. Why do you think we hurt ourselves when we're hurt?

CS: Why do we self-destruct when we feel like we've been ruined? It's a signal to the people around us that we're saying, "Help me." It's also a test. Is there anyone out there who loves me enough to help me? In my case, I also interpret it this way: There was this mythic division in my past between the good mother who's been taken from me and the bad, dark father who abandoned me. If I can't be the woman my mother raised me to be—that ambitious, generous, light-filled person—maybe I can be the junk, the pile of shit, the darkness that my father nurtured in me.

There was something that I had to figure out about those primal relationships that I had to rage against and understand and revise. A lot of people who've written to me as Sugar—they write to me with a problem, but really the problem is that deep, deep river that's flowing beneath all the troubles, that subterranean channel that is your parents. Those early stories you received, your losses and your gains and your wounds that you have

to heal. And sometimes healing is an ugly thing. For me, I had to pass through everything. When I saw that I was going to lose everything after my mom died, that's when I turned to heroin. That's when my response was, "Okay, if the house is going to burn down, I'm going to burn the whole land down."

The hard thing about that is, of course, some people stay there. They get lost there. They're walking through the ashes forever. I'm so grateful that that wasn't my fate. I had to do that stuff in order to realize that I wasn't the person my father raised me to be. My father didn't raise me. I was the person my mother raised me to be. That's why I said that so much of that stuff was about love: I realized that I was trying to show the world, "Listen, this amazing woman is gone, and I am suffering." I wanted to, with my own life, demonstrate how gigantic that loss was. And what I realized is the only way I could do that was to make good on my intentions. To be the woman my mother raised me to be, as I said in *Wild*. I would have to live my life and try to honor her with it. And what's so crazy and cool and beautiful about that is—I did. People all over the world know my mom's name.

DM: You brought her to life through your words, and she brought you to life through her life.

CS: I was the same age when she died as she was when she was pregnant with me. So I lost her at the same age that I came into her life.

DM: You were twenty-six when you embarked on your solo three-month 1,100-mile hike along the Pacific Coast Trail. For people who are considering taking this same hike, what advice might you give?

CS: Well, go. Whether it's the same hike as mine or any long hike—if you have any desire to do this, do it. Okay? I've talked to so many people who have taken long walks and long hikes, and all of them say, "That's the best thing I ever did for myself." Because walking, especially walking a long way for many days on end, is a deeply challenging thing. You gain a sense of your own strength and your own ability to endure difficulty, monotony, pain. What happens on the outside, one foot in front of the other, also happens on the inside. I love

this idea of the body teaching us what the soul and the spirit and the heart need to know. And that's what happens on a long walk.

DM: As I was rereading the book and watching the movie again, I thought that it was very likely the last moment that we weren't all walking around checking our emails and texting on our cell phones. It seems unimaginable to me to consider hiking 1,100 miles in near solitude with my phone off the entire time.

I had to be an absolute relentless warrior and a motherfucker on behalf of my own self as a writer.

CS: This was 1995. It wasn't until I was midway through *Wild* that I realized, "I'm actually writing a historical memoir about a world that is now past." Our experience of the wilderness is now one where, first of all, we can research everything online. I prepared to the extent that I could, but there wasn't the Internet then. I went to the Minneapolis Public Library and said, "What books do you have on the Pacific Coast Trail?" They had one, and it was the book I already purchased at REI. It wasn't like information was available—you just had to go and see how it was. And I was absolutely alone. The first eight days of my hike, I didn't see another person. There was no way to contact anyone except if I came upon a payphone or if I sent a letter. I'm so grateful that I took my hike during that time because I think had I not done that then, I would have spent a lot of time tweeting at people.

DM: And Instagram, right? With all those great pictures you took.

CS: Yes, and getting feedback from people and not just sitting in my solitude. The thing about deep solitude is it's just you and there's nothing to do but reckon with yourself. There's nothing to do but allow memories to emerge. By the time I was finished with my hike, I felt like I had thought about everything I remembered in my whole life, every relationship, every person. What a therapeutic experience.

DM: Monster was the name of your backpack, which at its heaviest weighed nearly seventy pounds. Even at its lightest, it was fifty pounds. You've said that the act of remembering your suffering can become pleasure afterward. How so?

CS: I call it retrospective fun. This is also advice I'd give someone wanting to take a long hike or any kind of journey: You have to acknowledge that often the best things we do are painful and complicated and difficult and exhausting and require us to be out of our comfort zone. If the journeys we take are exactly how we imagine and everything is idyllic and blissful, we would think, "Yeah, that was fun." But there's no texture to it.

DM: No grit.

CS: No grit. The grittier an experience is, the more it teaches us. We never forget the lessons we learned the hard way. I began a backpacking novice. I became a backpacking expert. I thought that I couldn't do that, and I did. I said to myself over and over again, "I can't go on. I can't." And I always did. And then that becomes part of who you are. Ten years later, you're in labor—as I was trying to give birth to my eleven-pound baby boy—and I was thinking, "I can't do this." And the deepest voice in me said, "You know you can."

DM: While you were working on Wild, you also started writing your advice column, "Dear Sugar," for The Rumpus. I know you've referred to self-help work as intellectually mushy. In Wild, you weren't giving advice, but people have read it that way.

CS: When I was writing Wild, it never occurred to me that anyone would experience it as inspiring. I was just trying to write the truest, rawest story about that experience, about my grief, about my finding my way on this long walk I had in the wilderness. Even with Torch, I realized

after it was published that people were experiencing it as a lifesaving book. I guess that doesn't really surprise me because that's what I've taken from literature too. That's what I meant when I said books are my religion—I felt saved by them. I felt seen by them—in Jane Eyre, in Alice Munro's short stories. There I am in Toni Morrison's Beloved. There I am in Mary Oliver's poems. I didn't intend for my books to be self-help. When Tiny Beautiful Things came out, it was in the self-help section of many bookstores. I saw that and thought, "What?" I think of myself as an accidental self-help writer because "Dear Sugar" columns are self-help, and yet they are also literature.

DM: You've been at a crossroads now as different opportunities have come your way. You've stated that you think the things that mean and matter the most come down to one question: Do you really want to do it? So, how do you know when something is the thing you really want to do?

CS: For me, it's when I feel like I can create something that's larger than me. If I write a book and not only is it a deep and true expression of some deep and true things I want to put into the world, it also becomes something that is meaningful to others. That's a big thing to contribute to the world. If this mission is fulfilled, will it extend beyond my small little life?

DM: What is the thing you want to do most next?

CS: Finish my next book. I am ready to do that. Wild and Tiny Beautiful Things were published within four months of each other in 2012. And basically my life since was like a volcano.

DM: Yes, movies and Oscars.

CS: I had the movie and the stage adaptation of Tiny Beautiful Things, and I was involved in the podcast and the public speaking career. Also, the kids. During all this time, I have these two little kids, who are now fourteen and sixteen. I am now ready to sit there and write my book. That's what I'm doing, and I really want to do it. I'm also afraid and doubtful and scared. I'm all the things I am when I'm writing, which means I'm writing my next book.

GABRIELLE

Back in pre-pandemic times,
Gabrielle Hamilton founded and ran Prune,
a bistro in New York's East Village.

1. But in March, after twenty years in business, she had to lay everyone off and close the doors.

2. Indeed, the shutdown has been such a catastrophe for restaurants that one wonders how many of them will be left when it's safe to socialize again.

3. But, fortunately for us, Gabrielle Hamilton's talents extend beyond the kitchen.

4. This four-time James Beard–award-winning chef is also the author of a bestselling memoir, *Blood, Bones & Butter: The Inadvertent Education of a Reluctant Chef.*

5. She's also in the Emmy-winning television show *The Mind of a Chef* on PBS, and she's a columnist for the *New York Times*.

HAMILTON

DM: Gabrielle, you encountered some of the best food of your life in very unexpected places. And you also learned what it really meant to be hungry and realized that to be fed in that state, often by strangers, that state of fear and hunger, became the single most important and convincing food experience you ever had. How so?

GH: When you define the best food you've ever had, for me, that is when you're hungry and you get something satisfying that you'd really like to eat. I would make these long inter-country journeys without eating often or without having any money, and someone would be like, "You seem hungry. You've been sitting in the back of this bus for three days without leaving. Can I get you a sandwich?" Or to have arrived in a foreign place where you can't even read the alphabet and to be greeted by someone who plops you down on the terrace and throws an apple and milk and honey in the blender and puts some incredible butter on some fresh bread and fries an egg with olive oil and hands it to you without asking if it's okay. It's the best food, it's the best care, it means so much. It taught me a lot about my senses.

DM: How did it impact how you began to cook professionally?

GH: By the time I opened a restaurant, I was a very good cook. But I didn't understand anything about how to run a restaurant. Besides being a bit of a compulsive, clean person and a hard worker, I didn't have a traditional resume. I didn't have any credentials. But I relied upon this experience, this repeated experience I had of bringing something to someone who needs it. Or in my case, receiving something I needed and couldn't get on my own. It was revelatory. What I lack in plumbing schematic information and what I don't know about a certificate of occupancy, I can probably learn. What I do have is this very, very acute sense of what it is to offer hospitality and take care of someone.

DM: You began a ten-year stint working in what you've called the most unsavory corner of the food industry. What part of the industry was that, and why did you feel it was the most unsavory corner?

GH: Well, it's slightly hyperbolic, but I hope you giggled a little bit when you read that sentence. I'm trying to be a little bit funny. But, in fact, I was working in high-volume, high-end catering in New York City. While that world does come with some amazement and feats of ingenuity that you can't even believe—the way we could produce hot well-cooked dinners for one thousand people out of a metal box with cans of Sterno in it in a back hallway of the Museum of Natural History, with Saran Wrap and duct tape. But it was also pretty soulless. It's like factory work. You are making sixty thousand little filo purses all day and then you're sitting in the back of an unrefrigerated van on an overturned five-gallon bucket. Or maybe the five-gallon bucket is actually full of demi-glace and not overturned and empty, and you're sitting on it and driving out on the Long Island Expressway to the Hamptons to set up your makeshift shop in somebody's four-car garage. And you're trying to get the lettuce on the plates before it wilts, and you're wearing gloves and your hairnet. And the crews tend to be quite mercenary, understandably. You just want to pass through, make your money, and get out. And if the sour cream goes in the mayonnaise, and the mayonnaise goes in the crème fraîche, no one really gives a shit. I really prefer to do excellent work. I do the best I can, no matter where I am. Sometimes I find myself in uncomfortable situations when I'm not in a group of like-minded people, and I am automatically alone or abrasive. It was good for me to get out of there eventually and run my own shop and make everything go the way I think it should.

DM: At that point, aside from what you've described as an ironclad work ethic, born of an early understanding of self-reliance, you were struggling to understand if you had anything else to offer and wondered if you could still have a life of meaning and of purpose. Was that what made you decide to go back to school for an MFA in fiction writing?

GH: Yes. After too many years cooking food for rich people in the Hamptons, I didn't quite understand what my purpose was. I wasn't writing. The purpose of freelancing is that it is supposed to keep you free and you make enough money to pursue whatever it is that you're actually interested in pursuing. What I found in

my freelance life is that I would work eighty hours a week, and on whatever day off, I just wanted to eat and drink or sleep and not write my great American novel. I did what I think many people do when they're at a crossroads or they're lost. They go back to school. And that's what I did. I applied to grad school and got into the University of Michigan and did the MFA program there in fiction writing.

DM: What was that like?

GH: I had a blast in grad school. It felt like a vacation. It felt like my first vacation in over twenty years. It was incredible. You got to read and write all day and read and write all night. And the workdays were so short by comparison. I had spent the prior twenty years in kitchens, and those shifts are much longer.

DM: What kind of writing were you doing at that point?

GH: I really ended up fudging my way through, which I'm not sure you're allowed to say. But hopefully there's enough decades between now and then. But I was submitting shit to a workshop I had written in high school, just like, oh, you have to have twenty pages due on Thursday. I was like, oh, let me dig something up I have. I did write a whole thesis, and I did some stripper work while I was in Michigan.

DM: Did you ever write about that?

GH: That was my senior thesis—I wrote my stripper novel. I think it's good to get that out of your system and not have that be your debut. That can just be shelved and live in the University of Michigan library.

DM: You graduated and came back to New York and once again took a temporary stint, at a West Side Highway catering company. What made you decide to do that?

GH: Well, when I got back to New York, I also did some stripping here.

DM: Really? Where were you stripping?

GH: At the Baby Doll and at Blue Angel.

DM: I probably would have wanted to do that if I ever felt like I had the body to do it, but I never ever felt like I did. And never will.

GH: You see, that's the mistake a lot of people make. That's not the connection that the dudes are looking for. It's really not about your body.

DM: What is it about?

GH: It's about how they feel. If they feel cared for and connected and touched, held, etc. Like we all want. But I got a job by way of a friend who knew a catering company that needed an interim acting chef. And while I was doing that, this restaurant Prune, what would become Prune, became available. And that's when I found myself at a pretty incredible crossroads. I took the lease, as you know.

DM: Why were you having such a hard time writing at that point?

GH: I don't know how to work unless somebody wants me to do the work. I don't wake up in the morning thinking the world's dying to hear from me. I have to work to please somebody. That's why a contract or a deadline or an advance really works for me—because now I owe them something.

I don't know how to work unless somebody wants me to do the work. I don't wake up in the morning thinking the world is dying to hear from me.

DM: When you were first offered the opportunity to rent this space that would then eventually become Prune, your restaurant, were you struggling with the combination of being able to be both a restaurateur and a writer? Or did you feel that you would have to give up the life of a writer to own your restaurant?

GH: The most painful self-reckoning I've ever done was to roll up the gate on the restaurant and understand that I had put to bed a twenty-year dream and ambition of being a writer. That's not the kind of thing that comes easily. You got to really lie down on the floor and bawl your brains out for a while.

DM: It seems like from the moment you walked into the space that would become Prune, you felt an electricity about what that space could be. And yet, you were also mourning what you thought your life was going to be. How did you navigate between those two states of mind?

GH: The first thing I did was close the cleavage in my heart by letting go of the idea of being a writer. I experienced an enormous wholeness when I stopped this constantly looking over my shoulder toward what I thought would be a greener pasture—of writing and a life of literary pursuit. When I finally focused my eyeballs and my heart on one thing, I said, "You're just not a writer, you're a cook, so get with it." It was incredibly liberating. To have your feet moving in the right direction, to not be straddling two conflicting passions—it gave me a lot of energy and purpose and meaning. The miraculous thing I didn't know is that up ahead the two paths reconverged. You never know what's ahead.

DM: Prune was born in the ungentrified and still heavily graffitied East Village, and from nearly the time you opened, you got extraordinary reviews. Were you surprised by the initial response?

GH: It was profound and overwhelming and completely surprising. The name alone, Prune, was a point of contention. Prune is a terrible name for a restaurant because it conjures diuretic or poop jokes and old folks. About five years into my restaurant, the United Plum Board of California or the prune council of California [now called the California Prune Board] asked if they could switch their name to dried plums.

DM: I remember that—because Prune was so unsexy. You made it sexy again.

GH: I can't help it—it was my name and it was true. The whole restaurant was going to be about the food I cooked naturally or that I had really come from.

DM: On March 15 you shut down Prune because of the pandemic. And now you and hundreds of other chefs in New York City and thousands around the country are staring down the question of what your restaurants, your careers, your lives will look like. How are you and your wife and co-chef, Ashley Merriman, managing?

GH: It takes a very long time—or it took us a very long time, I would say—to drain all the fluids out of our hydraulic systems. I don't know if that metaphor conveys how profoundly exhausting the last four months have been, emotionally and spiritually, to have had a complete, abrupt cessation of income, routine, purpose, identity.

DM: Yes. I read that you visit the restaurant every day. Do you have any sense of when you're going to be able to reopen?

GH: I really don't have a sense of when we'll be able to reopen. And the question for me is, "Why would we?" The question I also have for my peers is, "Why should we?" We have a remarkable amount of power right now. People are desperate for us to open, and I wish so profoundly that we would join together in some sort of collective action and refuse to reopen until we've fixed some major problems that we had prior to the pandemic, that the pandemic merely illuminated. I really wish we would figure out if we can all have health coverage. If we could actually figure out a freaking wage that would work for people, and not have the restaurant itself act as the government, which we've been doing. This experience of working in a restaurant, of going to a restaurant, is so delightful, but it's also—not to use too radical a phrase, but it's on our backs. It's on the backs of people. And it has to stop. We have a moment here. I hope we don't squander it.

"There is nothing that makes me happier than when I hear someone say, 'Oh Right! You're so-and-so on Twitter! Didn't we have a conversation the other day?' That's what I want. I want people to meet up and make connections and maybe end up building something cool together. A designer can meet a developer, or you can make a connection that can help you in your industry, or just get you out of your cubicle."

Tina Roth Eisenberg

designer and entrepreneur

June 22, 2015

PART

3

CULTURE
MAKERS

OLIVER JEFFERS

MICHAEL BIERUT

NICO MUHLY

ALAIN de BOTTON

MIKE MILLS

ERIN McKEOWN

AMY SHERALD

CEY ADAMS

MALCOLM GLADWELL

AMBER TAMBLYN

OLIVER

Oliver Jeffers is a visual artist and an author working in painting, bookmaking, illustration, collage, performance, and sculpture.

Curiosity and humor are underlying themes throughout Oliver's practice as an artist and a storyteller. The Belfast-bred illustrator and artist is the number one *New York Times* best-selling author of many children's books that are celebrated both for their illustration and their writing. They have been translated into more than forty-five languages and have sold more than twelve million copies worldwide. He has also codirected a music video for U2, exhibited his paintings around the world, and worked on design and illustration projects for TED, Apple, and Rockefeller Center. In this interview, Oliver Jeffers talks about how illustrating and writing children's books has changed his fine art painting.

JEFFERS

OJ: I was about eleven years old. I realized that there was me and one other guy in my class who were always being asked to help decorate the set for the school play come Christmastime. I thought that was great because I got out of doing math lessons. I suppose at that point I realized I had talent, and it was a few years after that that I decided that was what I wanted to do. The education system in the U.K. is interesting in that people have to start closing doors at a very early age. That suited me because I loved making images and I knew that I was a visual person and my parents were very encouraging. My family accepted it as a viable career option.

DM: You've stated that everything in your life changed as an artist when you learned to stop copying others and listened to the way your hands wanted to draw and paint. Could you elaborate on that?

OJ: It's like everybody having their own handwriting; everybody's got their own little quirks and tweaks. It's the same with drawing and probably the same with thinking. You can't help the way certain little things happen as you let them happen. And I realized that there's certain things that I enjoy drawing and there's certain things that I was good at drawing, and once I recognized that, there was an ease and a flow and a charm about the drawings that I was able to turn up the volume on. That was essentially me finding my style and that sense of, "People actually like the way that I draw and the way that I see things." That's when I realized this is possible, that I can do this.

DM: Do you have a conscious sense of dialing that charm up or down?

OJ: Often the charm is in the composition of where the drawing sits in relation to other drawings, rather than just that one moment with the pen and the pencil. There's also pacing. I normally find that the faster I draw something, the more charming it is because the more human it is, I think. There are more flaws, and people find flaws charming.

DM: Why is that?

OJ: I think it possibly reminds themselves that they're not perfect and it's okay to not be perfect, and that is accessible.

DM: You got your degree in visual communication in an effort to get a job, but by the time you graduated, you decided you never wanted a day job. Why not?

OJ: When dealing with visual problem-solving, I can normally see an answer immediately. It's frustrating to try working with other people whenever they don't see what the clear answer is. Especially if anyone is telling me what to do—that's extremely frustrating for me. I say this as a joke, but it's somewhat serious. In the first couple of years after college, I did three things: commercial illustration, then fine art painting, and then picture books. When one wasn't paying, the other one was. They kept each other aloft, and about four years ago I dropped commercial illustration. In the end, I did get myself representation for that, and I enjoyed it as a way to keep my mind sharp. It's like an exercise. It's like doing push-ups. You're given a challenge and you have to visualize the solution.

DM: The story of your getting a deal for your first book, *How to Catch a Star*, is quite remarkable.

OJ: I'm amazed nobody had tried that tactic before. I had an idea for a kid's book, which I completed as part of my college final. I looked at the publishers who were publishing the books that I enjoyed and put them together in a list and figured out which ones would be best suited to me. Then I went about trying to find the name of somebody who worked there, so I was sending it to a person rather than an anonymous desk. I then thought quite carefully about what to actually send them. The old saying that nobody judges a book by its cover is wrong. People do it every day. I took great care in making a package that would stand out from the other crap that people were sending in and it worked. It landed on the right person's desk. It looked good enough for the editorial assistant opening the bigwig's mail to immediately bring it to the editor, who called me about twenty minutes later.

DM: Now your books have been translated into over thirty languages around world and *This Moose Belongs to Me*, one of your most recent books, debuted at number one on the *New York Times* Best Seller list.

OJ: The book is about ownership because at that time I was reading about the sale of Manhattan to the Dutch and how the natives told them, "Sure, you can buy it." But nobody really owns land, anyway, so they didn't leave, and that was to the great confusion of the Dutch. In thinking about that, there was an element of truth: we only own something because everybody agrees that we do. I thought that this was a really interesting concept, and I applied it to owning a pet.

DM: There could exist this dual reality of ownership. I read that your father told you that your version of the truth is not the same as somebody else's, and I'm wondering if that's something that has influenced your work.

OJ: I remember my father telling me that truth is the first casualty of any conflict, and so he always encouraged me to read more than one newspaper. The idea is that just because you think a certain thing about a scenario does not mean that the person you're dealing with thinks the exact same thing about that scenario. This idea was reaffirmed by this ancient Greek form of philosophy that my father discovered later in life called the enneagram. This system says there's nine personality types and that every one of them will deal with any given situation completely differently. For my father, the enneagram wasn't eye-opening so much in an understanding of himself as it was an understanding of other people. Something else my father said to me was, "To understand other people, it's more important to look at motivation than action," and that's something I've also always tried to hold true to heart.

DM: Does this come into effect when you're creating a character? Each of the characters in your books seems to have a soul and an essence and an utterly distinct personality. It goes way deeper than the charm you discussed before—there's the elegance of humanity in all of your characters.

OJ: It's more of an instinctual evolution. I draw somebody or I come up with somebody who fits into a storyline, and everything after that doesn't get too much scrutiny. It either feels right or it doesn't and that possibly goes back to the storytelling that seems to flow naturally from the mouths of people from Belfast.

I remember my father telling me that truth is the first casualty of any conflict, and so he always encouraged me to read more than one newspaper.

DM: There is something rather heartbreaking in a lot of your books, as much as they're fundamentally optimistic. Penguins get lost, boys reach for stars, crayons are tired of being overlooked. Though it's always reconciled by the story's end, why so much searching and longing?

OJ: People have asked that before, and I'm not entirely sure why. One person did read into that, "Was it because you grew up with so many brothers and so many cousins that the books are your escape for solitude and quiet?" That's possible, but I also have a sense of curiosity in me. I'm fully aware that the world is not always a beautiful place where everything works out, and there is a sense of poignancy to the things I do because that's just the way things are. I'd rather embrace the honesty in my storytelling than hide from it.

DM: In your new monograph, *Neither Here Nor There*, Richard Seabrooke writes in the foreword, "Oliver is especially curious about the idea of duality. The concept that something can mean one thing to one person and something entirely different to another." What is it about duality that intrigues you so much?

OJ: Another realization that people have offered is the duality in which I grew up. Belfast was a split city, really. There was a lot of violence, but there's also a lot of happiness—I think it leaves its marks way down there. But in making the monograph project, I fell in with a professor in quantum physics and I discovered the actual theory of duality, which looks at light in particular—how light is measured in particles and waves. What I took from that was, "It's up to us how we define that." We choose the equipment in which we measure, and distinguishing between a particle and a wave is therefore up to us. That's perspective, really.

DM: It's our subjective measurement.

OJ: We have the ability to look at anything and make it anything we want, to some degree. That's why I started making art about that sense of, "Can we look at things logically and emotionally, all at the same time?"

DM: The painting that you're referring to—you included a mathematical definition of light in a painting of light refracting through glass, with Tropicana in the background. Why the combination? What intrigued you about that combination?

OJ: To go back a little further, the very early iteration of this project was individual paintings that included just a single word or small phrase. I was using the canvas to suggest a narrative, and you fill in the rest. When I discovered picture books, that completely satisfied my thirst for storytelling and using words and pictures mixed together. Quite naturally, words and narrative started to fall away from the paintings I was making, and I began asking questions rather than telling stories. That painting you reference was the first-ever attempt at putting numbers and pictures together. My wife was an engineer before she came to work with me, and we were talking about the difference between our college educations. In art college you can essentially do whatever you want as long as you've got enough guff to back it up, and there is no such thing as a right or wrong answer, whereas in engineering school there's very much a right answer. Here I was thinking,

"God, here are two very valid but completely different ways of looking at the world—emotionally and logically. Is it possible to do both at the same time?" Hence a figurative painting with a mathematical equation slapped on it. I didn't know what I was doing with that mathematical equation specifically; I just tried to pick something that was relevant rather than completely arbitrary. I picked one about the refraction of light and then tried to have that be the light source of the painting. It was purchased by this professor of quantum physics, who assumed it was about Bell's string theory, and I had no idea what he was talking about. That was what began that whole project of trying to see the world logically and emotionally at the same time, of mixing figurative painting with equations.

DM: One of the things that excites you most about duality is that it always leads to an unanswerable, unresolvable scenario.

OJ: For the duality to be a singularity, there's only one possible way of thinking of things, and I don't know if that's ever going to be true.

DM: Why would you search for unanswerable, unresolvable scenarios? Shouldn't art try to reveal some universal truths?

OJ: I suppose that's what I'm trying to do. I fell in love with quantum physics' search for the unifying theory of everything. Pretty much everything that I have worked on in fine art since then has its roots in that series of conversations with quantum physicists. But the idea of art opening up the world to be seen in different ways? I don't think we know anything about this world at all.

"I think that a lot of people want to be given permission to like art, because they think that there's a whole set of rules.

There is not."

Jen Bekman

gallerist and entrepreneur

March 2, 2012

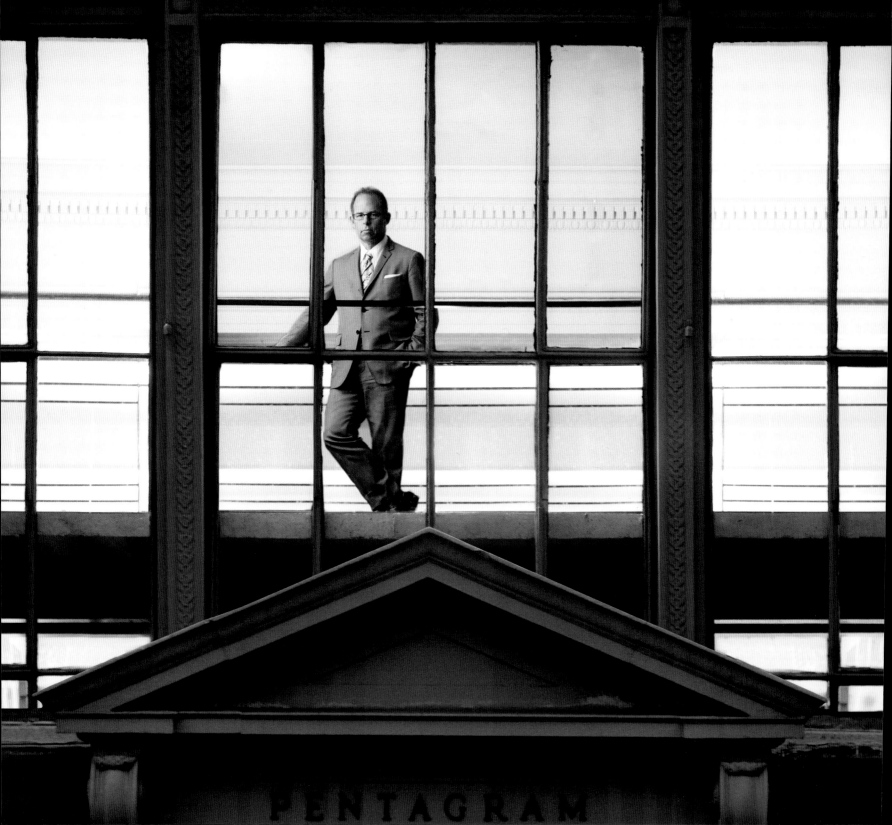

PENTAGRAM

November 2, 2015

MICHAEL

As a partner at Pentagram, Michael Bierut has created some of the most celebrated design work of his generation

for clients as diverse as Harley-Davidson, the Brooklyn Academy of Music, the *Atlantic*, and the New York Jets. His monograph *How To* showcases dozens of his projects over the years and, along the way, dispenses wisdom, philosophy, and insights on creating meaningful design. In this conversation, Michael confronts the intimacy of graphic design at different stages of his career.

BIERUT

DM: Michael, *Wired* recently published an article in which you stated you don't believe in creativity.

MB: I don't believe in the myth of the creative artist, or at least I personally cannot embody that myth.

DM: What's the myth?

MB: The myth is that people who are "creative" are possessed by some irresistible and inexhaustible source of self-expression, and that their quest is finding patrons who will indulge that compulsion to be expressive. I remember realizing at a really early age that, even though people all knew I was the best artist in school...

DM: ...it kept you from being beat up several times.

MB: Yes, being able to draw realistically had some status in my childhood, and I made sure that people knew I could do it. Drawing was soothing for me, but it wasn't like I had to do it because I had all of these ideas that had to get put on paper. It was all about using art to achieve another end: if you're a girl, you might think I'm cuter than I actually was; if you're a guy, you'd be less inclined to punch me in my very punchable face. When I do graphic design, I save the creativity for when it's absolutely needed. Instead of approaching it with, "Every single thing has to be completely new and start from scratch," I'll say, "Let's take everything we know about this situation. What do we know it has to be? It has these limitations. It has these conventions it has to respect and adhere to."

DM: When you were about five or six years old, you were in the car with your father on the way to get a haircut. You stopped at a light, and your dad pointed at a forklift truck parked in a nearby lot. Tell us what happened next.

MB: He said, "Look, isn't that clever?" And I said, "What? There's a forklift truck next to us." And he said, "Well, look at the way they wrote the name of the truck." And the name of the truck was Clark, C-L-A-R-K, and the L slides under the left-hand leg of the A and lifts it up. He says, "That's what the truck does." I remember thinking, "Oh, my God. Wow. How did you know that? And are there more of these? Are people taking the time to build in these little moments of joy and pleasure and surprise?" I was so happy that someone had done that. And why would they do it? What was the point? I had no idea there was something called a "logo." I had no idea there was something called a "commercial artist" or "graphic designer." I had no idea that there was any process that led up to that moment, but I was thunderstruck by it.

DM: I have a sneaking suspicion, Michael, that you still feel that way about graphic design, which is what makes you such an incredible spokesperson for the craft and the discipline. What is it about graphic design that you find so utterly, endlessly fascinating?

MB: I thought about this for a long time, and only very recently have I come to realize that, in a way, I fundamentally disagree with my old boss, Massimo Vignelli. Massimo used to think that all design disciplines were as one. If you can design one thing, you can design anything, from a spoon to a city. I think graphic design is special because it participates in the world of communication—the way we exist as citizens depends on our ability to communicate ideas, and needs, and demands, and resistance, and all these things to each other. We do that through words, and the more pressure is put on the communication, the more it requires the intervention of someone who does this thing called graphic design. The other design disciplines play a role in culture, certainly, but they're not right there escorting ideas from place to place so intimately as I think graphic design does.

DM: Another moment in your childhood that I'd like to talk about is your poster for your high school play *Wait Until Dark*. Showing up at school a few days after you finished the poster and seeing it hanging everywhere was an epiphany for you. In what way?

MB: When I was a kid and it became evident that I had "art talent," my mom and dad signed me up for Saturday morning art classes at the Cleveland Museum of Art, which has one of the greatest collections in the United States and the world—beautiful paintings that are just amazing. And I remember admiring those paintings and also feeling a bit sorry for them.

DM: Why? Lonely?

MB: Yes, they were lonely. They were trapped in this museum. Sometimes I'd be the only person looking at them. Meanwhile, my poster gets silkscreened, and, in my own mind, I was king of the high school. More people would see those posters than would see the play. And anyone who saw the play would see it because I had personally recommended it to them with this poster.

I think graphic design is a game, but it needs rules to be fun.

DM: So it made you feel important.

MB: It made me feel important, yes. The other people were acting in the play. And that's one way to go, I suppose. But doing the poster for the play? My God.

DM: You went to high school and college in Ohio, yet when you first visited New York City, the only souvenir you brought back was the Vignelli subway map. I read that the map had a talismanic quality to you. Did you know at that point you wanted to work for Massimo?

MB: No, and I'm guessing I didn't even realize at that point that a man named Massimo Vignelli had anything to do with the making of that map.

DM: But you knew that the map was designed.

MB: I understood the map was designed. I also understood the map was beautiful and mysterious. And we're talking about the abandoned, notoriously disavowed Vignelli map.

DM: The one where things aren't necessarily where they are geographically.

MB: Right, but the whole thing is a beautiful geometric diagram that accurately describes the relationships of all the stops—just not in relation to the geographic layout of New York City above the ground. It also seemed to have this mind-blowing sophistication that was completely new to me. And how did you get this souvenir? You simply walked down into subways in 1974, and you said, "Can I have a map?" They give you a map. It's free. I took it back with me and pinned it up on my bedroom wall like it was a poster of Farrah Fawcett-Majors or something.

DM: You worked for Massimo Vignelli for ten years before starting at Pentagram. Steven Heller asked you what was one of the most important things you learned when working for Vignelli, and you stated, "Probably the most interesting thing I learned is that a lot of the things about design that tend to get designers really interested aren't that important." Can you elaborate?

MB: When you're educated as a designer, I started at the bottom. I started with mastering a craft that involved distinguishing between very similar-looking typefaces, resolving the white space in a layout, carefully selecting colors that work well in different situations, taking the curve of a shape, and making it "exactly so." For some time, I thought that that was the highest form of activity that a graphic designer could engage in. And, indeed, when I worked for Massimo, he demanded attention to that kind of detail.

But what made his work successful, I think, had less to do with all that stuff, which simply enabled that success. He was a great editor and a great storyteller visually, who could come up with the overall idea of how something should be presented.

Let's say you're designing a book: my tendency as a young designer would have been to fret over some novel way of handling the page numbers. Meanwhile, Massimo understood that if someone's going through a book, they just want to read the words and look at the pictures, so how can you sequence those pictures? How can you vary their scale? How can you make the layout seem both surprising and inevitable? And those decisions are about intuition. Their execution requires a very keen sense of craftsmanship, but the craftsmanship alone is almost meaningless. For a long time I thought, "I'm going to focus on the progressively bigger issues." And then, after you feel you have a handle on them, all of a sudden the difference between Garamond and Sabon starts to look interesting again, mysteriously enough.

DM: You admit in your book that you don't have a style, something that you refer to as the "Michael Bierut thing." Is that intentional?

MB: No, no, I'm too equivocating. I could never make up my mind and do things this one way all the time or even say that this is the best way things should be done. I admire people who actually do have a really distinctive, identifiable handwriting. I think that that's actually closer to being an artist. On the other hand, I swear to God, as much as I love art and music and all these other things, when I think about people who I really admire.... I went through a phase where I was

enraptured by the story of Holland-Dozier-Holland, the three-person songwriting team at Motown Records. Lamont Dozier, Eddie Holland, and Brian Holland were salaried employees at Motown Records, working for Barry Gordy, and on the weekends and after hours, they would go to clubs and play the music that they loved, which is really good jazz music. By day, to make a buck, they had this job doing what some people would have called "hackwork" for Motown Records. They were good at that—although my suspicion was they didn't feel that that was the best use of their talents—and the legacy they left us was "Where Did Our Love Go?" and "Dancing in the Streets" and dozens of number-one songs that if you heard any one of them, it would conjure up a whole world for you. A world of beauty and excitement and nostalgia that's inspired people for years just listening to this stuff. And these are people just doing cheap commercial music. The ability to reconcile the need to fulfill a frankly commercial end but also leave behind a thing of beauty that could inspire someone, like a forklift truck logo, is the thing that I live for.

DM: It seems as if you need parameters when you work. Full freedom doesn't really work for you. You'd rather have limitations and uncaring clients and no budget rather than freedom and a receptive audience and an empty table and a blank check.

MB: Yes, yes.

DM: Why is that?

MB: I think graphic design is a game, but it needs rules to be fun. Indeed, my least favorite kind of assignment is one where someone says, "Do whatever you want." Sometimes, I'll just turn those down. If it seems too easy, I can't do it.

DM: The chapters in *How To* are relayed as problem solvers. How to invent a town that was always there, how to raise a billion dollars, how to behave in church, and so forth. What made you decide to organize the book in this way? And what is the backstory behind the chapter about making people cry?

MB: Actually, there's been several occasions where I've done design that made me cry.

DM: Like what?

MB: The very last case history in the book, which is the one I learned a very important lesson from, is a long-running project I had done with the Robin Hood Foundation here in New York. They were rehabbing libraries in economically challenged neighborhood schools that needed all the help they could get. I had made a logo, and thought I was done, but then one of the architects for a library asked us whether we could do a mural in the space between the ceiling and the uppermost shelf that elementary-school kids could reach. So, we arrayed pictures of the kids around the top, and the librarians liked that so much that we then did that in about twenty libraries after that, enlisting all sorts of amazing artists.

As it happens, I had people in the office who had done all of the working drawings for these things, and I'd never actually seen any of them because they're in sometimes remote parts of the Bronx or Brooklyn. So we visited libraries, and it was so great to see them filled with kids—and, most important, how the librarians themselves felt they'd been given a special stage upon which to perform. They owed it to the kids to take this gift and make it into something.

It was winter, so it got dark early, and light was falling when we arrived at our last stop. And the librarian was closing up in this one library, and she said, "Let me show you how I turn off the lights." She turned them off in sequence, saving the light on the faces of the kids above the shelves for last. She said, "I like to remind myself why I come to work every day." That makes me cry even right now. It's nice to reach these kids. But to make these librarians feel that they were valued—the kids would come and go, but the librarians would change the lives of those kids by feeling passion about what they were doing. And this inadvertent thing, helping to fill the space between the shelf and the ceiling—I never sat and thought, "But let's remember to change the lives of the librarians." That never occurred to me. To have this reminder that work we do can be seen by people and experienced by people and occasionally change their lives is thrilling. And it happens when you least expect it.

"Every

single thing around us,

everything we consume,

everything we buy on a daily basis,

is a package that somebody has designed."

ANDREW GIBBS

entrepreneur, publisher,
creative director, educator

December 2, 2011

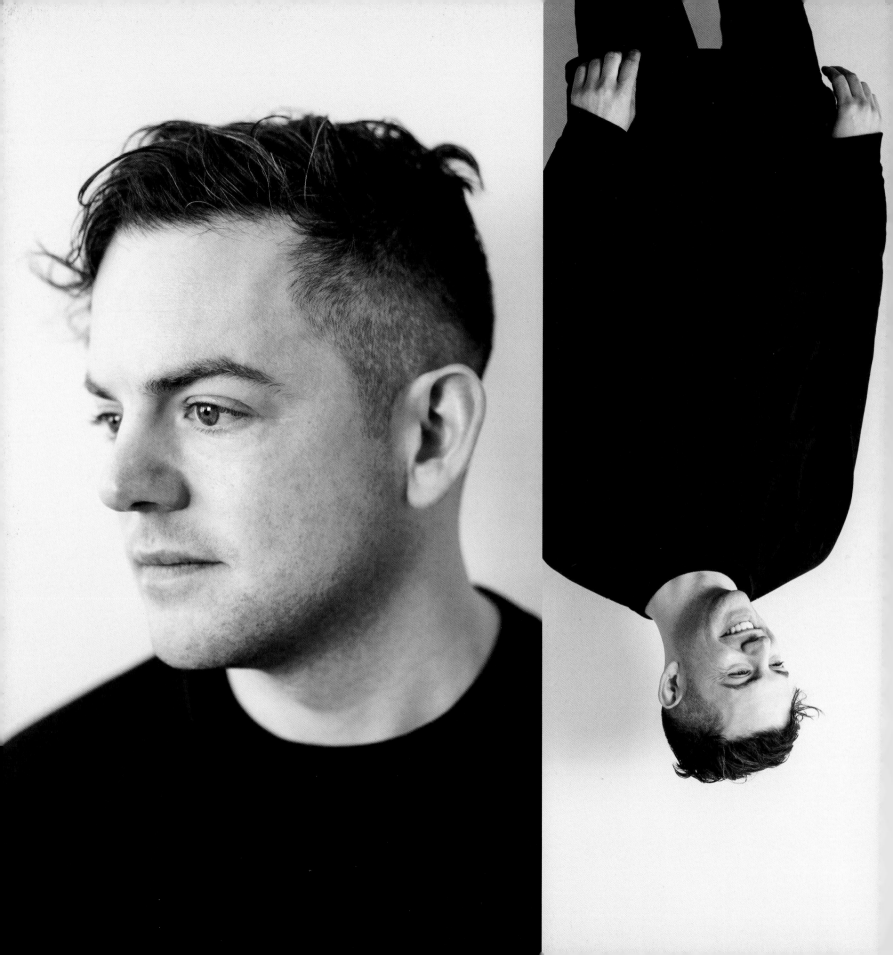

May 2, 2016

NICO

Nico Muhly composes chamber music, orchestral music, operas, music for ballet, film soundtracks, you name it.

He is an even rarer bird among contemporary classical composers because he is hip and has fans under the age of thirty. Maybe this has something to do with his efforts to reach beyond the classical music tradition or his collaborations with Björk, Grizzly Bear, and Philip Glass to break those barriers. In this interview we discuss the origins of his music and the musicians who interpret it.

MUHLY

DM: Nico, your mother is a painter and a teacher and your dad is a filmmaker. That must have influenced you quite profoundly.

NM: There were a lot of ideas going in and out of the house. My father is an eclectic filmmaker, so he worked extensively in Egyptian archaeology and then in stone cutting and then in caves in South Africa. He was one of these documentarians for hire, so he knows 82 percent of the available information about, like, four hundred things.

DM: I read that at the age of seven, you spent some time living near an archaeological site in Egypt, where you were chased by a pack of wild dogs.

NM: I think my dad was working on a dig. I don't specifically remember, but the structure of this town was essentially a vertical necropolis. As is the way in a lot of the developing world, dogs are randomly everywhere. Sometimes they decide that you might have something of interest to them. I probably had an apricot or something, and then I was running really, really, really, really quickly away from them. For me, it's an abstract memory, but, of course, for my mother, it's this Grimm's fairy tale. It's a very specific memory for her. She painted that episode, and I have it next to the mirror that I use to get dressed in the morning.

DM: So you look at yourself being chased by dogs every day.

NM: It's actually the sound of me being chased by dogs—there's no physical depiction of anything. There's just blue space, and then there's this kind of sonic representation, which in my mother's shorthand looks like a good Wi-Fi signal.

DM: I understand you sang in a choir at Grace Episcopal Church in Providence, Rhode Island, where you lived when you were growing up. Was that your first foray into music?

NM: More or less. Between eight and eleven, I'd simultaneously started playing the piano because there was a piano in our house.

DM: In the basement, right?

NM: In the basement of our house in Providence. Basically, I took piano in the way that kids take piano. You go once a week and devote yourself to it as much or as little as you can. Then a friend of a friend said her son was in this choir and that it was strange and interesting because it belonged to a chapel tradition of music-making that's pretty specific to England. It's essentially an unbroken chain from the 1500s, and even though I didn't know what that meant, it felt weird and special. I certainly got addicted to that music, particularly the music of the English Renaissance.

DM: When you've previously discussed the piano in your basement, you also talked about feeling like you came to composing rather late, how there are children who are playing Chopin as soon as they come out of their mother's womb. Do you really consider yourself that late?

NM: Let me put it this way. There are structures for preteen kids to study music that are almost professional, and if you go to any big city in the country, you'll find many such places, where there's a Saturday school and a Sunday school and the students learn a rigid way to play the violin, for example. Sometimes the kids are into it, and that's a different argument, but essentially, when I turned up at Juilliard, a lot of people had been at it for much longer. I have a friend who plays in the Boston Symphony, and her house is covered with pictures of her at the age of two and a half playing the violin.

DM: But how do you bring a natural sense of joy to playing at that age?

NM: This is an argument that I've never quite bought, because here's the thing: playing music is so awesome that even if you're forced to do it, it's great. Yes, you were probably tortured and made to play the clarinet, but you were also tortured and made to learn trigonometry and other subjects, and we all made it through somehow. But at some point in your life as a child, something happens, right? I saw this again, at Juilliard—kids who definitely would have been locked up in a basement in Korea since they were two years old, and then they had that moment at age eleven where they realized, "Now I'm in this to win it."

DM: Absolutely. I read that you were fascinated by the emotional function of church music as opposed to concert music as you were growing up. You said that

church music is more directional music, pointing upward, and the satisfaction of a job well done is the only one you're going to get. When you finish the piece, you don't look at the audience and smile, you don't graciously bow, and the composer vanishes in addition to the performers. If you are really good, you disappear. Is that fulfilling to you? Do you want to disappear?

NM: Enormously.

DM: Why?

NM: You've made something that hits that sweet spot, where it's so beautiful that you don't think that lamp is great—you think this room is great. You think, "My day is better because I'm in this situation." You don't approach church music like a play in an analytical sense, right? The great thing about church is that there is one story: "Do unto others, and the rest is commentary."

Church music is not designed to be about itself, and it's not designed to be an art that references itself. It's meant to create and direct an atmosphere that's for a play to which we know the plot. Church music can do something in one second that is tricky to explain. For instance, if you're talking about Christmas, you need to taste a little bit of the gall of Good Friday. You have to look at the baby and understand, "He's going to die." In thirty-three years and a couple of months, it's a wrap. The music can do that in one second.

DM: How?

NM: Well, what you do is you shimmer on a note or you lean into a piece of text, and this can be written into the music itself or into the performance. This is a vulgar analogy, but if it happened in a film score, you'd know it. You'd feel a tautness about it. Because we know the plot, you're hanging your art on this structure that we already appreciate, so there's room to be very weird and stylized. That's when music starts getting interesting, where you have these insane French composers who, at a certain point in the twelfth century, decided, "What if we took these notes that were normally melodic and made them last for, like, a minute each?" They Gothicized notes. It's crazy.

DM: Sounds like Glenn Branca.

NM: But way before—by many centuries. It's the same thing that happens in ecclesiastical architecture, this experimenting with highly stylized lines, which doesn't happen in vernacular architecture. This is especially true in the Islamic world because there's not much depictive art. Instead, you say, "Okay, we have to make the letters create the joyful expression," so when you write a bismillah, the letters are huge and the vowels are these gigantic shapes and the whole thing turns out to be the shape of a peacock. That, for me, is the fun of sacred art.

DM: I've had a number of musicians on *Design Matters,* and I keep trying to find an answer to what I consider to be one of the world's biggest mysteries. Where does the music come from? How does it arrive to you?

NM: The minute I figure that out is the minute I'll stop having to do it. Each expression has its own way. If your life includes a space for music, you'll figure out how to put it there. What I'm saying practically is to have a deadline, and what I'm saying slightly less practically is you imitate what you've seen before. You basically take what your teachers have left you, you collect things you heard in the concert hall or someone humming, and they become part of an arsenal to fill up silence.

DM: Okay, but if you're writing the opera *Two Boys,* how did that happen in your head?

NM: I know I'm giving you more of a practical answer than the one you want, but essentially you look at the text and you say, "What are we doing here? How are we getting from A to B? Where's this piece of music going to deliver us in the time that it has to be performed?" When you see the architecture of the journey, you ease your way into pitches and see what works and what doesn't work. Usually it doesn't work, and then you get it right. The mystery of that moment is very energizing.

DM: It's creating something out of nothing.

NM: With classical music, there are a lot of things that are pre-compositional exercises. They range from what I would describe as going to the supermarket to assembling your ingredients to doing a very elaborate mise en place in Thai cooking. Thinking about it in terms

of food is very useful because sometimes you want to follow a recipe from *The Food Lab* and do exactly what it says, and other times you want to go to the store and buy six things and then see what happens when you get home. I think, at least in my practice, music can go in either one of those directions.

DM: How so?

NM: There are schools of modernist thought that are essentially seven thousand days of mise en place, and then do fussy shit with it, and then that's the piece. This kind of explosion of content that you've generated in advance can be beautiful and great and wonderful, and, I find, not particularly spontaneous, but again, this is a great process. There's another mode where you buy all the ingredients, and that's usually a process of discrimination where you decide what you're not going to do, what you're not going to use, and what you are going to use in the piece. The challenge is how to make something satisfying out of what you have, and then from there, that's when your technique comes into play. You do a little bit of pre-composing, and then you figure it out.

The great thing about church is that there is one story: "Do unto others," and the rest is commentary.

DM: What's interesting about music as an art form, if you compare it to, say, literature, is that nobody is going to perform the book. What is it like for you to create something and then hand it over to somebody else to play it and interpret it?

NM: It's surreal. My friend Stephen Karam is a playwright who just had a play open on Broadway, and the anxieties he was having about that were very similar to the ones that I have—you do this thing and your craft is on the page, and then all of a sudden other people are doing stuff to it and it's doing stuff to them. Things are happening and you've vanished. It's a weird feeling, but it's one

that you get almost used to. I think what is tricky about it is that you have to do two things at once. There's the practical job, where you're given a pile of money and you send back a pile of paper...

DM: ...it's really paper for paper.

NM: Right. Then what you do is you have to make sure that what's on that paper is really, really indicative of what you'd like to have happen. It gives incredibly specific instructions about how to realize the thing that you heard in your head when you heard it in your head.

DM: Is it open to interpretation at all?

NM: Well, it is, but here's the interesting thing: the amount of room between what you write and what ends up happening—with contemporary music, there are so many different paths. There are people who give enormous amount of freedom, John Cage being a great example, or there's a way that you can argue that all of Yoko Ono's instructions in *Grapefruit* and other pieces are scores because it's an instruction that you deal with in your own way. On the other hand, there are detailed instructions that you can give, super-complicated things where you say, "I want you to hold the flute like this, and I want you to top that there, and do this," and you can get into that mode too. We can set up a false binary, but for me there's a sweet spot that details what I'm talking about with room for musicians to continue the conversation when I'm dead or when I'm not in the room. I always try to be as specific as I need to be, without ever approaching it like, "To cook this, stand facing the stove. Lift your left hand out where you were meant to have put the"—there are scores like that, and those things can be wonderful, but there's a control freakishness to it.

DM: I read an interview you did with Molly Sheridan for *NewMusicBox* where you explained that while you consider yourself a classical music composer, that does not preclude you from working within a variety of musical genres. You said, "It's like being from Nebraska. You're from there if you're from there. It doesn't mean that you can't have a productive life somewhere else. The notion of your genre being something that you have to actively perform I think is pretty vile." You're laughing.

NM: It makes sense, yes. I stand by it.

DM: Why do we need to pigeonhole art? Why do we need to signify where something comes from or where it's supposed to go or what's supposed to happen next?

NM: The radical interpretation is that it's this proto-colonial thing, where you have to make a taxonomy of the thing so that you can kill it and control it. For me, the classical music tradition can mean a million different things, but it's the tradition in which I cut my teeth. We're all working with moving definitions in a fluid way, and a great way to waste three hours of your day is to try to answer what's the difference between a musical and an opera. If you want to spend three hours doing that, that's great. Just don't call me.

DM: You turned the classical music industry on its head with the way you do things, the way that you think, the influences that you've had on your work, and the influence you're having on others. In your second album, *Mother Tongue*, some of the sounds included a pair of butcher knives scraping against each other, a recording of whistling Icelandic wind, and the sound of raw whale flesh slopping around a bowl. Can you talk about how you choose the instruments you use?

NM: It is the work of the ancestors that allow me the freedom to do that, right? Cage and Gershwin and before. With *Mother Tongue*, I was trying to create an archive of a language and an archive of a space, and the glory of an archive, for me, is not moving from A to B to C. Rather, the eye is drawn to things. I wanted to open up the instrumental possibilities to the wild, to the moments we find ourselves obsessing over. We don't think in sentences in our head, at least I don't. I'm not thinking, "I will walk to the stove and do this thing." Instead, there's a repetitive thing that's going on, then I'm making toast and thinking about something else, and then that pivots quickly to the noise of the dog outside. I wanted to see if I could musicalize that. The album was an experiment in folding in those sounds, seemingly drawn at random, into a Meredith Monk texture.

DM: You are the youngest composer to have ever been commissioned by the Metropolitan Opera. *Two Boys* was your first large-scale opera. *The New Yorker* praised *Two Boys* as a bright-hearted, fearless work and declared that you handled this lurid story with thoughtfulness and compassion. The story combines two elements rarely seen on the operatic stage: a police procedural and a dramatization of the mysterious and lonely lives of those who inhabit the darkest corners of the Internet. Why did you pick this topic?

NM: I'm glad that it read as a very new thing because in my head, it was actually a very old thing.

DM: You mean an epic story?

NM: Well, in a lot of the great operas, let's say *Partenope* or *Così fan tutte*, the basic premise is that there's two women and they have fiancés, and the fiancés are testing the women's fidelity. The fiancés pretend that they're going off to the army, and they come back as Albanians, whatever that means.

DM: It sounds like a Shakespeare play.

NM: They dress as "Albanians" to trick the women to see if they'll be unfaithful, then, of course, the women fall in love with them. The Mozartians at that point are geniuses. They tell each other things that they would never be able to tell each other in their normal context, which is the most online thing. This is the oldest story, where you can tell someone a deeper, darker truth when you're in costume than you can face-to-face.

That, to me, is what happens in *Two Boys*, where there's this younger boy who's in this love-infatuation thing with an older boy, but because of being in the north of England in the 1990s, he's not about to say that. But he can say whatever he wants if he pretends to be all these different people. He can have a sexually aggressive relationship with the older boy, he can have a seductive relationship, he can have a predator-prey relationship. He can say exactly what he wants. That, to me, was the fun of that, which is to say the Internet is allowing us to deliver to ourselves the same drug that we've had in Shakespeare, that we've had in Mozart, that we've had, ultimately, since the beginning of drama.

ALAIN

**The Art of Travel,
The Pleasures and Sorrows of Work,
How to Think More About Sex,
How Proust Can Change Your Life:**

these are just some of the books written by the prolific Alain de Botton. Throughout his writing, Alain is graceful, witty, and wise, a voice that comes through in both his cultural commentary and his novels. In our conversation, he spoke about his career, his always surprising take on the world, and his thoughts on the evolution of relationships.

DE BOTTON

June 27, 2016

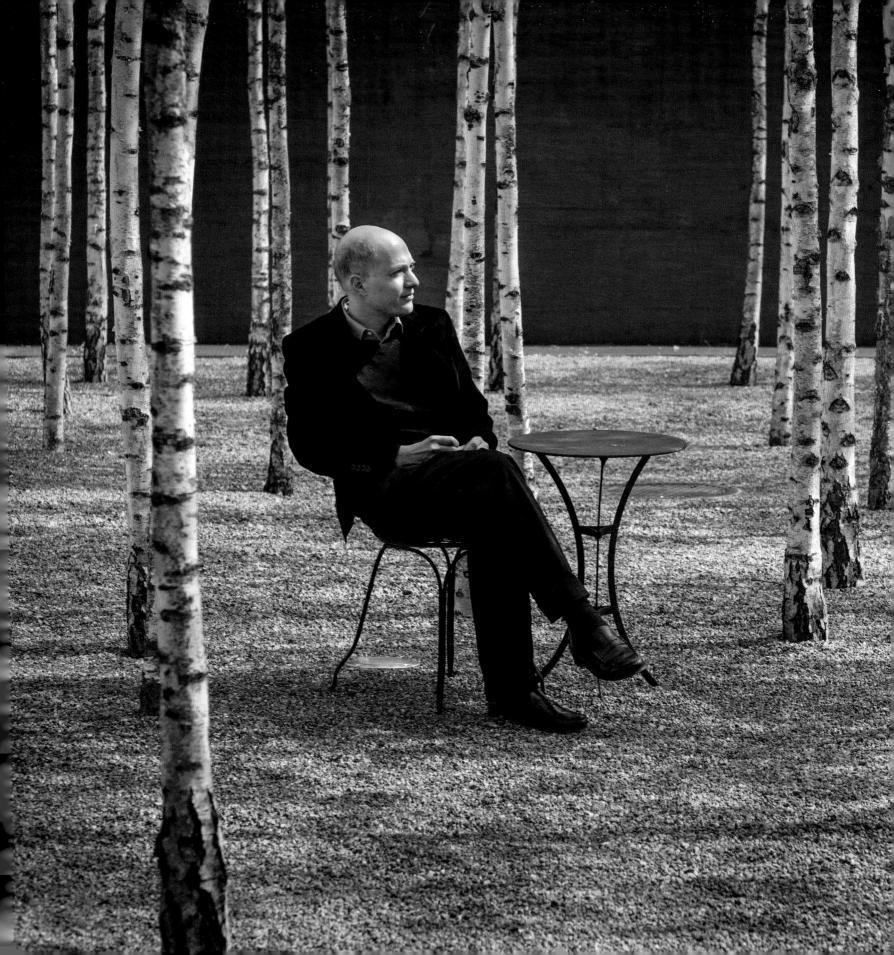

AD: I'm a people pleaser. Filmmaking often requires you to have an incredibly powerful vision in such a way that you may have to upset and manipulate a lot of people around you into accepting that vision. I have a very strong vision, and yet I want to keep other people happy. Writing seemed a much better way because you can do it on your own. You don't need to persuade large numbers of people.

DM: Your first novel, *On Love,* was published in 1993. In that book you describe the arc of a relationship from the moment two people see each other to the moments when their love ends. The book is written almost as a philosophical analysis of a relationship. Was that your intention, to craft it in that manner?

AD: I wanted to play with an opposition, or a tension, which was alive in my own life and that I wanted to bring out on the page—and that is the opposition between rational thought, experience, cultural knowledge on the one hand, and on the other, feeling, emotion, the dramas of the heart. I wanted to collide these two opposed elements. I wanted to put Plato in the kitchen. I wanted to have a minute analysis of small moments of relationships. I wanted to bring an academic's forensic eye to the minutiae of love.

DM: There are many lines in both *On Love* and your new book, *The Course of Love,* that I'm going to read back to you to ask for elaboration, maybe to challenge you to some degree. You say we fall in love because we long to escape from ourselves with someone as ideal as we are corrupt.

AD: I think that there is often a desire to escape oneself in love. It's not so much that one wants to be welcomed by another person. It's that one wants to forget oneself and immerse in the perfection of another. It's not necessarily always healthy.

DM: Is it ever?

AD: We have this enormous capacity to locate perfection elsewhere, and this is what the crush is all about. The crush—it sounds silly, but it goes right to the heart of how romantic love is perceived. You're walking down the street. You see an attractive stranger, and instantly you're overwhelmed by a sense that this person would be perfect. You know that it's a crazy feeling, but you detect something in the corner of their mouth, something about their eyes, something about the way they're holding their clothes. Something just gives you that certainty. It's absurd, and, in a way, it's the central sun around which the planets of love—as we understand them today—revolve. The crush is the instantaneous certainty of the location of the ideal, and there's an awful lot of projection and deception—self-deception—in it. And it can take us years to unpack that, but when you're twenty-two, it is powerful.

DM: I think Freud talked about that initial crush as a psychosis. Perhaps the easiest people to fall in love with are those about whom we know nothing.

AD: That's right. The more information you know, the more you're forced to realize that actually they are an independent person outside of your fantasy, and I think Freud was alluding to the way that when we decide that someone is perfect, often what we're doing is transferring feelings that arose in early childhood around perfection and satisfaction. Freud said that those feelings arise initially in relation to the mother, and later we relocate those feelings to another. But that's why the less information there is, the more our unconscious can hold onto this rather peculiar piece of emotional trapeze work.

DM: In your book *How Proust Can Change Your Life,* you ask this question in the chapter "How to Be Happy in Love": "How long can the average human expect to be fully appreciated?" And the answer is, "Often as little as one-quarter of an hour." So, we metabolize love. We metabolize everything.

AD: That's right. One of Proust's concerns—and this is what makes him such a fascinating and quintessential

artist—is that he's aware of how much we fail to appreciate the beauty and interest of things that are often around us. He understands art as a mechanism that can restore beauty and interest to things that have been unfairly neglected, and that's how he reads the history of art. So when he reads the Impressionists, for example, he understands that these are people who looked at ordinary scenes—wind blowing through a tree or a bunch of asparagus on a sideboard—and were able to reawaken us. And in a very humane and fascinating way, he argues that we shouldn't simply take in the works of art at the Louvre or the Musée d'Orsay. What we should do is learn art's general lesson, which is its power to reanimate our relationship with the world.

I think that there is often a desire to escape oneself in love.

DM: You often speak of the importance of understanding one's own psychology. Are there questions that you ask yourself that help guide you to better understand your own psychology with regards to love and work? Do you go to analysis?

AD: I've been to analysis for many years, and I think it's a tremendous discipline. It gives you a tool with which to understand yourself because another person's interest and curiosity makes you more interesting to yourself. The very fact that you're asking me these questions now leads me to go into my own mind. Normally, one hovers on the outside of consciousness. When there's somebody asking questions and listening carefully, you travel inside, and that is what therapy can help you to do. But it's not the only thing. There are versions of therapy that one does on one's own, including having a hot bath, or going on a country walk, or simply lying in bed with a pen and paper and downloading the content of one's mind. All these are forms of mental self-investigation.

DM: In both of your novels, the characters want to create a persona that will best excite and entice the other person. You state that as they are falling in love and attempting to make the best possible impression on each other, this question is posed: How can I abandon my true self unless I know what false self to adopt?

AD: There's a real tension in love—at the beginning of love, particularly—between the desire to be honest about who one is and the desire to win the affection of another person. Of course, ideally, we can both be honest and loved for being honest. That's the dream. But for many of us, perhaps most of us, there can be moments of conflict where we think, "If I am totally honest, I will sacrifice the affections of another." We're all quite skilled at swerving away from the challenges of being honest, maybe for good reasons. This happens particularly around sex, where many of us don't want to frighten our partners.

So we edit ourselves on many levels. We may not want to reveal how much time we want to spend away from them or indeed how much time we want to spend with them. And it's touching. It's also very dangerous. I think that to some extent, maturity is about an ability to talk in an unfrightened way—and a reassuring way—about some of one's more troubling desires. I think that as people get older, they get better at this. Many of our sexualities are at odds with who we are in the rest of our lives. There's a general realization that things that were seen as very much on the margins of human desire actually may lie quite close to a kind of a norm. And one has to go very carefully because issues of power are so troubling in the outside world, in the world outside the bedroom, and so I think there's been an attempt to say, "Well, where do we go from here?" Our societies have done amazing things about recognizing lesbian and gay desires and legitimizing them, but this is only one part of an enormous spectrum of human sexuality that still lies outside that very punishing normative sense of what is usual and what is normal.

DM: In *The Course of Love,* Rabih, the protagonist, loves from a feeling of incompleteness and from a desire to be made whole. That's not really love, is it?

AD: No. He's a romantic, and I think in many ways the novel is a journey from romanticism toward a more psychological form of love. It's looking at this thing called romantic love, which is at best two hundred years old and is a troublesome ideology that tells us things like: a lover will make you complete. A lover will solve loneliness. A lover will be your best friend. These are the ideas that we think of as romantic, and they're beautiful but they're trouble. In many ways, the novel is the story of how two people who've bought, like most of us, into the romantic idea, learn that love might be a little bit different. The novel is the story of how they very painfully learn that love might need to be a skill. What is that skill? It's about understanding oneself, understanding the other person, and learning to communicate between the gulf that separates a couple.

DM: I was just having a conversation with my partner where I said, "Didn't you know when you first met me how sensitive I am?" And she said, "No, you seemed so confident and easygoing."

AD: It's "unromantic" to have to find the words to spell out aspects of one's psyche. This is why the sulk traditionally has a very important role to play in romantic love. Because what is a sulk? A sulk is fury that the other person hasn't understood something key about you mixed with a real commitment to not explaining what that thing is. So you're blaming them for not understanding you but refusing to explain because that seems a betrayal of love. In many ways, relationships are about teaching. Successful relationships are ones where the couple—each part of the couple—allows the other to teach them and takes on board the lessons without fury, without bitterness. There's tremendous resistance to that kind of pedagogical aspect of love.

DM: One of the characters in *The Course of Love,* Kirsten's mother, thinks there is no one more likely to destroy us than the person we marry. Do you agree with that?

AD: I think so. Marriage is not a particularly kind thing to do to someone you truly care about.

DM: That's a profound statement. You just snuck that in there. We seem to treat our partners worse than we would treat people we really loathe, and we supposedly love our partners, right?

AD: Of course, because they won't run away. And this is the irony of love—that love gives us the security to demonstrate and reveal all kinds of dynamics that are really troublesome that we hide from everybody else.

DM: A person has to feel safe around someone else to be that difficult.

AD: That's right, that's right.

DM: Children demonstrate this kind of dynamic. You write that before a child can throw a tantrum, the background atmosphere needs to be profoundly benevolent.

AD: Absolutely. I've daily demonstrations of this with my own children, who sometimes behave in absolutely foul ways. Most modern parents spend an inordinate amount of time trying to reassure their children that they are loved, and in return they'll get some pretty awful behavior back. Because you've shown you can take it.

DM: You say that if we're not regularly, deeply embarrassed by who we are, the journey to self-knowledge hasn't begun. What bad habits and types of self-sabotage do you think deprive us of self-knowledge in work and in love?

AD: We've all got such an investment in seeming more or less sane and normal and in avoiding humiliation. When people say things like, "So and so is afraid of intimacy," well, a fear of intimacy is normal and natural. Of course we're afraid of intimacy. Intimacy is frightening. So we need to be kind and patient with that fear. It's coming from a very legitimate place. We need to spend most of our lives very defended, and then true partnership involves taking down the defenses. No wonder we can't necessarily do that with total flexibility and speed all the time.

"**It's**

actually close to abusive to force people to be vulnerable. When people have gotten to a point where they realize that the way they're doing things aren't working, and they're curious about another way, that's when you can have a chance."

PRIYA PARKER

facilitator, strategic advisor,
author, and podcast host

May 21, 2018

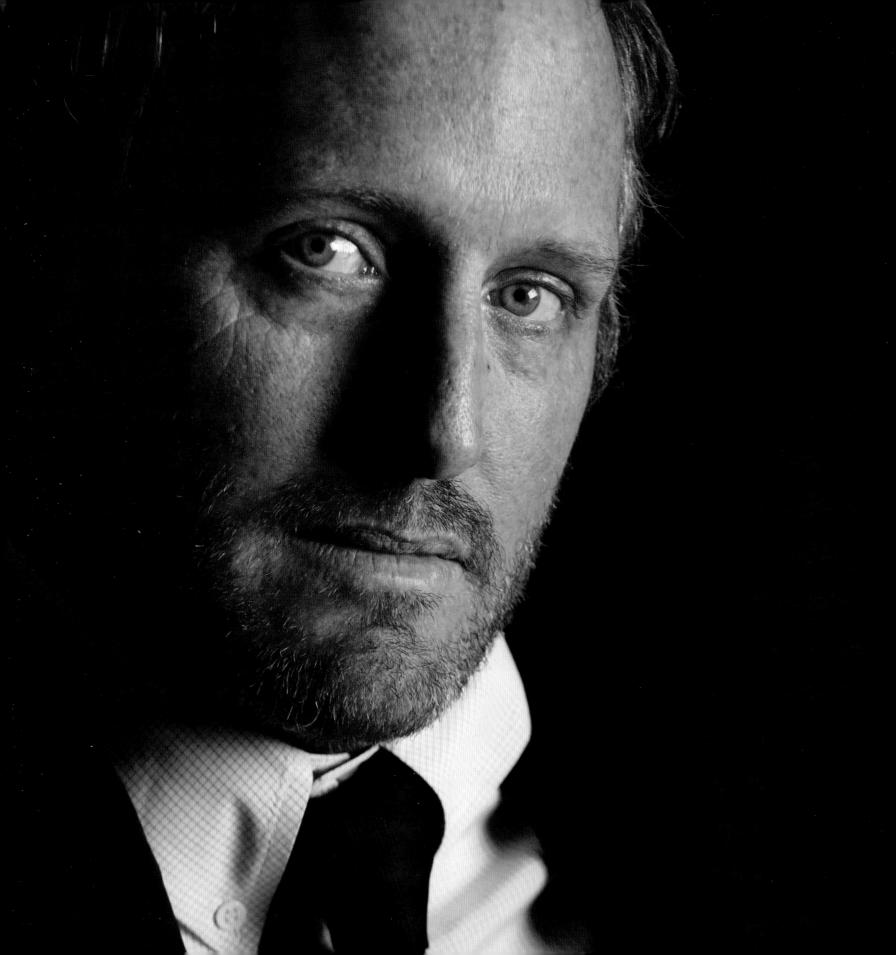

MIKE

Mike Mills has done so many different types of work it's hard to imagine how it all comes from the same person.

As a graphic artist, he's designed album covers for Sonic Youth and the Beastie Boys. He's also designed scarves and skateboards. He's created music videos for Yoko Ono, Moby, and Pulp, and commercials for Nike and Old Spice. His artwork has appeared in museums in the United States and Europe. His featured movies include *Thumbsucker*, *Beginners*, and his Oscar-nominated *20th Century Women*. Mike joined me to talk about his extraordinary career and what it is that all his various creative endeavors might have in common.

MILLS

DM: Mike, you were born in Berkeley, California. Your father was an art historian and museum director, and your mother was a draftsperson who looked like Amelia Earhart and wanted to be a pilot in World War II. Would you say your home was a creative environment?

MM: Creative and highly entrepreneurial. More than anything, my parents were Depression-era kids. They were born in the 1920s. When they turned eighteen, the draft for World War II started. My mom wanted to be an architect. She wanted to be a pilot in World War II. Back then, that was not allowed. She was the only woman in the drafting room in the early 1940s. My dad was shipped off to the Aleutian Islands, where he was a gay man doing Morse code for four years in a Quonset hut with a bunch of men.

DM: Sounds a little Alan Turing-esque.

MM: If my parents were here, they would say that America was different then. America was more bohemian. America was more socialist. My mother's always saying, "All the characters are dying. Go talk to Mary Steele over there at the dinner party. She's a true weirdo." My parents had that weirdness to them, even though my dad wore a suit every day. They were very hardworking people, not typically arty. They were deeply bohemian and from an older, weirder America.

DM: Your parents got married in 1955. They were married for forty-five years. You've said that your mother knew your father was gay. Your father knew he was gay. Growing up, did you know your father was gay?

MM: When I was eighteen, my older sister mentioned something about it. Anybody who has deep family secrets or open secrets will know that you're both shocked and totally not shocked. As an eighteen-year-old Santa Barbara boy in the 1980s, I thought, "He was gay and now he's not anymore." It was a convenient story. He didn't seem gay at all. He voted for Reagan. He wore a suit and tie every day. Sex just seemed completely devoid from this person.

DM: Your parents conceived you when they were forty, many years after your sisters were born. You've stated that you were the product of their recreational sex. They must have loved each other.

MM: They were complicated. They definitely loved each other—they knew each other since junior high. I'm not sure how much joy permeated their relationship. There was no heat in the house. There was darkness and unresolved things. You have to contextualize it in their

time. No one from their generation did what they wanted to do, or very few did. Self-sacrifice is interwoven with everything. My mom was equally complicated in different, mysterious ways.

DM: You said that she was a combination of Amelia Earhart and Humphrey Bogart—that sounds very butchy.

MM: She was very butch and hard drinking, hard smoking. I have memories of her with a sandbag over her shoulder, nailing up a two-by-four. All the gender stuff in my family was very fluid. They were interesting people. They had overcome so much—more than I ever had to. They had this incredible work ethic and postwar American mission to be part of a community. They lived the belief that you have the social responsibility to develop a community, participate in it, and make things better so that the world will get better. My dad was a museum director at the Oakland Museum of Art and the Santa Barbara Museum of Art, so he had a dinner party maybe every week with guests like Ed Ruscha and Richard Diebenkorn. The dinner parties were twenty to one hundred people, so the house was a community center.

DM: Salons, right?

MM: Salons makes it sound a little more romantic than it was. Santa Barbara in the 1970s was a drunken weird intersection of a whole bunch of different kinds of people. The art world back then was more heterogenous than it is now. My parents were hosts to parties both in their house and metaphorically, in life. That's how I treat directing. I've invited you all to this get-together. I am the host. I take a lot of cues from my parents' generosity and how contagious that is. In a weird way, the biggest influence on my work was their dinner parties.

DM: After high school, you followed your sister Megan to New York City in 1984 to attend Cooper Union, where you started to think that the art world was too rarefied. Was that why you chose design?

MM: Totally. I started at Cooper in 1984, which at that time was defined by the whole SoHo, Mary Boone world. I'm doing Sean Scully wood prints and my friends are breaking Julian Schnabel plates. We all have front-seat exposure to the art world, but we're punky, entitled nineteen- or twenty-year-olds and very critical of it all. That gallery world is a fucked up version of art—making toys for wealthy people. I was highly influenced by Hans Haacke and Ellen Lupton and people who are involved in a more socially conscious understanding of what your practice was and how it was interacting with the world. When I

The work was always a place where I could be bigger or braver than I am.

started to do conceptual art sculptures, I migrated to the design floor because I needed to set some type, and I thought, "Huh, these people—they wear nice clothes." They weren't dressed like all of us on the sculpture floor. We were just dirty sawdust-ridden monsters.

DM: You've described being nervous around designers that you did all this amazing work for, like Tibor Kalman. I also read that you were nervous and self-conscious around Kim Gordon and Mike D when you were doing projects for Sonic Youth and the Beastie Boys. How did you get over this nerdy self-consciousness?

MM: I'm not self-conscious in the work. The work is where I could always be free and somewhat myself. I can get nervous around anybody. The work was always a place where I could be bigger or braver than I am. Tibor could be a very intimidating person, and he was not an easy person to work for. He was very hard on all of us. He never let you draw a sketch bigger than a quarter. He wanted a ton of ideas. He didn't want you to get involved in the aesthetics of your idea very much and work it out. He wanted lots of quarter-size ideas on a page.

DM: You've said that you feel you have the best shot at making a good movie if you work from a world that you've closely observed--things that you truly love, and things that truly confuse you. Why the confusion part?

MM: That's the most important part, in a way, because you need to have a live question or something that you have to desperately heal or understand more. The questions that are gnawing at you and tearing you apart—that's great film material. That's going to keep you charged all the way through. It's going to have a certain electricity. I love Allen Ginsberg's "Howl" because it has that desperate sense that he has to write it to be sane.

DM: Your first feature film, *Thumbsucker,* came out in 2005. It starred Vincent D'Onofrio, Tilda Swinton, and Vince Vaughn. It's based on Walter Kirn's novel about an adolescent boy's mutiny against his family. You wrote a script. You raised $4 million to make it. I read that you aspired to the simplicity of Yasujiro Ozu, the Japanese filmmaker who placed his camera at only two levels, sitting height and standing height.

MM: If you're starting as a filmmaker, that's a great model because it takes out a million questions. Lenses and what they do to faces and to the emotions of a scene—that's such a complicated craft. As a fifty-one-year-old, I'm only now understanding how a 75mm lens changes a scene compared to a 35mm. A 35mm is basically what your eye sees. I learned that subconsciously through Jim Jarmusch, who is a huge Ozu fan. His films have that observational plop-down camera quality. Again, this is very much soothing to me. There's no virtuosic envelopment to it. It's like a documentary photograph, in a way.

DM: The movie you did after *Thumbsucker* was about depression in Japan. How much does depression figure in your work?

MM: Depression is something that's in my family that you can't talk about, that you inherit, that you take on as a child, but it's illegal to speak. You spend the rest of your life trying to have a space where you can feel it and not be shamed for having the feeling, where you can hold the feeling without drowning in it. So much of my art and *Thumbsucker*, in particular, is about a place to have your shame, to have your vulnerability and survive. I'm attracted to art that does that.

DM: Do you still experience a lot of shame?

MM: Sure, but less and less. Years and years of therapy have expunged that, as well as being an adult and being married and having a kid, but it's the background.

DM: Your wife—the artist, writer, and filmmaker Miranda July—said, "Making things is what you do to comfort yourself if you feel an inborn loneliness that won't go away." Do you agree?

MM: Oh, yeah. We both share that dynamic. The mirroring that we wanted from the family just didn't work out. There are certain artists you meet and they're the chipperest people, but all their songs are like Leonard Cohen's. Their creativity is a place where their depression, where their unknown mystery of that which is not happiness, resides. Whenever you make anything—any drawing, any book, any movie—you go into that river. It's not always a negative.

DM: *Beginners* is loosely based on your own relationship with your father. The movie starred Ewan McGregor as a graphic designer whose seventy-five-year-old father, played by Christopher Plummer, has just come out. He wants to experience the gay life he denied himself when he was married. When you were scripting *Beginners,*

you wrote on an index card the words, "This has already happened to everybody all the time." Why?

MM: That story's totally based on my life. It's creative nonfiction. When my dad died, that was my second parent dying. That's quite intense and sad and a huge milestone. My dad's coming out and having five gay years but not having as much as he wanted—and dying wanting to eat more of the peach—you can get precious about all that. Even the experience of your parents dying—you can feel like it's an individual experience and become precious about it. I wanted to invoke the blues. These are things that happen to all of us, all the time, everywhere. Everything in that movie came from the real world, down to the dog. I wanted to put it into a fire and release it to the world. That's what making a film about it is doing. I also had Fellini in my head for both those movies. His stories come from a very personal space, but he's saying it to all these strangers in a dark room. He treats it like a lyrical myth, and he understands the connection between the two things.

DM: You've said that your father coming out was actually a gesture of him saying, "I want life. I want something." When this very polite, quiet man came out, it was the beginning of him becoming more vivid and hot and present, which was often messy but always wonderful. That must have been incredible to witness.

MM: He was also a vain, egotistical museum director, so it's not like he was so shy and everything that entails, but he was shy. He didn't do what he wanted to do for so long on a deep, deep level. To see him become an adolescent late in life, after my mom was gone, was often very difficult because he was not boundaried and not good to my sisters and me. But it was beautiful to see him very in love, in an obsessed way.

DM: Your film *20th Century Women* is set in Santa Barbara in the late 1970s and stars Annette Bening as a fifty-five-year-old single woman raising her teenage son, Jamie, in a boarding house full of wonderful misfits. The film is autobiographical, a way to try and understand your mother. In making the film, you stated that as a heterosexual cisgender guy talking about women, you were worried and wanted to find where your limitations were and make them part of the piece. Do you feel like you did that?

MM: It's something that I have thought about a lot and that has often stopped me. Abbie's character is based closely on my sister, and luckily my sister was very generous. I interviewed her, and interviewed her, and interviewed her. I also grew up in a family with a very strong mom, two very strong older sisters, and a closeted gay dad who's not the patriarch of the family. I lived in a matriarchy, and I'm used to trying to figure out women to survive, to not be in trouble, to get what I want. Then as an adult, making a movie in a public sphere, I thought, "Holy crap. What am I doing and how am I going to do this?"

DM: You end the movie by saying that you'll never be able to explain your mom to your son. I believe your son is now four years old.

MM: He's five now. I definitely made the movie for him in some ways.

DM: What part of you made it for him?

MM: As a maker of something that takes that long—five, six years—there are so many times where it can fall apart, where you're desperate. It's brutal. During those moments of collapse, it comes out: I'm doing it to be alive. This is how I communicate with people in a real way. I'm doing it to be a part of the world. I'm doing it because I feel like I know these people, my mother and my sister. If I have feet on this Earth, it's because of them and because I've seen them, so maybe I can make a movie about that, and maybe I can exist on this Earth and tell that to Hopper, my son.

DM: You've described your work as overly sweet and earnest. You've said, "I'm trying so hard to be nice. At times I just feel like, 'Let's do something nasty, Mike, with some evil people. Let's fuck some shit up.'" Do you have any plans to do something nasty?

MM: I wish I could. I do feel like it is too sweet sometimes, but to do those other things isn't my predicament. My predicament is this vulnerable Swede trying to be kind and generous. There's a Milan Kundera quote that I love. He's talking about kitsch, which is basically sentimentality. In art and in life, kitsch is this metaphysical teleprompter that asks us to look in the mirror and fall in love with what we see there. It blinds us from knowing what we have lived. There is a sweetness that does block some complexity and honeys some experiences that shouldn't be honeyed. In my attempt to see my life, I want to get out of that, but my creativity, my world, my vibe comes from this kind place that's sometimes embarrassing, and that's what it is.

"The

only path to success

is through mountains

of killed ideas."

CHRISTOPH NIEMANN

illustrator

December 10, 2018

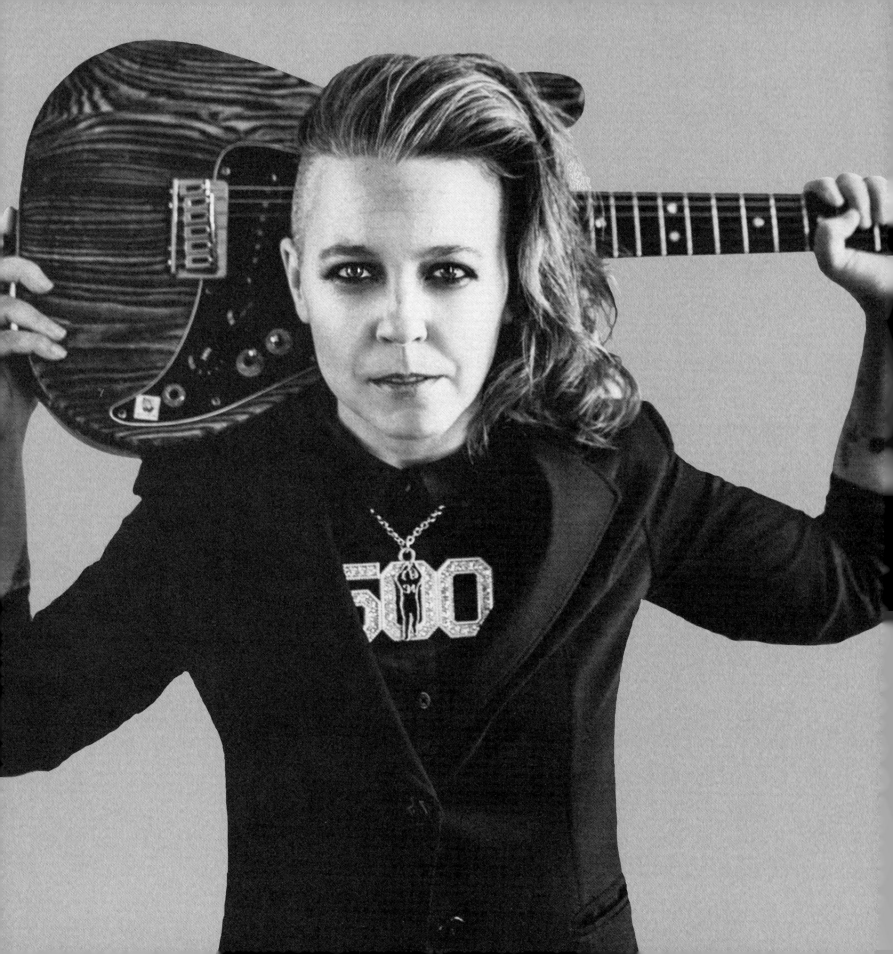

ERIN

**Erin McKeown doesn't like labels or categories,
but it's safe to say that she's a musician,
a playwright, and an activist.**

She has toured with performers including Ani DiFranco, Josh Ritter, and the Indigo Girls. She's a former fellow at Harvard's Berkman Klein Center for Internet and Society, where she worked to connect the worlds of policy, art, and technology. She's also deeply involved in social justice and immigration issues. Along with Quiara Alegria Hudes, she wrote the musical *Miss You Like Hell*, which opened at the Public Theater in New York in April 2018.

McKEOWN

DM Erin, you've said that the narrative structure that influences you most is biography, the order of a life, making sense of a life lived. I'm so thrilled to be able to ask you about how you became you. You said idols and heroes are important teachers and that growing up, the music you loved most was the music that helped you feel more than you were capable of feeling. You felt that music was more vulnerable and angrier than you were. Music made you imagine yourself on stage when, as you put it, in real life that seemed impossible. Why did it seem impossible?

EM Part of that comes from class, the class aspirations of my family, of trying to contain and fit into a more rigid idea of family. I don't think I had a lot of models for how to feel any of those things beyond the boundaries of what felt acceptable. I think that's true for a lot of people. That's what music and art do for a lot of people—it helps them understand and feel things they maybe don't have practice with.

DM You've said you played just about any instrument you can think of, but does playing instruments come naturally to you? How do you just pick up an instrument and know how to play it?

EM Something changed for me. I can trace it to a certain moment. My freshman year of college, an artist named Martin Sexton, an acoustic artist from Boston, came down to Providence and played at a church coffee house. At that show, he whistled and he played piano, he played his guitar like a bass. His musicality spilled over the tools in his hand. It didn't matter what was in his hand—he could be musical on it. I was so inspired by that. I wanted that freedom. That spirit of being able to be expressive in music no matter what's in my hand has driven me.

DM You regard the act of singing as the most intimate and vulnerable a thing a musician can do.

EM Singing is still a mystery to me. It is tied to childhood. It is tied to the very essence of wanting to be heard and not feeling like you're being heard and having to use that voice. It's completely metaphorical and physical at the same time. When I talk about using my voice, I really mean both my agency as a person and the technical muscle in my mouth.

DM

How do you write a song?

EM You hope. This is what I tell my songwriting students. Songs are not precious, and if you come at songwriting from that perspective, you're going to be fine. You have written songs before, you will write songs in the future, and you will write many of them. Hopefully you will write so many of them that you can't count, and you won't remember which ones are good, and you won't remember which one is your favorite. There will be ones that connect more with different people in different ways, but you as the writer, the less precious you are about your songs, the better it is. The other thing I say is that it's like fishing, and I didn't come up with this metaphor, I believe I heard it from my friend Mary Gauthier, who is a wonderful singer-songwriter I met in Boston who now lives in Nashville. I remember her saying one time that it's like fishing. Think about how you fish. You have to choose the right spot, you have to have the right tools, you have to be patient, but some days you're not going to catch a fish even though you're in the right place at the right time. When you do catch one, you have to take care of it, and you have to nurture it, and you have to bring it out of the water in the right way, and that's how you do it. Maybe underneath your question is that question of, "Do the words come first or does the music come first?"

DM It was really more about how does the idea for a song come to you?

EM There are a hundred different ways. I've had songs come to me in dreams, where I heard them, and I saw them, and I just had to wake up and write them down, and that's a gift. I'm always thankful for it, but not many come like that. There are songs that come from conversations. Then you have songs that just come because you feel like you can't help but write them. You have to recognize when the little spark has started. Another thing I like to talk about with my students is something called a "container," the thing that makes the song a song. The container could be a particular chord progression that all of a sudden is more than the sum of its parts. Or a particular combination of a word and a melody that feels repeatable. For me, that container is often a combination of a rhythm, a melody, and a set of words. Once I have that, then I get to repeat it and fill it.

DM In almost every bio or article about you, it's noted how you have a prolific disregard of stylistic boundaries. *The Rumpus* wrote that every new song you release is a total surprise, which is something I think you love.

EM I have a love-hate relationship with that. As I've grown older and have stopped giving as many fucks, I appreciate that about myself, but I certainly would have a different career if I had been able to write the same song over and over again, and I would have a different career if I had been able to write a song that was more easily categorizable. It created a marketing problem for my record label, and it created a problem for trying to introduce me as an artist to the world. I certainly really thought hard about that and definitely spent some years trying to fit more into a box that could be more marketable, or at least more easily described, and I just couldn't do it.

DM How did you get to that "zero fucks given" place?

EM Well, the bottom had to fall out. The music business is different than it used to be, so the economics changed. I am a nonbinary-looking female-ish person who was never interested in being photographed or marketed in any sort of way that was, like, "make men want to look at you." And I got older, and then my fan base had children. There's this way that many people in their thirties into their fifties disappear from culture because they're raising families. I really try to come at that without judgment. But anyway, all of that added up to the bottom falling out for me, in terms of having a more viable career. It didn't stop me from wanting to make music, didn't stop me from making music, but it kicked the chair out from under my financial situation, so I started teaching more, I started doing more record producing and stuff that wasn't dependent on people coming to shows. In 2011 Quiara Hudes wrote me an email through my website, and she said, "Do you want to make a musical?" Not to be too dramatic about it, but it really saved me. It really saved me. I just got to this point, again, where all the things I did to try to get what I wanted didn't work, so zero fucks.

DM I'd like to share something you said when asked if you had to compromise your ideals with the realities of the industry. You said, "In my early twenties, when I had a lot of opportunities, a lot of money, and a lot of choices to make, I had to make the kinds of choices that you're talking about where you have to decide if it feels like a compromise and if it does feel like a compromise, are you going to go through with it and how do you make a decision? In my early twenties, I struggled more with those things or felt like there was more of a morality or felt that a choice felt right or a choice felt wrong or like a compromise was difficult or not. I feel infinitely less bothered by any of those questions as an older person who had a bunch of success and then it went away. Life gets level, which is: I make my choices based on, "Do I like the person that I'm working with? Does this bring me an opportunity that feels creatively challenging?" That's what I make my choices from because I've lived with and without money and I have lived with and without recognition of what I'm doing and I'm fine." How did you get to this place?

EM So much therapy. I'm not kidding. I stopped drinking in 2008, and making a choice to not drink or use drugs helped my life get level. Making a commitment to examining my childhood with professional help helps life get level. Having a monthly budget that stays the same and is minimal—for me, that helps life get level and, again, it gives me an enormous amount of freedom and takes away a lot of anxieties. It's nice, the recognition the show is getting. It is by far the most visible thing I've ever done, to have a new musical at the Public that is written and seen by all these different folks and has now been, gratefully, nominated for a lot of awards, which is really cool. And it will go away. I've learned that. That's totally cool and that's what I mean by life gets level. I'm going to be fine.

"You

become the thing that you want to be. I couldn't claim to be a designer when I was starting because I hadn't designed anything. George S. Kaufman used to say that if you do anything long enough, they'll build a theater around you. I think that that's more of what having the office for forty-one years is like. I think we're good at it now."

EDWIN SCHLOSSBERG

designer

March 5, 2018

A M Y

The subjects of Amy Sherald's portraits are African Americans.

They wear clothing with vibrant colors and patterns, and they stand out from richly colored textured backgrounds. They look right at us and they seem to be taking our measure. Their portraits are beautiful, luminous, and intense. When Sherald was asked to paint Michelle Obama's official portrait, she produced a painting that was a departure from the traditionally stodgy First Lady portrait. Wearing a voluminous dress, Mrs. Obama is seated against a sky-blue background and she's looking right at us, taking our measure.

SHERALD

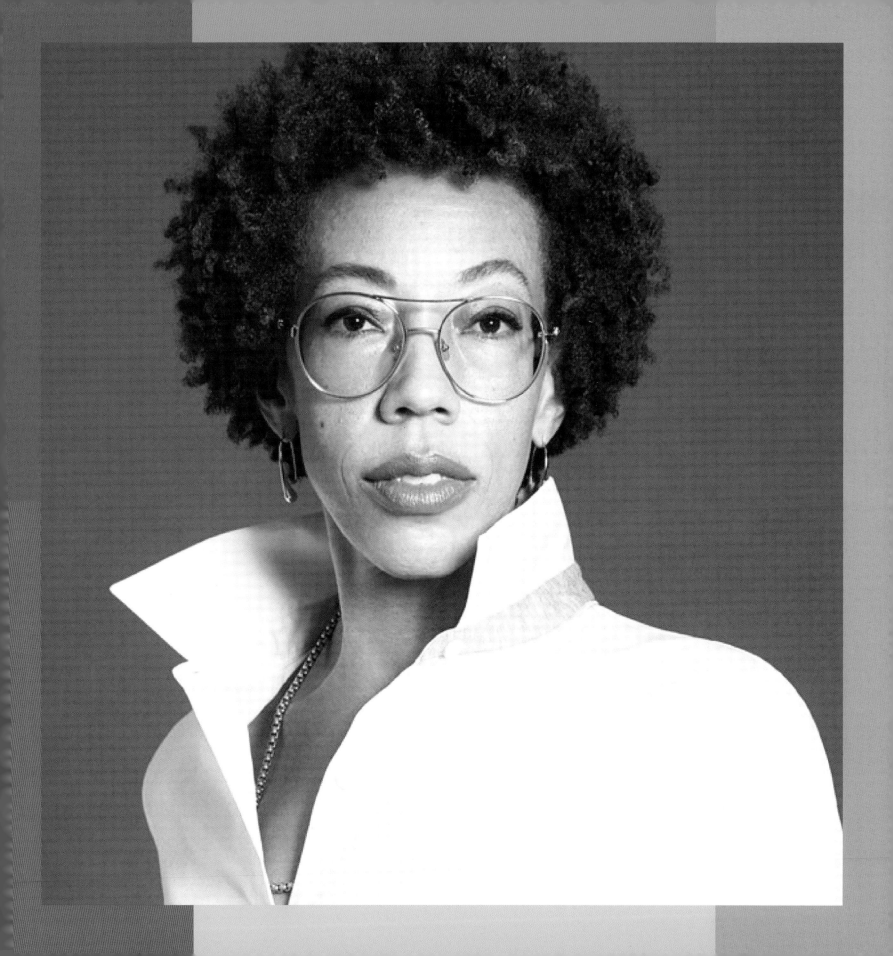

DM When you first started school, you would draw pictures at the end of every sentence you wrote. Whatever was in the sentence, you'd bring it to life—a house, a flower, a tree, a bird. What did your teachers and parents think?

AS They thought it was cute. Now my mom tells the story like, "She was an artist in the second grade."

DM Does your mom still have any of the drawings?

AS She does. She was surprised I wanted to be an artist, but every single activity I did outside of school was art. That's what I did my whole freakin' life. Then she's like, "You want to be an artist? I don't understand. You said you wanted to be a brain surgeon when you were five."

DM You started to take art classes with the Panama-born artist Arturo Lindsay, whose work focuses on the African influence on the cultures of the Americas. You've said he opened your eyes to what it was like to be a living artist.

AS He was the first living artist I knew. I begged him to let me work with him. I brought these paintings over that I was doing—it was your typical face of Miles Davis that everybody does, that close-up shot, and then some images I had torn out of a *National Geographic* magazine that I tried to render. He was really nice about it because I'm sure they were really, really bad, but he let me work for him. I worked for him for free for five years, but I got so much out of it. Now, I call him my godfather.

DM After you got your master's degree in fine arts from MICA, you left Baltimore to return to Georgia to take care of several members of your ailing family, and you didn't paint then for four years. You said that care-taking satiates something inside you, and you didn't miss painting when you were taking care of your family because it comes from the same place.

AS For a short time I was like, "Do I even want to paint anymore?" But then what else would I do? It's a salient part of who I am.

DM While you were taking care of your family, did you question whether art was your true path, whether you would go back to it?

AS I did. I tried to make some things work out while I was there, like I tried to get a studio, but it just didn't work out. If I had done all the things I wanted to do at the times I wanted to do them, then maybe I wouldn't have been at the right place at the right time for some of the greater things that happened, like being able to paint Michelle Obama.

DM Let's talk about your style and your process. Early on you had a friend who suggested it would be easier to paint flesh if you did so in gray scale first, and he suggested black and Naples yellow over black and white, comes out very silver, and you tried it and liked the result of the gray skin and decided to keep it. Can you tell us a little bit about why you chose to move forward with that specific look philosophically?

AS I knew I wanted to make these images and these paintings of Black people that were just that, paintings of Black people. I was subconsciously a little afraid that the conversation would be pushed into a corner. I didn't want the work to be marginalized because I needed it to live and to be bigger and to exist in a different space. That's why I settled on that. All of my decisions are, at first, aesthetic.

DM How did you arrive at the decision to exclusively paint people of color?

AS It was a natural decision. I don't think it was a choice because I don't think white people sit around and think "I'm only going to paint white people." They paint their ideal selves and I'm painting my ideal self. People ask me at artist talks, "Are you ever going to paint anybody white? We think you should." I'm like, "Well, I think you should reconsider what you're asking me because you need to take a little walk around the museum and you should probably open up a history book or two and then get back at me." It's really interesting how they can see the absence of themselves but they can't translate that and see how I may feel that there's an absence of myself.

DM Let's talk about one of your paintings that has captivated our culture, your portrait of Michelle Obama, which was unveiled alongside Kehinde Wiley's portrait of Barack Obama and marked the first time official portraits had been created by Black artists. Tell us the story of how the commission came about.

AS The National Portrait Gallery worked with the White House curator and gave them a portfolio of twenty-one artists. They made a short list of five, and then I got the phone call and went to the White House in July 2016 and had a conversation with them in the Oval Office. I was able to talk about some of the work I did with Youth Works and working in the Baltimore City Detention Center and reentry programs I want to start in the future. We got to the art at the end of the conversation, and I said, "I really would like to paint you, but I don't want to do it unless I could do it the way that I paint."

DM What was it like when she came in and sat for you to photograph?

AS I was really nervous and tried to be as present as I could, but it's almost impossible. I had an hour and fifteen minutes, and I just did what I had to do, like set up the camera and figure out where I was going to photograph her. It was fun. We put on rap music and made it happen.

DM Was she wearing the dress she was ultimately
 wearing in the portrait that you painted?

 AS Yes, that's the dress she showed up in. I worked with her stylist, Meredith
 Koop, and vocalized what I wanted, what I was looking for. We started
 with eleven dresses and narrowed it down. The one that she wore was
 one I was really into. I needed the dress to be a painting too.

 DM You have said it's your job to paint people, and you were approaching
 the project of painting Michelle Obama as if you were painting just
 another person. Did you feel the extra weight of her significance?

 AS I felt the judgment before I even finished it.

 DM Were you concerned about what
 people were going to think?

 AS I was because I'm normal. You're making one of the
 most important paintings in the world. You can't please
 everybody, so those thoughts passed through my mind
 and I tried to push them away. I had to just make a
 painting and not think about anything else.

 DM You've said that as a portrait painter you have
 the capacity to capture something that is not
 captured in photography. What do you feel you
 were able to capture about Michelle Obama?

 AS When I first started to do research for the painting, the first thing
 I did was go online and look at the thousands of pictures on the
 Internet. All of them are her public self. What I was sharing with
 her in that moment was very intimate, I wanted it to be a part of
 her that we don't get to see. I think I captured that.

"**I** received an email

that said,

'Come work

for the president.'"

JOSH HIGGINS

creative director and designer

December 13, 2018

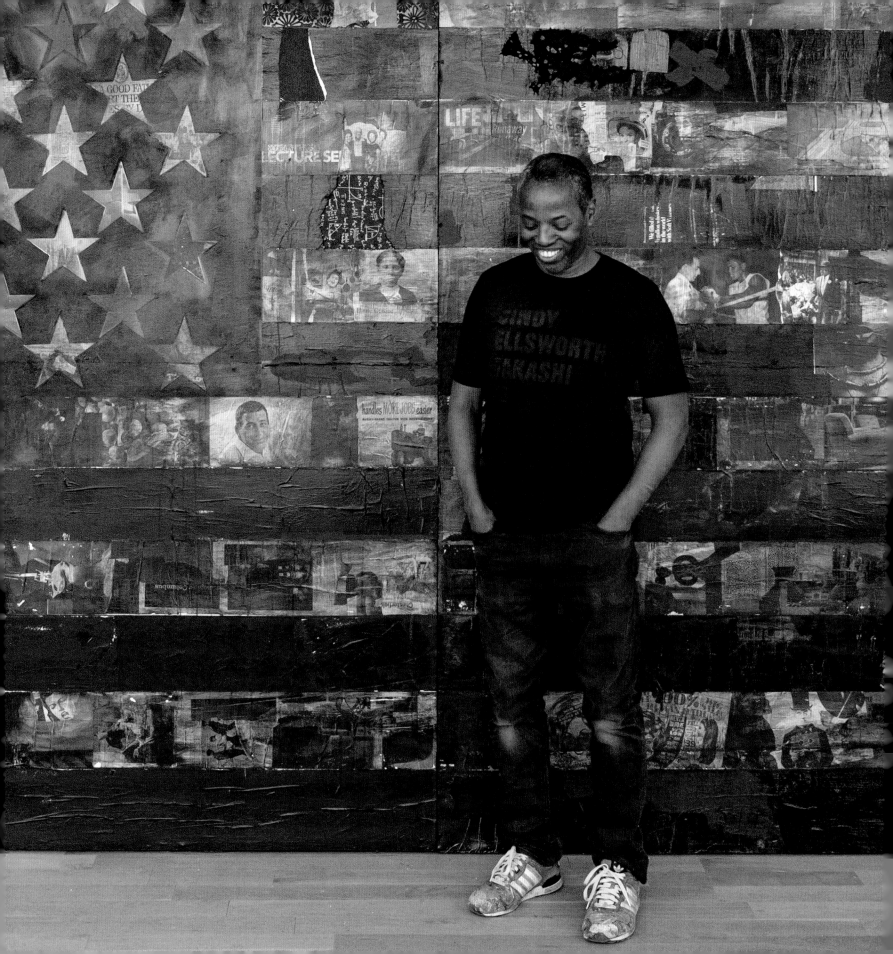

C E Y

**If hip-hop is the soundtrack of America—
the visual language of hip-hop—rooted in graffiti
and wall murals—also saturates the culture.**

One big reason for that is Cey Adams. He started in New York's downtown graffiti movement of the 1970s and 1980s and came of age along with Jean-Michel Basquiat and Keith Haring. He was founding creative director for Def Jam Recordings, and he created the visual identities for the likes of the Beastie Boys, Public Enemy, and Notorious B.I.G. He's also worked on advertising campaigns for HBO, Nike, and more. Over the years, he has put together an extraordinary body of work that explores brands, pop culture, race, and gender.

A D A M S

DM You began writing graffiti when you were young. When did you
 first become aware of graffiti and when did you start writing it?

CA Probably in junior high school, early to mid-1970s, but I didn't "turn professional" until I was able to
 really leave the house, so at that point I'm still just tagging in the neighborhood, which wasn't quite
 as big of a deal as it was when I started to travel to the Bronx. And then I started to see all these
 amazing top to bottoms and whole cars that were really beautiful. That was when I caught the bug.
 I wanted to take it to the next level, and that meant sneaking out at night. And it meant figuring out
 how I was going to get paint and materials and how I was not going to get caught by my parents.

 DM I read that when you were first mesmerized by graffiti,
 it then wouldn't leave you alone. I love that, the sort
 of passion of not ever being able to get away from it.

 CA It was everywhere because the thing is, I'm a teenager, I don't have any money,
 I was never really savvy when it came to talking to girls, so I wasn't going out
 on dates. I was a somewhat decent athlete, but even those things cost money.
 Graffiti was one of those things that sort of didn't cost anything.

 DM Did that make your parents angry?

 CA You know what spray paint smells like, and magic markers. Imagine somebody
 playing with turpentine all day in the bedroom. It was a problem, for sure. My
 brothers and I would tag the dressers, the back of our door, and there was the
 three of us and we shared one room so it wasn't a lot of real estate to begin
 with, but they also knew where we were. My thing was always ink, and magic
 markers, and spray paint, so my folks got off pretty easy.

DM Do you remember the first graffiti you put up?

 CA Everything I remember was in my room. I don't have a vivid memory
 of when I went out with a paint can and really tried to make my mark.

 DM Why?

 CA Because it was just so bad. That's the
 only way I could describe it, just bad.

DM Then what about
 "Cey City"? CA City was a graffiti crew. I came up with that because
 I thought it looked good next to Cey and it stood for
 Children Invading the Yard, which was the subway yard.

After starting with tags, you stepped up to larger and larger pieces and then hit the subway, and back then that was the holy grail.

CA Looking back now, it all seemed so dangerous. It's funny because I have a fear of heights, and I spend so much time trying to conquer that when I'm painting murals today. Back then there were these elevated train tracks. They still have them in the Bronx, but now there's a metal grate there when the workmen work on the catwalk. In the old days there were these two-by-fours, and because of weather and rain and snow, they would be really weathered. When we were chased by workers, we'd have to run on those things, not even walk, and this is like one hundred feet in the air—very scary. I still marvel at the courage I mustered up to be able to do that.

DM Take us back to what it was like on the streets back then. Were the cops after you a lot?

CA Yeah. I was very fortunate I never got arrested. My mom was like, "If you ever get caught, don't call here," and that was it.

DM Really?

CA Yes. That was the one bit of advice she gave me. My goal was always to not be the slowest one in my crew. The city was a rougher and tougher place, but it was a simpler time, and things like graffiti weren't considered a huge crime the way it is today. Back then there were so many things you had to do. Number one, you had to steal all your materials, and that required craftsmanship and being clever.

DM How did you do it?

CA You send one friend in the store first, and he goes left and the security guard follows him, and then you go in and go right. You go to the paint rack and you do whatever you have to do, and then you walk out. There was an art form to it for sure. When you are just starting out in graffiti, there's already a blueprint to follow. Everybody would share information, so it was common knowledge how you did things. You would apprentice under somebody more skillful until you learned.

DM Was it fun?

CA Sure, but for me it was a means to an end. It's kind of crazy to think back to all of the nutty stuff we did in the name of painting your name on the side of a train to make your mark, but that was what we had to do in order to let people know that we are here. We exist.

DM In 1984 Russell Simmons and Rick Rubin formally launched Def Jam Recordings and you became their chief creative director.

CA I didn't have any experience managing talent, working with artists or illustrators, any of it, but neither did they. We all learned together. It was an opportunity to succeed, but it didn't feel like a big opportunity. It was just more like, "This is better than getting chased by cops. This is better than breathing in spray paint fumes. I think I can do this." And because I had a graphic sensibility, the work I did translated very easily to other media.

DM In 1986 you and Steve Carr founded the Drawing Board, which was Def Jam's in-house design team, and you worked with Run-DMC, LL Cool J, Mary J. Blige, Public Enemy, Jay-Z, Stevie Wonder. In talking about the Drawing Board, you've said the goal was to create a platform for visual artists to express themselves in a way that was different than working in an art department for a record company. In what way?

CA First and foremost, we were making art and were, for the most part, African American artists that had a different sensibility than R&B. The idea was that this was Black rebel music. This was music that had real energy, that was from the street, and it was raw. I knew it was really important for us to get it right because the music depended on it.

DM You worked with all of these amazing artists and performers. You traveled the world with the Beastie Boys and Run-DMC, and I read that when you got off the plane, you've said that people treated you like royalty. Yet despite all the fame around you, you've focused on the work and you only ever wanted your name in the liner notes. Why is that?

CA I'm working behind the curtain. The job of a designer is to execute the vision of the product or the person you are working for. It's not an opportunity for you to shine as bright as you can. Your job is to make them shine bright, and that was something that I always had in context. I worked at a desk. My job is to create a beautiful visual, to enhance the package or the product. The end. That's the end of it, and then I move on to the next job. I'm not doing this so I can stand on the podium and take a bow.

"We

have all these preconceived notions about what it means to be an artist, that somehow it means you're a professional or you make money from it. But really, being an artist is just anyone who wakes up and intentionally makes things."

LISA CONGDON

artist

November 25, 2019

MALCOLM

Some people will always identify Malcolm Gladwell with his *New Yorker* articles and his books, among them *The Tipping Point*, *Blink*, and *Outliers*.

Other people know his writing but might be more familiar with his podcasts. Malcolm's *Revisionist History* goes deep into events, ideas, or people that have been overlooked or misunderstood, like the inventor of the birth-control pill, who was also a committed Catholic. *Broken Record*, which he co-hosts with Rick Rubin and Bruce Headlam, is a conversation about, or with, musicians. Malcolm Gladwell is also something of a podcast mogul, having cofounded the podcast company Pushkin Industries with Jacob Weisberg. His book *Talking to Strangers: What We Should Know about the People We Don't Know* was also released as an innovative audiobook. In this interview, we discuss the mistakes we make when encountering strangers as well as the fundamental—and sometimes misguided—human inclination to trust.

GLADWELL

DM: Malcolm, this is our fifth interview and your third appearance on *Design Matters*. Today, I primarily want to talk with you about *Talking to Strangers*. You begin the book by discussing the case of Sandra Bland, an African American woman who was pulled out of her car by a police officer named Brian Encinia following an argument after Encinia stopped her for failing to signal. That "traffic violation" occurred while she was trying to get out of his way, thinking that he was trying to stop someone else. Encinia arrested her, and she was found hanged in her jail cell three days later. Why did you start with Sandra Bland?

MG: I was interested in writing a book about what's going wrong with our interactions with strangers. What is it about people we don't know that defeats us so frequently? And it struck me that so many of the high-profile cases that we were consumed with as a society were versions of this problem. The Bernie Madoff Ponzi scheme. People thought they knew Bernie. They didn't. The Larry Nassar case at Michigan State. People thought he was a dedicated doctor. He was a pedophile. And then we have the Sandra Bland case, which is fundamentally about a tragic misunderstanding. A policeman becomes convinced that a young woman is dangerous when she's the furthest thing from dangerous. In many different parts of our modern lives, we appear to be encountering strangers and making these catastrophic errors with them. That notion struck me as a good premise for a book.

MG: We've devised enormously efficient ways of gathering and disseminating news. Not many years ago, I would read the newspaper in the morning and then I wouldn't gather any other news until the next day.

Now, I just look at my phone, and I can get moment-to-moment updates. In one sense, we're bombarded with so much that we tend to linger only for a brief period of time on things. Weirdly, the flip side is also true. I am more and more impressed by our ability to focus and dedicate ourselves to things when those things are of high quality. The audiobook of *Talking to Strangers* is outselling the physical book two to one, which speaks to my point—it's not that we have lost the capacity to pay attention to complicated things, it's that we're selective. If you make something of quality, it is astounding how much people are willing to drop everything else and immerse themselves in the experience.

DM: In the book, writing about the police officer, you state, "We were in danger of looking at police shooting cases and saying the officer in the Sandra Bland case is a racist. Shame on him," and that is a deeply, deeply unsatisfying conclusion. What I'm going to say now plays right into your thesis about the way we listen and experience reality. As I was reading, I was thinking, "Of course he's racist." When I listened to the audiobook, I thought, "He's definitely a racist." Then I looked him up online, and I thought he looked like a racist too. How do you feel about that?

MG: Was race a component in the apprehension and death of Sandra Bland? Absolutely. Black woman is stopped by white cop in rural Texas. She's twenty-eight years old. She's driving a Hyundai. If she is a white woman who's sixty years old and driving a Mercedes-Benz, she's not stopped, and if she is stopped, the encounter goes profoundly differently, right?

MG: So, absolutely race matters. My question is this: "Is looking at this case through a racial frame a useful way to make sense of it?" I have become increasingly convinced that the racial perspective on these kinds of crimes is problematic. We use it as a way of shutting down discussion and concluding, "Dude's a racist." And then you shrug and say, "What are you going to do?" As you said, I didn't want to move on. Why do we move on? We move on because the way we make sense of

it, "This is just a racist cop," doesn't permit any further exploration. It's a conversation stopper. This idea that personalizing problematic encounters and making them all about what lies in the hearts of the participants is a way of avoiding bigger issues. And that has been central to a lot of very profound arguments within the civil rights community.

DM: And what are those arguments?

MG: There's a brilliant essay by the Black historian Charles Payne called "The Whole United States Is Southern!" which is one of the most profound things I've ever read about race in America. In the 1960s the white Southern segregationists wanted to turn every racial question into a matter of interpersonal relationships. They wanted to say, "The real problem is that we don't love each other. We don't look each other in the eye. We don't treat each other right." They wanted to make it about one-on-one. And if you can solve that one-on-one, then this whole racial problem in the South is going to go away.

And Payne's point was, that's an evasion. The issue in the South is not that Black people and white people don't look each other in the eye and shake hands and sit down and have coffee. The issue is there is a series of institutions, structures, laws, and practices that fundamentally enshrine a principle of prejudice and inequality. And what's going on in our hearts is irrelevant. What matters is what's going on in the laws, what's going on in the infrastructure. The fact that Black people are denied opportunity and can't vote and are in second-class schools and on and on. The Southern segregationists tried to change the subject. They tried to turn the conversation from a discussion of institutions and structures into a discussion about hearts and minds. And Payne concludes, "They won," because, he says, "Look around the world. How do we discuss this now? We discuss it in terms of hearts and minds."

Reading that essay was an incredibly radicalizing experience, and I thought, "I'm not going to play that game. I'm going to discuss this case, and I don't want to bring up what's going on in the heart of the officer. I don't want to talk about whether he's a racist or not. I

want to talk about the structures and institutions and practices that made it legitimate for a police officer to pull over a perfectly innocent woman on a street in the middle of the day in rural Texas. That's what I was interested in.

DM: In delving into myriad historic situations and modern events, you note that the parties involved relied on a set of strategies to translate one another's words and intentions, and in each case, something went very wrong. You explore Jerry Sandusky and Penn State, Bernie Madoff, Amanda Knox, the suicides of Sylvia Plath and Anne Sexton. Was it hard to settle on specific cases?

MG: It's a very, very imperfect process. You have a story you'd like to tell, and in my case, I wanted to give an alternate explanation for what happened to Sandra Bland. The kinds of stories I like to tell are stories that are digressive, and the middle part of the book is one digression after another on various themes of that encounter. And I chose all of those cases that you mentioned because they illustrated various parts of the story I was telling, and I'm still not sure they're the right ones. This book is very emotionally intense. There are few moments of comic relief in this book.

DM: There are not a lot of happy endings.

MG: It's very dark, and I worry it was too dark. I was always thinking of this as an audiobook from the beginning. And when you understand how powerful and moving audio is, I did begin to worry about the experience of eight hours of delving into it—there's a chapter on tortures, there are two pedophiles represented, and I have sociopaths galore.

DM: In one of the case studies in the book, you detail how in pre–World War II Germany, British leaders met with Hitler, and when he said that he had no desire for war, some of them were deceived by Hitler and some were not. The puzzle you outline is that "the group who were deceived are the ones you'd expect not to be, while those who saw the truth are the ones you'd think would be deceived." You go on to declare the following, "This could all be a coincidence, of course. Perhaps [they] were determined to see the Hitler they wanted to see, regardless of the evidence of their eyes and ears. Except

that the same puzzling pattern crops up everywhere."

Can you elaborate on what that puzzling pattern is?

MG: At that point in the book, I'm trying to account for the fact that face-to-face encounters with strangers seem to yield far less value than we would imagine. In fact, they very often yield negative value. We appear to be worse off in the accuracy of our estimations of others after meeting them than if we never meet them at all. In the case of Hitler, the people who completely misunderstood him were the ones who met him, and virtually everyone who saw Hitler for who he really was, before World War II, had never met him. So that's a puzzle. Because we structure our society on the assumption that it's crucial to meet a stranger face-to-face if we are to make sense of them. It's a radical thought to think that when we're making high-stakes decisions about strangers, we might be better off not meeting them.

DM: You write that there are a vast number of scholars worldwide who study human deception and discuss Tim Levine, who developed a unified theory of deception to try to answer one of human psychology's biggest puzzles: Why are we so bad at detecting lies?

MG: Psychologists as a group have been puzzled for years by this question of why we're so bad at spotting liars. From an evolutionary standpoint, you would think that we'd be good at it. You'd think that evolution would have rewarded those who could spot deception because that's obviously a very valuable thing to have in your back pocket. Tim is a professor at the University of Alabama in Birmingham, and his argument is, no, that's actually backward. Evolution has in fact favored those who trust everyone because implicitly trusting others is enormously rewarding. Statistically, that's the right strategy because the number of liars and sociopaths in the world is quite small.

DM: And why is trusting the right strategy?

MG: Being trusting allows you to be a good person and to enter into productive relationships. It makes you pleasant to be around. It allows you to start companies. People who are paranoid and suspicious cannot start companies or create organizations. They cannot belong to churches or have a large, warm circle of friends. Levine's point is that it would be nice to be able to detect a liar, but that would require a level of paranoia and suspicion that would make you so unpleasant that your genes would not get passed on. If you have a choice between the trusting person and the paranoid person as a potential mate, you go with the trusting person every time. Levine calls this "Truth-Default Theory." He says that we have evolved to default to truth and we will only come to believe that someone is lying if the evidence gets overwhelming. But otherwise we're going to assume, "No, it's the truth." That is why we're able to do so many good things in society, but it also means that we will occasionally be the victim of the Bernie Madoffs or Jerry Sanduskys.

DM: There was mountains and mountains of evidence about Bernie Madoff from so many different people and organizations. Why was he able to dupe so many people?

MG: One of the key observations about default to truth theory is, "It's not them, it's us." The reason sociopaths and liars get away with their lies for as long as they do is not because they're geniuses. It's because we're not built to spot them.

DM: You also investigate a number of sexual assault cases in Talking to Strangers: the Brock Turner case, the Stanford student who raped Chanel Miller while she was passed out; the Jerry Sandusky case at Penn State, where he sexually abused many, many boys he was coaching; and the Larry Nassar case, where he was sexually assaulting hundreds of young female gymnasts. Is there a common denominator that you found in investigating these types of stories?

MG: In some sense, yes. In the case of Sandusky, there was a lot of blaming the victim—people who were deceived by Sandusky were prosecuted when he went to jail, which seemed crazy. You can't criminalize the human impulse to believe others. He was a pretty slick sociopath. Many people were fooled by him. There wasn't a lot of evidence lying around Penn State about this. It took them years to make even the beginnings of a case against him. To this day, I am profoundly angry about

the way the prosecutors in that case, having found Sandusky and put him in jail, then decided that they would also put in jail the leaders of Penn State, who did nothing wrong. I firmly believe that if any of us had been in the same position as them, we would have done exactly as they did.

DM: What about the Larry Nassar case?

MG: The Michigan State case is very, very different. In Nassar's case, the allegations were not sporadic. There was a flood of them that was going on for years. They were not ambiguous. They were explicit. The people in positions of leadership were repeatedly told in no uncertain terms that something was profoundly wrong with the behavior of this man. In that situation, I am more than willing to hold leadership accountable. I bring up those two cases in the book to contrast them, not compare them.

In one of my podcasts, I interviewed this forensic investigator of police shootings. He said something that is so simple, but I have never forgotten. When he sat me down, the first thing he said is, "Malcolm, the one thing you need to remember when you're in this business is every case is different." When these cases come up, we need to keep that in mind. Every single one of them is different. They have different dynamics, they have different sets of responsibilities, they have different causes, and we need to respect that difference when we look into them.

DM: You conclude *Talking to Strangers* by stating that the right way to talk to strangers is with caution and humility. Can you elaborate on what that means?

MG: What it means is you may think that you have the tools to make sense of a stranger after a brief encounter. You don't. And the first step to avoiding the sorts of tragedies that I detail in the book is dismantling that kind of overconfident expectation. You have to go into an encounter with a stranger with deep humility. You cannot know what you need to know in a simple encounter. You have to be satisfied with less, and you have to hedge everything that you think you've learned. Everything should begin with, "Based on my limited observation,

You can't criminalize the human impulse to believe others.

I think maybe X." That's as far as I would go. When does someone ever emerge from a job interview or a police detective leave an interrogation and say that? No one ever does, but we should.

DM: Has the way you interact with strangers changed since you started working on this book?

MG: I was already backing off my certainty. Now I've abandoned all certainty and I'm trying to train myself to be agnostic about people I meet—in the best sense of that word. I'm trying not to draw conclusions, since I'm seeing just a tiny little piece of someone. The worst thing I can do is draw a conclusion. And, if I do, the best thing I can do is to be ready to throw that conclusion out in light of the slightest bit of contrasting evidence.

AMBER

Amber Tamblyn is an actor. She launched her career on the soap opera *General Hospital*,

then went on to star in the primetime show *Joan of Arcadia* and the *Sisterhood of the Traveling Pants* films. She also directed the 2016 film *Paint It Black*. That's just the beginning of the extremely long list of television, film, and theater credits. Amber Tamblyn is also a poet. Her book of poems *Dark Sparkler*, about the lives and deaths of famous child actresses, was published by HarperCollins. She is also a novelist and a political activist with a front-row seat to the #MeToo movement. Her book *Era of Ignition: Coming of Age in a Time of Rage and Revolution* is a feminist manifesto and memoir.

TAMBLYN

DM Amber, in your second book of poetry, *Bang Ditto,* you write about how when you were fifteen years old, you decided to test out the most famous, worst nightmare possible, and walked onto your high school campus completely naked, a blue Jansport backpack over your shoulder, Puma's on your feet, and six pubes to your name. You got as far as the first quad of the school before getting tackled with a coat by one of your teachers. True or false?

AT Very True. DM Details please!

AT I'm thirty-six now, and I've been acting since I was ten years old. That was the beginning of me testing the limitations or maybe the ability of my body outside of an object that was owned by an industry. I completely forgot about it until you brought it up. I'm blushing deeply on the inside.

DM One more true or false question. You write about how at sixteen, you got your nipples pierced the same week you won a *Hollywood Reporter* award for your role on *General Hospital.*

AT Again, just the exploration of what I was allowed to do with my own body in an industry that dictates not only everything you need to wear to be successful but the way in which you have to speak and look, the way your face has to look, the texture of your face, the texture of your body. I was highly aware from a young age that I didn't feel right in my skin in a certain way. And I wanted to test the limitations of my own physical skin.

DM I want to talk a lot more about that. I want to just take you a little bit through the early parts of your life pre being an actress. You were born in Santa Monica, California, to a family immersed in show business. Your father, Russ Tamblyn, starred in the iconic films *West Side Story*, *Seven Brides for Seven Brothers*, and the television series *Twin Peaks*. Your grandfather Eddie Tamblyn was a vaudeville performer. And your uncle Larry Tamblyn was a keyboardist in the 1960s rock band the Standells. Family friends include Ed Ruscha, Neil Young, Dean Stockwell, and Dennis Hopper, who was rumored to be your godfather. Was it just assumed you were going to follow in your family's Hollywood footsteps?

AT Yes. I was born and raised around a lot of narcissistic white men.

DM So was I, but I'm not a famous actress. You played Pippi Longstocking in a school play when you were ten years old, which in many ways launched your acting career. You then got the role of Emily Quartermaine on *General Hospital* when you were eleven. Were you able to go to school while you were doing this?

AT I went to public school—public grade school and high school—and never went to college. But you have to go back and forth from set. It was very complicated and difficult. By law, you had to do a certain number of hours of tutoring on set per day, and then you would take these pink slips saying you did that work back to the school, back and forth.

DM You're known for many iconic roles beyond Emily Quartermaine. How do you feel about those roles now?

AT I have many feelings. I've spent so much of my adult life having an exorcism of the pain of those experiences of growing up in the business. But I also have a deep sense of love and pride for those characters.

DM Is it true that you told John Cryer to go fuck himself in your audition for *Two and a Half Men*, which was in front of Chuck Lorre?

AT
100 percent.

DM
What brought that on?

AT
I also think I told Chuck Lorre to go fuck himself.

DM
Fair.

AT The character…she was sort of supposed to replace the half-man idea. She was Charlie Harper's daughter, who was basically a woman version of him—an alcoholic foul-mouthed womanizer. I was like, I actually don't really care if I do *Two and a Half Men*. This is not an audition that's going to break me. I was rude to all of the men in the room and got my part.

DM You said show business is voyeuristic and that if you're an actress, you're playing that which the voyeur looks at for a living. People look at you to escape their realities, to invent their own new realities. How did you manage to keep your own identity and how have you been able to avoid the often treacherous pitfalls other child actors have succumbed to?

AT Having parents who were a strong support system was a real privilege. And I think also poetry. Poetry really saved me. Poetry was a third parent. Poetry was a guardian. It was a way for me to reflect on those experiences and be able to put the feelings I had on the page, whether it was anger or frustration or feeling invisible or feeling objectified.

DM You said poetry was one of the few areas in your life where you felt like you had full control. Why did it make you feel like you had control?

AT As an actress, you are creating something that's only really half yours, if that. You are putting yourself on the line emotionally, often, physically, psychologically for something you have no control over. You are interpreting the words of someone else that they've written. I really felt like writing—at least if I failed by it, I was failing by 100 percent of my own self-expression as opposed to 50 percent of an expression that was part of me that still might fail anyway, if that makes sense.

DM There seems to be a lot of judgment when an actor tries something other than acting, whether it be writing, music, politics, even activism. Did it feel it was harder to be taken seriously as a poet because of your celebrity?

AT Absolutely. I think I got discouraged early about ever sort of submitting my work or doing anything with it other than just writing and performing. I would do book tours. I would frequent a place called Beyond Baroque in Los Angeles, where I would read. Around the time I was writing *Dark Sparkler*, I was deep in the middle of a real existential crisis trying to figure out what I wanted to be outside of this idea of going into other people's rooms and auditioning and interpreting their work and knowing I had so much more to offer.

DM What did the existential crisis stem from?

AT People always ask me, like, "How old were you when you knew you wanted to act?" It's not really a child's choice. That's the choice of adults and then the child spends their time trying to please adults by performing, and so then your life becomes performative. *Dark Sparkler* was this reckoning for myself, coming to terms with how you talk about this pain. How do you talk about this invisibility while still knowing you are the most privileged person in any given room?

DM On September 16, 2017, you wrote an op ed in the *New York Times* which is your account of not being believed about your experiences with sexual violence. The article went on to become one of the most read and shared op eds in *New York Times* history. You wrote this one month before the #MeToo movement exploded. You're now a founding member of Time's Up. What motivates your political activism?

AT I'm motivated by the motivation of others. I'll speak for women because those are the people I know best. The way in which I've been able to show up for myself and for the activism I've done has been in community with other women whose experiences do not reflect mine. It's our responsibility as women, and especially as white women, to be out in the world. Being in community and linking arms with women who come from different experiences than we do. Just as I would hope they would do the same. Our ability to understand where people come from and the way in which some communities of women have been held back more than others—we can't have any of that unless we are having deeper, more complicated conversations with each other about what is missing.

"**The**

single greatest compliment

I've ever gotten in my career

is a performer saying to me:

'I don't have to do the dramaturgical

work, because I know who I am and

where I am, being on your stage.'"

DAVID KORINS

set designer

TREND
SETTERS

PART 4

EMILY OBERMAN

CHIP KIDD

BRANDON STANTON

AMANDA PALMER

SARAH JONES

THOMAS KAIL

AMINATOU SOW

CHRISTINA TOSI

JESSICA HISCHE

SAEED JONES

THOMAS PAGE McBEE

MICHAEL R. JACKSON

EMILY

Chances are you've seen Emily Oberman's design work.

Oberman has crafted work for *This American Life*, *Sex and the City*, and *Lucky* magazine. She's created campaigns for MTV, VH1, and HBO, and for the past two decades she's designed the title sequences for *Saturday Night Live*. Emily started her career working for the legendary designer Tibor Kalman at M&Co. and went on to co-found the firm Number 17, which closed in 2010 after a seventeen-year run. In 2012, shortly before we conducted this interview, Oberman became a partner at Pentagram, the global mega-design firm, working alongside Paula Scher and Michael Bierut.

OBERMAN

DM I first interviewed you during my very first season of *Design Matters*, and so much has changed for you since we last spoke. You moved from Manhattan to Brooklyn, you gave birth to twins, and you became a partner at Pentagram. When you first told me you were considering joining Pentagram, you told me something that I thought was very powerful. You stated that deep down a part of you always hoped that your career would be in three parts. First with Tibor Kalman at M&Co., second with Bonnie Siegler at Number 17, and third with Pentagram. This has all manifested rather remarkably. Can you talk about the sense that you had? It seems a little magical.

EO The truth of the matter is, I wouldn't have thought that I wanted my career to manifest itself in three parts until I was already on my way to part three. When I was with Tibor at M&Co., it was the most wonderful place in the world to be, and I wasn't thinking "What's next?" the whole time I was there, nor was I when I was at Number 17, which was one of the great loves of my life. The partnership that I had with Bonnie was fantastic and inspiring, but when Pentagram became a possibility, it occurred to me that it was nice to have a third act.

DM Each section of your career arc is so fascinating, and I want to start way back when you were with Tibor. You were his longest-running employee and worked with him more than anyone else, except Maira Kalman, his wife. In our previous conversation, you talked extensively about working with him. All these years later, why do you think he's still so influential and revered in our business?

EO Because he was smart and challenged the norm, because he tried to see things differently, because he was a mouthpiece for seeing things differently, because he was passionate about the things that he felt needed to change, because he was funny. His way of thinking has become a way of thinking that continues to exist in the design world and for me. It still influences everything that I do, sometimes in a good way and sometimes in a bad way. For instance, sometimes I have a good idea that's my first idea, but because of the way Tibor worked and the way I worked when I was with Tibor, I still feel the need to run the gamut of other ideas before I know that the first idea was the best. Sometimes that's exhausting.

DM It sounds like it.

EO Sometimes I feel like torture is integral in getting to the right idea, even if the right idea comes easily. There's a certain part of me that thinks, "I've been doing this for a while now. A good idea probably should come easily." But I still feel like I need to go through the paces to make sure that it is a good idea.

DM You say that Tibor still influences you daily, both good and bad. What is his biggest, most positive influence?

EO The same thing. I try to get all the way to a good idea, and I'm not satisfied until I know it's a good idea.

DM Why did you decide to leave M&Co. and start your own company? What made you choose to leave chapter one and go into chapter two?

EO Time, change, Bonnie. I'd been with Tibor for a long time, and Bonnie and I had been friends for a long time, and we always thought that we would start a design firm together. There came a moment when for all of us, it was clear that it was time for a change.

DM While you were at Number 17, you created the ubiquitous launch campaign for *Jane*, helped Condé Nast invent *Lucky* magazine, designed for *Glamour* magazine, and worked on HBO's *Sex and the City*. You created identities for the Mercer Hotel, the Maritime Hotel, and restaurants including Vong and Spice Market. You also collaborated with author Stephen Dubner on the deluxe illustrated edition of *SuperFreakonomics*. Did you and Bonnie have a business plan? Did you go into your business thinking there was a very specific type of client that you wanted in media, film, or culture?

EO We did not have a business plan. We did not have any plan except that we knew we wanted to do good work for smart people for products that we liked.

DM You just did it—you held hands, jumped in, and started.

EO Exactly. The closest thing we had to a business plan was that we didn't ever take out a loan. We never owed anyone anything for starting our business, plus we started in Bonnie's living room, so we didn't have any overhead. We did that for a while with some real clients, and then we were able to get a space and build from there. It all just happened. It wasn't like we had a specific plan of, "We're going to do this for this amount of time, and then we're going to do this and this." It was more like, "Here's the work that we need to do. How can we do this?" And then, "Now we need a little bit more space. Let's go find some more space." It evolved naturally.

DM In talking about your approach to design in a profile about you in *Fast Company*, you stated that you believed that the idea is the most important part of the design process. Can you talk about what that means?

EO Sure. I do think that, but I also don't think that that thinking is unique to me. I think that most good design that you see—the design that makes it out there—has an idea behind it, and those designers have become savvy enough to know that it is the idea that starts something off and makes something good. It's not just about making something pretty. Part of what's great about Tibor's influence was that he forced the issue of "idea" and ingrained it in me, but I also think he forced it hard enough that it's ingrained in a lot of people now. I think that's becoming the norm.

DM The article was part of a series of pieces that came out when you first joined Pentagram, and this was one of the articles talking about how and why. What made you decide to take this next big leap?

EO Change and time. The same answer for why we started Number 17 is the same answer for why we ended Number 17. It was just time. Right around then, this opportunity presented itself, and it seemed to me like in the world of third acts, it's a pretty good one.

DM Were you nervous? Were you scared? Do you worry about having to prove yourself?

EO Yes, I was nervous, but probably in a good way. That fear has always been a very good motivating factor for me. It's been a driving force in my life. Being nervous or worried about something gets me out of bed in the morning, and it helps me go to sleep at night because I'm afraid that if I'm too tired, I won't do well the next day. I think it's a healthy kind of fear.

DM You're also doing brand-new things that you've never done before at the same time as you're in an entirely new environment. You just created your first video for the band They Might Be Giants, which is an infectious, joyous piece titled "Alphabet of Nations." What is it like to be doing all of these new things while you're in a brand-new situation?

EO It's exciting. It's also daunting. Sometimes I have to stop and breathe. The They Might Be Giants video was thrilling to me because I've been a fan for so long. It's a kids' video, so it's a very fun little ditty where the whole song is literally country names. To collaborate with them on a project was very rewarding.

DM You crowdsourced images of children from around the world for the photographs shown in the video.

EO John Flansburgh, one of the Johns, had the original idea that this whole thing would be crowdsourced and that they would use the Internet to gather images from their fans all around the world. It had a good spirit to it and a liveliness that was exciting. Working with John on it was wonderful because he's so smart about They Might Be Giants. He knows his brand so well, and he's smart, funny, and keen, and he's interested in pushing it further.

He would tell me, "I know this is a kids' video, but let's not make it look like a kids' video. Let's make it look more grown-up." It was him pushing us. It was incredibly exciting, and we worked in the constraints of no money and a short period of time. It was fun to work on and figure out ways to create the video on a shoestring. It ended up being a very type-heavy montage of all the country names and the alphabet. Also, my kids now know at least twenty-six countries in the world by heart and can sing a song that's very charming.

DM You also designed the branding and a commercial for a product called Ablixa, which is a fictional antidepression drug in Steven Soderbergh's film *Side Effects*. In the film, Rooney Mara plays Emily Taylor, a depressive who is prescribed Ablixa by her doctor, played by Jude Law. The drug has a very pivotal role in the film. You and your team developed an identity program for the film that has all the hallmarks of a big pharma branding project, including a scarily upbeat ever-present logo, packaging, marketing literature, a website, promotional items like mugs and pens, and a commercial for the drug, which you narrated yourself. Pentagram's New York office even appears in the film as Rooney Mara's workplace, where her character, Emily, sits at Emily Oberman's desk. What was this experience like for you?

EO It was pretty meta. The hair color of Rooney Mara's character is not dissimilar to my hair color. And the person who wrote the movie, Scott Burns, is a good friend of mine who I've known for years and years. Scott has written many great films and happened to write a movie about a depressed woman who was a graphic designer with reddish hair, and Pentagram is cast as her office. I had a moment where I thought, "What are you saying, Scott?" He told me that the similarity hadn't occurred to him. The beauty of the project, besides a couple of days when Jude Law and Rooney Mara were hanging around our office, was this opportunity to do this product design for the movie: to design a fake antidepressant that has to have all the hallmarks of a real antidepressant. It was tough to put myself in the skin of a project that I would probably never get asked to do and try to do it in a way that was without irony but ended up having some irony. We then took this product and fleshed it out completely, which included creating a website. We literally made a full TV commercial for it, which appears on screen for a millisecond. And then, add to that, the meta-ness of the story and of them shooting at Pentagram—it was a nice moment.

CHIP

**People like to call
Chip Kidd a rock star,
and with good reason.**

In his thirty years at Knopf, Kidd has designed some truly iconic book covers, like those boxers for David Sedaris, that dinosaur skeleton for *Jurassic Park*, and pretty much every Haruki Murakami book jacket you've ever seen. Chip is the one book designer people know by name. In recent years, they've been getting to know him for his writing, which now includes the bestsellers *The Cheese Monkeys* and *The Learners*, and two stunning monographs, *The Peanuts Poster Collection* and *Go: A Kidd's Guide to Graphic Design*.

K:)DD

DM Your latest book is called *Go: A Kidd's Guide to Graphic Design*. And the title is a double entendre, as this book is not only written and designed by Chip Kidd, it's written for kids. Why kids?

CK I owe this entire thing to a wonderful woman, writer, and designer named Raquel Jaramillo, who might be better known to your audience as the author of a book called *Wonder* under the pen name R. J. Palacio. Three years ago, unbeknownst to me, she moved to Workman Publishing, and she emailed me one day out of the blue and said, "I don't know if you remember me, but I'm now at Workman, and I'm a creative director but I'm also an editor, and can we have lunch because I want to talk to you about something?" So we did, and she said, "I think it's high time somebody did a book to teach graphic design to kids, and I think it should be you."

DM Did you have reservations, or did you say "yes" immediately?

CK I said "yes" right away. Correct me if I'm wrong: to my knowledge, such an exact book does not exist.

DM Correct.

CK That, to me, was a strong motivating factor in doing it. I put together a forty-page proposal, which I finished in four days, and I felt very good about it. Most of that is still intact in the final book.

DM So the entire book is by you?

CK Yes, although there's a lot of Raquel in it. She has two sons who are the age that we had in mind, so she had great ideas, like, "Let's have a two-page spread in the beginning that simply shows examples of graphic design that kids take for granted to remind them that your milk carton and your cereal box were put together by a human being, that they didn't pop out of a machine."

DM You start off the book with a bold statement: "Whether you realize it or not, most of the decisions you make every day are by design." Can you elaborate on what that means?

CK I don't think I started thinking about who was making what or how things got made until I was in college. As a kid, you're trying to negotiate so many other things growing up that you probably don't think about who designed that exit sign or who designed your clothes. I do remember way back in third or fourth grade, our teacher told our class, "Try this for a week: lay out your clothes for the next day on the night before." It had never occurred to me to do that, and at first I thought, "That's stupid! I decide two minutes before I'm going to put them on." That exercise forced me to think about what I was going to wear, and then the next morning I didn't have to stress about it. I could just put it on and go. That's what I mean. All these things are by design— by planning. If they're not, that's when you run into trouble.

DM You then ask a nearly unanswerable question, "What is graphic design?" And you provide both a dull but correct answer and then a far more interesting answer. It's a wonderful answer, but also it reflects the tone that you take throughout the book—you've written this in a very relatable, very earthy way. You write, "The far more interesting answer is that graphic design is problem-solving (and sometimes making something really cool in the process).

 CK There are all kinds of problems to solve: good, bad, complicated, easy, annoying, fascinating, dull, life-threatening, mundane. There are problems that matter only to you and no one else, and problems that determine the fate of mankind. And some of them are truly unsolvable—but of course that doesn't stop people from trying, and it shouldn't. But the main thing to learn about graphic design problem-solving is that the best solution can usually be found in the best definition of the problem itself. I know that shouldn't sound contradictory and weird, but it's true."

 DM Well done. But I have to ask you to help me understand this, because I never heard it described in this way. How is the best solution usually found in the best definition of the problem itself?

 CK

At Penn State, they were pounding
this into us since day one.

 DM Give me an example.

 CK In the book, I cite the speed bump and the history of it. In the mid-1950s people were driving too fast in a suburban area, and Arthur Compton wanted to slow them down. The problem is, people are driving too fast in an area where you have a lot of pedestrians. And why is that a problem? Because people could get hit, so you want the cars to slow down. What's going to make them slow down? Well, we'll put up a sign. Well, what if they ignore the sign? What's something that's going to make them slow down that they can't ignore? A lump in the road. This is a brilliant design solution. It's not necessarily a graphic design solution, which is a sign saying, "Slow, bump ahead." But if you don't pay attention to that sign, then ba-boom.

DM People ask if a tree falls in the forest and nobody hears it, then…

CK …does it make any noise?

DM It's the same with graphic design. If you create a graphic design but nobody uses it, sees it, or understands it, then is it graphic design?

CK It's still graphic design, but then it's probably bad graphic design. It's like what Chris Ware says about comics. People keep saying that comics are such a cinematic art form, and he says, "Absolutely not. That's baloney." You sit and you watch a movie. You have no control over the pacing. You have control over the interpretation, but it's essentially being laid all out there for you. With comics, you, the viewer, can control the pacing. You can decide what somebody sounds like. You can linger over a page or a panel for as long as you want. It's bringing something to you, and then you have to bring something to it. Comics are a form of graphic design. Posters and ads and what have you work the same way or are trying to work the same way.

DM Since we're talking about comics, you spend some time in *Go* talking about Batman—about why you believe that Batman has stayed so popular in modern culture. It was fascinating. I didn't know, for example, that the darkness of Batman was intended to complement the bright optimism of Superman.

CK Superman first appeared in 1938. It was the end of the Depression, and America was on the brink of war. Superman was the perfect symbol for that time, and Superman, obviously, survived that time. But I think Batman's far more malleable to the needs of the culture, if the right people are writing the stories or making the movies. When I say Batman's a great American design, it's just the lore: here you have somebody who had everything, had it all taken away, and then had to get it back piece by piece by reinventing himself as somebody else. And frankly, that new character has a great design sense—that's captured in the idea that Bruce Wayne can't really get that much accomplished, but this other persona that scares people, that they don't understand, can get things done that he wants to get done.

DM Do you think that that's at the heart of what makes him so eternally popular, or is there some other psychological trick to Batman that we don't quite understand?

CK First of all, he's human, so we can relate to that. There's also a way that you can adapt the costume for a movie or a cartoon. But what it comes down to is great writing, great drawing, great design sense, or great filmmaking or great animation, in the versions that are successful.

DM In *Go,* you talk about how graphic design as we know it today is a relatively recent phenomenon. It wasn't even called graphic design until 1922. What happened in 1922?

CK In 1922 William Addison Dwiggins, the great book designer, coined the term in an essay that he wrote. As far as I'm concerned, who better to do it? He was a great hero of mine.

DM You state that he may have made his greatest contribution to the world of graphic design by coining the term. Do you believe his covers or his terminology were better?

CK Do we have to pick one or the other? He did amazing book design. My favorite of his was the Random House special boxed edition of *The Time Machine*. It's a beautiful, beautiful book.

DM From your book I also learned that, while numbers were created before letterforms, Roman numerals originated from slash marks made on wooden logs and animal bones and rocks. You also include charming design projects at the end of *Go,* and you talk about them being thought provoking, maybe eye opening, and hopefully fun. But you let people know from the outset that they're not meant to be crafts. I'm wondering why you decided to make that distinction between graphic design challenges and craft projects.

CK There's a very, very fine line, and I don't know how well I've maintained it. There's nothing wrong with crafts, I love crafts. But a lot of these assignments are about ideas and concepts and problem-solving. Create your identity. That's a pretty major thing, but kids are creating identities for themselves all the time on their phones, on their computers. To me, that goes beyond what we call craft with a capital C. That's really thinking about who you are and how you want to represent yourself to the rest of the world, and there's many different ways to do this.

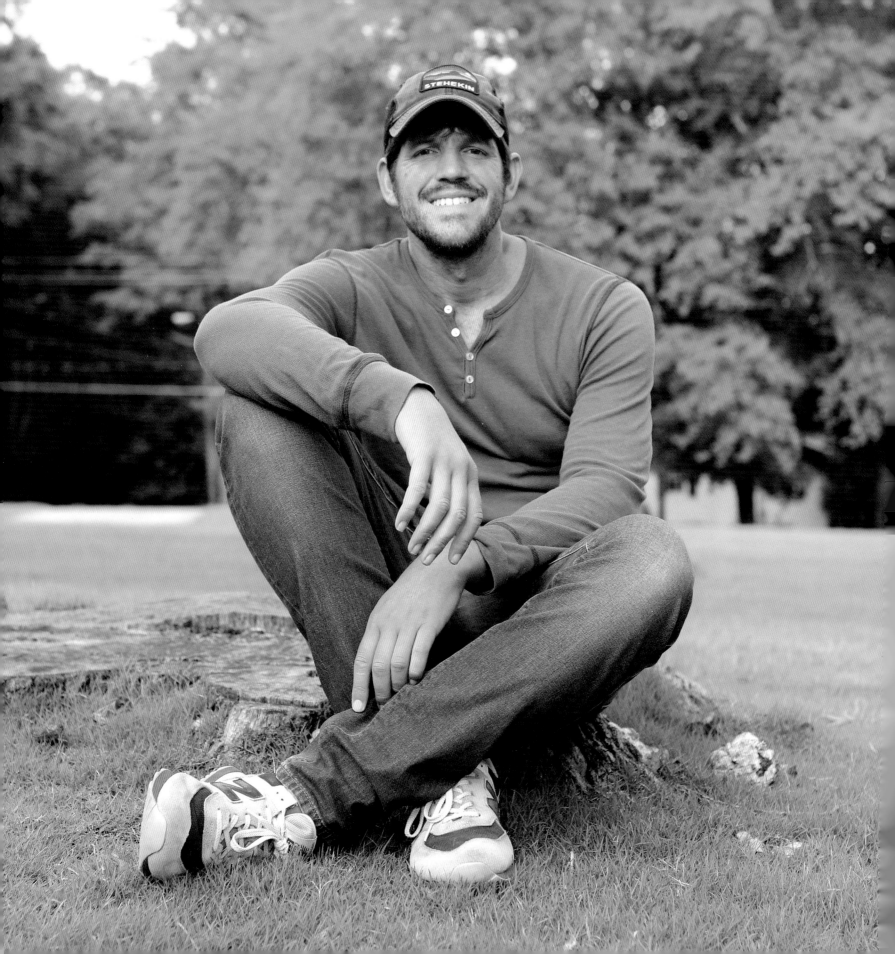

March 14, 2016

BRANDON

**The portraits are arresting.
An elderly couple looking frail
on a busy street. A young boy
in an orange tie holding an
enormous guinea pig.**

A man in a cowboy hat, tattoos covering every inch of his face. Along with the portraits are stories of love lost, of lives gone wrong, of dreams still being chased. Brandon Stanton is the photojournalist behind these images. While the project began simply enough, *Humans of New York* has since become a wildly popular website, blog, and many books. In our interview, Brandon discusses how practice and compassion transformed snapshots of New Yorkers into a revelatory career.

STANTON

DM: Brandon, I understand you've been borderline obsessed with saltwater aquariums, the baritone euphonium, reading, piano, filming, the financial markets, New York City, and photography.

BS: I had the habit of finding something and convincing myself that I was going to be the best in the world at that one thing. Which led to my mother telling me at a young age that I was never going to stick with anything. When it was saltwater aquariums, I read everything about them, I saved up all my money, and then spent it all on an aquarium that I later neglected to the point where I had four snails in there. If there's going to be an image to represent the deterioration of obsession, it would be seeing the inside of my saltwater aquarium only through the streaks those four snails left in the algae. So, this is how my mind works. And it's the cast of mind that made *Humans of New York* possible because that takes a certain amount of obsession.

DM: In a Reddit "Ask Me Anything," you stated that you remember being extremely social in high school. You could talk to anyone. When you went to college, you went through a bit of a depression and withdrew into a shell. What happened?

BS: Marijuana, maybe. I really got introspective.

DM: I thought you were going to say, "I really got into marijuana."

BS: Well, that too. I think they went hand in hand.

DM: But when you came out of the depression, you noticed that you'd become awkward with other people. How did you get comfortable talking to people again?

BS: Being social is a learned skill. In high school I started clubs, I was student government president, I was a very social person, and I always assumed that this was some inherent quality. When I went through more of an introspective phase and then started to re-engage with the world, that's what made me realize that communicating with people can be developed like any other skill, like algebra or spelling. Extrapolating that to *Humans of New York,* I was so scared when I first started doing it. I was just terrified to approach a stranger. I didn't know if it was something you can do. Now it's second nature. It was a learned skill.

DM: Was it a conscious decision to go out and do this and learn to do it fearlessly?

BS: I put it in a framework that said I was going to photograph ten thousand people on the streets of New York City. So, in a way, yes, I did force myself because in order to attain that goal I had to approach twenty or thirty thousand people. It was a very systematic, replicable process of going up to strangers every single day and asking for their photograph.

DM: Back in 2008, during your senior year of college, you took out $3,000 in student loans and bet it all that Barack Obama was going to win the presidency. What made you so sure he was going to win?

BS: I was very, very passionate about Barack Obama, the same way I was passionate about a saltwater aquarium or baritone euphonium. I would go to RealClearPolitics every single day and I would read all ten articles about him every single day. There was a point I was convinced that he had the Democratic nomination wrapped up. Yet Vegas still put him at a 70 percent chance, so I took out $3,000 in student loans, which was all I could get at that time.

DM: You would have taken more?

BS: I would have taken as much as I could to bet that he would win the presidency. Then I told that story to a friend of mine who worked in finance in Chicago, and that's how I got a job as a bond trader even though I was a history major. They hired a lot of young, smart kids. We would watch the markets and then buy and sell based on a strategy that they taught us.

DM: And you did this for two years. Did you like it?

BS: I loved it.

DM: After two years on the Chicago Board of Trade, you were fired from your job. You've said it was because you were taking too many risks and pushing too many boundaries. Were you upset that you were fired?

BS: That's the starting point of *Humans of New York*, because when I was working as a bond trader, all I was thinking about was the markets. I was obsessed with it. But I didn't view myself as somebody who just wanted to make money. That wasn't my personal identity. I viewed myself as a creative person who was going to build this cushion of security and then pivot to creative things that I loved. Once I finally lost my job, I looked back on those two years, and I lost that time and I didn't have any money to show for it. And I thought that, more than my physical time, I needed freedom of the mind to do things that I wanted to do. I was so afraid of getting fired, and then the day I got fired was strangely a relief. It opened up my mind about what I really wanted to do, and it was through that thinking that *Humans of New York* eventually emerged.

DM: In 2010 you bought a camera and started taking photographs in downtown Chicago on weekends. If you found something especially beautiful, you would photograph it from twenty different angles just to be sure you'd gotten a good shot.

BS: That's how I taught myself photography. I would find something I wanted to photograph—whether it was a street sign, graffiti, or whatever—and I would photograph it twenty different ways from twenty different angles because I had no idea what I was trying to do. Then I would go home and look at those twenty shots, and I would choose my favorite one. Through that, I started to learn what I was drawn to, what my aesthetic was, and what I enjoyed, so that the next time would be fifteen photos, because I have a little bit more of an idea, then ten, then five. When *Humans of New York* started, I used to drive people crazy because I was still in that mode of not knowing exactly how to photograph. So I'd make somebody stand there forever as I photographed them from all these different angles.

DM: You say that there are still some people who think you're not a good photographer. Does that bother you?

BS: No. Actually, I take a little bit of pride in it because *Humans of New York* is so successful. The fact that I'm not that technically proficient shows that something deeper than technical proficiency makes it powerful. I view *Humans of New York* as storytelling. And I view the photography as subservient to the storytelling. When I embrace that as my identity and someone criticizes my photography skills, it's very easy for me to shrug off the criticism.

DM: How did you support yourself in the beginning?

BS: I had $600 coming in every two weeks from unemployment benefits, and that was enough to maybe pay my rent and eat about two meals a day. I lived in a room in a sublet in Bed-Stuy. There was no furniture, nothing on the walls. I didn't go to bars. I didn't go to restaurants. I didn't go to movies. All I did was photograph. That, mixed with a few odd jobs and some loans from my friends, was enough to keep me afloat for about a year and a half.

DM: I read that you didn't want to think about spending money. You wanted to think about how you were spending time.

BS: I think we're oriented to think of time as a means of accumulating not just material things but also degrees, extracurricular activities, or things that will look good in a job interview. Stepping back and looking at time as a resource itself—as the most valuable resource—you say to yourself, "I'm going to not try to use my time to structure a life. I'm going to make decisions that allow me to completely own my time."

DM: You started first by taking photos of people, then you added captions. Now, you've included interviews with people, where you're hearing a story or a quote that is very intimate and very revealing. How do you inspire people to tell you the deepest part of who they are?

BS: There are two things. One, you ask. And two, you accept that some people won't answer. The reason *Humans of New York* is so hard to replicate is you have to be willing to do it over and over and over again until you find the person who's willing to share.

DM: You said you have a 65 percent success rate?

BS: Success rate refers to people who allow me to talk to them. My standards have gotten a lot higher because I've interviewed ten thousand people now. A unique story is not what it used to be. To get a story that I think is fresh and will be interesting to my audience—that takes a longer time now. It takes a heightened level of honesty from the other person. So, I would say one out of three people say "no." Two-thirds of the people who say "yes" will be comfortable enough with the process to allow me to create interesting material.

Before I came here, I spent an hour in the Times Square subway station dissecting a man's failed marriage from thirteen years ago. Just a complete autopsy. The guy had never heard of *Humans of New York,* and we were dredging up things that he hasn't talked about in a long time. I think that's because there is a validation that comes with somebody taking an interest in your story. For some people, their story is all they have. A marriage failed or they lost their job—all they really have to offer is their story.

DM: Do people get angry when you ask certain questions?

BS: No, never. If it's coming from a place of curiosity, as opposed to some sort of journalistic ambition, then there's nothing a person won't tell you. In my favorite interviews, both of us are thanking each other at the end because I've never heard somebody tell me what they've told me. And they've never had somebody care enough to ask what I asked them.

DM: Do people scare you with some of their stories? Do you hear things that frighten you?

BS: There's a large range of human experience. There's a lot of racists out there. But here's what I say, and this might be going too far. I just went to five different federal prisons, and I interviewed thirty inmates. I think that the truth—and this is a dangerous line to draw because you get into moral relativism—is always exculpatory.

DM: In what way?

BS: If you dig down into why this woman strangled this eleven-year-old girl, then you learn about her paranoid schizophrenia, which she didn't know was schizophrenia. And if you dig even further, then you find out about the uncle who raped her every night from the age of seven to eleven. You start realizing that these people were acting with the information that they had about the world. And they were speaking in the language that they knew. Once you dig down to that level, everything can be explained.

DM: That's a very compassionate, generous view of humanity.

BS: It's not a view that necessarily can be acted upon, because you do need to draw lines. That story was an actual story on the blog. She killed a young girl and her mother because she had this paranoid break. For me, this prison series revealed the schism in America between compassion and accountability. And it is a schism that runs through every comments section on the blog.

DM: The problem is that we believe that because we feel something empirically, then others should feel that way too. That there is an empirical view of the universe that everybody should believe.

BS: Yes, especially overparenting. Some of the biggest arguments on the blog are when somebody is talking about raising their child. Talk about people having moral imperatives. In the minds of so many parents, there is only one right way to raise a child, and it's the way they're doing it.

DM: And that's about fear because their kids aren't grown up yet and there's no way to prove a belief.

BS: Yes, yes.

DM: In addition to interviewing inmates in prisons, you've spent two weeks collecting portraits in Iran. Following the Boston Marathon bombings, you spent a week collecting portraits in Boston. You conducted a fifty-day world tour in partnership with the United Nations in 2014. What are some of the common denominators you've discovered about the humans of the world?

BS: In the course of *Humans of New York,* there was a point when I realized that the project was not photography. I'd approached ten thousand people on the street, and I'd gotten about as good as anybody at stopping a random stranger and creating this bubble of comfort where I could learn their story in a very raw and honest way. Then I realized I could take that bubble with me anywhere. I also realized that people were coming up to me on the street and saying, "I used to be so scared of that neighborhood until I saw the people that lived there on HONY." Or, "My mom was so scared of New York. She didn't want me to move here. I showed her the blog." Telling these random stories had a very palliative effect, so I applied it to populations and demographics that are feared.

DM: You have used that awareness to help quite a number of different organizations, schools, and people raise money. When you went to Pakistan, for example, you concluded your series by bringing attention to Syeda Ghulam Fatima's efforts to help twenty thousand brick workers.

BS: A Pakistani-American journalist named Fazeelat Aslam hooked me up with a wonderful interpreter and fixer on the ground. On my way to Pakistan she sent me an email and said, "Hey, Brandon, I know you're going to be busy over there, but I want you to meet this one person." And she hooked me up with Fatima.

I started learning about her work, and I became very attached to her and her purpose. And I realized that money I raised on the blog, especially American dollars, would enable her in a massive way. So, I told her story, and I think we raised something like $2.5 million.

DM: How does that make you feel?

BS: It sounds arrogant to the point of delusional to think you can take a group of twenty million people and establish a culture or draw any sort of conclusions about that group. But the twenty million people who follow *Humans of New York* are some of the kindest, most public-spirited individuals. Five million dollars raised in one year. One million petition signatures in seventy-two hours for a refugee who got denied security clearance to the United States. These are people who care, who show up and who participate.

Some people just get bored with *Humans of New York.* We're not judging people. We're not making fun of them. We're not criticizing them. If you're looking to do any of those three things, you get bored and you leave. What's left is this massive group of people that is less cynical than the rest of the world. More compassionate. And more willing to step up and make a difference.

"We're in such a state of optimizing and monetizing every freaking second that there's never a state of just being. And that needs to be valued as a society, too."

TIFFANY SHLAIN

filmmaker, author,
founder of the Webby Awards

December 9, 2019

AMANDA

In the Internet Age, a musician can't just make a recording and expect fans to pay for it

when it's so easy to stream it or download it for free, but you can ask them to help out. This has been Amanda Palmer's approach. The alt-rock singer and songwriter asked her fans to support her in making an album, which became the world's most successful music Kickstarter. She writes about these new rules of exchange in her book *The Art of Asking: How I Learned to Stop Worrying and Let People Help.* In this interview, we talk about copyright issues, what it's like to be a dominatrix, and what it means to ask for help.

PALMER

DM You grew up in Massachusetts in a Colonial that your mother and stepfather spent the entirety of your childhood trying to make habitable, and you started playing piano when you were three. I understand you hated practicing, but you could figure out how to play anything you heard on the radio. How could you do that?

AP There's an intuitiveness to music the same way there is an intuitiveness to drawing. It's a little harder to explain to someone who doesn't speak music. What I found is there's an incredible tool in the human voice: you match your voice to whatever you're hearing, then you can figure out where it is on the piano. That's partly a talent, a gift, and also practice. If you play enough piano, you start to match tones the same way a visual artist would match the brown of a tree to the brown in a Crayola box.

DM As somebody who does do a lot of drawing...drawing is reflecting what you see two dimensionally whereas music has had a really magical context for me: it feels like you're making something out of nothing.

AP That's just because you're thinking about eyes and ears differently. But if you just think of ears as things that see sound, it's a much easier translation. There are a lot of great parallels between the way artists visualize and then reinterpret information and the way musicians hear and then reinterpret sound.

DM You attended your first rock concert when you were eleven, and it was only then that you realized that Cyndi Lauper was a real person. Up until that moment, you thought that Cyndi Lauper, Prince, and Madonna were being played by actors. Really?

AP Not really, really. I did have live music in my life in church. I went to church every Sunday, but to me that was sort of somebody else's world and somebody else's music. That wasn't the music that I went home to. Then there was the world of school music where you're handed out sheets and made to sing songs. All of those things were somewhat disconnected. We don't all speak a common musical language. We've become very silent. Music used to have a common purpose and the songs were shared. There was no ownership, there was no copyright, there was just music we do together when someone dies, when we want it to rain, when we're unhappy. Nowadays we've gotten about as far from that as possible, with Taylor Swift battling artist X about who should and shouldn't put their music up on Spotify. It's a sad state of affairs, considering what music can make possible.

DM You write about how you couldn't handle criticism no matter how well intentioned, and how playing live terrified you since any rejection of your work felt like a direct rejection of the entirety of you.

AP I don't know many artists who can separate criticism of their art from criticism of themselves. The more personal the art, the harder it is to compartmentalize. But what artist doesn't consider their art personal?

240

DM You graduated when you were twenty-two, and you have written about how you really, really didn't want to get a conventional job. Jobs in tall buildings, jobs that involved computers, jobs about which you understood absolutely nothing and in which you had no interest. I want to share a list of jobs that you had.

AP Go for it.

DM You rented a room in Somerville, Massachusetts. This is where you became an ice cream and coffee barista making $9.50 an hour plus tips. Aside from being the artist you are now, you were an unlicensed massage therapist but did not give happy endings. You were a naming and branding consultant for dot-com companies. You were an unpaid playwright and director, a waitress in a German beer garden, a vendor of clothes recycled from thrift shops, an assistant in a picture-framing shop, an actress in experimental films, a nude model for art schools, an organizer and hostess of donation-only underground salons, a clothes-check girl for illegal sex fetish sloth parties, and, through that job, a sewing assistant for a bespoke leather handcuff manufacturer, a stripper, and, briefly, a dominatrix. What was it like to be a dominatrix?

AP What I found about my dominatrix job was the same thing I found about my stripping, which is those are not really jobs about sex. They're about emotion. The seven-hour shifts I would clock at the Glass Slipper were not about sex and they were not about nudity. They were about lonely people. I could be romanticizing it a little bit, but pretty much these people just desperately wanted to be seen. Most of my evening was spent talking with people and giving them a space to feel acknowledged as a human being. I was pretty good at the job. And as a person who was not afraid to take their clothes off and be naked, the gyrating-on-stage part was easy.

DM You said that every single one of those jobs taught you about human vulnerability.

AP Any job that I've ever had has definitely taught me about the human condition, the humanness in all of us, and all of our desperate need to be recognized. By the time I was on stage with the Dresden Dolls, I had had a pretty hefty education in how human beings would like to be fundamentally acknowledged for who they are and what they need.

DM While working at the ice cream shop in Boston, you began to work as a living statue—a street performer standing in the middle of the sidewalk dressed as a white-faced bride, the eight-foot bride. How did you first come up with the idea?

AP As a child, I remember my parents taking me into Harvard Square to see a film and get ice cream. The fact that I was exposed to street performers on every corner was certainly something I took for granted at the time. So, I remember at age twenty, twenty-one, thinking, "Well, that's an option. I don't know how one does that, but it looks pretty simple. You stand up, you make art, you put a hat at your feet." Actually, doing it was much more frightening than theorizing. If you talk to a bunch of different street performers, they all had a trial by fire because all of sudden it's just you asking the world for attention and money, and it feels very, very vulnerable. If you're not in the right head space, it can feel very crass: when you're in the street, this is an unchosen audience.

DM There was this moment where you're setting up when you're just like everybody else on the street and then suddenly you're not.

AP Yes, you change. There's the moment where you're asking the environment to give you attention. And, especially when people are busy and you feel like you're bothering them, it wears your ego down very slowly. You're not allowed to say, "Hey, wait a second. Fuck you! Why aren't you stopping and paying attention to me?" You just become a Zen performer, and you accept that you are not in the driver's seat. It's the audience's choice whether or not they are going to pay attention to you.

DM You recount people throwing things at you, people groping you. But you also really connected with people. You were a silent statue, you connected with people with your eyes. You've written about how you would silently try to communicate to people and say, "Thank you, I see you." And their eyes would respond, "Nobody ever sees me, thank you." It seems to me that you helped them feel real. Did they help you feel real?

AP That was a two-way street, and it still is. I think my music career has been honestly no different from that. In that sense, I am so happy that I walked through the hall of street performance, especially in silence. I wasn't playing music for people on the street, and there was a kind of egoless-ness that I didn't start with, but I came to understand that profound and spiritual moments take place when an artist and an audience member merge in a mutual gaze. Getting to have that mutual recognition with a lot of people was a fantastic education and a really wonderful experience to send me off into the world of music making.

DM How did your relationship with your audience change as part of the Dresden Dolls?

AP In my street-performance days, everything was pretty much unspoken, though sometimes people would express positive feedback in words after a performance or through notes they left in my box. Coming into the Dresden Dolls, Brian Viglione and I would go out into the crowd after a show was over. The pretense was to sign merchandise, but that was pretty much the excuse to connect with people and gather their stories. For every person who just wanted a CD signed, there was another person who said, "Your album got me through the death of my father, can I have a hug?" "Your music has meant so much to me." If you hear that again and again and again, you can't help but think maybe this job you're doing isn't vanity. It's important to separate out a desire for fame, success, and recognition from a different brand of authentic recognition. From the outset, success was just status. What I really wanted was to feel like I was doing something that mattered—to contribute to other people's lives like the way I had felt so touched and magnified by other people's music when I was a teenager. So, the street performance, and the Dresden Dolls, and the whole music career can be seen under that one umbrella.

DM You and Brian released your first album together on your own label. You then signed with a major label, but ultimately you'd do whatever you could to get out of your contract. You've said that given the opportunity, a small portion of the population will happily pay for art, and that was unequivocally proven true after you left the label and decided to create a solo album funded by a Kickstarter campaign. You asked for $100,000 to make your album *Theatre Is Evil,* but you made history when your fans contributed over $1.2 million to help you make the album. You've said that if you love people enough, they will give you everything. How do you love people enough?

AP I think everything that we've talked about up until this point is part of that answer. I never wanted to separate from the audience. Brian and I approached the Dresden Dolls that way, and we treated our fans like family always. We considered our fans our lifeblood, our supporters, our patrons, and our comrades in this mutual conversation about love and art and life. When I went solo, nothing changed. I was still in a constant conversation with my fans as my community. They went through my hardships with me. I blogged my life and my trials and my tribulations, and it was such an ongoing intimate relationship. Years rolled on, and I had stayed in a million people's houses, and I had called upon my fans to contribute information and help and rides and food and places to stay and suggestions for opening acts. It was just one big messy, beautiful collaboration. By the time I landed in 2012, I went to that community and said, "I'm going to take all of this money and manifest it into things that I'm going to send back to you. But, you need to trust me that you're going to get this stuff in six months." And when I asked them to trust me, their answer was, "Of course we're going to trust you because we've been engaged in a relationship with you for years." When I went back to them later and said, "Hey, support my Patreon. Let's get in an even deeper, longer-term relationship, and I'll keep your credit card forever; when I feel like making art, I'll charge you." Seven thousand of them have now said, "Yes, we trust you that much." Had I not overdelivered on my Kickstarter, those seven thousand people might've not felt able to trust me.

SARAH

HABIBA

JONES

JOEY

Sarah Jones contains multitudes.

One moment it might be Habiba Rahal, Professor of Comparative Literature, the next moment it's officer Joey Mancuso, a twenty-year veteran of the force. Perhaps you might meet Lorraine Levine, a Jewish grandmother who isn't shy to remind you about your manners and will probably tell you to tuck in your shirt. Sarah is a Tony and Obie award-winning playwright and performer whose one-woman shows are a tour de force of multicultural character studies.

LEVINE

MANCUSO

RAHAL

JONES

DM Sarah, you started performing your poetry in 1997. This was a very difficult year for you. It was the same year that your eighteen-year-old sister died of a heroin overdose. I'm so sorry.

SJ Thank you.

DM What motivated you to start performing at that time?

SJ The last sentence you uttered says everything. I lost my sister in a way that was so unfathomable, and yet it was such a present part of my life. It was like this new being entered and took up all the space in my world, the being of her no longer being. It was the era of heroin chic, so a lot of kids were just trying it. I remember thinking, "This is, without question, the most horrific thing I could ever imagine." Now I'm not afraid of anything. I'm not afraid of all of the things I thought mattered, what other people think of me, or what I might do with my career. It upended everything in a way that I couldn't know then was going to be ultimately very freeing. My sister set my characters free. I had been afraid to be too multi-culti and not Black enough. I was always worried I wasn't fitting. All of a sudden it just didn't matter, and I was able to access an authenticity that defied these conventional notions of what was cool or what was popular. My characters just started leaking out of their own volition. She really did unearth something in me that I didn't know was there.

DM That next year, in 1998, you debuted your first character sketch work at the Nuyorican Poets Café in your show *Surface Transit*, which ultimately won a Helen Hayes Award and was nominated for a Drama Desk Award. The show drew upon the diverse group of people both in your family and in the neighborhood you grew up in in Queens. How did you capture their spirit? How did you decide who you wanted to become?

SJ I think people self-selected. They were larger than life. This wasn't central casting. This was someone who actually talks like this when he gets on the train. This is actually a voice that's coming out of his mouth. He really is, "Yeah, she got the house and the boat. Can you believe that? I mean, get the fuck out of here." That guy, that real person, was so compelling to me. I would subtly eavesdrop for as long as I could, sometimes missing my own real subway stop.

DM I understand that you conducted extensive research in order to create your characters. Can you describe some of what you do and how you go about inhabiting them? Because the cadence of your voice changes, the energy in your body morphs—everything transforms except your physical presence. How do you do this?

SJ It really is a matter of seeing you and feeling such a gratitude for your you-ness that I'm willing to go to any length to represent that as accurately as I can. It does mean, for example with Miss Lady, you know, I had to be willing to get very not glamorous. The first time I did Miss Lady I thought, "I'm never going to get a date again after people see my face looking like this," but I would rather honor her and look like however I got to look so I could really let her have her time on the center stage.

DM You've said that you're interested in the invention of self or selves and that we're all born into certain circumstances with particular physical traits, unique developmental experiences, geographical and historical contexts. You go on to ask, "But then what?" To what extent do we self-construct, do we self-invent? How much of your character invention has influenced who you are now?

SJ That's a powerful question, Debbie. It's funny, thinking about and being Rashid, he had a certain kind of invented masculinity, his bravado and his hip-hop persona. I always wondered, "What would it be like if he got to soften a little bit?

DM

Or went to therapy?

SJ Or went to therapy, which he's not interested in. I've asked him. As I think about who I bring with me and why and where, I get to see my own evolution. They influence me and how I see myself as hopefully a participant in a larger conversation about community, about social justice, about theater, and culture.

DM You have said that empathy is a portal into saving ourselves. Can you talk a little bit about how that empathy impacts how you portray your characters, and how you believe that empathy can indeed save ourselves from ourselves?

SJ To live in a culture where self-alienation can be the norm, a culture that says you're not doing enough, you're not perfect enough—it's so hard to come home to ourselves and have a sense of self- compassion. By cultivating compassion for other people, by standing in the shoes of another person and imagining for a moment what they're experiencing, that they are doing the best they can with what they have at every moment, even the people we cast as monsters in our world, imagine that if we were standing in their shoes we'd understand the logic behind everything they do, how they feel, how they behave. It also works in the other direction. If I have self-compassion, if I'm less critical and exacting about every detail of my life in ways that actually feel punishing, I may do well and achieve. I've actually had that experience in my life of achieving a great deal and still feeling like it's never going to be enough. That drives me to be harder on others. It drives me to judge others as well. I find that the reverse, when I can loosen and soften and get a bit gentler about how I see my own ability to take up space, however imperfectly, on this planet, I can accept the way others are eking out an existence, doing the best they can. Then I can take it a step further to actually loving them, respecting them, seeing the bright spots in everyone.

DM The one common denominator all of your characters embody is a lack of self-loathing. One of the things I've enjoyed about getting to know the characters is their lack of shame. They are all very upfront about their shortcomings. Take it or leave it. I find that to be so comforting. There was such a sense of, these people are inherently lovable.

SJ That's so gratifying to hear. You're helping me realize they do that for me. They strip away my shame in a lovely way.

DM Based on *Surface Transit's* success in 1999, you were invited to be a regular on the MTV series the *Lyricist Lounge Show,* but you ultimately walked away after the first episode. Tell us what happened.

SJ It was a really challenging experience. I was new and green and trying to figure out how do I maintain my integrity? It's interesting, branding. I had a brand. At least certainly in my own mind I knew that I wanted to be about authenticity, integrity, all of these buzzwords, but from a place of this was how I survived the slings and arrows of misogyny. I'm not just talking about hip-hop. It was Howard Stern or just whatever it was that was casting women as objects all the time. I wanted to be able to embody something that stood in strong opposition to that. This show was great, but it also had some scripted elements that were really degrading. I worried so much that I was going to end up a bitch and a hoe.

DM Didn't they ask you to be a Puerto Rican woman with nine children?

SJ Yes. It's not worth it to ride limousines and walk red carpets if this is how I'm portraying other people or myself. Eventually, to their credit, they changed the writing staff. It ended up being a great show with another actress who I love to this day, but at the time it wasn't something I could do. I walked away.

DM Were you scared? Did you have regrets at the time?

SJ Are you kidding? I was like, I'm never going to fly on a first-class plane again! I was like, this was going to be so much fun. What did I just do? I'll never work in this town again! I ended up meeting Meryl Streep because I walked away, which I think is a wonderful reminder.

DM Isn't that amazing? You met her during your run of *Women Can't Wait,* your second one-person show. It was commissioned by the human rights group Equality Now and the Ford Foundation. Following the first performance, you were featured in the *New York Times* and made the cover of *Ms.* magazine. At that point in your life, you were twenty-six. In the *New York Times* article, you stated that you've always got some sort of ax to grind in your work. I'm wondering, do you still feel that way?

SJ No. I've decided that ax to grind was something I let the world superimpose onto me. There was this illusion of a separation between "political" poetry or theater, or prop work, and theater for its own sake, that's more pure, and it's the more desired road to take. I now realize that all work is political. Some of it is apolitical, but that's a political choice. It's a luxurious political choice that says, "Nothing's impinging on my rights, so I'm just going to write about anything I want." I don't take anything away from work that doesn't directly address, say, political issues of the day, but I think it's not about having an ax to grind. It's about having a point of view.

"Theater

is a social art, not just in terms of how it's made, but in terms of what its subject matter is. It's about the world around you. It's not an abstract art form. It's the least abstract of art forms."

TERRY TEACHOUT

journalist, playwright,
theater director, author

November 25, 2013

T H O M A S

You could say that directing a musical is a form of design, and the materials are music, lyrics, and human performers.

Thomas Kail has directed some of the most memorable musical-theater experiences of our time, including *In the Heights* and *Hamilton*. His collaborations with Lin-Manuel Miranda are now the stuff of legend, as are the shows he's created on his own. In this conversation, we discuss the joys of collaboration, the mysteries of transcending time, and his thoughts about his extraordinary life and career.

K A I L

TK: Yes. I was standing outside this classroom. It was just starting to snow. It was the day before my twenty-first birthday. I was pretty alone there at the Dartmouth exchange program. I didn't know a lot of people. I had a question, and I didn't want to ask it in front of the class because I was too nervous and my heart was beating. He was standing, smoking a cigarette in the doorway. I said, "Mr. Wilson, there's an outhouse that's referenced in the play, in Joe Turner. Does it symbolize...?" and then I had the most collegiate possible thing to say about it. He looked at me and he said, "It could, but sometimes an outhouse is just an outhouse." He exhaled and he walked away to the left, framed by the snow and the bare trees of Hanover, New Hampshire. I thought, "I have to be a playwright." I went back to my dorm room, and I flipped open my computer, and I started typing. Not writing but typing, as Kerouac would say. Six hours later, I looked up and I hadn't felt the disappearance of time in a very long while.

DM: The title of the play was *Re: Peter*. The experience initiated you into the world of theater. What was *Re: Peter* about?

TK: In those early days of email—this was 1998—we were starting to use subject headings. This was a play that was repeated. What you thought was a play was, of course, a rehearsal, which you thought was in the rehearsal of the play, and which was neither of those things. It was a triptych. I decided, "I'm going to take this back to Wesleyan and I'm going to find my little group." We mounted that and it was the first thing I ever directed. It was a revelation for me because I made this thing that I had imagined in my head. The experience left an indelible impression on me.

DM: After graduation, you worked as an assistant stage manager at the American Stage Company and then as personal assistant to the Tony-, Grammy-, and Emmy-Award–winning performer Audra McDonald. Eventually, you started a small theater company called Back House Productions with some of your Wesleyan friends.

TK: Correct.

DM: You were introduced to Allen Hubby, the owner of the Drama Book Shop on 40th Street. Allen was looking for a startup company to produce plays in a fifty-seat performance space in his basement. You signed on for the challenge. What did you learn from those early productions?

TK: We had to keep that thing moving and we had to keep it full. I learned not only how much bigger the world was than my little group of friends but that there were people who were going to make things that I would never to be able make. I welcomed that. There's a line in *Hamilton* that is taken from a quote attributed to Burr: "If I had read Sterne more and Voltaire less, I would've known the world was wide enough for both Hamilton and me." When Lin and I both read the book, before we'd really started talking about the musical, we both circled that. A lot of that was cultivated down in that basement. I needed those other people to make those productions. Otherwise, they would not exist. This binary idea that it's you or it's me was completely exploded back then. It never occurred to me that someone else's success meant I couldn't achieve or there wasn't space for me. I think there is a way to create space.

DM: You and Lin met in the spring of 2002, though you had been given the script and score of the musical *In the Heights* two years before. I read that you were immediately taken by the play, yet you waited for two years to meet.

TK: I was waiting for him to graduate. At twenty-two years old, you're not aware of time. I thought, "We'll wait two years till he graduates." When I went to visit Lin with my friends, it never occurred to me that he wouldn't say "yes." I thought, "We're going to say, 'We have a little theater on 40th Street with fifty chairs.' Why would you not want to go there?"

DM: What appealed to you about *In the Heights*?

TK: When I listened to the songs, I thought, "He's writing about my life, and it sounds like the kind of music that, if someone said, 'Hey, here's the new Tribe album, or the Fugees made this, or here's De La Soul,' then it would have felt authentic to me in the sense of, 'Oh, they have a song about this.'" Lin was a guy writing in the context of story—a larger story, a musical—songs that felt like they were speaking to me in that way that I think we're always looking for, the way we're looking to find something that feels like it's for us.

DM: When you and Lin finally met at the Drama Book Shop's theater, you sat and talked for this five-hour mega conversation. I read that you said that you'd felt like you'd been looking for him your whole life and didn't know it. Were you scared by that in any way? Did it feel so overwhelmingly powerful that you didn't want to blow it?

TK: I knew that I couldn't blow it because we were saying the same lyrics at the same time. Our mutual feeling was,

"Where have you been?" That's what it felt like more than anything. I didn't want to stop talking to him. I feel the same way fifteen years later as I did then. That five hours felt like ten seconds.

It was not real time and space. It was this *Ratatouille* moment. It was life-changing in a way that I couldn't possibly conceive at that point. It was both the gaining of knowledge and a reminder that there are people out there that you simply haven't met yet.

DM: Isn't that amazing?

TK: These people can take the top of your head off. I've been seeking them. There are so many people in this world making so many things. To have the chance to be in a room trying to figure something out with those people who spark that connection. Do everything you can to get back in that room. My goal was to find a room to inhabit where we could stare at something and see what we could do.

DM: Lin has said that, for every idea that he had, you had fifteen, and that 50 percent of what you talked about that day, during those five hours you met, made it into the Broadway production of *In the Heights*.

TK: He's never been a numbers guy, but I had a couple of ideas that I'd been sitting on for two years. That's the only reason I was able to talk for such a long time. He hadn't thought about it in two years, and I had only been thinking about it. That was also a good lesson for me: to see that, if someone is confident in their work in the way that Lin was, they can be open to receive. That was a reminder for me to be open to receive. When I'm directing, it's like the creative team around me is wearing glasses that I don't wear and they can see things I don't. I want them to be able to share that. I want to try to create an environment for them to access that part of themselves. Very early on in our creative process, Lin said, "I'm listening. Even if we don't use an idea, let's talk about why. Let's talk about why not." That set up this very fluid interaction with creative ideas.

DM: Six years of developing *In the Heights* led to an Off-Broadway run in 2007, and the musical officially opened on March 9, 2008, at the Richard Rodgers Theatre on Broadway. It went on to get thirteen Tony nominations—more than any other show—and you won four, including the Tony Award for Best Musical. You also won a Grammy Award for Best Musical Show Album. Pretty good for your first show. *Hamilton* originated in one of your Gchats with Lin, where he casually mentioned getting a book about Alexander Hamilton while he was on vacation. You responded, "Cool, what are you doing tomorrow?" I guess it wasn't a slam dunk—you weren't immediately convinced to make a musical out of an Alexander Hamilton bio.

TK: Lin reads a lot of books.

DM: The book was Ron Chernow's exhaustive biography *Alexander Hamilton*, which Lin bought on impulse. After you both read it, you made a list that was 612 items long summarizing what you responded to in the book. How did you craft this story from these 612 things?

TK: Six hundred twelve might have been rounding up. I said to Lin, "I have one chance to read this without you in my head, so I'm going to go and read and you go read. Just write down everything that's a scene, a song, a character, or a moment, and I'll do the same. Then we'll see where the Venn diagrams overlap. A lot of the stuff that we wrote in those initial scribblings ended up in the show.

Since we were thinking about *Hamilton* as a concept album at that time, what I wanted to do was not build a fence around him. If he wanted to write something that happened when *Hamilton* was at the end of his life, good. Go and write that. I knew early on that it couldn't be, "And this happened, this happened, this happened, this happened." A series of events does not a musical make. My priority was, "Where was Lin feeling the juice?" Go to the juice. See what's there and then find out what we have afterward. That, I think, allowed him to not feel encumbered by a story that needed to have certain things happen in an Aristotelian structure. Instead, that initial process was, "Go and write what moves you."

DM: *Hamilton* made its Off-Broadway debut at the Public Theater in February 2015, where its engagement was sold out. The show moved to Broadway in August 2015, again at the Richard Rodgers, where it became a cultural sensation. We barely need to discuss it since it's so well known, but it received an incredible critical reception as well as an unprecedented advance box office. It garnered a record-setting sixteen Tony nominations, and won eleven, including one for you—Best Director. When talking about your role, you've said that you've realized that, as a director, people are going to look to you to set the tone. But how do you actually direct?

TK: You're going to do it the way that you do it. I've learned. I've watched a lot of directors. I've read a lot about directors. I studied a lot of directors. Then I realized, "Find your own voice. Take the thing that's useful from someone else," but you have to rely on instinct, in the same way that an actor's going to do their preparation, and then go on stage.

If you've only seen the technique, then that's not the most helpful thing for trying to get to the center of the

truth. When I walk into a room, I'm constantly thinking about the fact that the temperature is set by a few people in the room. I often am one of those people. I want to keep the temperature low, even when the stakes get high. I also want to remind the group, as I remind myself, that we're allowed to live in a space where I don't know the answer, which is something that I had to learn, and that this is, in some way, in contrast with this mortality obsession I have. Sometimes, you say, "Let's come back tomorrow," and that's okay too.

DM: How do you navigate that combination of certainty and uncertainty?

TK: It's a lot of instinct. It's a lot of being twenty thousand, thirty thousand hours in. Being a human being is very connected to the kind of director I want to be. I want to be able to listen. I want to be able to edit, suggest, sit, and other times be up and engage. You have to read the room. It's about moment-to-moment reacting. I also like to talk to the people that I'm working with—"Here's what we're going to try to do today, over the next couple of days"—to let them know roughly where we're going, but there's not one way to get there. It's about treating people like adults. We've all made a decision to be there. I try to create some sort of environment that is founded on respect and listening.

DM: You've stated that your job as a director is to not necessarily have the best idea in the room at any time but to identify the best idea. How do you identify the best?

TK: You rely on your instinct. You rely on that, hopefully, honed gut that you have. For me, when I don't listen to it, that's when I don't sleep. That's when I find myself in a situation that I probably shouldn't be in. So I allow myself the space and reserve the right to change my mind.

DM: You've said that the realization that you don't have to have the best idea, but rather you have to identify the best idea, was unburdening. In what way?

TK: It takes a lot of pressure off when you're not thinking, "It's me. They're all looking at me." They're not all looking at me.

DM: And yet as a leader, you have to be accountable for the decisions.

TK: Yes. Making decisions has never been challenging for me. I haven't always made the right decisions, but my impulse is to go in a certain way or to try something. I've never felt that the decision to do something—even though often it is at a certain point unchangeable—was ultimately unchangeable. That illusion of possibility, even for evolution or mutation, has given me comfort and solace.

DM: Once a show is up and running, what is your role as a director?

TK: When I go to my shows, especially if a show has been up and running, a lot of my job is what happens when I knock on your door at 7:30 p.m., not what happens from 8:00 to 10:30, when the curtain goes up. *Hamilton* is now coming up on two years on Broadway. There's some people I haven't given a note to in months, and there's some people who still want to talk about a scene. There's some people who only talk about their family or this thing that we once did together. My role is often to convey, "I'm here, and if you want to continue the conversation about the work, I'm available for that too." So much of my role is acknowledging that whatever the moment requires is going to be different from person to person and understanding that you need to talk to the group many times in one collected arena, and, outside of that, most of your relationship is one-on-one.

Directing happens all the time. Directing happens because you happen to take the subway with someone and all of a sudden you have twenty more minutes. It happens in hallways. It happens outside. It happens well outside the confines of rehearsal, and most of it is about creating space for someone to be excellent in.

DM: One line that I read many, many times in my research and heard you say in a number of different interviews was, "Humanity over talent, every time." Tell me what that means.

TK: It means I don't want to be around negative energy. I don't want my company to have to navigate that. This thing is hard that we're trying to do. If I can protect the room, and if it's partly my decision, along with the producer and the writer, to choose who's coming in the room, then I will. If you're an actor in a show, you're going to walk into the first day of rehearsal, and I'm going to say to you, "This guy's playing your brother. You really love each other. Have fun." You're relying on me. You're relying on me implicitly to try to put you with someone where there is the possibility, at least, of finding some sort of relationship and connection. I don't want to be around people that are not kind and people that are not thoughtful. I'm not interested in it at all.

DM: Getting back to *Hamilton,* at some point in your development process, you and Lin decided to live together for eight days at Vassar. Tell me about that.

TK: After we did this concert in New York where we had ten or eleven songs, we went up to Vassar to New York Stage and Film. We spent eight or nine days living there

together. Alex Lacamoire, our orchestrator and arranger, lived with us. Lin would skateboard up and down the halls. We'd ask him, "Did you bring your homework in? We need a song for tomorrow." He would say, "I got it. I got it." We were together for twenty hours a day. That was an important part of our microwaving. We thought, "Let's get in there and see what happens if we're together."

> DM: Tell me about the process of "One Last Time." I know that Lin was struggling with it for about eight-and-a-half months. Then you suggested something to him and forty-five minutes later, it was done. Eight-and-a-half months, forty-five minutes.

TK: I'll debunk a little bit, but it was forty-four minutes. There was a song that was in that initial six-hundred-item list, and it was called "One Last Ride" when we were downtown at the Public. I kept saying to Lin, "There's this moment where he and Washington put on their old uniforms, see if they fit, and they go out guns blazing during this Whiskey Rebellion. Don't you think we need something like that in Act 2?"

At this point, we were thinking about act structure. It's where we get a chance to see them grapple with what it means to get older, that their clothes don't fit, and all of that. Lin writes this song called "One Last Ride," and it's performed 117 times at the Public Theater. It plays. There's a Whiskey Rebellion in the middle of it, which is a little bit of a left turn, and we ran out of time.

We knew we had another version. We knew there was something else in there. We just didn't get to it. Months go by. The show runs. We're still talking about it. The show closes in May. We're about to reopen in July 2015. While we're in rehearsal, end of June 2015, Lin's struggling with it. He's in the other room, and I pop into the room to go see him.

> DM: And what did you tell him?

TK: My mom is an archivist who works at a historical house called Tudor Place in Georgetown. At Tudor Place there was a letter from George Washington where he talked about this return to the vine and the fig tree. It's something Washington said. He would talk about a certain kind of destiny, and he had these phrases that he would come back to. I thought I'd mention that to Lin at some point. I said to Lin, "If this is about going home, it feels like Washington just wants to go back to Mount Vernon"—which is fifteen minutes from where I grew up—"and he wants to parallel the end of the story of Cincinnatus, who led the Roman army all those years ago then returned to his farm once the crisis was over. Washington was very moved by that story."

Lin said, "Well, I don't know what vine and fig is. What's that?" I said, "Look it up. It's this phrase that he would say when he talked about going home." Lin sat up in his chair and cocked his head. I said, "I'm going to go in the other room."

He came in within the hour, and he said, "I got it." He said, "I'm going to have this by the end of the day," and he did. It was the six months, it was the two years of all that work until he could do that one little thing. I think about it like when you have sand moving through the hourglass. There's that sensation that it's going faster even if it's not. There's the illusion of that. That's all it was, and then all of a sudden...voom! He was there.

> DM: That's magic. The notion of time is a recurring theme all throughout *Hamilton,* and for me, it is one of the most exquisite things about the production.

TK: It's one of Lin's gifts and one that we all tried to honor. We were thinking a lot about *The Matrix,* which was a big reference for us—the bullet time of *The Matrix.*

> DM: I loved that. You feel it.

TK: You knew you needed to stop time at the end, so when we came up with the idea for "Satisfied"—which is the number that basically rewinds and stops time that we've seen play in "Helpless"—that was giving us the equipment we needed later to slow everything down. There was a moment, when Lin wrote that song, that felt like it had a lot of power.

> DM: When time stops in "Helpless," that's when I knew that this show was something completely different from anything I'd ever seen before. I can vividly remember that moment. Every time I listen to the song, I'm back in that moment and time has stopped. Everything is just silent and perfect and infinite.

TK: I think you just said something very nice, so thank you for that. So much of all of this is saying, "I was here." I've made a lot of shows where people are talking about what they've left behind.

There's some part of me that is constantly thinking about the fact that we're not going to be here eternally, so if we're writing messages in the melting snow, to paraphrase Peter Brook, or we're scribbling something before the wave comes up and washes it away, art at its purest can say, "You are not alone. I am here too, and you are seen."

AMINATOU

Aminatou Sow doesn't like when people tell her she can't do something.

After being told that women and technology don't mix, she created an online meeting hub for women in technology. She also went to work at Google. She was born in Guinea and lived all over the world before settling in New York City. She was named one of Forbes 30 Under 30 in technology and KQED's Women to Watch. In this interview, we talked about the popular podcast she co-hosts, *Call Your Girlfriend,* and her life as a digital pioneer.

SOW

DM Aminatou is the Guinea version of Aminah, Prophet Muhammad's mother, but from what I understand, every country has a spin on the name. So for example, in Senegal, it's Aminata. You've said that when you meet other people from West Africa, they want to call you Aminata and that drives you nuts. You've also stated that what people call you categorizes them in different places in your life. In what way?

AS Aminatou is the Fulani version of my name. I will never grow out of that name. And Amina was really, I think, who I was when I moved to America. People said my name wrong a lot of times. And sometimes it annoys me. I talk to a lot of other immigrant kids about this. There's a way you can reinvent yourself subtly. Professionally, I always write my name as Aminatou Sow. That's the name my parents gave me. I'm proud of it. I love it. But most of my American friends call me Amina. And it's always a reminder of, like, what phase of my life somebody met me in.

DM And I understand your Starbucks name is Amanda.

AS Oh, yes. My Starbucks name is firmly Amanda. And the funniest thing about that is that I have a friend who is also an immigrant with a harder-to-pronounce name. And in college we met at a Starbucks, and when they called out "Amanda" we were like, wait, that's my coffee. So.

DM Your family is from Guinea in Africa. And you've said they were political refugees by the time you were born. So you grew up in Nigeria and Belgium. Your parents were diplomats?

AS I have been trying to uncover a lot of my own family history because we've always not lived where we are from. My passport is from Guinea, but I have never lived there, I don't have a strong sense of that being home for me. And politically, it was never a place that was safe for us. By the time my mom and my dad left for Nigeria, the political regime was not encouraging of people from our tribe. My dad lucked out and got this job in Lagos, Nigeria, for this organization called the Economic Community of West African States. It's essentially the EU for African countries. My dad got to work at this cool international organization his whole life. I always joke that he's the only person I know that has worked at one place his entire career.

DM That's extraordinary. Your mother was an engineer by trade. In fact, she was one of the first women to study at university in Guinea, but she was a stay-at-home mom. And in high school, I read that you realized she was a genius and was actually smarter than your father. And you didn't understand why she was the one staying home.

AS Honestly, it made no sense to me. You know, the way that my parents explained it to us was that, in my dad's job category, due to conflicts of interest, a lot of times the wives do not work. And I would say that that was mostly true for a lot of the kids my age at my dad's job. But I think that a lot of it is also just, like, very oldschool African sexism. She passed away over a decade ago, but I still think about how there wasn't a path for her. And she never complained about it.

DM You've said you've always been a feminist but can't pin the origins of that identity down to a single cathartic moment. And you've said that you think a lot of it was being a girl in a conservative Muslim family.

AS To their credit, my parents did a lot of really brave things that made me who I am today.

DM Like what?

AS They were the first in their families that married for love, and it had really big consequences for them. My dad never treated me differently. That's a thing I felt at a really young age. We still had to go to Arabic school to learn Qur'an because my family was Muslim. We still had to do the whole respect your elders, whatever. But he never told me, "You will not get to make decisions in this family." He let me play sports. My parents also did not circumcise me or my sister, which was huge. I did not understand how monumental that was until later in life. My parents were not wave makers. I wouldn't call my dad a liberal by any stretch of the imagination, but I do think there is something, even for very conservative men, when they look at their daughters and can think, "If you are my legacy, I want you to have better than I have." And I think my dad was able to do that for me in ways that were really concrete.

DM You've said that you communicated with your father through knowledge seeking. Can you tell me more about what that means?

AS My dad's telling me more about his life, and we're becoming friends. But that was not true when I was growing up. I was kind of terrified of my dad, but one of the things he always did was that he made us into very curious kids. We watched the 8:00 o'clock news all the time. At dinnertime we talked about current events.

DM You were voracious media consumers.

AS He never cared about what your interpersonal relationships in school were like, but it was very much, "What do you think about the crisis in Burkina Faso?" It was also the only vocabulary we had for getting along.

DM What is the foundation of your resilience?

AS I come from resilient women. I come from a part of the world where, if you make it to five, you're probably going to have a longer life than most people. And I have seen some hard things. Hard things have happened to me. But I also think life is worth living. I don't want to feed into some bullshit, like African people are strong people narratives, because I think a lot of times, that's how it gets misconstrued. And even in America, people think Black women specifically are just stronger, and that's not true. We all have the same emotional reserves everybody else has, but our lives can be more challenging. And if you're choosing to live, you're going to tap into that.

CHRISTINA

> "No one teaches you how to be prepared for the things you chase down in life."

Those are the words of Christina Tosi, who once upon a time was writing food safety plans at Momofuku when Chef David Chang asked her to make dessert for a private party at the restaurant. The cakes and pastries were divine, and so began the journey to creating Milk Bar at Momofuku. Shortly thereafter, it spun off as a standalone bakery in the East Village. Now, there are Milk Bars in New York City as well as bakeries in Los Angeles, Washington, D.C., Las Vegas, and Toronto. Now Christina Tosi is also a television personality and an author. Her latest book is aptly titled *All About Cake*.

TOSI

DM Christina, is it true you name all the refrigerators in your eleven-thousand-square-foot kitchen in Brooklyn after superheroes and celebrities?

CT We name every piece of equipment at Milk Bar because we learned early on, once you have more than one refrigerator and more than one mixer, when someone's like, "Girl, the mixer's acting up or the walk-in's running hot," it's like which walk-in? It's a lot easier to communicate and as you can imagine makes the job much funnier when the log reads, "Lil' Kim was acting up today. Luke Skywalker is running hot. Christopher Walken is running cold." All of a sudden you are a member of a secret society where you're talking about equipment in the kitchen. One of our core values is making things funny to keep them real.

DM Your grandmother's dense oatmeal cookie with some cinnamon thrown in had a profound impact on you.

CT One hundred percent. I use that recipe as a guide on a bunch of different levels. It's the recipe that I crave the most. She has since passed, but it's the recipe. I could stand next to her and make the same recipe side by side. And somehow my oatmeal cookie never came out the same. It never tasted as good, it never tasted like it had been made with the same love. I realized my path in desserts was to not create something that had already existed. It feels less creative but more importantly, it wasn't my job to compete. The reason I love that oatmeal cookie has nothing to do with the technician or trained pastry chef I am. It's a moment that has been sealed in my heart and tugs at my heartstrings and taste buds. And that's a big part of why we don't sell oatmeal cookies, let alone chocolate chip cookies or apple pie at Milk Bar.

DM Is that when you started to become more creative in the way you were interpreting recipes?

CT My poor mother. I'd walk into the pantry and be like, "I'm going to make cookies." It was a given. And then I became obsessed with this pursuit of the Rice Krispies Treat when I was in tenth grade, I would make a batch of Rice Krispies Treats every single night. What I loved about that pursuit was I was just going into the pantry. We never really kept Rice Krispies in the pantry. We always kept whatever cereal I wanted to eat with milk. I started falling in love with mixing and matching them and wondering, "What if I make a Rice Krispies Treat but with only this cereal? Or with this and this kind of cereal and sesame seeds or that kind of cereal and butterscotch chips or what have you?"

DM In college, you majored in applied math. Was there any part of you that was imagining doing something with applied math when you graduated?

CT I realized in graduating that there were certainly professional tracks for the subject matter I had studied. But the one thing that kept tugging at me was, I want to be on my feet all day and I want to be exploring. And I like to travel and wander. I had a voice in my head that was like, "I want to be creative for a living," and that was something that was not a part of my upbringing. Now, being creative was absolutely a part of my upbringing—you've never met a more artsy-craftsy family of women—but that was what you did in your free time. That was what you did when you got home from work. It was certainly not something you made a profession out of. So I set out to figure out what that was.

DM After you graduated, you applied to the French Culinary Institute. Was that when you decided, "I want to devote my life to this?"

CT I was working in a restaurant while I was going to college. I became really obsessed with restaurant culture, the sense of family. I would bake a ton at home and bring the baked goods in, and it just triangulated itself to wondering, "What's the next step? What are you going to do?" And the only answer was to make cookies. My parents are really big on education and professionalizing yourself, and professionalizing yourself if you'd like to make cookies means becoming a pastry chef.

DM Your first jobs in the industry were as a maître d' at Aquagrill and you also had a gig at Bouley. What did you do at Bouley? What was it like working with David Bouley?

CT That was the most amazing experience. You basically go to the top of the mountain with the least experience and you say, "I want to work for that person," and you get your butt kicked every day and you get worked like crazy. You get torn down just in case you weren't already torn down and terrified of that, being your first New York City kitchen job. I got torn down, and thrown around, and I was so blissfully happy because of it. It was those moments of, just, you're just dog tired, your feet hurt, your hands hurt, you know nothing. And you couldn't be happier because you're in motion. It has given me the backbone and the strength for everything else I chose to do.

DM What is the biggest thing you learned from David Bouley?

CT I learned the thing about leadership and teamwork that I carry with me to this day. If you're not going to help, no one wants you there. And when you're a new culinary student, to be clear, you're not helping. Or you're helping and you're messing something up. The only way I was ever going to get my foot in the door with the pastry team was to assimilate—figuring out how to find common ground, how to share a goal, and how to get people to trust you and to let the respect come after that. To show that you want to give something to the relationship and to give it first.

DM Meanwhile, you realized you didn't really relate to the fancy desserts being served in the restaurants you were previously working in, and you've described them as precious. What would be a precious desert?

CT A precious dessert is one that you have to eat with a knife and fork. One that includes multiple sauces. I think, more than anything, the most precious part of a precious dessert is the beautiful thing shooting up from the dish. It's the thing you adorn a beautiful dessert with, and to handle it technically you have to be incredibly precious about it. And I am a bull in a China shop when it comes to that sort of stuff–it would kill me every time.

DM I believe that, philosophically, the opposite of that style is what first attracted you to the work of chef David Chang. Is that correct?

CT In so many ways, Dave was the male version of my history. He grew up in Northern Virginia miles away from where I did. He went to school. He was always seeking acceptance or knowing he was an outsider. He had this democratic approach and this democratic vision to creating a restaurant and feeding people. It was simple. It was pure. It was necessity.

DM You joined David at Momofuku, but your jobs there included payroll, clerical work. Why not cooking?

CT I'd been in New York at that point for several years. It was Momofuku Noodle Bar's second year. Dave was starting to gain some pretty significant acclaim. The world of food was starting to take notice. We were giving up white tablecloths to go and sit at his wood-cladded noodle bar. I was drawn to him. There was a magnetism to what he was doing, to his vision. Honestly, it was equal parts that I got him, I got what he was doing. I saw it. And I was raised in a family where when someone needs help and asks for help, you say "yes" and you don't think twice. You just go and you do.

DM You opened your first Milk Bar next to Momofuku in the East Village in 2008. Today you have a network of stores all over the United States. *Bon Appétit* has described Milk Bar as one of the most exciting bakeries in the country. You described your philosophy a number of years back, and I quote: "You have to embrace the failures as much as the successes. Much of the boundary crossing of Milk Bar came from mis-measurements, overbaking, or stumbling upon a discovery and a failed recipe test. It's about staying strong and getting creative when the going gets tough that really defines who you are. Embrace, embrace, embrace the burnt batch of cookies." How long did it take for you to get to that magnanimous place?

CT We're not great at Milk Bar because we're great at Milk Bar. We're great at Milk Bar because we're resilient, and we're great because we're not afraid to take chances. We're not afraid to get into arguments with each other. But more than anything, we're not afraid to do what needs to be done and to do it right.

"I think writing a recipe and writing a poem are very similar. You're trying to convey an idea of something as economically as possible. You're trying to get the point across and give your reader enough information. A recipe really can go on and on. You could write a whole book about how to bake a cake or scramble an egg. It's the same thing with poetry. Hopefully, reading a recipe has the same effect."

JULIA TURSHEN

cookbook author

April 20, 2015

J essica

Jessica Hische is a lettering artist and illustrator who has designed and released several commercial typefaces

and has worked for clients like the *New York Times*, Apple, and filmmaker Wes Anderson. She is also an author and followed up her *New York Times* best-selling picture book, *Tomorrow I'll Be Brave*, with *Tomorrow I'll Be Kind*. In our interview, we talked about what it means to achieve success early in a career, and how she delineates between her various creative practices.

HISCHE

DM: I read that you were raised by parents who fed your artistic creativity with ample crayons, scissors, and construction paper. What was the young Jessica Hische making back then?

JH: Young Jessica Hische was obsessed with anything art related. And I thank my parents so much because they gave me endless art supplies. That's not something I feel all parents who don't have an art background would do. But I think part of it was that I was so well behaved in my art world. They could sit me at a table with art supplies, and I would be good to go for six hours. I got really into replicating *Far Side* comics when I was in the fourth and fifth grades. Then I got really into drawing maps of my house, plotting the dogs throughout the day. It was like drawing battle maps. I was definitely a color-within-the-lines kind of kid who didn't do a lot of experimental drawings. I was obsessed with trying to draw things realistically, and felt I was rewarded for that as a little kid.

DM: In high school, your parents got a divorce. You've stated that this started a fire in you—you needed to become independent as soon as possible to find yourself and your voice. What was it about their divorce that served as that catalyst?

JH: Your parents are these omniscient beings when you're a kid, and when you see them go through a very harrowing experience personally, you get to see them as humans. That was jarring and made me feel like I had to grow up fast. Also, my mom had put all of her eggs in this basket of marriage and raising kids. She had given up her career in order to be a parent. Now, as a parent myself, I see just how much work goes into parenting, but back then I didn't want to be put in a position where I had to rely on another person's livelihood to exist. I wanted to make sure that I could make my own way. Even as an adult I feel protective of my career, and I never want to be a person who doesn't contribute financially to my marriage equally.

DM: Is that remotely possible given your success, Jess?

JH: Yes, of course. There are highs and lows in every career. I've been very lucky in that I've obsessively stayed on top of it.

DM: You're one of the hardest working people in the design business.

JH: Well, I realized early on that you can't put all of your eggs in any one basket, even professionally. I was freelancing from the age of twenty-three, twenty-four and found out there are parts of the industry that dry up seasonally. So, I would have to make sure I didn't have one kind of work, or I didn't have just one kind of client. It's a little more normal to do that as an illustrator versus a designer. Freelance designers have clients that come back over and over again, but as a freelance illustrator, I feel like I go on a bunch of epic first dates. I've had, of course, some repeaters, which have been wonderful and lovely. But a lot of times, by the time they come back to me, it's an entirely different creative team. So I needed to diversify revenue, and I did that by making sure I had stuff that was making money for me when I wasn't able to make the money myself.

DM: You started drawing letters when you couldn't afford fonts. How quickly did it become apparent to you that this was something that you were good at?

JH: It's hard to say if it was because I was good at doing it or because I liked what it brought to my projects. Initially, it was partially a budget concern, so I would try to trace and manipulate fonts. But also I started realizing that as I was doing that, my work felt so cohesive because I was doing the illustration. Sometimes I was doing the photography. I was doing photo compositing. There's something that you can do in your work when you're touching every aspect of it that made me realize the importance of the artist's hand. As a designer, I feel like you lose that sometimes because you are working with other people's assets or it's just more hidden. Doing the typography within my own work made the entire thing feel so cohesive.

DM: You've stated that, when you started lettering, naivete allowed you to do weird things that people with

experience do not know how to do anymore. What kinds of weird things were you doing back then?

JH: There were a lot of little mistakes that I would make in my drawings of words and letters that I could not force my hand to make now but which gave a lot of personality and character to the work. Things like having the weight be on the wrong side of the letter, or mix-and-match serifs. I would have little inconsistencies from end to end or between the letters. I was very into a lot of outsider lettering people at the time, and at first that was the direction my work was taking. Now I get people who approach me referencing an earlier piece of work that I did, and I tell them, "You need to hire someone with ten years less experience to do this because if you tried to get me to do it, it will feel so forced and stupid."

DM: You seem extremely self-motivated to make and get the things you want. Does that self-sufficiency come from your parents' divorce?

JH: That was a catalyst, for sure. It's also rooted in getting out of my hometown and getting to a place that was much bigger than me. In New York I began to understand that it's not wrong to ask for what you want. It's not selfish to ask for what you want. I give the example of trying to make plans with your friends to go out to a restaurant: if there's nine of you standing on a street corner in the rain and you say, "I really want sushi right now," nobody looks to you and goes, "You're being selfish for saying that you want sushi." You're just trying to move the crowd forward. Stating what you want is not inherently selfish because you're simply putting it out there and then other people can react to it. The thing that's important is how you react to their reaction.

DM: How did you get so good at being able to say "no" and generally articulating your needs?

JH: Saying "no" takes practice. The first couple times you think to yourself, "Will I ever work again?" But living unapologetically is important to do as an adult. You don't have to apologize because you want to live your life a certain way. When I was younger, I always thought of that as bitchiness, and I think that's society's fault for training me to think that that's how a woman should

be. Now, I feel that assertiveness is not hinged on that at all. It's just about you trying to live your truth and everybody trying to do that individually together.

DM: You're very outspoken now, so some people may be surprised to know you felt like an idiot back in college for not being able to do self-expressive artwork because you didn't feel like your opinions mattered. You've gone on to say that design allowed you to express other people's opinions. Would you talk about that delta between being able to express your own self versus being able to express others through artwork or through design?

JH: I think a real sign of maturity as an artist or creative is being able to give yourself permission to do things that you want to do. I think we all struggle with feeling like we have permission to do certain kinds of work. I felt that way with the kid's books—I've always been interested in kid's books, but I couldn't give myself permission to make kid's books until I had children because I wanted to understand the space more.

DM: You've also stated that the process of writing was difficult for you, given that you weren't formally trained as a writer. How did you break through that barrier, and has it gotten any easier for you?

JH: Here's something I struggle with when becoming educated on anything. I feel like I'm pretty good at connecting dots and teaching myself things. But because of that, I oftentimes get autopiloted by teachers. Getting people to realize that you want substantive training is hard. I even found that with *Tomorrow I'll Be Brave*. When I sent off my first draft, the only feedback was about the art and there was nothing on the writing. And I told them, "The writing is clearly not great. You need to critique my writing. I need you to give me feedback. I need you to tell me what's wrong with it. It can't just be good enough."

DM: But was it? Did they feel that it was good enough or great?

JH: Well, I think they felt it was good enough because they knew that the writing wasn't going to sell the books. When people know you're going to be able to sell a thing no matter what, they don't think about how

high of a quality it can be. But Penguin has been really wonderful. I pushed them a lot for *Tomorrow I'll Be Kind.* Because I struggled so much more with that manuscript, I straight-up said, "This is not where it should be." I felt self-conscious about the manuscript because this isn't the thing I was trained in. So, it takes so much positive feedback from other people to convince me that it is.

DM: Your first book, *In Progress,* was released in 2015 as a kind of textbook for designers. Then, you decided to make a picture book for children. *Tomorrow I'll Be Brave* sought to imbue kids with the confidence to try new things. How did you see the need for a new genre in children's books?

JH: One thing that I saw missing were children's books that talked about self-reflection or talked about higher-level emotional things that I feel little kids are actually more capable of doing than they're given credit for. That's one of the things that Fred Rogers was so famous for and so good at—understanding that even tiny kids have rich emotional lives. The only thing is, they don't know how to control their emotions. I wanted to make a book that was both written for the adults and the kids and that introduced the concept of self-forgiveness. I wanted to make something that was encouraging but also talked about self reflection and setting intentions.

DM: Why was the concept of self-forgiveness important to you?

JH: Because I needed it like crazy when I was a kid. I abandoned sketchbooks because I had one bad drawing in them, because I couldn't forgive myself for having ruined the whole thing. I could not accept that I could fail. It was as though if I failed once, I was a failure. I wanted to write something for kids who struggled with that too. For kids who saw failure not as part of the growth process but as a thing that defined them. Failure shouldn't define you; it should help reconfigure you and help you move forward. But I think so many of us fail at something, and we feel our legacy will be that we failed at that one thing. Even tiny kids.

DM: You followed up *Tomorrow I'll Be Brave* with *Tomorrow I'll Be Kind.* Like your first book, the main text

is a poem, which means once again your illustrations are a big, big part of the story. Why the word "kind"?

JH: When I was working on *Tomorrow I'll Be Brave*, I had this huge bank of words that I was working with, all of which I wanted to illustrate. I started organizing them, trying to limit myself, and these two camps started to emerge. There were the brave words, about taking care of yourself and preparing yourself for the world and making your own life better. Then there were the words that were about you helping everyone else around you, about you making the world better.

DM: Was this book prompted in any way by a lack of kindness that you were witnessing in the world?

JH: Yes, but I think there was more of a tie-in to all of the tools I was learning in therapy, honestly. Because of the postpartum, I needed to figure out a way to not feel I was in crisis mode all the time, and I was in weekly therapy for three years. It was so good for me, and I feel like it's improved every relationship in my life. I wasn't totally aware of a lot of my destructive behaviors, which were all very subtle things that were undermining the good parts of relationships. With the kindness book, there were a few things that made it into the book that I was specifically learning on my own.

DM: Like what?

JH: In the "generous" spread, a parent bunny is giving birthday gifts to the child bunny. But the following spread shows we all have ways of giving back. There are different examples of showing your love to people. At that time, I was really obsessed with the love languages, so if you actually look at that spread, all five love languages are represented in the illustrations. Understanding that people want to feel love in different ways, and they want to express love in different ways, just blew my mind. So, you shouldn't undermine someone's version of expressing love because it's not the way that you want to feel love. You should just have a conversation about it.

"I loved the Letraset and the rubdown type on teen magazines of the '70s. I loved the chart pack rules and the weird illustrations, the cut-out heads. The designs were loud, and fun, and there was just stuff everywhere and I thought, 'Wow, who does this? How do you get to do this? I want to do this when I grow up.' If *SPEC* and *16* were still around I'd be working for one of them now. That would make me so happy."

GAIL ANDERSON

designer, art director,
writer, educator

February 23, 2011

SAEED

Saeed Jones is a polymath. He is a writer, a poet, a talk-show host, a cultural critic, an educator, and a bon vivant.

He has won a Pushcart Prize, and his debut poetry collection, *Prelude to Bruise,* was a finalist for the National Book Critics Circle Award and was awarded the 2015 PEN Award for Poetry.

Saeed just released his highly anticipated memoir, *How We Fight for Our Lives,* and a review from NPR declared, "Jones's voice and his sensibility are so distinct that he turns one of the oldest literary genres inside out and upside down.

In this memoir, Saeed has developed a one-of-a-kind style that is as beautiful as it is powerful, and he has cemented himself as an essential writer for our time."

JONES

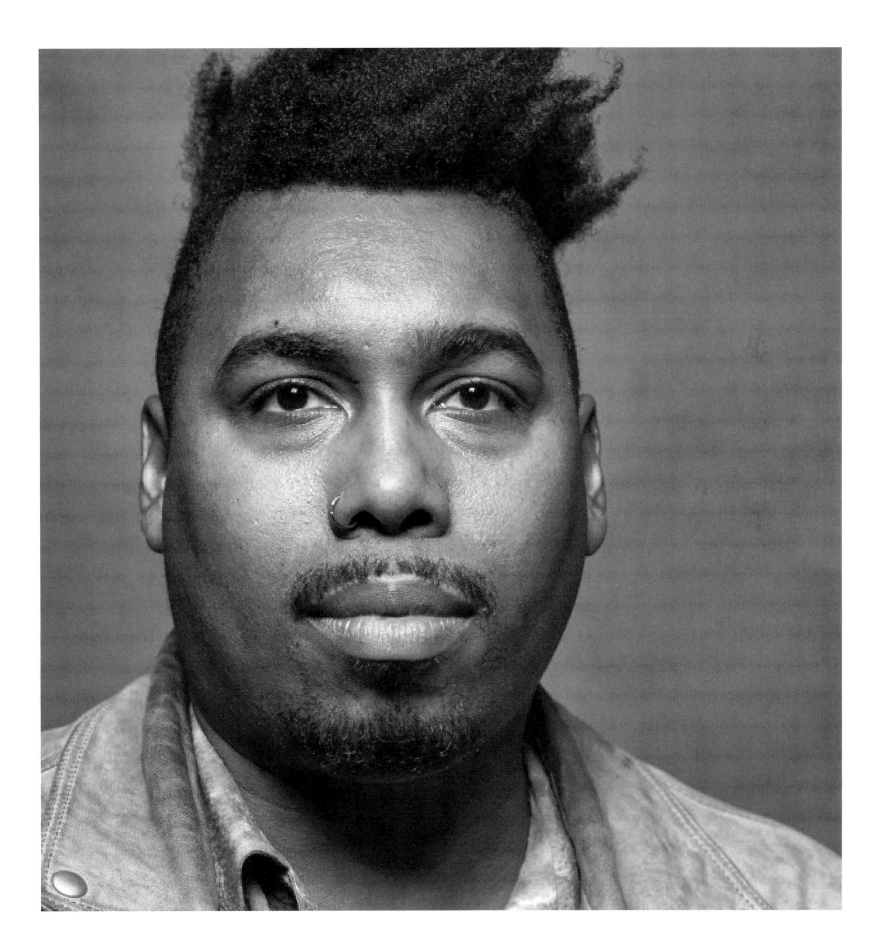

DM I understand that your mother named you Saeed because it means "happy" in Arabic.

SJ Yes, and it has relationships to Muslim faith and Persian history. Sometimes I'm told, often by taxi drivers, that it's good or happy and fortunate, which is what my mom always said. I've always liked my name.

DM You were really impacted by the deaths of Matthew Shepard and James Byrd Jr. I read that you stated that, just as some cultures have one hundred words for snow, there should be one hundred words in our language for all the ways a Black boy can lie awake at night. How did you cope? Were you always in a state of fear?

SJ Not necessarily. I was a very creative kid. I was reading very, very passionately, particularly when I was in middle school. We didn't have the Internet, dial-up. I started writing. I had a really rich creative life. I didn't realize I was coping. My reading and what became my writing life manifested in this rich interiority. I have such an overactive imagination. I had elaborate fantasies and a world to myself. That kept me from feeling dead inside and kept me from feeling that the way America was outlining the borders of my identity in barbed wire, that they were never going to get to who I really, really am.

DM I grew up in such a state of both cultural and personal homophobia, I didn't come out until I was fifty, so I totally understand. You said that "gay" wasn't a word that you could imagine actually hearing from your mom, that if you pictured her moving her lips, AIDS came out instead. You finally came out to her in 2005, when you were nineteen years old. You described the experience saying, "I had come out to my mother as a gay man, but within minutes I realized I had not come out to her as myself." Can you elaborate?

SJ As a queer person, I feel that the coming out narrative is so simplistic. It's so limited because what does it mean? What kind of gay? It is certainly a vital bit of information, but it is far more important to the straight person than it is to the person saying it. We know we're coming out constantly. It is an ongoing dynamic. I came out to my mom. I said, "I'm gay." She asked me, "Do you use protection?" I did appreciate that because there was no judgment.

DM Writing a memoir relies quite a bit on memory. About memory, you said, "You don't just have a memory randomly. We react to it. It acts upon us." You go on to state that you wanted to capture the way our memories and our desires and our anxieties are always with us. They're that passenger with us as we're making our way across the landscape. Saeed, why the combination of memory, desire, and anxiety? That's an interesting trifecta.

SJ Memories, for a lot of us, are rooted in what happened and what we wanted to happen. A lot of the memories that become formative...it's kind of framed in our brains by between: this is what happened, this is what should have happened, or this is what I wish happened, this is what I thought was going to happen—and that kind of colors it. That's the difference between a happy memory and a sad memory, right? The happy memory is I wanted that bike, and I got that bike, or I got something even better. Or the sad memory is I thought he was the one, and he wasn't the one. He broke my heart. That's what defines how we kind of organize it in our brain. Then there's anxiety. Do we hold onto this memory?

Do we share it with other people? Whether we are writers or not, there's constant anxiety about are we right? Do we remember it as we think we do? We have anxiety about these formative memories, these stories we've held onto about ourselves. If you can't be confident about your memory, do you even know who you are? That's a lot, and I'm really interested in it. When we live in this world and this America, where it's just a constant state of a loss of control, the rigor of unpacking that triumvirate of memories is really enriching.

DM Your writing is really powerful. That feels like such an understatement. It's lyrical. It's urgent. It's captivating. There's a passage in the book that I think really takes that trifecta, that memory, and desire, and the anxiety in the way that you describe a time when you got home, after your mother died, in 2011. It will give our listeners a sense of your prose and its extraordinary, emotional weight if you could read it for us.

SJ Of course. Thank you. "The air was noisy with crickets chirping and leaves rustling in the breeze. With my eyes closed, all the trees shifting in the night sounded like faraway ocean waves. I walked slowly down the long gravel driveway between the house and the road. About halfway I fell to my knees. I ran my hands through the dirt, pushing the stones, then pulling them back in handfuls, as my tears stained them. It didn't matter how I acted anymore. A friend told me once that after her father died, she cried so intensely a blood vessel in one of her eyes burst. It had seemed like an impossible marvel when she told me at the time, but now, I knew. Tears don't always just fall. Sometimes they rip through you like storm-painted gusts instead of mere raindrops."

DM There really is nothing like the death of a parent. I had a very, very complicated relationship with my father, but I did love him very, very much. I found out he died en route to trying to see him. I started wailing. There were noises coming out of me I didn't even know existed. I don't know that they ever will come out again quite in that way.

SJ Exactly the same. Crying, and the way I captured my tears in that scene, and the way I had never cried like that before. I hope I never cry like that since. You wail until your throat hurts, and then you just start coughing. That level of keening really is an intense physiological experience. Your muscles are sore. So, you wake up hungover, though you were totally sober the night before.

DM Right. Because you don't wake up. When you wake up, you don't always remember.

SJ The finality of death with one of the people who made you is such an overwhelming and fluid and evolving revelation, and it takes like a full year or two for you to kind of process this. You keep remembering all the things that will never happen again, and you don't remember them all at once. That's the other thing. It's a proof of love. Like you said, your complicated relationship with your father does not negate the vibrancy of the love. Even if you couldn't currently access it, it clearly was in your mind and in your body. Love is almost like gasoline reserves in your body, and you don't know how much is there until it's all burned out.

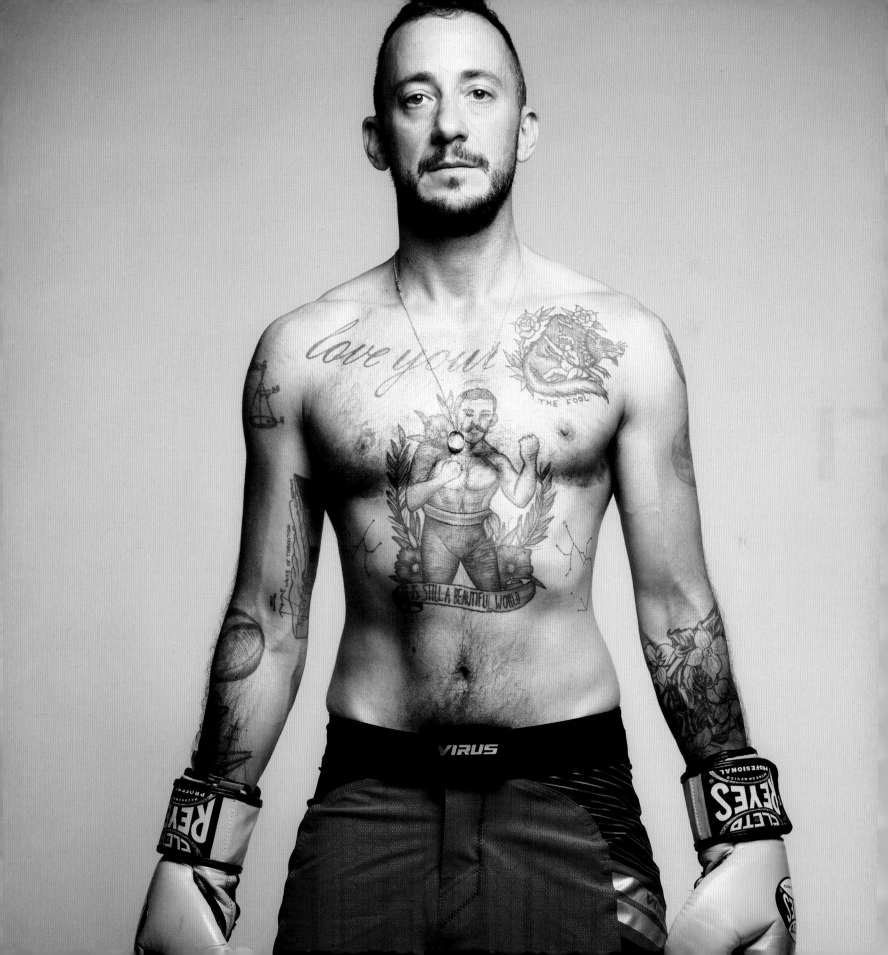

THOMAS

Thomas Page McBee's first book was his memoir, *Man Alive*, which is his very personal answer to the question "What makes a man?"

PAGE

The second book, a researched memoir called *Amateur*, is also about masculinity. It is about learning how to box and what boxing tells us about masculinity's connection to violence. McBee comes at the topic from the perspective of a transgender man and the first trans man ever to box at Madison Square Garden.

McBEE

DM Thomas, when you were twenty-nine, you and your partner at the time got mugged. You were almost murdered. The fact that the mugger thought you were a girl ultimately saved your life. After, you began having recurring dreams of a bearded version of yourself running shirtless. How did that make you feel?

TPM What was so shocking is that it was the second real experience I've had with trauma. I had this abuse background, and I knew there was something else going on, a compounding issue with my gender, and I didn't even have the language for that. This terrible experience where I was held execution style on a sidewalk for like ten minutes, and I didn't say anything. My partner at the time was trying to get this guy's attention, and it was clear he didn't care about her. He was really focused on me. Eventually, I just said whatever she was saying. When I spoke and my voice was not a voice you'd typically associate with men, he said, "Run." He let us go. There was such a potent metaphor to that. I spoke and it saved me to be this thing I had in some ways always struggled with being. I'm a feminist, and I felt so bad about that. I wanted to like being female because I love women and being a woman is awesome, but I wasn't one. In this strange and profound way, this man, seeing me for who I wasn't, and that saving my life, it was almost like okay, now I can close that door. That's why I had to be in this body, that's why all of this had to happen, and now that's resolved, and I ran.

DM You wrote this in the *New York Times* about the experience: "Our mugger showed me the universality of trauma, and something tore loose inside of me, like a tooth wiggled free from the gum. I was, in fact, completely normal. I had behaved as anyone would…. And just as trees move toward sunlight, I had survived, not only the mugging, but also the abuse of my childhood and discovered that the life I had was the one I had deserved all along." Where did that epiphany come from? Did it manifest through the experience?

TPM I remember that night after the cops came and we gave the report and going back to our apartment. My partner at the time had such a different experience. She was horrified, understandably. I remember her being thrown off by my reaction because I was so happy to be alive and then that euphoric feeling of survival. I remember how I had survived in this other way.

DM Let's talk about your second book, *Amateur: A True Story About What Makes a Man.* After you transitioned, men appeared wanting to fight you. Why do you think that that was happening and did it take you by surprise?

TPM I'll give you a bit of context because nobody I know has had this happen to them. But my mom died in 2014, and it was really sudden and awful. It was also a few years into my transition, and I had just moved to New York, and moving to New York was nightmarish. I also was at a point where I was feeling really frustrated about, how do I even live in this body because everything about…. My range of emotion was feeling more and more limited, not because I was on testosterone, not because of something with the hormone, but because I felt like when I was expressing beyond this very limited range, I was met with a negative reaction. I was walking around really angry because I felt rage from being in grief, which is a normal part of grief, but I also felt like it was the only appropriate expression of grief that I could have. In retrospect, I think a lot of men were really angry.

DM Hence the 2016 election.

TPM Exactly. But nobody was talking about it, and that was part of the problem too, nobody was talking about it. Because of the economic crash, there was a lot of conversation about men and work and so on, but people weren't talking about the broader emotional stuff in a big way. Anyway, I was walking around angry and there was this one summer in 2015 where every single month a guy tried to street fight me. It was over dumb stuff like a bicyclist who almost ran me down going the wrong way on a one-way street and then was mad at me about it. But I was also probably willing to engage with people like that because I was mad. I realized, I've got to do something different. And a question came into my mind, which is, "Why do men fight?" I pitched a story about that question to my bosses, and they were like, "Yeah, sure. Go write a story about boxing." That's how I came to learn to fight.

DM In 2015 you fought Eric Cohen, a private-equity firm partner, at Madison Square Garden as part of a charity organization that puts together boxing matches. As you described it in 2016, "Here we are, two dudes with almost zero ring experience, exchanging blows at a white-collar charity match in front of 1,700 drunk finance-types in that hallowed hall of American boxing, Madison Square Garden." Thomas, you were the first known transgender man to ever fight in Madison Square Garden. What was it like?

TPM I was coming at it from such a dark place in the beginning. It took me a long time to realize that there was some historical element. I'm not a real boxer. I'm just a guy and I also had not enough experience. Five months is not long enough to train to fight.

DM It's not enough time to train for anything.

TPM It was a wild idea in retrospect. I didn't have time to think about anything. I didn't even have time to report. I was working a sixty-hour-a-week media job and then I had to go to this other job I had, which was training to box with these incredibly high stakes. Coming into Madison Square Garden when I was going to fight was the first time I understood what was happening, and then I was really excited.

DM Leading up to the fight, somebody asked you why you were doing it, and you wrote, "I usually mumble something about an anthropological study of masculinity. But the truth is a mosaic of horrors snapshots of unresolved rage and loneliness that boxing, I hoped, could deliver me from." Did it?

TPM I've been thinking a lot about fighting ever since because I'm not a particularly violent person. I go to Quaker meeting. It's part of my nature to not be violent, but I was always a fight fan and I understood what boxing was, but I didn't understand it in a physical way. Boxing redelivered me to my body. I got to have a really deep experience of my own body and its strength. It's really interesting that half of people in our culture are taught to fight and told that fighting is the right thing to do. And half of people are taught to do the opposite, to freeze, to give up, maybe to run. But knowing how to fight is terrifying. Boxing is an incredibly challenging sport. And it's really exposing. It's a very vulnerable sport. There's something very sad about the fact that the cover of violence allowed for me to have such intimacy with the men that I would never have had otherwise.

DM You've described the masculinity crisis as a spiritual, health, and environmental crisis. How do we even begin to try to combat this?

TPM I would focus more on boyhood, both as a place where we can make some real difference and impact but also where men can think back on where they learned some of this behavior that I think of as innate but that troubles me. Most men, in my experience, are troubled by the things we are all troubled by. Niobe Way, an NYU psychologist, said to me, "Instead of asking yourself 'am I a good man?' ask 'What am I doing to maintain the status quo?'" That's really profound. I think about it every day because if the status quo is causing harm and you agree with that, that is an opportunity there, you can be an agent of change as a man.

"I'm

fascinated with people who take risks
because I put off taking risks for a very
long time. I tried to be very safe.
And it just wasn't working for me."

TINA ESSMAKER
writer and coach
November 17, 2014

MICHAEL R.

A playwright, composer, lyricist, trash-talker.

That's how Michael R. Jackson identifies himself on his website. Jackson won the 2020 Pulitzer Prize in Drama for *A Strange Loop*, a groundbreaking musical about the creative process of an artist writing a musical. It deals with issues of identity, race, and sexuality. A strange loop, indeed. In this interview, we talked about some of the loops in his extraordinary career.

DM Michael, what intrigued you about soap operas?

MJ I didn't know it at the time, but I was learning how to tell stories and about what the power of stories accurately was. But on a sort of surface superficial level, I just liked watching crazy things happen with these people, women getting into fights in fountains and people being locked up in the basement by their crazy ex-boyfriends, and there was a such a Grand Guignol melodrama aspect to it that I found really, really appealing.

DM When you were twelve, your mother took you to Toronto to see the plays *Phantom of the Opera* and *Show Boat*. I read you didn't really understand *Phantom* but were complete knocked out by *Show Boat*. Why did it move you so much?

MJ Early on, it was a sign that I was very interested in story and really understanding what the story was. Those were my gateways into musical theater. I loved those cast albums, and I used to play the cassette tape over and over and over and over and over again. I still have it. It's worn out on both sides. You can't see any of the words on the tape.

DM A family friend then shared the movie *West Side Story* with you. You've said that after watching that you lost your mind. In what way?

MJ

West Side Story was one of those cultural artifacts I'd always heard of but didn't really know anything about. I don't even think I even knew who Stephen Sondheim was. It was the music and the dancing and the story—all these elements together with such attention to detail and style. I wasn't at an age where I could really reckon with the problematic aspects, given that it's three white writers talking about Latin people, but the artistic gestures of it bowled me over.

DM Your former teacher, John Polinko, taught a class on the craft of playwriting and screenwriting, and he shared a definition of story you've carried with you to this day.

MJ John defines story as a character wants something, they're presented with obstacles, and they either achieve, abandon, or fail at their story purpose. It's always been this very simple way of thinking about what's happening in something I'm writing if everything else is failing. If I can just boil it down to: "What do they want? What are they doing to get it? Do they win, do they lose, or do they change?"

DM You've said it helped you prioritize story over everything else. How do you go about doing that? How do you make that conscious decision?

MJ I have to know what the journey is. With *A Strange Loop*, for so long I didn't know that the issue was that you have a character who wants to fundamentally change himself and thinks something's wrong with him. And the truth is that there's nothing wrong with him. Once I knew the journey, it was easy to go back and order all the steps and story points that would lead to that conclusion.

DM I came upon a quote about that and reading what this play has taught you about yourself was really moving. You state that Usher, your main character, "didn't know he hated himself and you didn't know you hated yourself and you didn't know that's what it was. And, in fact, there was nothing wrong with you. Once you know that there's nothing wrong with you, you can actually move forward, albeit with a lot of the same problems, but not from the point of view that there's something wrong with you." How did you come to that realization? It's so profound and you're so young to have figured that out.

MJ It was a lot of hitting my head against the same wall over and over again in various areas of my life, whether it was how I felt about myself in terms of other men, other gay men, whether it was when I was working terrible day jobs that were so crushing and racist and capitalist and bearing down on me. And then me feeling that somehow there was a failure within me to beat a system that was bigger and older than I was. I had to go through many cycles of that plus going to therapy and actually sitting and talking to someone.

DM You decided to go to graduate school and you were rejected from every school you applied to except the NYU graduate Musical Theatre program, but you'd never written a musical or even written a song lyric. What inspired you to apply to the Musical Theatre department?

MJ I was very musically inclined because of my background playing piano, and I used to play for church. I used to try to write songs when I was in high school, but I didn't understand lyric or song form. I gave that up, but I still would make up little tunes on the piano. When I graduated from undergrad, I didn't know what I was going to do with my life so I applied to a bunch of grad schools and this boy I liked, who was also applying to the graduate school theater writing program, said, "Hey, let's apply to the graduate school theater writing program together." And then he started dating someone else. I was devastated. And we were both in the program together. We were ushering at the *Lion King* together. The person he was dating also worked with us at the *Lion King*. It was a soap opera. But I applied because I felt like I needed some more time to figure things out. It ended up being a really important move. I grew in leaps and bounds because once I learned what song form was as a lyricist, the musical impulses had somewhere to go. I decided to take my musical impulses, put them with my lyric impulses, which were really honed by then. The song that came out of it was "Memory Song," which is in *A Strange Loop*. If I hadn't gone to the program, none of those things would have happened. And the teachers in the NYU grad program were incredibly nurturing to me artistically and encouraged me. Those years were really vital.

DM You've written about how white rocker women can let you know everything that's going on with them in their music and can do it without facing any consequences. Whereas if you're a Black person, you will inevitably have to pay the consequences for that. What consequences have you had to pay?

MJ Listening to Liz and Tori and Joni, the thing I found most inspirational was their individual voice and their commitment to saying what they had to say without giving any fucks about it. And also being very emotional and tempestuous and funny and sexual. They could do anything. I was so inspired by that. But as a Black artist, I felt like that quality was less appreciated, or it seemed to me at the time, particularly as a teenager, which is when I encountered a lot of this music. I began on a journey to figure out if there's a way that I could, in my own art and later my own music, be that singular in expression and not be boxed in by any outside expectation.

DM What do you think of the brouhaha surrounding the Cardi B and Megan Thee Stallion song "Wet-Ass Pussy"?

MJ "Wet-Ass Pussy" was pretty dry for a song that's called "Wet-Ass Pussy." Artistically speaking, it was pretty dry. I'm more shocked by Liz Phair's song "Flower" because of the tension she puts in that song about talking about her sexual desire but singing it in a baby girl, baby doll voice. When I listen to "Wet-Ass Pussy," it seems like something that was thrown together and is not as empowering as it could be, artistically. I'm not talking about how it empowers women. I'm just unimpressed by the song as a song. As a song, let's raise the bar. Let's do things that make me feel it, make me see it, I want to see it dripping. That's just my opinion. Cardi is a hot icon of our time. Who am I? I'm just a humble Negro musical theater writer in New York City.

DM Let's be real here. You're a hell of a lot more than that. When my wife first mentioned she wanted to go see your play, she told me the name. I was like, "What? There's a musical about Douglas Hofstadter's book?" She had no idea what I was talking about. That became a little bit of our own *Strange Loop*. You've said that Hofstadter's theory gave you a container for a piece that was inherently about self-reference. I also read an interview with you where you cited the W. E. B. Du Bois quote about double-consciousness. How did that impact your viewpoint?

MJ W. E. B. Du Bois talks about how to be a Black person in this country is to have a double-consciousness. That wasn't an explicit thing in the soup of what I was writing. It just, it was inherent in my own experience. And thus Usher's own experience of life is that we're African American people who live in this white container. And yet we ourselves are Black people who are having our own experiences of self. That's why in *A Strange Loop,* Usher is creating the context for his piece, but he's also responding to the world outside that's also impacting the thing he's creating the context for. It's this constant duality of the white world and the Black world, and Usher being the little molecule flowing back and forth between those worlds.

DM *A Strange Loop* is about a character named Usher. He is a heavyset queer Black man who works as an usher for the *Lion King* while struggling to create a musical about a heavyset queer Black man who is struggling to write a musical. Did having a character who was an usher named Usher have anything to do with your sharing your name with a famous musician?

MJ The thing I always try to remind people about *A Strange Loop* is that it's not autobiographical. I think of it as self-referential, or if I had to characterize it in any sort of way as out of autobiographical, I would say it's emotionally autobiographical, which is to say that I have felt everything that Usher has felt. But the story of Usher in *A Strange Loop* is a piece of fiction even if I drew from some of my own personal experiences to write it. There are many loops within loops of the show because it has to do with self-reference. It was important to echo my own experience by having Usher be a "famous name" because my name is such a huge part of how people relate to me because of Michael Jackson, the pop star. There's this character who's trying to figure out who he is and change himself, while there are other people who still think of someone else first when they meet him. He's like, "No, I'm the center of this story. I'm the nucleus. And yet I hate the nucleus." I'm fighting against being this person people already think of me as. I wanted to create as many loops that take him both far away from himself and closer to himself at the same time.

DM Does it ever get tired, people asking you about your name?

MJ No, because at this point I feel like I own the mantle. I don't say this in a bragging way, but I'm just realizing that I'm probably the most famous living Michael Jackson. My website is called *The Living Michael Jackson* and all my social media handles are *The Living Michael Jackson* because I also want to remind people that whenever you think about me, think about him. I can never get away from it. And yet when I reference it, it refers back to me because I created that structure of referring to him when you refer to me.

" I think that my trajectory in life is that I wanted to be Stevie Nicks, and I ended up being Lindsey Buckingham."

KAKI KING
musician
February 18, 2018

VISION
ARIES

5

SHEPARD FAIREY

MARIA POPOVA

LOUISE FILI

ISAAC MIZRAHI

MAIRA KALMAN

KENNY FRIES

MARINA ABRAMOVIĆ

DAVID BYRNE

THELMA GOLDEN

TEA UGLOW

IRA GLASS

EVE ENSLER (AKA V)

SHEPARD

Shepard Fairey is the mind behind OBEY, the most prevalent urban street artist in stencil-art propganda history, and a student of the arts of persuasion.

Fairey began his epic satire on the science of celebrity endorsements and the alchemy of suggesting desire back in 1989, while he was still a student at the Rhode Island School of Design, majoring in illustration. Currently, Shepard is based in Los Angeles, where he runs the design team at Studio Number One. His most recent exhibit is in New York City, and it is titled "E Pluribus Venom." Shepard Fairey's new body of work contains politically charged paint, screen print, stencil, collage, and mixed-media pieces that use metaphor, humor, and seductive decorative elements to deliver provocative but beautiful results. His work blurs the perceived the barriers between propaganda and escapist decoration, political responsibility, and humor, with the intent of stimulating both viscerally and intellectually.

FAIREY

DM It's been an incredible twenty-four hours for you. You went to the hospital last night for emergency eye surgery, and now you've been discharged and somehow still wanted to do this interview despite everybody else in your life wanting you not to do it. It was even canceled, but you insisted that we continue on. Shepard, thank you so much for being such a trooper.

SF I doubted you had Banksy on speed dial to replace me, and I try to do what I can. I'm glad to be here.

DM I understand from your wife that you have Type 1 diabetes, and you had to have eye surgery last night to relieve some of the problems that you've been having. Can you tell us a little bit more about how you're doing physically?

SF Sure. I have what's called diabetic retinopathy. Diabetes is very hard on your blood vessels, and eventually you can develop bleeding in your eyes from the smallest blood vessels, which are very sensitive in your eyes. That happened to me about four years ago, and we did some laser surgery to correct it, and then while I was in New York for my show, a piece of the scar tissue from the laser surgery started to pull off the surface of my eye and detached my retina.

DM Oh, my God.

SF Right after I got back, I underwent surgery wherein they cut open your eye, remove all the vitreous gel in the round space in your eye. The scar tissue is removed, you get more laser surgery, the gel is replaced in a saline solution, and a gas bubble is created. The gas bubble floats to the top and forces your retina to heal in place. It's a pretty serious surgery, but I already had it done to the left eye three months ago, and that went perfectly. I was in New York saying, "All right, great, I got both eyes in perfect order," and then this happened. But I think everything's going to be fine.

DM It must be incredibly terrifying, it's the worst possible nightmare to not be able to use your eyes as an illustrator and artist.

SF It's frustrating. In the years I've had diabetes, I wasn't always taking good care of myself. That changed five years ago when I had an initial bleed in one of my eyes. Up until then, I'd always been really healthy. I don't think I was as on top of it as I should have been, and once that happened I got on an insulin pump and I regulated my blood sugar. But it takes a long time to correct all the years of damage that accumulated. Sometimes there's nothing that can be done except these types of surgeries. I was told that if I recover well from this surgery, it could be many, many, many, many years—if ever—before I have problems again. So I'm optimistic.

DM Artists choose so many different paths to follow. What made you choose street art?

SF I choose street art mostly because I was too chicken to send out slides and pound the pavement. I also have a background in skateboarding and punk rock, and both of those cultures were very marginalized do-it-yourself cultures in the 1980s. We had a "If the mainstream doesn't accept us we're just going to make our own scene" attitude. I think that I was bringing a bit of that philosophy into what I was doing. I studied commercial illustration, but I didn't think that I ever wanted to be an illustrator. I took a lot of graphic design electives and photography electives and printmaking, and what got me really excited was screen printing. As an illustrator doing paintings and drawings, I often felt like I couldn't experiment enough. I'd either overwork a piece or felt like I should take it further, but I was scared to change anything and mess it up. With screen printing, I felt like I had a lot of latitude for experimentation.

SF Then I started getting into putting stickers and post up on the streets. It was only logical that I use the screen printing that I had—techniques that I've learned to make multiples—to put stuff up on the streets. I think it was the conversions of several variables that made me choose street art, actually. But I never wanted to pander to the elitist fine art world, and I still don't think that I do. I still do street art. I still make $35 screen prints, which people then flip on eBay for triple, quadruple, hundreds of dollars. I ignore market forces to keep my work affordable for the people that I most relate to, the people that are skateboarders, punk rockers, college students, and for who my work could be a gateway into appreciating art on a level beyond album packaging or skateboard graphics or T-shirts. I still make T-shirts that are affordable. People look at those items like that makes you a sellout. But I believe that this is the most appropriate place for my work. It is both rebellious and accessible.

On the other hand, doing work in a gallery is an opportunity. Selling my work in a gallery gives me more of an opportunity to spend a lot of time on a piece, and I feel like I'm making—if I may be so bold—masterpieces. When you're making work that has to be inexpensive, you have to find a balance between quantity and quality. When I was first doing street art and putting posters up, I would print a few of the posters for the street on ticker paper so I could sell them. It was incredibly efficient selling them for $20 or $30, but now I have a market where I can make pieces that I think are more sophisticated and will endure when people see them in books as part of our history.

I try to work every angle. I think Banksy's doing the same thing. Banksy still does work on the street. It's free. You see it on the street, and it's free. He still makes books. I was talking to him when his book first came out, and he said that the publisher forced him to do the hard cover first, but he couldn't wait until the soft cover—which was going to be less expensive—because he wanted everybody to be able to get it. This is someone who is making a lot of money with their art, but they're also trying to keep what they're doing accessible.

There have been other artists who have started as street artists because they knew it had a rebel cache and that it would be a great marketing tool, and then they've quickly transitioned to doing nothing but gallery shows. The street art was a post, it was a way to move up the ladder more quickly. I don't respect that.

DM Is it true when people ask you what you do for a living, you say that you are a graphic designer?

SF Yes, I'm a graphic designer. When I graduated from college I was working as a professional screen printer and the street art was just a hobby. As I realized I didn't want to pull a squeegee all day, I went into graphic design.

DM But you're also an artist, and there are many, many other titles one could apply to you. Why is "graphic designer" your de facto title?

SF I think "artist" sounds pretentious. DM Why?

SF Every time I meet somebody wearing a hippie-dippie outfit and they hand me a business card that says "artist" as their profession, I have to roll my eyes. I just think that the best way to describe what I do is "I'm a graphic communicator." I really enjoy the poster and print formats, and as a poster artist I think clients saw what I was doing and felt my work was well suited for products and advertising. I was never opposed to that; I felt like being a graphic designer was a great way to make a living and hone my skills. I could apply everything I was learning to my own poster work. But what goes into both my graphic design work and my artwork is virtually identical, with the exception of my artwork does not deal with anyone else's agenda except my own. Nevertheless, I still feel like my artwork falls under the realm of graphic design.

DM You designed the movie poster for the Johnny Cash movie *Walk the Line*, you've designed record covers for Billy Idol and the Smashing Pumpkins. You've also done work for Dewar's Scotch. Do you ever feel that your commercial work compromises your artistic vision or your philosophical mission?

SF I'm in a position now where I have enough revenue streams from the T-shirts that I do, my artwork, and my design firm that I actually don't have to take on any work that would compromise what I want to achieve artistically. In the past I definitely had to deliberate over a few projects because I was broke and I needed the money. It wasn't something that I felt was furthering my agenda as an artist, but the big question I asked myself was this: "Did it contradict my agenda as an artist or did it undermine sort of my ethics as an artist?" I've turned down work in the past from gas-guzzling vehicles and from cigarette brands. I've taken some work from Coca-Cola, and I've turned down other work from Coca-Cola. It all depends on the project. But at this point, working with bands that I am a fan of, like Billy Idol or the Smashing Pumpkins or Black Sabbath, is something I'm proud of. A lot of the work is very political, and it is perfectly in step with what I'm trying to do as an artist, and it's a beautiful marriage of art and commerce. I will stand behind that 100 percent no matter what anyone says, and I try to do as many projects like that as I can.

DM What would be the distinction between accepting one job from Coca-Cola and rejecting another?

SF One job was doing work that was going to have a very street art feel to it, and I felt like it would look like I was a puppet of the Coca-Cola Corporation and it was a sellout move. I don't have a problem with Coca-Cola, I drink Diet Coke daily, but looking like I'm a pawn of Coca-Cola or that my integrity's been compromised by them—I don't want that. It's a delicate balance.

DM Have you gotten caught putting your art up? And what other cities do you post in besides New York?

SF I have been caught putting my art up. Every time I go out and put a poster up, I know that I could get arrested, and I've been arrested thirteen times. I've put my art up in almost every major city in the United States. The work is ephemeral though. Street art can be up for days or weeks or years, but it's always impermanent, and sometimes it gets cleaned very quickly. But I know that everything I put up will be seen, and that's incredibly empowering. A lot of people don't feel like they have a voice at all, and street art is a sure way to make sure that if you want to express yourself or you have a political statement that you want to make, you can put it out there.

DM How would you describe how your work has evolved?

SF It has evolved a lot. Anything you put out in the public space becomes repetitive over time and you become numb to it. It also has the potential to become passé, and I actually love that because it just gives me the motivation to try to keep my work evolving.

I began early on with the Andre the Giant sticker as a pop culture reference. The initial posters and stickers were mostly highjacking the cultural currency of things that were already established. Early on, I likened the coup of making something silly seem more important than it was by associating it with something that was more established. It was both a highjacking and sort of desecrating pop iconography as I was making pop art.

Around 1995 people thought that my posters were from a cult; they didn't understand them and felt threatened by them. It made me think of all the things that people were assaulted with in American society that they should be threatened by but aren't. They don't consume with enough discretion. They're easily manipulated by politicians. I decided I wanted to be more provocative with what I was doing. I'd also gotten into propaganda posters, particularly Russian Constructivism, and I decided to start integrating the word "obey."

DM Why?

SF I was thinking about what people do the most that they actually want to do the least. And I realized that it was being obedient and following the path of least resistance. They make excuses about why they're unhappy with their routine but are going to stick with it anyway. I felt that being confronted with the word "obey" would force people to deal with a lot of this and maybe inspire them to act. In a sense, it was reverse psychology.

I'm not an anarchist. I'm not saying "disobey." It was more about questioning authority and questioning a word that I felt might provoke that. I also wanted to take my work away from the silly Andre the Giant perspective and move it more toward a "Big Brother is watching you" Orwellian critique of what is going on in society. I felt like I wanted to move into a direction more reminiscent of Russian Constructivism, Barbara Kruger's aesthetic, and some of the work of Robbie Conal.

Initially I was making my posters on the copy machines at Kinkos, and I was so broke, I figured out how to rig the machines with a paper clip so I could get free copies. They had a red toner cartridge and a black toner cartridge. I would make bold images that I could run through the copier once for red, and once for black, and get them free, and have eleven-by-seventeen posters. This is extremely important, and probably as much of a persuasive factor as any of the other things: my color palette was dictated by my aesthetic as well as some of my interests, but the deal was sealed by the Kinkos ink, even though I was probably moving in the direction of using red, black, and white anyway.

DM I want to end our interview by reading a quote from your book, *Obey: Supply and Demand. The Art of Shepard Fairey.* This is about your work and is written by an artist named Zephyr (Andrew Witten). "Shepard Fairey is the most obsessed artist I've ever met. I don't believe there is anyone living as committed to supporting their art around the planet as Shepard is. Thank God, he's a great fucking artist who does beautiful, thought-provoking work or we might be bumming out right now, begging him to stop. So thanks for doing your thing, Shepard, and stay safe out there. We need you to keep on doing it, but you're obsessed so we know you ain't going to ever stop."

March 9, 2012

MARIA

Maria Popova sorts through the amazingness of the Internet and gathers it all on an ebullient website called *Brain Pickings*.

The site, as well as its accompanying Twitter feed and newsletter, is a neuron-firing, hyperlinking, wildly creative space for the curious mind. While Popova admits that she spends far too much time curating her showcase of art, reflection, and insight, more than a million people benefit from her tirelessness. In our conversation, we talked about the roots of her argument that creativity is combinatorial and how that concept dovetails with curation in the Internet age.

POPOVA

DM You were born and grew up in Bulgaria then moved to the United States in 2003 to attend the University of Pennsylvania. What was your experience growing up in Bulgaria?

MP Communism fell in the early 1990s, and my formative years were very constricted both culturally and materially. The subsequent shift was very interesting. A culture that had been oppressed for so many decades trying to find its way into democracy and consumer culture—it's very overwhelming to behold that. I guess that's why I'm interested in how we make sense of the world through objects and materials.

DM It's interesting that you describe the situation as overwhelming because the amount of information that you cull through, curate, and communicate for *Brain Pickings* can feel overwhelming, though in the best possible way. I wonder if experiencing the fall of Communism influenced the way in which you produce and share information now.

MP I've never thought about it as stemming from that far back. In my mind, my curatorial habits are more closely related to my more recent experience in higher education here in the United States. But it's an interesting concept. I'm sure it must have something to do with the shift from near zero to near infinity.

DM When you were growing up in Bulgaria, did you think, "One day I want to move to the United States?"

MP Escapism is the culture there. It's going to take decades for that culture to recover from jadedness and non-entrepreneurship. There are some really, really smart people in Bulgaria, but they become disillusioned easily, and a lot of them leave to pursue what they're truly passionate about. And, of course, there's the other factor of every teenage girl wanting to be as far away from her mother as possible. In my case, I decided to put an ocean between us.

DM While at the University of Pennsylvania you worked four jobs in addition to your full course load. I read that you said it was tough, but it taught you something about what money means.

MP I went to a school with mostly wealthy people who didn't have to work and had a very different kind of upbringing. I did not relate to these people. At the same time, to stay in school I had to work all these jobs where there was a huge disconnect between work and vocation. I was trying to find my calling in the world while working jobs that pretty much had nothing to do with a calling. So, I was constantly thinking about how we define ourselves through what we have or what we can have and whether there's a way to have a relationship with money that is more aligned with what you want to stand for in the world.

DM What were you thinking you might want to do for a career at that point?

MP I was very interested in branding and consumer communication, precisely for that reason of understanding our place in the world through the stuff that we own. I'm still fascinated by that. I think it's a very interesting facet of our conditioning and our socialization. But, over time, I became more interested in other things that have to do with our bigger-picture creative actualization.

DM You had already started *Brain Pickings* while you were in college. From what I understand, you were curating content via a tiny text-only newsletter that went out to eight people. Tell us about how that began and who those eight people were.

MP I was near the end of my sophomore year in college when I joined a creative startup in Philly. I noticed that, for inspiration, my friends and coworkers were circulating material that came strictly from within the art and design industries—things that were very narrow. It was counterintuitive to how I thought creativity worked.

DM In what way?

MP This is the fundamental philosophy of *Brain Pickings*. Our creativity comes from stuff that we gather over the course of our lives—memories, inspiration, information, knowledge, insight, soundbites, visual memories—and then we recombine them to create something new. It hinges on having a very broad and vast pool of resources. So, I decided that, every Friday, I was going to send five links to five really interesting things that had nothing to do with advertising. They would be anything from an obscure short film from the 1930s to a new poet from Brooklyn. I started by sharing that with the eight people in this startup, and now I share it with a million people, but the editorial litmus test is always the same.

DM You believe that we create by combining and recombining existing pieces of knowledge with insight and information that we gather over the course of our lives, and that our capacity for creativity hinges on the breadth, diversity, and richness of that mental pool of resources. Do you feel that all creativity is combinatorial, or that a certain kind of modern creativity is that way?

MP I absolutely believe all creativity is like that. I think every idea builds on what came before, consciously or unconsciously. Even remix culture, which we think of as something nascent, isn't really. In the Middle Ages, there were these manuscripts called *florilegia,* a word that comes from the Latin for "flower" and "gather." *Florilegia* were excerpts of writings that a quote-unquote author would take from existing texts and remix, reorder, and edit together in a way that better explains whatever point he's trying to make or to explain a specific doctrine or idea that is already talked about in disparate other texts. This was one of the first recorded examples of remix culture but also the first recorded example of curation as a form of authorship. The interesting thing about those *florilegia,* by the way, is that they were the most lavish and expensive books to produce at the time, so we clearly used to place a lot of value on this form of authorship. When did we start treating it as a second-rate service?

DM Do you feel that remixing is regarded as such?

MP Things today are much more complicated because of the proliferation of platforms and the way our intellectual-property laws are written. The very notion of intellectual property is so bizarre. Property ownership is a very antiquated way to think about our sharing culture, which is how we actually interact with ideas today. The law is taxing our cultural understanding of authorship; it is not conducive to evolving it.

DM Do you consider yourself a curator?

MP Well, the giant disclaimer to this whole conversation is that this word has become vacant of meaning—it's become fluff.

DM I was looking at the Institute of Contemporary Art's website today, and there was a piece by a curator in which she said, "Curators don't design, they organize." And I thought that was a very limited view. Wouldn't you say that curating is far more than organizing?

MP Yes. I think a lot of this is semantics. Organizing is a form of design. It's the architecture of thought, which is essentially design. Organizing is not just cataloging, so I think "curation" is actually about creating a framework for what matters and why. Curation also means building that framework according to a pattern that manifests through the curatorial process.

DM You've compared curation to pattern recognition before.

MP I think pattern recognition means different things to different people, but to me it is about finding threads that run across different disciplines or eras or modalities and pulling them together in a way that's greater than the sum of those parts.

DM I read recently that intuition is, in fact, culled over years of recognizing patterns and their possible outcomes, and that when you intuit that something might go a certain way, you're really just reaching back into past patterns.

MP It's so interesting you bring this up because I am rereading a book called *A General Theory of Love,* in which the authors talk about this notion of attractors in your brain. These are neurons that are conditioned to respond to certain stimuli that we encode very early on. And later in life we seek out situations, people, and patterns that have these stimuli so we can activate the attractor cells. I think what is true of relationships and of love is true of creativity and intellectual life. The so-called rational mind is there to confirm what we intuit, and we're excellent at finding evidence for what we want to believe.

DM I think some people come to that book thinking it's about romantic love, when it's really about why we love. As mammals, why do we love? How do we find love and express love?

MP There's one line that has stuck with me from the book, which I think is brilliant and so true. The line is, "Who we become depends in part on whom we love," and that is absolutely true, certainly in relationships but also professionally, creatively, intellectually. The artist Austin Kleon once said, "You are a mashup of what you let into your life."

"That

side job can be your passion project or
that side job can be the thing that pays the bills.
There's no shame in either version."

GRACE BONNEY

author, entrepreneur,
and founder of Design*Sponge

November 7, 2016

LOUISE

Louise Fili is a master typographer, a lover of food, and an extremely Italian Italian-American.

When you step into her studio, you see it all. There's an amazing collection of Italian tins stacked beside an equally gorgeous collection of Louise's own designs. Indeed, there's a wall covered with books from Louise's tenure at Pantheon, during which she designed over two thousand book jackets. Some of this breadth is now captured in *Elegantissima: A Monograph on the Design and Typography of Louise Fili.* In our conversation, we discussed the transition from book covers to restaurants, and she reveals how sketching is the beating heart of her design process.

FILI

DM: You stated in *Elegantissima* that before you even knew what graphic design was, you knew it was something that you wanted to do. Did you want to have a creative business, or was there a specific attraction to typography and lettering?

LF: I was always fascinated by letterforms—even when I was very, very young. I think my earliest creative memory was when I was three or four, carving letterforms into the wall above my bed. I couldn't read yet—I don't even know if I could form words—but I was fascinated with letterforms. My parents would not only take that carving tool from me every day, but the next day I'd go recover it and go back at it. I also used to make alphabets all the time, and my parents would say, "Why do you have to use twenty-six pages of papers when you can just put all the letters of the alphabet on one page?" And I said, "Well, that wouldn't be right. Each letter has to be looked at on its own."

DM: You went to Skidmore College, and you've said that anyone there who couldn't paint was labeled "graphically oriented." It sounds like a disease.

LF: Yes, that's what it felt like.

DM: And is that how you were described? I can't imagine you being a bad painter.

LF: I was a bad painter. I don't know what it was. I love color. I love drawing. But painting was beyond me. Fortunately, my painting teacher was also the graphic design teacher. He had gone to Cooper Union with Seymour Chwast and Milton Glaser, and he took me under his wing and that made a huge difference.

DM: You learned typography in school by getting your hands literally dirty, by setting metal type. What do you think that taught you?

LF: So much. I used to get so obsessed with setting metal type that I used to see it in my sleep—fitting everything in exactly right and tightening it up. The tactile quality is a really important part of what I do today. Something else I've taken from that period is printing my own type and feeling the impression from that.

DM: Is it true that your senior project in college was a hand-lettered Italian cookbook?

LF: Yes, and it was for the same teacher. He was more critical of the recipes than he was of the calligraphy. I had to fix the marinara recipe before I could graduate.

DM: In one of your first jobs out of college, you were a designer at Knopf, where you also worked on illustrated books.

LF: Getting the job at Knopf was a very lucky break. All of the important moves I've made in my career have been just a matter of dumb luck and good timing.

DM: I find that hard to believe. I think that dumb luck hits you once or twice, but not for an entire career.

LF: Maybe it's knowing when to seize upon the dumb luck.

DM: You were hired as a senior designer by the legendary Herb Lubalin.

LF: Yes. Someone had recommended that I go see him, and I said, "No, no, no, I'm not ready to see Herb Lubalin yet." In the meantime, he was my idol. That was my dream job, but I didn't feel like my portfolio was ready. This person who recommended me said, "No, you're ready." So he made a call, and I had an appointment to see Herb.

Herb was not a loquacious guy, so he flipped through my portfolio and didn't say anything. Finally, I had to be the one to speak up, which is not what I usually do, either. I said, "Are there any job openings?" He replied, "I'm trying to get a budget for *U&lc*," which was new at the time—*Upper & lower case* magazine. So, maybe someday it would happen.

I knew that I had to find a way to keep in touch with him. I said, "Well, have you ever thought of doing an article on rubber stamps for *U&lc* because I collect rubber stamps?" And he said, "That sounds interesting." And I said, "Why don't I drop them off to you?" Then I had a reason to keep in touch with him because there was no email and in those days you had to call. I dropped them off, and I would call every couple of weeks, and I got to know his secretary very well.

One day I called, and she told me, "He's seen them. You could pick them up." And I thought, "Now what? Now what do I do?" I went to pick them up, and he was sitting at the end of his office. Herb had the office in this beautiful converted brownstone, and he was in this private office that was very long and narrow. He was sitting way at one end of this bowling alley, and I was at the other end. He had his back to me because he was always sitting at the desk making comps with both hands—he was ambidextrous.

I realized I better say something, or this is over. He said one thing, "What's new?" I had to go through a little dance and tell him what I was doing. And then finally I said, "By the way, you had mentioned that there might be a job opening. Is that still happening?" And he said, "No, I never got the budget for that, but somebody just

gave notice today. Could you bring your portfolio back tomorrow?" And that's how I got the job, walking in the door at the right time.

DM: At the right time. But you had been calling and calling. You write in *Elegantissima* about what it was like to watch Herb Lubalin sketch. You found it mesmerizing. Can you talk about what you saw?

LF: I think about Herb whenever I'm sketching because for me it's all in the sketch. If you can achieve in the finished piece what you've got in the sketch, then you're very lucky. His sketches were so extraordinary because he had this very, very wobbly line, but he knew exactly how to comp out whatever font he was working with. When it would go downstairs to the mechanical department to put it together, it would always match perfectly. He knew his fonts. It was as though he was tracing it in his head, and they were rough and at the same time they were anatomically perfect.

DM: You mentioned that it's very important for the sketch to manifest in the final design. Why?

LF: Because that's the soul of the design. When I get excited about a design, it's in the sketch stage. I have this feeling, "Ah, this is it. Now I really have something." Every now and then it doesn't work, but that's the great thing about design—always full of surprises.

DM: After two years, Herb decided to relocate his studio to a converted firehouse, which would have cost you your private sun-filled office. And you took this as a sign to move on. Are you a big believer in signs?

LF: Yes. I went to go visit the converted firehouse, which was beautiful but had no soul. I was going to be in the bullpen in the basement, which was not very appealing to me after having this beautiful office. It didn't feel right for me. And that's when I realized that it was time to move on even though I didn't have a job lined up.

DM: You found a new job at Pantheon, an imprint of Random House, which you've said was distinguished by its extremely mediocre jackets.

LF: I took the job for the southern exposure. I had no idea what the job was, but I figured it had to be better than being in the basement of a firehouse.

DM: You describe in *Elegantissima* how you automatically thought of a book jacket first in terms of typography.

LF: Absolutely. When I would start working on a book cover—and this is the same process that I use now, whether it's a logo or a book cover or whatever—I would take the title of the book and I would draw a 5½ by 8½

inch rectangle on my tracing pad. Then I would take the title and I would write it over and over and over again to let it speak to me. It would go from being this very amorphous jumble of letters to something more precise. And that's when I realized that this was a typeface that didn't exist and I would have to figure out how to make it. That was a very important part of it for me. And that's still the way I do logos. That's the way I do everything.

DM: You were very determined to break away from the constraints of the look that dominated book jackets at that time—you wanted your book jackets to be more intimate. How were you able to sell this notion to publishers and authors?

LF: I did it very slowly, very quietly, and very cautiously. I took baby steps. But the good thing was that because Pantheon had these very mediocre covers, no one ever took them seriously even though they had a roster of very impressive authors. These were books that you would want to read but wouldn't want to touch. I started with, "Okay, what have I got here? I've got 5½ by 8½ inches, and I can't change that. I've got two or three colors and maybe sometimes four colors, I can't do much about that. I can do a little bit about paper stock." So the first thing I did was introduce matte lamination. That made a huge difference because I was going for the tactile quality again. I wanted people to pick up these books and want to own them, to find them as objects of beauty that they wanted. Then I went after the colors—trying to explore color as much as possible because we only had three-digit Pantone numbers in those days. I used to go to the hardware stores and collect paint chips of the colors that I wanted to use. That's what I used for *The Lover* cover, for example.

DM: *The Lover* by Marguerite Duras is one of the most famous book covers of the twentieth century. Very unusual, very ethereal, very beautiful, very haunting, poignant, and heartbreaking, all at the same time.

LF: The photograph was so compelling that all I had to do was have it airbrushed, and then I had the shadow type done to echo that. It was done in that lamination with muted colors. And this was a breakthrough design for me. This little understated jacket design was Pantheon's first bestseller since *Doctor Zhivago* in 1958. *Publishers Weekly,* which is the trade rag, wrote an article about it. They interviewed booksellers who actually said, in print, that this book became a bestseller because of the cover, which was huge. After that, the salespeople didn't fight with me anymore.

LF: Designing the type for book covers transferred over to the way I design logos—so did that need for the tactile quality that I was striving for in book publishing. Once I moved over to designing for restaurants, I was able to take that a lot further because all the menus were always special paper stock. Whereas at Pantheon, the only way I could get a special paper stock is if I traded in a color: "Okay, I'll do this in two colors if you can give me this textured colored paper." Now, I could foil stamp and deboss and all kinds of things that I always wanted to do. Going from there to food packaging literally took me into a third dimension—it gave me a lot more to work with. Different kinds of paper, different containers. There were many, many more options. It all started with trying to make as many inroads as possible in book publishing where no one had ever bothered to try because there were so many constraints.

DM: There are very few designers who have been so successful in numerous categories. How were you able to break away from being typecast? It's not as easy as it sounds.

LF: No, and people always tend to know you by the work you did fifteen years before. So, it's taken me until fairly recently to shed my persona. When I started my studio, I knew that I had to do something other than books. Those were the only clients I had when I started my studio because I had always been freelancing for other publishers. But I knew I had to go beyond that, and I wanted to. So that's when I started going after restaurants, and the process takes some time. It's a whole other world. Whereas in publishing, you're dealing with people who are used to working with designers, in restaurants, very often the first conversation I had to have with some people was explaining to them why they had to pay both me and the printer.

DM: How do you go about determining an identity for a restaurant? How do you make that happen?

LF: Usually I sit down with the owner and try to get a sense of what the concept is. If there is an architect, I like to talk to them and look at drawings or materials or anything that I can get some clues from. But again, many of them are not used to dealing with designers; they're not always very articulate. And very often none of them

can be bothered, and I'm left on my own and I have to play twenty questions just to figure out, "What makes you different from everyone else?" It's always a challenge. There are very few times when I had something to work with. However, once I started working with architects like Larry Bogdanow, it was much, much more satisfying. We could truly share our ideas—I had things that I could give him, and he had things that he could give back to me.

DM: I visited a couple of restaurants—Marseille and Artisanal—in preparation for our interview. One of the things I noticed was the integration between the logo and the overall decor. Was that intentional on your part, and, if so, how hard or not hard is that to accomplish?

LF: It's very hard. Especially when you're trying to get direction from people and those details don't exist yet. For a restaurant like Artisanal, I was lucky because they already had the space: Adam Tihany had designed that years and years before in a previous incarnation. But yes, it's very important to me, in whatever nuanced way I can, to refer to the interior so that it feels correct when you're sitting there looking at the logo in the space—you feel like you're in the right place and you're not looking at someone else's logo.

DM: You said the difference between a logo and a brand is about $500,000. But is there a philosophical, rhetorical difference between a logo and a brand?

LF: No, it's really about the money. Plus the fact that I don't like working with big companies and I don't like brand speak. I try to never even use the word "brand." The only time I ever use it is when my clients are trying to do something destructive with my logo. And I tell them, "No, you can't do that because it will dilute the brand."

DM: So the word does have power.

LF: Yes, although it feels very hypocritical for me to say that. I prefer working for smaller businesses where I can work more intimately with my clients, and it's very satisfying for me to watch them succeed. I hope that it had something to do with the logo, even if in a very small way. So that's what that statement is about.

"It's

time to reassess what it is that we're putting out there. Communication, advertising, graphic design campaigns, all of it. Designers across the board are in the persuasion business, and so we want to ask ourselves, 'What are we trying to persuade people to do, and to what end?'"

ALLAN CHOCHINOV

chair, SVA MFA Products of Design
partner, Core 77

May 1, 2009

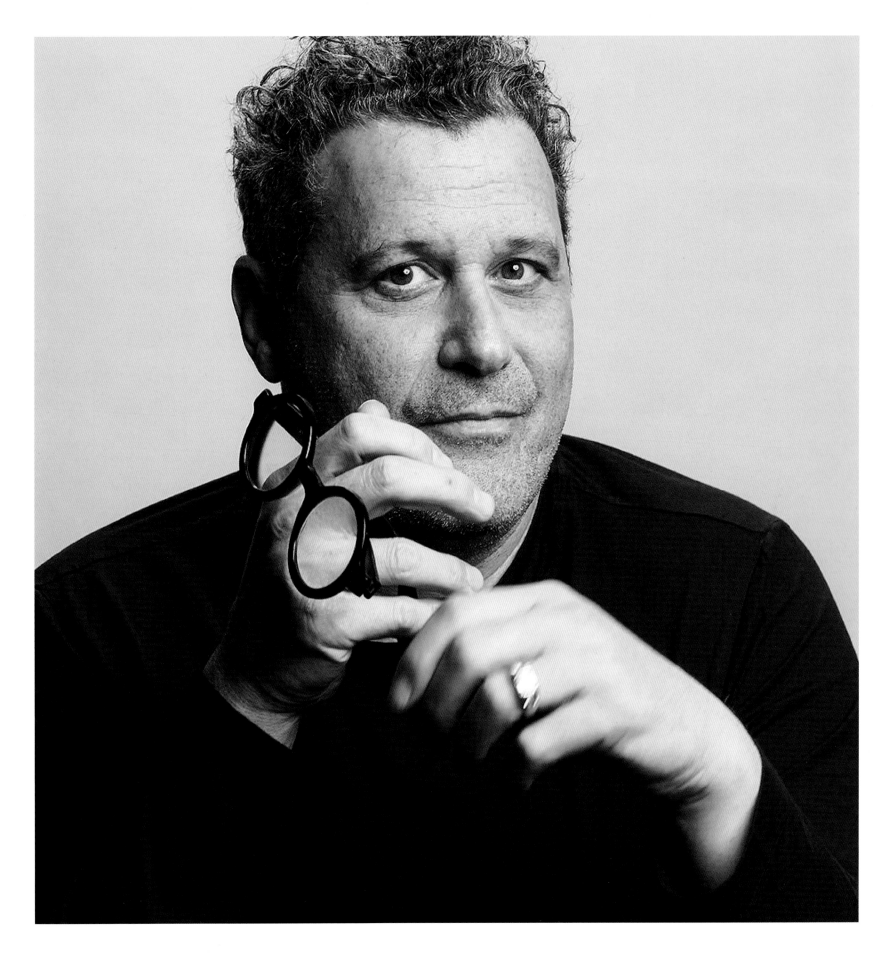

ISAAC MIZRAHI

March 2, 2015

In preparing for this interview, I did a little Google experiment.

I did a search for "Isaac Mizrahi is a…" and got thousands of results. Here are a few: Isaac Mizrahi is a busy man; Isaac Mizrahi is a married man; Isaac Mizrahi is a force to be reckoned with in the world of high design; Isaac Mizrahi is a floral, fruity fragrance for women; Isaac Mizrahi is a fan of unconventional challenges. It's clear that there are lots of Isaac Mizrahis out there, but the one and only fashion designer, writer, performer, actor, and TV personality has collected himself and talked with me about why he loves fashion and why he does so many things outside of fashion.

DM Let's start by talking about your background. We're the same age, both born in Brooklyn to observant Jewish families. How has your Jewish background influenced you, if at all?

IM It has influenced me in the respect that it was something for me to rebel against. I saw no value in it at all.

DM Do you still feel that way?

IM I do. It has not grown on me. Perhaps it's because of the, I would say, terrible, formative exposure to those rabbis. They were so mean on a level that was so wrong. It was so inhuman to be that way to any child, yet somehow I didn't feel like a child against it. I felt like a fully formed individual, and I knew what they were telling me had to be bullshit.

DM So you never doubted yourself. You just knew they were wrong.

IM Everybody doubts themselves, Debbie, right? Everybody does. But it gave me the ability to see beyond what they were telling me because it gave me this knowledge that your feelings don't lie. Your thoughts can be wrong, but your feelings cannot be wrong. I started therapy when I was in first grade or even before first grade; maybe they taught me, those people.

DM Why did you start therapy so early?

IM I was expelled from yeshiva. I was suspended so many times that finally they said, "We can't let him back in here unless you take him to some kind of child psychiatrist."

DM And it was because you were too creative?

IM No, it was because I was too insane and yes, creative. But I was very disruptive. I was very unhappy. I would have these horrible tantrums where I would start screaming because I felt somehow like I was in the wrong environment, but I didn't exactly know why I was screaming. It was probably circumstantial. But at the time, it was full-on panic and hysteria. I had this amazing eighth-grade English teacher who told them about a wonderful school in New York called the Performing Arts High School, and that maybe I should try to go into the acting department. She helped convince my parents to let me go to that school because that was a big move for them at that time.

DM I read that your father gave you a sewing machine when you were ten years old. Did you have an interest in fashion at that time, or did he find it on the street and thought you might like it?

IM No. My father was a children's wear manufacturer. He made little boys' coats and suits, and he had many sewing machines in the basement. At some point when I was very little, I commandeered the basement as my design studio and my puppet-making factory because I had a puppet theater in the garage. That's why I learned to sew. After a year or two, he introduced me to his machines, which were already in place in the basement, and they were professional power machines.

DM So, you attended the High School of Performing Arts, and you launched your own label, IS New York, at fifteen. What kind of clothes did you create?

IM It was a partnership with this woman named Sarah. Her husband also was in the children's business. He had a factory in Brooklyn that helped us make clothes as well as a good pattern maker who made samples. So, here and there we had these little shops that we made clothes for.

DM When you were attending the High School of Performing Arts, were you also thinking you might want to be an actor or a performer?

IM From when I was a kid, I think the end goal in my life was the entertainment business. I don't know exactly what I can say to prove that other than there's that movie *Unzipped* and I had a television show for a number of years. And now I appear on QVC all the time. You would think that, for me, fashion is a form of entertainment, and that's true. But entertainment is a form of entertainment. It's like theater and opera and whatever else. That is what I am moving toward, and I'm hoping to make a movie or a few movies someday.

DM Well, I think of fashion in the same way as movies or art or poetry. They transport you. They take you to a different place. They help you be a better you, and if we're putting something on, we're also sharing that.

IM It's a form of relief from strife, everyday strife. You buy something beautiful and new to wear, and it relieves you in the same way that watching a marathon of *Real Housewives* does.

DM I remember the first time I discovered your shop in Bergdorf's in the 1980s. I hadn't met you at that point, and I walked in and I was transported. The clothing was something that gave you a sense of who you could be on your best day.

IM That was before I had a collection. The Bergdorf's buyers came in, and they looked at what I was making, they liked it, and they bought it. It sold very well from the very beginning.

DM What made you decide to do a line for Target in 2002? That reverberated through the fashion world.

IM Well, Target's amazing. It's so accessible. It makes all products accessible, and it is smarter and has a better sense of humor about itself than some of the other big-box stores. And when we got the inkling that they were interested in talking to me, I wasn't interested in countering anywhere else. I felt it was only Target that could pull something like this off. Now I feel like everyone's in that business. But at the time, it didn't feel like that.

DM You described your line then as controlled and glamorous, elegant, distilled, refined, inspired by decadence in the diversity of New York City.

IM What I think people truly love is design. I'm not talking about showing a great big sweater tucked into panty hose, but the way a seam and a textile fall on the body. It's very important to me to invent designs that also refer to who a woman is and the psychology of her life—that's the most compelling part of it, really. The design element is gratifying in the way that cooking something wonderful or figuring out a recipe yourself is gratifying. But the thing that I love so much is when I can actually reach out to this woman and express to her, "I'm going to change your life in some way. This is going to make your life a little bit better." It's very exciting when a lot of people can be influenced by something that I do, and it's a little tragic. But the joy and the gift of it outweighs the tragedy.

DM What's the tragedy, though?

IM I don't make this couture collection anymore. I could always go back to it, but between you and me, that edge comes and goes. I'm not going to say it's a young person's game because there are plenty of people who discover their brilliance late in life. Rather, I don't care that much about mastery. I get a little bored. I want to move along and do the next thing.

DM It seems like you constantly have different paths that you want to take. So you take one path, and then that influences the next path, and then that influences the next path. I also like to do a lot of different things. And every now and then I wonder if that diversity of things somehow minimizes the mastery of any single one.

IM It does. It does, Debbie. That's the tragedy. This is what I'm talking about. My best friend is Mark Morris, and he is a fucking master. There's no tragedy about that. I look at him and I think, "Wow, if you just stick to something and you do it and do it and do it, you come to that point, right?" I can't do it. I can be his best friend and I can admire it, but it's not my fate.

DM Speaking of which, let's talk about some of the other things that you do aside from fashion. You're a singer and a performer.

IM Yes, I am.

DM You starred in your own cabaret show called *Les Miz.*

IM It was an Off-Broadway show, and then I did a few different cabaret performances at Joe's Pub and a few other venues around the city. And I feel crazy when I do that.

DM Why?

IM I am a harsh, harsh critic. I think everyone in my audience has their arms folded and their head cocked going, "Really?" And I am in the front row doing that to myself.

DM But would you be doing that if you had started first as a singer and then became a fashion designer?

IM No.

DM Because you would be doing that to yourself as a fashion designer?

IM Absolutely. It's what I do when I see the Kardashians or someone else doing clothes. And yet some of the Kardashian clothes are really good. So, it all comes down to balls. Do you have the balls to put yourself on a stool in a cabaret every once in a while and say, "Hey everybody, if you like this, you like it. If you don't like it, then I'm not here to please everybody." If one can live with diverse opinions of one's self, it's better. Then you can do what you want. If you let critical dialogue stop you, then it's a shame.

DM Do you ever get afraid of doing new things? IM Sure.

DM You've said that if you do one thing all the time, you get very bored. But when you were asked about your show, you declared that a little discomfort is a good thing.

IM A lot of discomfort is a good thing.

DM I'm terrified of discomfort.

IM I'm more terrified by stagnation. Then I really can't get out of bed. If you think I'm depressive and pessimistic and whatever, then you can ask my business partner Marisa Gardini to describe her job. Forget about making deals and making sure that people do what they're supposed to do. Her job is to make sure that I am not in the gutter all day long. I'm saying that because that's the game. The game is to keep your spirits at a point where you can function great.

DM I recently reread your book *How to Have Style*, where you state that before you can think about having style, you have to learn to look in the mirror and like what you see. Too many women are taught to hate the way they look and are encouraged to change everything about themselves from their lips to their bust sizes. Why do women have so much self-loathing?

IM Well, one thing I will say about that question, and I firmly believe this: if everybody responded honestly to their surroundings, everybody would be stylish. If you walk into a bakery, somehow we are endowed with the ability to know what food we truly want to eat at that moment, right? Well, we all have those impulses surrounding the clothes we want to wear and the people we want to be. But somehow, we always stop ourselves.

DM We're afraid of being judged, afraid of being rejected?

IM I don't know what it is that stops us. If you like it, darling, then it's right. Period. I can't think of another answer for that. I can't think of a better answer.

DM I read the reason there isn't more experimental fashion in places like the Oscars red carpet is that everybody fears they're going to be bullied on Twitter. We're beating originality out of people; we're shaming them to be mediocre or mainstream.

IM Most people.

DM Well, we'll always have Björk.

IM The iconic people are the ones who are able to take those remarks, you know?

MAIRA

Maira Kalman has authored and illustrated some of the most remarkable books of our time,

including *The Principles of Uncertainty* and *The Pursuit of Happiness*. Her work has appeared on countless covers of *The New Yorker*, in museums, and on the stage. Maira and I talked about her new book, *Beloved Dog*, about the twists and turns of her life and career, and about how ordinary objects inspire her art.

KALMAN

DM: Your parents left Russia to go to Palestine, and you were born in Tel Aviv. Your family moved to New York when you were four years old. Do you have any memories of Tel Aviv as a very little girl?

MK: My memories are probably more real to me than what's going on right now, which tells you something about our lives. It was an incredible time of beautiful sand and sea and cafés with fluttering awnings and music. People coming from all over the world, tango playing in the restaurants, and quite beautiful ice-cream cups with the little crackers in them.

DM: You've said that when you moved to New York, you felt like an outsider. Why?

MK: I felt like an outsider in the best sense of the word. It wasn't as if I was unhappy. I guess I became a journalist when I was five years old because I was very keen about taking everything in and thinking that it was all fantastic. I went from this sandy little town to this gigantic city. I felt comfortable, but I felt I had better observe a bit.

DM: Your mother, Sarah, encouraged your creative life— she took you to concerts, operas, and the library. Were you close your whole life?

MK: Yes. I was madly in love with her, as she was with me. We had this fantastic bond, and it never stopped.

DM: You stated she was very much a model of great integrity who said what she thought and taught you there was no right way to think about things. You also said that your mother had no real need for information. Her map of the United States, which you include in your book The Principles of Uncertainty, is a wonderful example of this. In the center of the map is a great blob of American landscape in which she wrote, "Sorry, the rest is unknown. Thank you."

MK: That was the absolute expression of a person who is so irreverent and has a great sense of humor but also is doing it naturally—not trying to be funny, not trying to be coy. Not getting something right, but getting it the way that you need to get it, is really the point of it all.

DM: So, everything was acceptable.

MK: That sense of unconditional love absolutely came through. Also the sense that you should daydream because that's the right thing to do.

DM: Maira, do you have any sense of how rare that is?

MK: I hear that from people, but I can't imagine how else it would be.

DM: You stated that your encouragement came from being loved and from being told that whatever you did was great. Do you still have this sense that what you do is great?

MK: No, I think what I do is terrible. I'm constantly tormented. I think that's the nature of creating anything— that there's something wrong with you if you don't have doubts. There is the duality that you have tremendous insecurity and a tremendous drive. So I am always worried and always waking up in the middle of the night wondering how I could have done better. That propels me into being very excited and almost hysterical about any project I do. But again, I've come to the point where I think that doubting or fretting is part of the process.

DM: You romanticize it in such a way that worrying almost feels totally acceptable and even more than okay. It feels almost aspirational.

MK: I'm in a good mood today, so it sounds like fun. It's not, but I say, "What choice do we have?"

DM: When did you decide that you wanted to be an artist and a writer?

MK: I decided to be a writer when I was a little kid. I read Pippi Longstocking and I said, "That's it, that's what I'm going to do. I'm going to write books, and I'm going to be a strong and wonderful girl." That disappears quickly when you emerge into your adolescence and then everything is very shaky—my writing in high school and college seemed turgid. I decided that I couldn't write anymore and it would be quite easy and delightful to draw my stories. Saul Steinberg was a big influence.

DM: You attended New York University in the late 1960s, and that is where you met the man who would become your husband, Tibor Kalman. Tell me about your first meeting. Was it love at first sight?

MK: I think for him it was. We were in summer flunk-out class, in economics, and we were both on the verge of being thrown out of school after our first year of doing very badly—or not really caring. He asked me to go out for a cup of coffee, so we went to Washington Square Park, and he drank black coffee and smoked a cigarette. I don't think he had done either yet, but I think he was trying to impress me. We knew immediately that we had found each other.

DM: In 1979 Tibor started M&Co., which was influential in so many ways. Not only culturally, not only in the community of graphic design, but also in the great number of people who have come out of M&Co. to create remarkable work.

I think that the decisions made without thinking are thrilling. That's your whole life, with all of the twists and turns.

MK: Tibor was a genius, and the constant inventiveness, the constant thrill of how his mind worked, was exhilarating in every way. When you ask about the determination to do a project through the worries, for me it comes to the Tibor factor. I understood and learned what it meant to be with somebody who was not daunted, who said, "If you have an idea, that's fine, but you better do something about it, otherwise what's the point?" That, to me, became the natural part of our life.

DM: Tibor died of cancer in 1999, and in your most recent book, *Beloved Dog,* you state, "When Tibor died, the world came to an end. And the world did not come to an end. That is something you learn." I first read that while going through what felt like a bottomless pit of grief that I'd experienced, and it gave me great comfort.

MK: He was ill for five years, and the process of that was devastating. But we had two children, and through it all we kept working and taking care of the family. I was sure that I wouldn't be able to survive when he died. I was sure that it would be over for me. Then, in some crazy kind of way that I don't understand, I felt like I had taken on his courage. I worked with a force and a fierceness that I hadn't had before. Of course, you understand that time is short and to make the most of your time, and when you have children you have to rally.

DM: In a 2003 interview in *Eye* magazine with Steven Heller, you stated, "Even though feminism burst into being one rainy night in 1969, Tibor and I still had a conventional relationship in the sense that I was in the background. I was insecure about dealing forcefully with the outside world. What made me come to the fore was Tibor's death. Maybe I learned more than I knew from Tibor, and maybe I realized that life is short, so why not do whatever you can think of that excites you? There's probably a myth about a woman not being able to really thrive without a man after a lifelong relationship, but people are incredibly resourceful. There are kids and friends and ideas and traveling to China. You know, life." When did you feel more courageous about dealing with the outside world? Was it immediate, or did a sense grow over time that you had something you wanted to express?

MK: It was absolutely immediate, which startled me. I've always been forthright in what I think. I've never been shy to say what my opinion is, but right away I said I'm going to do what I need to do here.

DM: In *Beloved Dog,* you admit that you did not always love dogs. In fact, your mom felt that dogs were bloodthirsty beasts. All that changed when you met Pete, the Irish Wheaten Terrier that stole your heart.

MK: When Tibor was ill and the kids were little, people were saying that getting a dog would elevate the mood of the house, a dog would be a bringer of joy and fun and happiness. It was true. I was a little bit nervous at first.

DM: How did you even allow a dog into the house if you felt that somehow he was going to upend your home?

MK: That's another mystery. Things happen, and all of a sudden your brain does a swivel. I think the most important decisions are made without any thought at all.

DM: Do you ever regret those decisions? Do you feel like they're always good ones?

MK: I think that the decisions made without thinking are thrilling. That's your whole life, with all of the twists and turns.

DM: Pete became your constant companion. He was your muse. And it became clear to you that over the last however many years, you'd been obsessed with dogs. You've also written quite a number of books about Pete. Why do you think dogs show up so much in your work?

MK: They're hilarious. And they're so heartrending, so earnest, and so nutty. As entities in our world, as we're walking around the city, I don't understand how you could not notice and obsess about all the dogs.

DM: You've said that you and Pete were a couple. And that you realized that he loved you above all others. What do you think it is about dogs that makes them so unconditionally lovable?

MK: First of all, they don't speak. Let's start with that. If you were with somebody who didn't speak, you'd probably like them all the time. Everybody talks too much and gives their opinion and needs support and needs encouragement. Dogs don't need any of that, so you don't have to give them anything, which is an incredibly selfish thing for people to do, but you don't have to give them anything except your presence.

DM: Though you've illustrated and written dozens of books, you've said that the term "artist" makes you uncomfortable. You much prefer and embrace the title of journalist. Why is that?

MK: It's a kind of cliché to think that the artist goes into a studio and has to come up with something. That's not how I work. I like to have the connection of an assignment. I like to have the connection of people around me. Then there is a construct to what I'm doing. As a journalist working for the *Times* or *The New Yorker*, I go out and look at something and then send back my report in painting and writing.

DM: You created an opera for the *The Elements of Style* with Nico Muhly and then again on a piece for *The Principles of Uncertainty.* In working with Nico, you stated that entering into that world and not knowing what the outcome would be was a big risk, yet you did it anyway. You met Nico I think when he was what—twelve?

MK: We were in Rome and he was twelve. He was my kids' age, so there was this fantastic connection. He and his mother were at the American Academy. She's a painter, Bunny Harvey. We became friends, and he would play the piano and I would sing. I can't believe how I would torture him with those afternoons. Then when he was older and came to Columbia, he worked for M&Co., and then he worked for me, so the connection was always there.

DM: How did you go about collaborating with him on an opera when you had never done something like that before?

MK: Well, Nico does the composing—we had separate tasks. I had a few desires. There were a few texts that I wanted to use and a few pieces that I wanted to have. I also wanted to have an orchestra of percussionists playing things I collect, like clattering teacups and saucers and typewriters.

DM: Wasn't there an eggbeater?

MK: Yes, because there is an eggbeater in the book. All of these mundane objects that fascinate me, that I paint, that I really love—I thought they could become a presence in this counterpoint with real musicians and real singers.

DM: What about these objects—these instruments—do you find so fascinating?

MK: They're all designed, so if you like how they're designed, you love them. They tell stories and they have relationships to times of day and what you are doing. When you're drinking your coffee, who are you talking to? Or who are you having a fight with?

DM: You also collaborated with Daniel Handler, aka Lemony Snicket, and Michael Pollan, illustrating their books. Is there a different approach you take when you're illustrating somebody else's words?

MK: I'm a little bereft that I've given up part of the control of the book, so I'm incredibly polite but maybe a little bit sad. I'm looking at the text the way that I would if I was illustrating something for a magazine and seeing what feels right. Then there's a back and forth about what's working and what might not be working—of course, that dialogue also includes a wonderful editor. If things are going well, there's a lot of trust. If you have to talk too much about something, you might be in a little bit of trouble.

DM: You've also collaborated with your son.

MK: This is true. Alex Kalman.

DM: It's not only a collaboration with your son, but it's also a collaboration with your mother. Can you describe what you did with Alex and with Sarah?

MK: Alex Kalman, my son, is the director of the smallest museum in New York and perhaps the world in an elevator shaft on Cortlandt Alley. It's called Mmuseumm. It's really a hole in the wall on a shoestring budget, and he's curated installations that reflect our life in an anthropological design vernacular—also with a sense of humor. Then he had another little space that opened up down the alley. When my mother died, I wanted to open a museum of her closet in her apartment on Horatio Street, but that didn't work out. We kept all of her things, and eleven years later he and I created an installation that's in this alley. It looks like a diorama in the Museum of Natural History, with the glass front and a light bulb. She wore only white, so it's a very graphic and stunningly beautiful, organized, neat-as-a-pin closet. We created Sara Berman's Closet together. If all goes well and they don't change their minds in the middle of the night, it's going to go to the American Wing of the Metropolitan Museum as an installation, as a counterpoint to the lavish and extravagant dressing rooms and furniture of the wealthy. This is one woman who didn't have any money, who came from Belarus, in her apartment on Horatio Street, and how that life is also important and should be celebrated in a museum.

DM: And you've said the Met is the best place on Earth, and that you go there all the time. So, again, it feels serendipitous that the closet should end up in this place that's become your second home in many ways.

MK: I know. It's so many full circles that I don't even know what to do.

DM: It's like a spirograph.

MK: I'm immensely grateful. Truly.

"I've

talked to so many smart and wise people across the years. People who've seen social change happen, and have been part of it, and studied it. One thing that they all know and can document across history is that at any given moment the things we're focused on, the things we're shining a light on, the things that are getting all the attention, or the people are getting all the attention, are probably not the ones who are changing the world."

KRISTA TIPPETT

radio and podcast host, writer

April 4, 2016

KENNY

Kenny Fries has made it his life's work to understand whether looks, ability, and talent make someone's life worth living more than another's.

As a disabled, Jewish gay man, he has spent years thinking about the world as an outsider, and he's transformed his personal journeys into deeply insightful books shedding light on the devastating effects of discrimination against the imperfect. In our interview he explains how one person's desirability is attitudinal, context based, and temporary.

FRIES

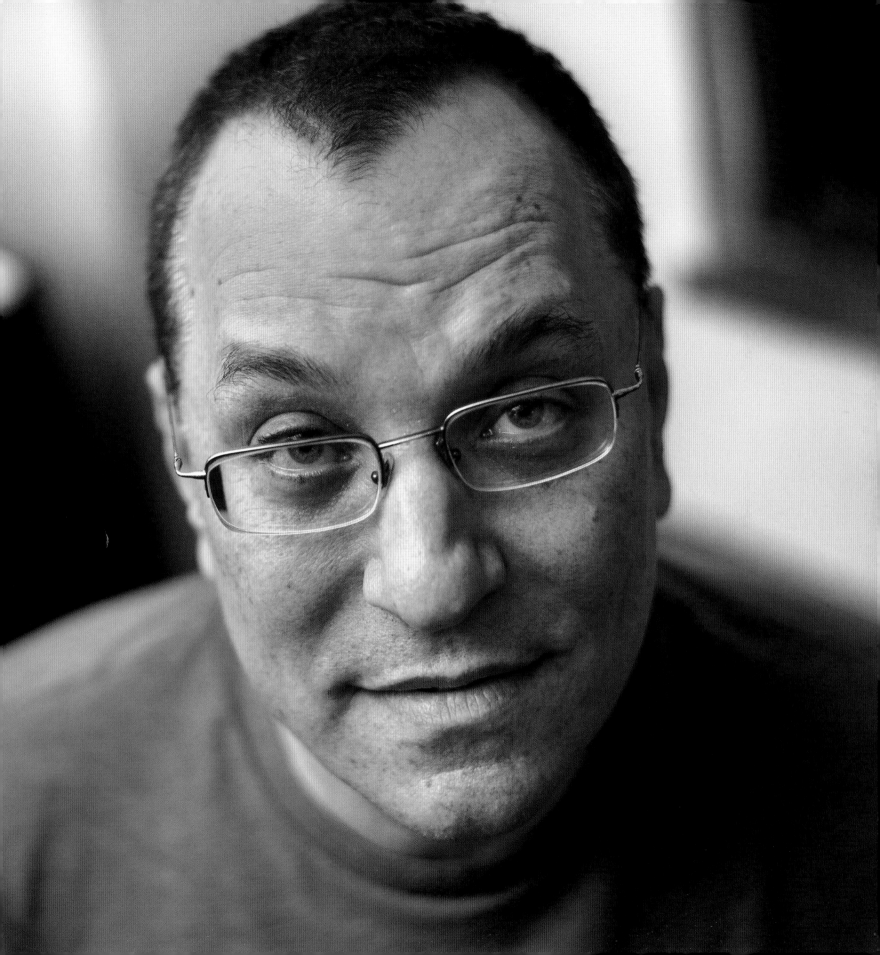

DM: Kenny, when you were born in 1960, nobody knew whether you would live or die. No one really knew why you were missing the fibula; why there were sharp interior curves of the tibia in both of your legs; why you had only three toes and posterior calf bands on each foot. I read that your father fainted when your maternal grandmother screamed, "My daughter gave birth to a freak!" Your father really fainted?

KF: Supposedly. You grow up with these myths. We create these stories about ourselves—or people create them for you—and then they become real.

DM: You were among the first generation of children with a disability to attend public school. Can you share the story of the boy you passed every day on your walks back and forth to school?

KF: That was the beginning of the book *Body, Remember*. I used to come down the street and there'd be a little kid there, and he would always ask me every day, "What happened to your legs?" And every day I would answer, "I was born that way." I don't know why I kept going down the same street. I just didn't think there were options, and I think that's a good metaphor for something. Probably we do these things and have to figure out why we did them later.

DM: You talk a lot about experiencing people staring at you as you were growing up. I've also heard you talk about this notion of good staring versus bad staring. It got me to think about the notion of staring in general: we stare at something that we don't understand. We stare at people who we perceive as beautiful or celebrities. What is it in our human nature that compels us to make this effort to see something?

KF: I would think it has something to do with looking for a mate—who could give us the best children?—or looking out for predators. Two different extremes. I'm a layperson, but I would think it's a carryover from the past. In my new book, *In the Province of the Gods*, I come to Japan and I have a revelation that I'm stared at not because I'm disabled but because I'm a foreigner. In a scene soon afterward, I realize how all the things I learned about disability were not mine. They were society's, they were other people's. I had internalized them, and they just seemed like my own.

DM: While you didn't feel disabled as a child, you internalized the devaluing messages of society from doctors, from your family, and from your brother. Your brother was particularly cruel to you. He also sexually abused you from a very, very young age. You have said, as well, that familiarity can impede recognition—that over time, the body adjusts until what was once a severe disturbance becomes white noise. Is this how you survived that period?

KF: I think that when you become accustomed to something—well, to go off on a crazy tangent, people say they don't want to normalize Donald Trump, but when you get used to something, how do you not normalize it? How do you not become accustomed to it? Somewhere along the line, I don't know where, I had this belief in myself. At the core, I know my worth. Same thing with my writing. If it gets ignored, it's not about me. It's about the culture that doesn't get what I'm doing or can't find a place for what I do. I think this came from my parents, which is ironic because they were also the people who allowed the abuse to happen. My parents have always been there.

DM: Now that I've read all of your nonfiction books, I can see there's no question that your parents love you—that they felt pain when you were in pain. When you were a child, you felt there needed to be a reason for why you were born with a deformed lower body and why you had to suffer through so much pain. You began to believe that your deformed body and the pain it caused you were a sign from God that you were important. Then you went to Japan, where you were shocked to learn that Buddhism sees disability in terms of reincarnation, that someone must have done something wrong in their past life.

KF: It's not only you. It could be something your parents did or something somewhere.

DM: What kind of species are we that we are continually discriminating against what we perceive as other, whether it be race, gender, sexual orientation, disability, or ability? In one hundred years, are we going to look back on these times and go, "What were we thinking?"

KF: Is it human nature to just do this? That to make yourself feel better or to feel secure, you have to find out how you relate to somebody in a hierarchical way? I don't know. It's a very strange thing, but it seems to be endemic in all cultures.

DM: We not only do this with how we appear but also in how we want to present ourselves. We not only discriminate against what we perceive as "other," but then we want to present ourselves as better than, so we can feel better about ourselves.

KF: We're basically striving for something that doesn't even exist. Maybe some of it has to do with capitalism today: the more you can have people strive to be something, the more products you can sell. Especially in the United States, the self-improvement phenomenon is crazy. I think it also keeps people quiet. It keeps people from complaining, from protesting.

DM: You brought up earlier that you were being treated differently in Japan not because you were disabled but because you were a foreigner. What was that like for you to suddenly be noticed or treated in a certain way for a very different reason than you were used to?

KF: It made sense, because I was a foreigner, where it never made sense for me to be treated as different in my own country because I supposedly "belong" here. That was my first big revelation in Japan. I was never accosted because I was disabled. I never felt people were acting strangely because I was disabled. If they were acting strangely, it was because I was a foreigner. As I say in the book, Japanese audiences asked me all the time, "What is it like to be disabled in Japan?" I couldn't answer that question. I could only say what it was like for this particular disabled person who was a foreigner, who had my particular disability, because I know being a disabled Japanese person is not an easy lot. It's not easy.

DM: Would you say it's harder than being disabled in the United States?

KF: I would say that you don't have the protections of the law that we have here, though here they're not as strong as they should be.

DM: Your disability was described as a "physical fact" in a passage from *In the Province of the Gods*. I'm wondering if you can share what that means.

KF: That term was given to me by a Japanese man who goes by the name of Masa, who I'd become involved with. He described my disability to somebody and then summarized the conversation as, "I told him about your physical fact." That's basically what it is. It's like your hair color or your eye color. It's no big deal. It just is what it is. Disability is surprisingly central to Japanese culture. That's what's so interesting. The *biwa hōshi*, the blind chanting priests who roamed the country, spread the legends and myths of the country and unified Japan. Some people think Japanese language and the whole mythology of the country are based on these disabled chanters. How more central can you get?

DM: As you spent more time in the gardens of Japan, you found yourself writing not about disability but about Japanese gardens. This body of work became a poem sequence that became a song cycle as well as a Japanese cloth designed by a Japanese calligrapher. I think it's called the *tenugui*?

KF: *Tenugui*, yes.

DM: At the end of your stay in Japan, you realize that you were actually writing about what it means to be alive in this ever-changing mortal world. You go on to state that living life in a mortal world is perhaps the greatest lesson learned from the experience of living with a disability. How so?

KF: The lesson one learns from living a disabled life is that life is change. The body just changes. Whether it's through age, through climate, through disease, or through an accident, the body changes. The nature of the world is change. That's something that Japanese culture understands much more than we do in the West. This is something I've come to learn in my life: this thing that's marginalized and ostracized and discriminated against, that people want to get rid of, that people are so afraid of, is the actual central truth of our life. We live a mortal life. Nothing's permanent, and disability is the key to understanding that.

DM: Right before you return to Japan for your second visit, you find out that you are HIV-positive. You write about the experience of hearing the diagnosis from your doctor in this way: "Waiting for the elevator, I feel as if I have left a part of myself in Dr. Shea's office," and then, "My life now feels sharply bifurcated into what was and what is." Do you still feel that way?

KF: No. That's the movement of the last part of the book, from feeling that there was a before and an after, to feeling that life is a continuum. That happens because of many reasons, but it comes to a climax when I meet two of the surviving Hiroshima Maidens—the group of women who went to the United States in 1955 to be medically treated for the disfigurement caused by the atomic bomb blast. There's something about my talking and interviewing them that makes me see life differently. I realize that life is not a before and after. I think there are two reasons why I felt that way. I was born disabled, so there was never "before and after"; I didn't become disabled in an accident or something like that. Second, before the HIV diagnosis, I almost died of blood clots in my lungs. I had a lot of physical issues, and I was able to figure out that nothing cuts your life in two, even though it might seem that way.

DM How would
you define
being disabled?

KF That's a humdinger. In my case, it's physical,
so I would say a physical disability is a physical
difference, something that's seen as different
and perceived as different. It's not something
pejorative. It's just different from what's expected.

DM

But the word "disabled" feels like it has real pejorative connotations.
It's not an objective word. It's a word that is embedded with
judgment. How do we, as a culture, try to shift that perception?

KF

I think we're stuck in this dialectic of disability and what I call non-
disability. Most people use able-bodied, but I don't use that term.

DM Non-disabled?

KF Yes, I use non-disabled. As long as we're in that dialectic,
I think we're in trouble because it's not a fixed category.
At any moment, we will become disabled in some way. It's
something that everybody has in common. The word is
also inaccurate because we get Darwin wrong. "Survival of
the fittest" is actually "survival of the fittest in a particular
environment." I can be more "able" than somebody else in
certain situations. It's the context that defines disability.

DM

You talk about being Jewish,
being gay, being disabled, but
what about being a writer?

KF

The joke I tell people is that when I was younger, I
was categorized more as a gay writer, and now I'm
categorized more as a disabled writer. But, no, I haven't
changed. I would love to just be considered a writer. I
would love somebody to talk to me solely about how I
put words together or how narrative works, but it's about
the content, which is fine. There's a lot of content there.

"I've

been told my body doesn't have value and I've been told somebody else gets to decide. So I like to go back in my work and say, 'Oh, really?' Because I think it's the artist's job to keenly look out and observe the world. Reflect and respond."

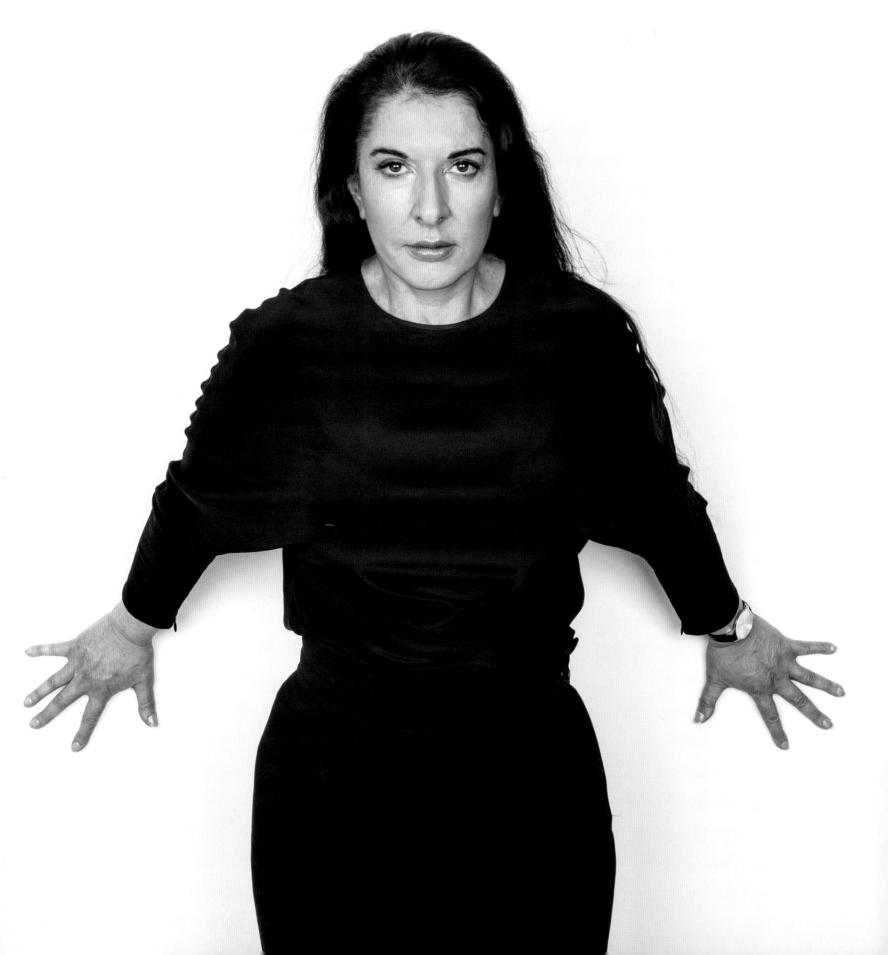

MARINA

Marina Abramóvić once said that she only learns from things she doesn't like– among them, pain, silence, blood.

She has methodically cut the skin between her fingers and on her abdomen. She has screamed until she has no voice. And for 736 hours she has remained in silence while peering into the eyes of strangers. Marina challenges audiences with uncomfortable and illuminating encounters, and she has permanently changed the way the world perceives and understands performance art.

ABRAMOVIĆ

DM: When you were four years old, you were walking in the forest with your grandmother, and you saw a strange, straight line across the road. You went over to touch it, which caused your grandmother to scream. What were you mesmerized by, and how did that impact you?

MA: This moment was one of my first experiences confronting fear. But the fear was not of the moving object, which was a huge snake. It was the scream of my grandmother. I didn't know what the snake was; I didn't have the shared experience. That fear embedded in my memory because she was afraid of the snake. Children get fear from parents, from society, from things already experienced, even if they didn't have this direct experience themselves. In the rest of my life, it was all about direct experience later on.

DM: I thought it was ironic because the night before you were born, your mother dreamed she was giving birth to a giant snake.

MA: Later in my life I was as afraid of snakes as everybody else. So, I decided to make a performance by putting five snakes on my body. Snakes follow the energy of the Earth, so I was thinking, "What if I'm this Earth, and I put them on my body and they just follow my own energy?" Just before the audience came, the trainer put a very big boa constrictor around my head and told me that if anything happened, please don't change your breathing pattern because she will really struggle at you. It happened that somehow I moved my head and she started tightening up, and of course the panic is natural. The trainer screamed at me, "Breathe slowly!" It was incredible to, in panic, calm down and breathe slowly. I succeeded and then the boa constrictor released slowly because I'm the tree. I understood then that my own fear could kill me.

DM: You said this about your childhood: "I was so ashamed of myself and my family, of the complete lack of love in my household. And that feeling of shame was like hell." Was that what first drew you to art?

MA: I dreamt a lot, that was my inner world. My dreams were very vivid. I had dreams in color. I had dreams that I fall in a dream and then I dream in another dream. I had dreams that would recur in different periods of my life. And as a young child, I was painting my dreams. Sleep was like work. I dreamed the dream, I wake up, and paint.

DM: You were creative in other ways. You made your own clothes from curtains because your parents were willing to spend money on paint for you but not on pretty clothes.

MA: I never got any present that I really wanted. I hated my birthdays because as a young girl I would have loved to have something that other girls had, and I would never get it. And until my mother had Alzheimer's and died, I could never impress her with anything because somebody else was better and somebody else had always achieved more.

DM: After your mother died, you read her diaries and you were very surprised by her inner life.

MA: If I knew one page of her diaries before she died, my relation to her would have been totally different. She was a very emotionally hurt woman but so hardcore outside. It was terrible. I think she wanted to make a warrior out of me. But looking back now, I would not want to be any other way. Artists suffer a lot in their lives. Nobody made anything from happiness. Happiness leads you to laziness. Depression is a sickness, that's something else, and it should be treated. But the suffering is like a teacher. Now I know things. Through all that experience, you become wise and can enjoy life so much more.

DM: I was reading an article about the difference between happiness and pleasure. The article stated that with pleasure, we just want more and more; we just can't get enough. But happiness is when you feel like you have enough. I think we're all chasing pleasure in the guise of happiness.

MA: But happiness is not permanent—everything is impermanent. It's important you understand how temporary these experiences are and don't attach to any of this.

DM: Impermanence brings me back to your first art lesson. You received your first painting lesson from the artist Filo Filipović. He was one of your father's friends. Can you share what happened in that first lesson?

MA: Filo Filipović was a soldier in my father's battalion, and he became an abstract painter after the war. When I was fourteen, I wanted oil paints because I was just using watercolors and crayons. He gave me my first lesson. He takes the canvas, but he didn't put the canvas on the frame. He cut it irregularly and put it on the floor. He spread some glue on it and then cement. Then he put on red pigment and yellow pigments, a little bit of blue, some white. And then he spread turpentine over all the stuff, took a match to this whole thing, and everything exploded. Literally exploded in front of my eyes. He looked at it and he said, "Okay, this is sunset." And he left. I didn't know what to do, so I couldn't even move. Later

on, thinking about this first lesson, it was so important for me. The process was more important than ending the piece. I learned that as an artist, you can make things from anything. You can make things from dust. I can use my body. I can use the fire, the air, whatever. From that point on, I started thinking of projects. Nothing involving the canvas or paint.

DM: You studied with the painter Krsto Hegedušić, and he felt that if you're a good artist, you might have one good idea. You have said that you've had only one good idea. Which idea was that?

MA: One good idea is working with my own body because the body is universe. Everything we have in the body is microcosms, and everything is reflected to macrocosms. But Krsto Hegedušić also said one more thing that I loved: "If you're drawing with your right hand, and you become better and better and better, immediately change to the left" because that's the danger of repetition. You start with something that you know so well, so you stop learning. And you stop risking, stop going to different territory. For an artist, failure is such a great territory to learn. To include failure in your own process of work is essential.

DM: Repetition figures prominently in the engagement of your work. You're not doing the same thing from project to project, but you're often examining bodies slapping into each other or staring at someone over and over. What is your emotional and spiritual experience as you go through those durations or repetitions?

MA: There are two different questions here. Let's take the example of slapping or screaming—we are going to physical limits there. You can go thirty or forty minutes or one hour. But the mental exercises, this takes a long period of time, like three months. Through this process, performers stop being performers because you can't pretend anymore. Even in one hour, you can still pretend, but with three months, that performance becomes life itself. Then you deal with the truth, with the here and now. Long durational performances are absolutely the most important, transformative kind of material to think about.

More and more, I'm thinking that it's not enough that the public is just observing and being. The public has to be part of something. I have to give the public tools for their own experience. This is essential because only then can they understand this long duration. How can the public see something without being prepared for it? You have to get into the stillness in order to understand stillness. So you and the public have to be in the same time, in the same space, to create this energy dialogue. Public and the performer complete the work. Performer without public does nothing.

DM: In *Rhythm 0*, which you performed, you placed seventy-two objects on a table, including a rose, a razor, and a pistol with a solitary bullet in it, and you invited the audience to do whatever they wanted to you over the following six hours. They started out rather kind and then became crueler. Can you talk about what happened?

MA: First of all, every performance has a reason. In that time, the early 1970s, performance was not seen as any part of art. They said we are masochists, we are sadists.

DM: People thought you needed to be put in a psychiatric hospital.

MA: Exactly. And that's totally dismissing us. So then I was thinking, "Okay, if this is the general opinion of the people, what if I put these objects on a table?" I had the little text on the table explaining, "I'm an object. You can do anything on me" using the objects, including killing me. For six hours. So, I give them permission to basically use anything. And I am not doing anything. I'm dressed and I'm standing there. So, I'm not a masochist, I'm not sadist. I'm not doing anything. I'm just an artist standing there and seeing what would happen if you give complete freedom to the public. After this performance, I knew that the public can kill you—that if you give the tools for the public to bring the spirit down, they will use them. But another lesson I learned is you also can give the tools to the public to lift the spirit, which took me twenty-five years to learn.

DM: Were you surprised at how cruel people could be? They ripped your clothing, they scratched you. If somebody hadn't interfered, you very likely would have gotten shot. But somebody pulled the gun away from the man who put it to your forehead.

MA: I prepared for this performance to be completely without will, which is not easy. It was so scary. After six hours had passed and the gallerist came and said, "Time is over," it was 2:00 in the morning and I start walking to them. I was half-naked, I was full of blood. I become me, and I start walking to them. And I was hell, a mess. And they start running. The people literally run out of the gallery.

DM: I saw pictures of you after that performance and you looked emotionally shattered.

MA: This is why I could never rehearse my performances. I have only the concept, and the energy of the public is essential. But I will never repeat that because I could never repeat in real life any of this.

DM: In 2010 you created *The Artist Is Present* in the atrium at the Museum of Modern Art in New York, where every day for three months you sat facing people for eight hours a day without moving, speaking, eating, or going to the bathroom. How did you mentally and physically prepare for this?

MA: I took one year. It's like preparing for the NASA program to go to space. I took it very seriously. One important element was how to change the metabolism of your body. For one entire year, I literally had breakfast at the same time, which was 7:00 in the morning, and never had lunch. I never drank any water until the evening.

DM: Initially there was a table between you and the people that were sitting across from you.

MA: I wanted to have a very formal situation: a table and two chairs. But then in the second month came the man with the wheelchair. They moved the chair to place the wheelchair, but I could not see what happened because the table blocked my view of the legs. I understood that I actually don't have full contact with someone because of the table, so when we finished the second month, I asked them to remove the table. They were always freaking out about security, but I didn't care; I wanted it to be removed. And the moment after they removed the table, the performance took off completely to another level.

DM: It was an extraordinary process to observe. The people sitting across from you were often visibly moved. From the beginning, people were in tears. Do you feel like you became a sort of mirror? What opened people's hearts as they were sitting across from you?

MA: If I did this piece maybe ten or fifteen years earlier, I really believe that that chair would have been empty. You know why? The time is different. I think that because of technology, because of how we developed ourselves—that we depend so much on the gadgets—something happened with human contact. I think that the public never has had more need to be part of something and to have the time to actually experience what they experience with themselves. Like now, we are facing enormous loneliness and pain and it's so difficult, and I never saw so much pain in my life than just looking at people and what they're bringing me. But I was there, vulnerable. I was there all the time, unconditionally giving them love, and they could take as much time as they wanted. And that was essential. This was something that we'll need now. In the museum, you just look at something. But I think we need to be part of something.

DM: To connect.

MA: And that's happened. Waiting was part of the piece too. Sleeping was part of it. The commitment was part of the work.

DM: While you were doing the show, scientists in the United States and Russia became interested in what you were doing and wanted to test the brainwave patterns triggered by mutual gazing and found that your and your seated guests' brainwaves were syncing up and making identical patterns. Did that surprise you?

MA: Seeing how different centers of the brain develop was new to me. And this was the most amazing conclusion—that in total silence, the subconscious brain works with full speed to understand another person so much more than talking. Talking is like you're pretending or you're trying to make an impression. Eyes are the doors of the soul in the real sense. And it's incredible what happened there. Total stranger, unconditional love. That's the key.

DM: You said it's crucial to include death in your life now, and you think about death every single day.

MA: You know how, when you develop, you start thinking about yourself as a persona in relation to the public? So often you make one image for the public and then you have to try to keep that image, and somehow that's the image the public gets. But in the meantime you develop other things because we are so full of contradictions. Every human being has contradictions, but we are ashamed to expose them. And I was thinking, "How can I expose things that I'm ashamed of and share that with the public?" This is incredible liberation if you can do that. Then I start seeing, well, there's three Marinas. I have myself that I like to show to the public. So, that one is heroic Marina, like, "I'm feeling like a warrior. I can walk through walls." And then there is the other Marina who is very spiritual, who goes to retreats in the forest, who doesn't eat, doesn't talk for long periods of time, and so on. And then comes the bullshit one. Oh, this one is a big deal. The Marina who really likes bad movies and shitty gossip stories. You know, all the stuff that a heroic Marina doesn't want to admit. But I like all three of them. If I can show you my bullshit, then you show me your bullshit and then we have real conversation.

DM: And I think you want to be buried now with three coffins, but no one's going to know which one you're in—either heroic Marina, spiritual Marina, or bullshit Marina.

MA: Yes, we have this three-coffin story. Actually, one will include my real body, the other ones not. But the important thing is to have a celebration of death. Bad news—we're all going to die. So it's very important that at one point of your life you prepare for that exit, so that exit has to be a celebration. I had a difficult but great life, and death has to be great too.

"**Innovation** and entrepreneurship happen at the edge of reason, because it is finding something that is unreasonable to most. Otherwise it would have been done."

SCOTT BELSKY

chief product officer, Adobe;
co-founder, Behance; angel investor

January 21, 2019

DAVID

The ultimate polymath.

When you think about David Byrne, you no doubt think of the Talking Heads, and some of the most joyful pop music ever. But there's so much more to this man. Over the years, he has collaborated with artists in dance, theater, film, and television, which has resulted in him winning an Oscar, many Grammy awards, and an induction into the Rock & Roll Hall of Fame. David collaborated with electronic DJ Fatboy Slim to create the musical *Here Lies Love*, about the life of Imelda Marcos. His most recent show is *American Utopia*, a Broadway musical that also has been turned into a film directed by Spike Lee, and a book by the same name illustrated by long-time collaborator Maira Kalman. Throughout his long career Byrne has produced and exhibited art, including the installations Playing the Building in Stockholm and Tight Spot, a site-specific audio installation at the Highline in New York City. He has published several books, including *Bicycle Diaries* and *How Music Works*.

BYRNE

DB: Yes. I don't know what age I was, but I was old enough to know that the mailman was a steady job. You got benefits and Social Security, and you got to be in the outdoors where nobody is bossing you around. You're just walking around and nobody's hovering over you and you can think to yourself or sing a song. You could mull things over in your mind. I thought it sounded like the best job in the world.

DM: You took up the harmonica at five years old, and by the time you were a teenager, you kept a transistor radio under your pillow so your parents wouldn't hear it. Yet it seems as if your dad encouraged your interest in music; he modified a small Norelco reel-to-reel recorder when you were in high school. What kinds of things you were recording?

DB: I remember trying to get as many layers of guitar and microphone feedback as I could possibly get; my dad helped me record what was then called sound-on-sound. This was a little tricky. It's not the same as multitrack recording, which is what exists now in recording. This is where you could listen to the sound coming off of a tape recorder, and then rerecord another recording head on the same tape recorder. You ended up destroying what was previously there, but in the process, you added something to it. However, if what you added wasn't perfect, you had to start from scratch. I remember creating one with a lot of feedback, howling sounds and very noisy, unpleasant stuff, layer upon layer. I also tried to do a version of the Turtle's song "Happy Together" using coffee cans as drums.

DM: Did you teach yourself how to play guitar and ukulele, and how to read music?

DB: Yes. I don't read music well, but I did teach myself to play. I had a Bob Dylan songbook, and the chords tended to be fairly simple. So when I learned three or four chords, I could play a lot of songs. Rather than learning scales and theory, this gave me the reward of being able to play a song that I heard immediately. If somebody wants to learn something, I think they should be getting rewarded constantly along the way.

DM: You began performing in local college coffee houses. You played rock songs in a folk music style and aggressive songs on the ukulele. What kinds of aggressive songs were you playing on the ukulele?

DB: I remember doing "Summertime Blues" and a song by a psychedelic group called Blue Cheer. I think The Who did that song as well. These sounds were all around, but the audiences were compartmentalized. The folk audience had never heard the pop songs. There were songs by various pop artists that were quite literate and their writing was really, really good. But the folk crowd stayed in their bubble and were unaware. I took advantage of it and played that music. This made me realize how we get into little aesthetic bubbles and might miss something as a result.

DM: Given the range of your artistic pursuits at the time, I was surprised to read that your teachers and guidance counselors tried to talk you out of going to art school. Why did they do that?

DB: Maybe they didn't see any financial future in it? I was also interested in engineering and science. I saw them all as equally valid creative endeavors, but again, they were each in their own bubbles, in their own silos. I visited one school and asked, "Well, can I take classes in the art department over there? Or in the science and engineering department?" And they replied, "Oh, no, you can't mix that." I realized that this was a problem, as I was interested in both.

DM: You were admitted to both Carnegie Mellon University and the Rhode Island School of Design. Is it true you picked RISD because the graffiti in the halls was better?

DB: There's a lot of truth to that; though it was not the only reason. I was able to sense the kind of creativity bubbling over at RISD. People were expressing themselves on every surface. In the science and engineering school, it all seemed very contained. I knew that there was creativity there, and very, very creative people, but somehow it seemed as if it was being tamped down.

DM: You spent a year at RISD, then transferred to Maryland Institute College of the Arts. While there, you formed a duo called Bizadi with Marc Kehoe, who played the accordion. You performed with a lighted candle on your hand-me-down violin bow while singing "Pennies From Heaven." Were these shows early attempts at performance art, or experimenting to find your voice?

DB: I suppose it had some aspects of performance art in it. Some of what we did was bizarre, but I think we both felt that it always had to be entertaining as well. We

might do something strange, but we wanted to keep it entertaining at all times, no matter how strange it was. I remember Marc playing "96 Tears" and I would strike poses: I'd stand on one leg and put my arms out and just hold it. Then I'd do another one. These were not difficult poses, but my demeanor said, "Check me out. Isn't this amazing what I'm doing?" Of course, it wasn't amazing at all. Anyway, back to jumping off the diving board. It wasn't just, "Look at me." I'm not an artist who does confessional work. I don't care if you know me at all. It's not about self-expression. At this point, trying to get attention in a group of kids was just for a dare and for fun and because you can. I went up on this board and thought, "How hard can it be to do a triple flip? I've seen people do it, I'm going to give it a shot."

DM: Marina Abramović would say that took a lot of stamina.

DB: Yes, it did take a bit of stamina.

DM: Was this around the time you shaved off your beard in the middle of a performance while Marc's girlfriend held up cue cards written in Russian?

DB: It could be around the same time. It's hard to shave off a beard without a mirror, but yes.

DM: You spent a year at MICA and then dropped out and returned to Rhode Island to visit friends and formed a rock band you called The Artistics. You've said this about your early performances: "I was flailing about to see who I was, switching from an Amish look to a crazy androgynous rock and roller. And I wasn't afraid to do so in public." Given how profoundly shy you were, what gave you the confidence to experiment so freely on stage?

DB: I think the freedom to be outrageous on stage came from feeling that I didn't have any social capital to lose. While I was shy around people in my day-to-day life, I could express myself on stage. I was announcing "here I am, I have something to say. Look at me, look at me, look at me."

DM: Without having to admit it?

DB: Yes, without having to say that's what I'm doing. At that age I wasn't quite sure who to be, and it was a period when I felt free to cycle through different versions of myself to see what felt most comfortable.

DM: In your book How Music Works, you wrote this about that time—"Desperate Dave did not have ambitions to be a professional musician, that seemed wholly unrealistic." When did that change?

DB: I don't think it changed until I performed in front of about twenty people or so at CBGBs, opening for The Ramones with Talking Heads. And when those people paid attention and actually applauded, I thought, "Oh, if these twenty people like it, maybe they'll tell their friends or maybe it'll be forty people next time, who knows. I could be on to something here."

DM: You've said that though much of your own music may initially have been composed in isolation, it only approached its final shape being performed live.

DB: It's true. When I first started making music and performing, the songs would take shape through live performance. You'd have to sketch out an arrangement, but the polishing and shaping all happened in front of an audience. The recording is an attempt to capture that. Now it's all flipped around. You create something in the studio or on the computer and then you have to figure out, "what do I do in front of an audience? Do I just reproduce this thing or do I have to translate it into something else that works in front of an audience?" I don't have an answer. It's a dilemma.

DM: Now it seems that so many performers have to emerge fully formed. We can no longer watch an artist find their voice.

DB: I agree. With everything being recorded, everything is pushed out to the public. It's rare that you have a tiny community that you can evolve in. And when you're ready and in shape, then you can release it to a wider public. That can still happen, but it's much harder for people to do now.

DM: As somebody who has spent a lifetime drawing and writing and designing and making things, writing music has seemed to be the one area of the arts that feels most mysterious, a sort of conjuring something up from nothing with melody and mood and words. It's such a gift.

DB: Yes. I've read that music engages different parts of the brain, and many, many senses all at once. More than some of the other arts and humanities, I think that music has a certain ambiguity to it. If something is written down in a novel, it has to be described, but in music, you're going straight to emotion. You can convey what it feels like, and you don't have to describe it.

DM: There could also be a tension between the way you're conveying it and what the words actually state.

DB: Yes, exactly. There might be other forms that can do this, but music does it really well. A piece of music can be very aggressive sounding, but the lyrics can convey loneliness or heartbreak. They can all be clashing against one another.

DM: David, collaboration has been a constant thread through your career, so much so Pitchfork once stated that you would collaborate with anyone for a bag of Doritos. You've written that though this wasn't intended as a compliment, it's not that far from the truth. Over the years, you've learned that you can work with people in a way that's not so dictatorial. How so?

DB: When I was younger, I was very much "my way or the highway" with my ideas. I had a very specific vision and expectation of how things should sound or look. I would get a bit aggressive and loud about insisting things be done exactly the way I wanted them to be done. Over the years, I've learned that you can often get the same results without having be that way. You don't have to yell. Guiding and the shaping can be done in a more subtle, joyful way. This dawned on me slowly.

DM: Maybe you are more comfortable in your own skin?

DB: Maybe after having achieved certain things, I've realized that if this doesn't work out, it's not the end of the world. I can still go on.

DM: You've stated that audiences love it when a performer walks the tight rope in front of them. Like sports fans, they feel their support is what keeps the team winning. Given the way you skate across so many genres, do you seek the tight rope? Do you feel comfortable being in a place where you're not exactly sure where you might fall?

DB: Yes, I do. In 2018, I toured for a good part of the year. Then, there was an interest in bringing the tour to Broadway. I knew that we'd have to change the show to do it there. We'd have to adjust for a different audience with a different set of expectations. I realized it was going to be a challenge. A Broadway audience may ask, "Where's the story?" But I thought it could be more challenging and more interesting than touring for another year doing exactly the same thing. I talked to the producers of the Broadway show recently and admitted that early on they really didn't know if it was going to work. There were no guarantees.

DM: You state this about the songs of *American Utopia* on your website: "The title is not ironic. The songs don't describe an imaginary and possibly impossible place, but rather they attempt to describe the world we live in now. And that world, when we look at it, as we live in it, as it impacts on us immediately, commands us to ask ourselves 'is there another way, a better way, a different way.'" And as I was reading this and researching your body of work, I was wondering if, on some level, this was a sequel to your film *True Stories*.

DB: Wow. I hadn't thought that. When you just read that description back to me, I thought, Wow, this is what we've been asking ourselves over the last year during the pandemic and Black Lives Matter. We're on pause now. When we go back, will we create a better way to do things? Can we rethink things? We don't have to go back to the way we were.

DM: You have a super-fan named Spike Lee, who directed the film version of *American Utopia*. When he began to work on the movie, you asked him if he wanted to shorten anything or open anything up or change the order, and he replied, "No, it works the way it is. I don't want to mess with it." The movie truly does manage to keep the energy of the live show, while also offering shots and angles that an in-person audience would never be able to see. Are you happy with the way the film came out?

DB: I'm very happy with the way the film turned out. I'm a big fan of Spike and also a fan of his director of photography, Ellen Kuras. Between the two of them, they mapped out how we were going to shoot the film and capture the energy. The result wasn't at all haphazard, we didn't say let's throw a bunch of cameras out there and keep our fingers crossed. There was a plan and I felt like the band and I were in good hands.

DM: You were recently asked what your greatest achievement in life was, and though you acknowledge that your answer was a cliché, I was really touched by it. You said that your greatest achievement in life was your daughter. You stated that coming from you, she could have been a mess, but she's not. She's very happy. Why do you think she could have been a mess?

DB: I wasn't a horrible parent, but there were times when I thought, "Oh, this parent thing, I really don't get it." There were other times when I thought, "Oh, this parent thing, it doesn't fit with the picture I have of myself of being an independent Bohemian artist." And yet I actually enjoyed it very much. Luckily, the little ones are more resilient than maybe we give them credit for.

DM: I see that your daughter is a designer. Perhaps creativity runs in the family?

DB: Maybe.

"We underplay creativity.

We snuff out the flame of curiosity

and we try and cram syllabuses into people,

and the spark goes out,

and it's a crying shame."

CHRIS ANDERSON

journalist, publisher,
head of TED

June 26, 2017

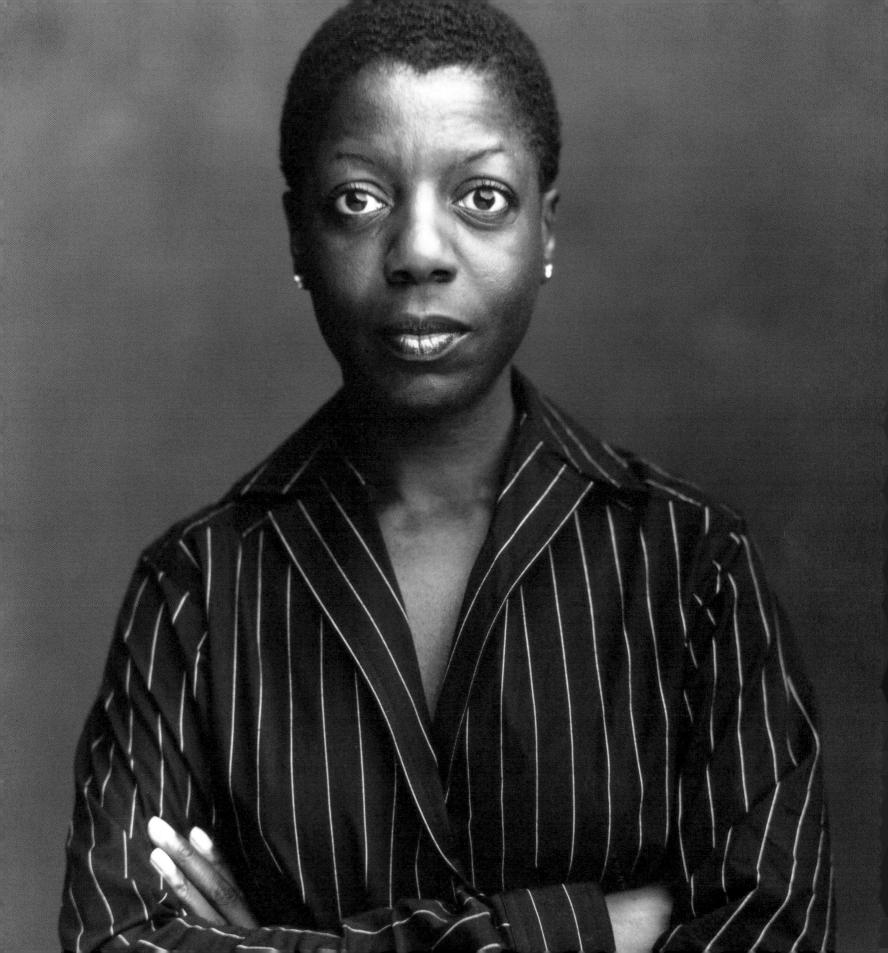

THELMA

Some kids dream of becoming artists. Thelma Golden dreamed of becoming a curator, and her dream came true.

In 1993 Thelma Golden brought many non-white, non-male artists into the Whitney Biennial, which she co-curated that year. In 1994 she curated another show at the Whitney titled "Black Male: Representations of Masculinity in Contemporary American Art." It was controversial and it put her on the map as a fearless curator with a gift for disturbing the racial status quo in art. She is currently the Director and Chief Curator of the Studio Museum in Harlem, where she continues to provoke and inspire.

GOLDEN

DM Thelma, you began planning your career in the art world following a sixth-grade art history class.

TG That art history class was the moment in which I understood that art could be studied. Until that point, I'd taken art classes and understood art making was invested in the idea of self-expression. But studying art history and understanding the way in which the study of art history was really a study of history, a study of culture, fascinated me. And I had an incredible teacher, Lucille Buck, who taught us art history very formally and supplemented that with those fantastic visits to museums. I began to understand that what we saw on the walls in museums was created by someone. I didn't know the term "curator" at that moment. I didn't understand the job trajectory. But I did understand when I went into museums that somebody made that possible.

DM You were also captivated by the museum guards. You've said, "I was deeply nurtured by museum guards who were incredibly gratified to see me, a young Black woman, in those museums. Many of those men have passed on now, but early in my career they all still worked in museums and saw me become a curator. I was invisible in the museums to the patrons, but the guards would come around the corners." Thelma, I understand that that's how you discovered Jacob Lawrence's *Migration Series*. Is that correct?"

TG Yes, it was through a guard at the Museum of Modern Art, a guard who had been there by then already twenty years. When he retired from the Museum of Modern Art, he'd been there for forty years and was someone who saw me often. He took it upon himself to point out the works of art by African American artists and made me understand the genius of Jacob Lawrence and the masterwork that series is. That really began my understanding of art history and how art history is written through these various artists' voices.

DM You mentioned getting a job as a high school intern at the Met. How does one go about getting an internship as a high school student at the Met?

TG The Metropolitan Museum, like so many of our great cultural institutions, including the Studio Museum, has a fantastic high school program. It's a program that combines art education and instruction. I was in that program for a year, taught by amazing artists Rico Burnham and Randy Williams. And then there was a program called the Apprentice Program, which was a high school internship program which placed you in a museum department to work three days a week after school through the fall and in the spring semester. I was an apprentice at the Metropolitan Museum in my junior and senior year in high school.

DM It was during your internship that you found your purpose and realized that your life's work would be curating. And you declared, "I began to understand that all of these works on the walls were actually created by people who had this deep expertise in a particular kind of artwork. A particular period. And that to me became fascinating as an idea that that was a job—that that was a job that I could do." That's a pretty profound realization to have so early in life. You never wanted to be anything else after that? You never considered becoming a fine artist yourself?

TG I don't know if it was a profound revelation as much as I just thought I could speak it into existence. The Apprentice Program also showed me curators at work—the real work, the research, the intellectual work, the labor that goes into making an exhibition. Making meaning for visitors in and around art. I respected that. I knew at that point I did not have that skill, but I pledged to myself in my aspiration then toward college and beyond that that's what I wanted to do.

DM People now know you as the Studio Museum in Harlem's director and chief curator. What they might not know is that you started there as an intern. How did you first find your way to the Studio Museum?

TG I found the Studio Museum because in many ways it's an institution I always knew. My father was born and raised in Harlem. The Studio Museum was founded in 1968, so through my childhood in the 1970s the Studio Museum existed and was open. It's a place I've visited with my parents. My parents were deeply invested in New York's African American cultural institutional scene, so I understood the Studio Museum in the context of other institutions like the Schomburg Center for Research in Black Culture, the National Black Theater, the Negro Ensemble Company, the Dance Theater of Harlem, Alvin Ailey.

DM After interning, you worked there as a curatorial assistant for a year and in 1988 took the job at the Whitney Museum of American Art. You were the institution's first Black curator. Did you feel the significance of this new role?

TG I spent a year at the Studio Museum as a fellow, a program we still have now for recent college graduates, and then I went to the Whitney in 1988 as a curatorial assistant working for the curator Richard Armstrong, who is now the director of the Guggenheim Museum. And in that role, I worked for Richard on a range of amazing exhibitions he made and got to see close up what it meant to be a curator and to work with such a fantastic curator. I then left the Whitney in 1990 to work for the art historian Kelly Jones, who was then running an incredibly innovative contemporary art program in southeast Queens, the neighborhood where I grew up. And working for Kelly for that year, year and a half, gave me the sense of possibility about contemporary curatorial practice. It was right at the time a job opened up at the Whitney for a director of the branch at Philip Morris. In that job I was, yes, the first African American curator at the Whitney Museum.

DM I understand that you used to be mistaken for your own assistant.

TG Often.

DM While people will be furious hearing this, you've said it was actually liberating. How?

TG It's something that, perhaps, could not happen now, though I have to say it has happened now, but in this world we live in now, where we have so much more visual information as a reference point, perhaps it wouldn't happen in the way it did in those days, pre-Internet, when people would speak to me on the phone for weeks ahead of an appointment, and then I would show up and their sense of who they spoke to on the telephone—who would have been this curator at the Whitney, and who I was when I showed up—could not be the same person. What I found was liberating is that being so profoundly underestimated gave me a sense of what my own possibility was. I never took that as an insult, but yet I understood that I was always disproving people's sense of limitation.

DM I'm curious, how does the idea for an exhibition begin to take root and develop in your mind? What makes something museum-show worthy?

TG Every exhibition has been different. In the case of "Black Male," it was a reaction to what was happening in the world. In the 1993 biennial, which was just the year before, John Hanhardt, one of the amazing co-curators of that exhibition, included the video of Rodney King being beaten. A brave, a bold choice, an important one, but one that was controversial. That video, that image, and the way in which it sparked a whole level of conversation among artists made me start looking, both in the present and then going back to the 1960s, to look at the ways in which the Black male image had been understood by artists as they made work from the late 1960s to that present. That exhibition came from the inspiration of the thinking of that moment. I also wanted to make an exhibition that looked at race. And I wanted to make an exhibition that understood or positioned a way in which a group of artists of that moment were making conceptual art about race. So there were several layers.

DM You're also recognized for nurturing artists. What does it take for someone or something to draw your eye? How do you recognize potential and choose who you are interested in working with?

TG The beginning of my relationship to any artist comes through my relationship to their work, so it usually begins because there is something in their work that I see and that makes me have a profound sense of wanting to be in a conversation around that work. If it provokes questions in me, if it creates a sense of confirming what I think I know or making me not comfortable with what I think I know, that's a way I want to be in conversation with more work by that artist. And that then becomes a process of dialogue. And with many of the artists I've been privileged to work with for many years, it's been an ongoing conversation. And in those ongoing conversations, I am able to be in a kind of collaborative relationship with them which can often result in a curatorial project.

DM In the *Brooklyn Rail*, you stated, "Curatorial practice is intellectual work, weaponized," and I'm wondering if you can elaborate.

TG The act of thinking about art and artworks and artists, writing about them, putting them into public space, taking those ideas and making an exhibition as a narrative in a public space, and engaging with audiences really then allows for something profoundly powerful, and that is creating space—intellectual space, emotional space, I dare even say spiritual space—for us to engage with ourselves and each other.

"I'm

not a doodler. I don't like to idly make something that has absolutely no meaning whatsoever. I don't like doing things that are predictable. I'm interested in things that have surprise juxtaposition that require figuring something out, that not only engage my own brain in the making of the thing but engage the brain of the viewer. I want them to do a double take to see something that intrigues them and make them stop and look at it further."

MARIAN BANTJES

graphic artist

January 11, 2013

T E A

Tea Uglow is a designer with a swanky official title.

She's the Creative Director for Google's Creative Lab in Sydney, Australia. But in the fluid world of design and technology, titles don't really tell you much about what the people behind them actually do or who they are. Tea Uglow works on projects that help artists, writers, and performers use digital tools in their work. She's written books, designed websites and apps, collaborated on films, plays, concerts, and exhibits. And this little resume doesn't even scratch the surface of her achievements. In this interview we talk about what it means to be female, why the shape of people's ears is a weird thing, and sexual diversity.

U G L O W

DM Tea, you've said that you were raised in a feminist tradition. In what way?

TU Gender did sort of play a role, but it was probably more of a kind of boy atmosphere than not. And therefore, you roll with that and you take these lessons. No one ever has to say, "This is a lesson about how to be a boy." It's just you are told again and again and again until you begin to understand that that's what you are, that's what they expect you to be. And there's no one, certainly not in the 1980s in Kent. We're talking about an era where it was illegal to teach about homosexuality in schools, to teach about homosexuality, let alone gender, let alone gender roles. So we were in a kind of dark ages in the U.K. in terms of gender and sexuality and the idea that these expressions were acceptable. And that's what I grew up with. If no one ever teaches you and there's no visibility, of course you're going to be what they want you to be because you think that's normal. That is normal.

DM You also played rugby, I believe. Was that something that you enjoyed, or was that something that you resented having to do?

TU I enjoyed playing the game. I really enjoy physically hitting someone with your shoulder, like a really hard tackle. There's something deeply profoundly enjoyable about that. I'm an introvert and not designed for that kind of sports club life. I don't know how I did all that, actually.

DM You started to have memories at about fifteen, which is also when you said you began to develop consciousness of being an individual. What does that mean? What did you find at that age?

TU My version of normal was probably not everyone else's version of normal, but I certainly found that there was this sense that you could construct an identity. That you could begin to borrow things from other people, just like if you're walking through a computer game and you can pick up bits of armor or special magic potions, or you can modify your appearance. For me there's not much difference.

DM When did you have a sense that you're female?

TU I've always, since I was three, known there would be a day when there was a switchover day. That didn't last very long because it became incredibly clear that there wouldn't be a switchover day, probably because that would be really unfair to all the girls. And then as you begin to develop sexual ideas and sexual feelings, it's so weird to tell the world about that. You get to a point where you're like, "Why is it that all my fantasies are about being a girl with guys? That's weird." And then you go, "Huh, must just be kind of normal." And then by the time you realize it isn't normal, you've worked out, thankfully beforehand, not to tell anyone, ever. It has taken me forty years to work out that maybe there's a benefit to telling ten-year-olds that they don't need to struggle with those thoughts.

DM I spent almost I would say the first fifty years of my life keeping secret after secret after secret, whether about abuse or sexual orientation or any number of things. And when I finally did come out at fifty, I had a real sense of resentment at actually having to declare anything, as if it was anybody's business who I slept with when I was straight, and why should it be anybody's business who I sleep with if I'm not straight? And I find that having to declare something like that, there's a certain inequality to it that I resent.

TU Within the trans community, enormously so. There's this kind of bizarre idea that you should disclose what genitals you have, whether you've had surgery or not. What other surgeries are people feeling entitled to know about?

DM Exactly. I don't walk around and say, "Hi, I'm Debbie Millman, I had a hernia operation when I was four."

TU More importantly, for anyone to be able to go, "So have you had a hernia operation?" But you see trans people on TV shows today who are being asked that, as if somehow these people owe the public some form of disclosure. And you see it with intersex people, and you see it with disabled people. You see it with all sorts of kind of minorities. You see it in mental health. There is a whole world of disclosure. I disclose a lot, and I disclose for a reason. I disclose because I know there are kids out there for whom it is important that I'm trans, and queer, and have a dissociative disorder and other mental health issues, the fact that I've been in a psych ward, and repeatedly, yet it doesn't affect my work or my profile or the things that I want to say. I will talk about those things, but I would still much rather talk about the work, the ideas, the people I do projects with, and the idea of information in space, and orientation, and sound, and why the shape of people's ears is a weird thing.

DM I didn't come out until I was fifty because I wasn't sure of my sexuality. I didn't come out until I was fifty because I was afraid of it, and I was afraid of how I'd be judged, and I was afraid people would think that there was something wrong with me. Because I thought there was something wrong with myself. When I finally did come out, I spent a lot of time even before coming out reading—I've been always endlessly fascinated by coming out stories, by transition stories. And for quite some time I was reading a lot about transition stories and *Portrait of a Lesbian Transsexual,* which is a seminal book from many, many, many decades ago. My partner at the time questioned whether I was trans, and I said, "No, I'm not, but I'm fascinated by what it means to stand up for who you are," which is something that I've only recently been able to feel. That sense of being proud of who you are, and the courage it takes to become who you are.

TU It is courageous. There's a generation who don't quite understand that what you're overcoming still are the stigma of your youth, not the lack of stigma. And frankly, you exist in a lovely bubble in this world which does accept you, and you don't need to be afraid particularly, Debbie. But there are lots of places in the world, there's lots of places in the U.S., where you need to be afraid. There are places in the world I cannot travel to.

DM What do you do when you are faced with the otherness being put upon you? How do you respond to that?

TU Othering is super important in terms of creativity and culture. It's incredibly important in allowing people to understand that they're different. The input for that is accommodation. Accommodating the fact that everyone is already different and is diverse. Whether it's neurodiversity and how your brain works. Whether it's about gender diversity, and gender fluidity, and how you present to the world and what role you want to play. Whether it's about sexual diversity, religious diversity, economic diversity, educational diversity. We already live in incredibly diverse environments. We know there are benefits to allowing or accommodating diversity. That's what we want to do, but we don't use the word "accommodate."

IRA

Ira Glass began working in public radio in 1978 as an intern at NPR's headquarters in Washington, D.C.

Over the next seventeen years, he worked on nearly every NPR news show and had nearly every production job they had: tape cutter, desk assistant, newscast writer, editor, producer, reporter, and substitute host. He is currently the host and producer of the radio series and podcast *This American Life*. He also co-created the podcast *Serial*, which is widely credited with popularizing the modern narrative podcast movement. His work in radio and television has won him awards like the Edward R. Murrow Award for Outstanding Contributions to Public Radio and the George Polk Award in Radio Reporting. In this interview we talked in front of a live audience at the On Air Fest in Brooklyn, New York.

GLASS

DM: You've said that you don't like interviewing famous people, mostly because they arrive at an interview with a mask that might be hard to penetrate. Do you have any surefire way to get them to lower the mask?

IG: There's a print reporter who used to write a lot for the *Los Angeles Times.* She and I used to talk about this because she would interview Nicole Kidman and people like that and I'd ask her, "What do you do?" She would tell a lot of stories about herself that would relate to things inside them—she was enormously empathetic as a person. Her subjects would get lost in a conversation with her—as lost as somebody can get who's in that kind of position. I've said this a million times, but an interview is a party that you are throwing, and if you are a three-dimensional person that gives the other person the opportunity to be a three-dimensional person back. I remember when I was interviewed by Mark Maron for the *WTF* podcast. He is so emotionally present and so bare that you feel like you have to rise to the occasion as the interviewee.

DM: Your mom was a clinical psychologist. Your dad started out as a radio announcer but then eventually became a certified public accountant. Have you heard his early radio announcements?

IG: He gave it up when my mom became pregnant with me, and I didn't really know about that part of his life when I went into radio. It's one of those things that had been mentioned but wasn't a part of his identity that we ever discussed. And I have heard the recordings. He's a 1950s-era DJ and doing the ads and doing the news with a much better voice than mine.

What was emotional about hearing him do something that I know so well and hearing him be so much younger than me doing it and—I hope this isn't a hurtful thing to say—not as good, if you know what I mean. Hearing him read really bad ad copy and having to perform it as if he's really saying the words and meaning them. Sometimes he's pulling it off, but sometimes not totally. Listening to those—it's like a different entry point to your own parents.

DM: *Peanuts Treasury* was one of your favorite books growing up. You've stated that it defined the emotional climate of your elementary years. In what way?

IG: I connected very strongly with Charlie Brown. *Peanuts* was art that's for kids, and yet it's so movingly sad. To me it never seemed funny. It just seemed very real. I remember my mom saying to me, "You're not Charlie Brown."

DM: Did that surprise you?

IG: That I wasn't Charlie Brown? It is how I saw myself. I saw myself as very much like Charlie Brown. I had

friends, but there's something about the aloneness of that character that I connected to.

DM: How do you think Charlie Brown grew up?

IG: That's really an interesting question. I don't know. I've never thought about that.

DM: I think he would be Chris Ware.

IG: I know Chris Ware. Chris Ware is this cartoonist who does these very melancholic comic strips and then became somewhat of an expert on Charles Schulz. I feel like in real life he's so much better put together and more successful. He invented this aesthetic for doing comic stories, but he also is a completely successful parent and husband and a functioning adult who is actually much sturdier and happier, I think, than his public persona. Though I think it would make him wince to hear me say that.

DM: Yes, I think so.

IG: Yes.

Feeling scared all the time is normal for a broadcaster, right?

DM: You loved to put on plays and shows when you were a kid; you made these plays with your siblings. I understand you knew every line and joke from *Fiddler on the Roof.*

IG: My mom took us to plays when I was a kid. There's a lot of Jews in Baltimore County and so *Fiddler on the Roof* would come through every year or two. I remember seeing it so many times as a kid. It imprinted itself so hard. That structure of pulling you in with comedy at the beginning and then gradually it gets more and more serious and by the end is quite sad—that structure was very influential to me. Coming up in my twenties, I was working at NPR in Washington, and once I understood the basics of how to do journalism, there was a feeling I was looking for in the stories that I wouldn't have named. I didn't name it to myself, but I had a sense of, "I want it to feel more." At some point I started to make stories that had exactly the structure of *Fiddler on the Roof,* where they would pull you in with something very light and then you get invested in the characters and then it gets more and more serious and turns out to be about a bigger something.

Obviously, this is a structure lots of people use in lots of different storytelling. While I was doing it, I don't think I had a conscious thought that that's what I was doing, I just had a drive to make journalism have this feeling

that I know a piece of work can have. In retrospect, I do think that's what it's about—that feeling I would get from those old musicals. I think it would mean something to my mother that that thing that meant so much to her would mean so much to me. I think that would be very moving to my mom.

DM: *This American Life* producer Julie Snyder has said that you love performing on stage in a way that is sincere and mystifying. I'm wondering if that all comes from that early experience of *Fiddler.*

IG: Maybe. There's something about me that I would just decide to go on stage. Yet there are other things in my personality that seem like they don't combine with that tendency. I started doing magic on stage only because I knew nothing about it. I went to the Baltimore County Public Library on Liberty Road and took out books on magic and then took out ads in the *Baltimore Jewish Times* saying, "Pay me $5.00, and I'll come do magic tricks at your kid's birthday." I didn't know anybody who had done magic. At the age of eleven I concluded, "I could do that." It's a very similar impulse that got me my own radio show—"I think I can do that."

DM: What was it about magic that was so intriguing to you?

IG: The actual mechanics of it are cool. Also, magic was a way to be funny in front of a group of people. I wasn't a very skilled magician, but I could hold a room of children. I could connect with them and I could tell a story and I could be very funny. Magic combined a bunch of things that I liked in the same way that doing the radio combines a bunch of things that I like. I like interviewing people. I actually enjoy it. And I'm nosy. I like figuring things out, and I love the editing part of it. Weirdly, the part of radio that I like the least is the actual performing on the radio. I feel like I can do it competently, but I've never been fond of it. There are so many times where I'd feel tense and it feels a little fake and a little off. It's like one of those games you get into where if you do it perfectly, nobody notices and it just sells—and then there's all these ways for it to go badly.

DM: Have you always been this hard on yourself?

IG: I used to not be as skilled at it, so I was harder. It's funny: when I give speeches now, I'll play pieces from the eighth year I was doing radio—not even the first or second year—and it's horrible.

DM: You've said that it took you longer than anyone you know in radio to actually be good.

IG: In the years since I've said that, I have still never met anybody who took like a decade to get decent. I wouldn't have been able to get an internship on my own show when I was in my twenties. I was not good enough.

DM: Why do you think you kept persevering? What kept you trying for eight years? That's a long time.

IG: I know. There's something about it that attracted me. I was a very awkward interviewer at first, but I could get material out of people. I could get people to say stuff and I could figure stuff out about material, about people, and have emotional moments on tape with people in a way that was very exciting to me. I feel like I was able to get certain stuff on tape even though I was awkward. Then, as soon as I was editing real interviews, I had an instinctive feeling for how to do it. So, there was a part of it that came so easily and where I felt so confident, and that essentially carried the rest. I just felt like this could go somewhere and I couldn't tell where and I had nothing else that I wanted to do. I wasn't ambitious enough or didn't think enough of myself to want to be a filmmaker or a real writer. I didn't have a good enough self-image to aspire to something like that, but quietly doing my little stories and sitting in an edit room, that seemed doable.

DM: Has your self-image changed at all?

IG: In my experience it has, for sure. But a bad self-image doesn't go away, in my experience. You just pile other things you learn about yourself on top of it. So, of course, now I'm enormously confident making radio stories and running a business and all of those things.

DM: What aren't you confident about?

IG: I'm often having to think my way through delicate management issues and dealing with people, but I think that's normal for anybody who's a boss of lots of people. Having done a show for so long, you would think that that had changed my picture of myself. Yet there's something where I still just don't think that much of it all, if that makes sense.

DM: What's the "it"? You don't think that much of "it" all. Is that you or your work or the combination?

IG: No, I feel like the work speaks for itself. I feel very confident about the work. But I'm not a person who's able to turn that into building up a sense of, "I'm really awesome." But I feel like that's okay. I feel like I don't think I need that.

Radio is so peculiarly dependent on the quotes. You can make a story about that person, but it shouldn't be a radio story if they can't talk about it. Another trick we do often is we'll go to a significant other because sometimes that person—a partner or a brother or sister—is a wonderful talker. Sometimes you can introduce a second character to the story who can carry the emotion of it. There are some beautiful stories we've done that way where the main character isn't carrying the feeling of it, but then somebody else will say, "They were really feeling this and that."

DM: You mentioned your interview with Marc Maron. You talked about his ability to sit in front of a microphone in a way that had a lot of feeling and a lot of heart. You go on to state that the easiest, most fulfilling, most intimate conversations of your day are the ones that happen in front of the microphone.

IG: Many days. I have to say in my personal life now...

DM: ...things have gotten better?

IG: Actually, yes. In my personal life I'm having conversations that are as intimate as that.

DM: Do you feel like you give more intimacy to the show than you do to others or have in the past?

IG: In an hour- or two-hour-long radio interview, it's easy to be very focused on another person with a goal. It's a situation that's set up for intimacy, versus you come home and people have different needs from each other or whatever. People come into a home situation with whatever it is that they need and have to collide and figure out what they're going to talk about and how they're going to talk about it. In a personal relationship, the things you're stressed out about are way more present than in an interview. I think that intimacy was always much easier in a radio situation, and I had to learn it more in a personal situation.

DM: How has *This American Life* changed over the time you've had the show?

IG: I feel like everything I have to say about this is everything that everybody knows: that we live in a moment where every bit of reality is contested by two different teams. There's my team, which is the mainstream news team, and there's the right-wing media team, and each one has its own narrative of every single event and many cultural things as well. I think that'll be with us for the rest of our lives.

DM: How do you combat fake news now, or the notion of what fake news is?

IG: We have a bunch of different strategies on our show. Sometimes we'll do origin stories like, "Here's how this became an issue and here's how it became to be thought of that way." Another thing is, sometimes we'll take the perspective, "This is in the news but without the emotional weight that you can get through a properly told narrative, where you meet the people and you feel something for them." So we'll do something like that. We went to Hong Kong, where you see protest; we spent time and met the people in their early twenties who are protesting, and they're talking very movingly about how they think China is not going to give them what they want, but they have to be out there. I feel like there were dimensions that weren't in the excellent news coverage that I was hearing on *NPR* and reading in the *New York*

Times and *Washington Post* and other places. There's a place for a narrative to make something that we all hear about feel more real; you can have more than an idea of it in your head—you can feel a connection with actual people. This is a very traditional sort of journalism but something that radio is particularly good for.

We did these two shows that I feel very proud of. It didn't get much attention, but early on in the Trump administration, there was this fight about immigration policy where the question was, "Does allowing in low-wage immigrants make for a better country or a worse country?" We decided, "Let's leave aside the national debate. Let's go to one town that got a ton of people coming in and look at how did it affect this town." Jeff Sessions would talk about these towns in Alabama where people would come in from Mexico to work in the chicken processing plants. Well, let's go to the number one town like that and then consider, "What did it do to this town? Did it drive down wages? What did it do to people's taxes? What did it do to schools?"—all the things that people talk about. And we hired economists to do a study of what did this do to people's wages—we tried to answer those questions in this one place. That seemed like something nobody is doing, or people do but it's hard. We do it.

DM: *This American Life* won a Peabody Award in the very first year of broadcasting, which is remarkable. You've won every major award there is to win in radio. Yet you've stated the following, Ira, and I was very curious about this. This gets back to what we were talking about earlier about self-esteem, but this is really about the show. You've said, "Honestly, making radio is still hard. I have really hard weeks on the show where I'm really frightened and really struggling to make the show good." In a recent interview in the *Guardian*, you stated that you feel scared all the time.

IG: Well, feeling scared all the time is normal for a broadcaster, right?

DM: No.

IG: Really?

DM: I don't think so. Maybe they're just not being honest with me, but not every broadcaster I know is scared all the time.

IG: But you don't know if the thing is going to be any good. It's like being in the middle of preparing a thing that's not done and you don't know if you're going to finish it on time and you don't have enough time. For me, fear is built into making things.

DM: But what about your track record?

IG: I feel confident we'll get it done as well as it can be done by us.

"**This** is one of the things that makes us human: the fact that we break bread no matter who we are, wherever we are, whatever our lives look like— and everybody has a story."

ELISSA ALTMAN

writer

October 14, 2019

Eve Ensler is no more.

After she finished her latest book, *The Apology*, written from the point of view of the father who physically and sexually abused her when she was a child, she changed her name. She is now simply V. In this conversation, we talked about her book *The Apology* and an extraordinary career that includes *The Vagina Monologues*, *I Am an Emotional Creature*, *Necessary Targets*, and the remarkable memoir and one-woman show, *In the Body of the World*.

DM: In *The Apology*, you imagined what your now-deceased father would say to you if he were able to apologize for the sexual and physical abuse he inflicted on you as you were growing up. You begin the memoir with a simple dedication for every woman still waiting for an apology. Why that dedication?

V: Listening to story after story after story for over twenty-odd years, what just hits me is how few, if any, women I've ever met who have ever received an apology from their perpetrator. There's not even an expectation of an apology. That feels outrageous. There is a longing for apology, for acknowledgment, for reckoning, for reparations, as there is with the Black Lives Matter movement and with indigenous people.

DM: I read that you've been disappointed by the self-pitying public apologies made by men accused of abusing women, and that you haven't seen a single man reckon with what he's done. Do you think abusers could use your book as a blueprint for an apology done right?

V: What's been surprising is how many men have responded to the book, how many male reviewers seem to understand it, and how many men are looking for a way to come to terms with what they've done but don't have the means. I'm more optimistic since writing the book that we could move into a time of reckoning. I don't know how real change happens without that reckoning. Something I have learned about the process of apology is that it's for the perpetrator more profoundly than it even is for the victim because all of us walk around with the residue, and the guilt, and the shame, and the pain, and the remnants of harm we have caused in other people. If we could create ways that men could begin to do these reckonings without being totally shamed, without being totally judged—I think it is the way forward. Looking at the details of what you've done and then looking at what your victim felt—going inside and sitting with the suffering you've caused—and then making amends. I think that process is deep and it takes time, but it's also so cleansing and liberating and allows one to begin a whole other kind of life.

DM: You were born in New York City but raised in Scarsdale. In *The Apology,* you write that your parents didn't think of you and your siblings as anything more than props for their evolving lifestyle. Can you elaborate on that?

V: You were meant to be seen and not heard, you were meant to disappear at cocktail hour. I never really saw myself as a subject but as something that got brought out for certain moments. I never felt real. I never felt like a real person to them, which is in some ways very objectifying and makes it much easier to hurt that person.

DM: Well, it seemed like your father didn't think you were real. The first five years of your life seemed rather typical. You were a bright, engaging, spirited, highly creative child. You were deeply ethical. You had an implicit and demanding sense of loyalty. You described how it was very important for you to be good. Where did that need for goodness come from?

V: I know where it came from after all the very bad stuff started because once my father incested me and then started to beat me, I was being called "bad" all the time—all the time. I was soiled. I think the quest to be good became the only thing that mattered in my life because he had told me so consistently and so often with such intensity and such rage and such violence that I was bad. I wanted to die all the time from that feeling of badness.

DM: Your father started to abuse you when you were five, which is unthinkable. When he stopped abusing you sexually at ten, he began beating you physically, and this went on daily. In *The Apology,* you described the transformation from bright, young child to abused ten-year-old girl and how your father worked daily to destroy your character. When you were ten years old, you were assaulted by some boys in your class. They stripped you and called you "seaweed hair" because your hair was stringy.

V: I became hysterical after they stripped me and they pulled down my underpants in front of the whole school. My parents were called in. My father immediately began to demand what I had done—what slutty, horrible thing I had done to get them to do this to me. I wasn't believed. I was wrong, and I was the reason that happened. For weeks after, we'd go into the cafeteria and they'd call me "slut," and they would call me "dirty stringy hair." Those of us who have been abused sexually radiate this strange, desperate energy that begins to attract more abuse. Whether it was working in prison for eight years or working in homeless shelters, I cannot tell you how often I hear the story of a girl being abused by her father or uncle and how that begins to attract rapes and abuse from all kinds of other people. It's almost like a pheromone. It's something you're sending out that says you're broken and you can be taken.

DM: Do you think people who have experienced this type of extreme, extreme behavior rewire themselves to either overcome it or be able to understand it?

V: I think that's one part of it. There's another weird part of it, which is it's very suicidal. You've lost any agency over yourself, so the world might as well just do it to you. That's what I deserved, right? That's how bad I was.

DM: You write about how you learned to separate from your shame and terror by constructing an alternative persona that developed the capacity to feel nothing, and you learned how to disappear. Do you have any sense of how you did that?

V: When I was being abused, I left my body. I floated out of myself. Everything about it was too much for my nervous system, for my developing sexuality, for my cells, for my consciousness, for my understanding. So, I began to learn how to go away. I learned how to shut down. I learned how to be dead. I remember my father would call me down and scream at me, and I would look in the mirror and I would literally talk myself out of myself. He couldn't touch me, but there's a huge price to pay for that, which is that you begin to split.

DM: You've written about how you turned off your valves of empathy because to feel anyone else's pain would have meant to feel your own, and you couldn't allow yourself to do that. And then as you were growing up, you said that drugs and booze saved your life until they started to destroy it.

V: By the time high school was ending, I was a complete drug addict and alcoholic. But something had happened at the end of high school where these two wonderful teachers had confronted me and said, "We don't believe you're stupid. We think you're really smart, and we want to work with you."

They helped me to the point where I passed this AP Honors History class, which was the only time my brain had ever been able to think in all those years, right? My brain was so tortured. I had no memory. I had no ability to concentrate. That was the beginning of something. My father had somehow applied for me to this school called Beaver College in Glenside, Pennsylvania. When I got there, I suddenly started to achieve academically. I started to do really, really well. I transferred after the first year to Middlebury.

DM: What did you think you wanted to do professionally at that point in your life?

V: From the time I was young, I knew I wanted to be a writer. I wrote because I had to write. It was like creating this alternative persona that lived in my journals, that lived where I wrote. I could create language and stories and another world where I could live, where I could be free—where I could survive. To this day, I have to write every day. That's what I have to do. It's how I survive, to be honest, and how I keep sane. When I came to New York, I was writing poetry, but in those days you certainly couldn't make a living being a poet. So, I thought maybe I'd direct theater. Then it dawned on me, "I could write plays" as the coming together of poetry and directing.

DM: One part of your story that is so incredibly heartbreaking is that you were accepted to a very prestigious graduate school, but because you didn't have any money and your father wouldn't help you, you couldn't go. Where were you accepted? You don't ever reveal that. Would you mind saying?

V: I was accepted into Yale. It was one of the most devastating moments. Now I don't regret it one tiny bit. I had no money. I had no support. I had nothing. I had years where I had to struggle and struggle and struggle and struggle. Those years made me. They created my character. They made me much, much more connected to working people, to people in struggle, to people in suffering, than I ever would have been had I gone to Yale. So, I lost the connections. I lost the network. I lost the pipeline to success. In a way, it opened my soul. It took me on a journey to the most amazing places in the world. I never would have written *The Vagina Monologues* had I gone to Yale. Never.

DM: Really? You don't think so?

V: Nope. I think I would have been carved into a much more traditional path. I would have learned what the limitations were and how to be careful of them, but because there was no one supporting me, I invented my life because I had to. There's something about that path that's very, very hard, but I highly recommend it because you end up as yourself.

DM: I do wonder if you had gone to Yale, what they would have thought of you writing *The Vagina Monologues.*

V: That's what I'm saying. I don't think it would have been like, "Oh, goody!" One of the things I've always believed is that if you follow your own curiosity, if you follow your own bliss, if you follow what you care about, you will write the best thing. I was interested in what women thought about their vaginas, and everything

that women said to me was so surprising, so startling, so amazing, so shocking, so funny. Every person had something wild to say, and I thought, "This is amazing." What was particularly amazing is when I first started doing this show downtown, women would literally line up after the show to tell me their stories. They needed to tell their story and a lot of it, unfortunately, was about sexual abuse—a lot of it.

DM: In 2006 the *New York Times* called *The Vagina Monologues* the most important piece of political theater of the last decade. What was it like to become suddenly so successful?

V: It was shocking. What was really, really exciting about it was the building of this amazing movement and community of women. The first V-Day we ever did was at the Hammerstein Ballroom, which seats 2,500 people. I had invited all these amazing actors to perform it, and no one had done it at that point. None of those women had ever said "vagina" publicly. So everyone was just completely freaked out backstage. Every time one woman would go out and do her monologue, everyone would be watching on this monitor. They all held hands. They'd all scream and yell, and it was the most beautiful sisterhood of support. To me, it was the beginning of the movement to end violence against women and girls. Now, there had been many women working on it before me, of course, because there is a chain of sister supporting sister, right? Our movement goes back to African American women who were fighting slavery, right? And now we've moved into #MeToo. But to be in that movement in those years of doing the play, spreading the play, getting women to share their stories and break the silence—it was glorious. It was beyond the dream. I don't even know that I could have had that dream.

DM: Yes, there have been other movements, and we hope that there'll be a time when we don't need these movements, but you have done more than most. You've raised over $100 million to help eradicate sexual violence. You've empowered women all over the world through your group One Billion Rising. What made you decide to build the City of Joy in Congo?

V: I had been in Bosnia. I had been in Kosovo. I've been in Haiti. I've been in Afghanistan. I've been in war zones where women were being systematically raped as a tactic of war. Someone from the UN called me and asked me if I would interview Dr. Denis Mukwege. I was so shocked that anyone from the UN was calling me. I

didn't want to do it, because One Billion Rising was already working in Afghanistan, in Bosnia, in Haiti. We just didn't have the bandwidth.

Then I read his resume, and I was so moved by what he was doing as a gynecologist that I agreed to interview him. When you meet someone and you feel like they are on some level of transcendent radiance and the work they're doing is so mind blowing—I mean, his eyes were literally bloodshot from all the horrors he had seen. At the end of the interview he asked me, "Would you help us? You're the only person I know who's talking about vaginas, and I'm trying to talk about what's happening to the vaginas of women in Congo." So I did. I have to say that trip was just the most devastating, shocking intersectional reality of racism, colonialism, capitalism, and sexism merging in this horrifying cauldron. And all of it was being enacted on the bodies of women. I can honestly say my brain was shattered. It was the beginning of another stage of my life.

DM: You've said that inside these women was a determination and a life force you had never witnessed.

V: Well, the City of Joy is in Bukavu, which is Eastern Congo, where most of the conflict has been. We opened it ten years ago so women could literally turn their pain to power. It hosts ninety women for six months at a time. Everything is paid for. They go through an incredible program of therapy through art, through theater, through dance, through music, and through basic therapy—but it's all group therapy because all healing is done in community. They learn their rights. They learn permaculture. They learn self-defense. They go from being victims to survivors to leaders over the course of those six months.

We've now graduated about 1,400 women, and it's unbelievable. The women are doing so well. They run collectives. They've become nurses. They've become doctors. What I'm most proud of about City of Joy is there are no outsiders who work there. They have professionalized an entire staff. It's completely theirs. Our work on this side of the water is to find the money to keep them going, but it's been one of the most beautiful, beautiful projects. We're ready to see whether we can start developing more City of Joys in other parts of the world.

DM: Talk about a purpose in life. What have the women of the Congo and the work you've done there taught you?

V: First of all, they saved my life. When we were opening the City of Joy, I got diagnosed with uterine cancer. I came very close to dying. I had seven organs removed. My body rearranged. I went through nine months of utter upheaval, chemo, and infections.

If you walk through City of Joy at any time of day, you will hear the most beautiful drumming, the most beautiful singing, the beautiful dancing. There's this spirit there that just feels holy. It feels from some other dimension, and it's healing. Whatever that energy is, it's the force of women who have turned their suffering into medicine. They've taught me that it's possible.

DM: It helps make sense of one's life.

V: Yes.

DM: When you discovered you had a huge tumor in your uterus, you've said that you touched death and it was the most powerful transformation of your life.

V: Even though there were moments during *The Vagina Monologues,* I don't know that I was fully inhabiting my body up to this point. When I woke up from that surgery, it was amazing. I had tubes coming out of every part of my body. I had bags. I was hooked up to machines. I had a scar down my entire torso, but it was the first time in my life that I was a body, that it was fully a body. When you sit in a room and the doctor looks over at you and tells you the odds aren't good, you die in that moment. There is a death that happens in your body. Then what begins to happen is you realize how much you want to be alive, and how beautiful life is, and how you want to actually live in your body and live fully in your life force, which has been muted, cut out, drained, destroyed by patriarchy, by violence, by all the things that have gone on in your lifetime to try to undermine and destroy you.

I feel that cancer was the spiritual alchemy that turned my life where it was meant to go. It was a transcendental experience. It was a shamanic experience. Chemo was an experience where I started to merge and become part of trees and part of the world in a way I had never, ever been a part of. I moved to the woods. I had to be with trees. I had to be with river. I had to be with birds. I had to be with sky.

DM: You wrote a remarkable memoir about the experience, which is titled *In the Body of the World.* You said the initial response to your illness was not only passive but downright suicidal—a resignation as if you were a voyeur noting your body from a great distance.

How did that change to being fully in your body occur? How did that happen?

V: Most of that disembodied part was before I got diagnosed. I had been sick for quite some time before I actually went to check on it. I looked at it from a distance because I had that detachment from my body, right? I had this passive resignation about my body. I didn't fight for my body. It wasn't until I got sick that that changed, that I came into this body. Now, I can tell you when something's wrong. I know instantly because I live in this body. Previously, I was always achieving, proving I wasn't bad, proving I was good—proving, proving, proving, proving. It's a surefire way to destroy your body.

DM: You stated that until that moment in your life, you had never been brave enough to allow yourself to be afraid. Did that impact how you felt about proving yourself?

V: Definitely. That tough veneer doesn't let us feel our fear. It's an invulnerability, even though underneath it we're horribly vulnerable. Now, what I feel is that I'm vulnerable. We're all vulnerable. We're human beings on this planet Earth. We have no idea what we're doing here. The greatest joy is living in that vulnerability. Which is different from insecurity.

DM: Oh, absolutely. I am working hard to understand self-worth separate from productivity or achievement.

V: It's such a different model to live not in proving oneself but to live in generosity—to live in what can we give, what can we show up with, what can we offer, what can we create, what we can make better as opposed to, "Look at me. Look at me. Aren't I doing it? Aren't I proving it? Aren't I making it?" Because that's what this capitalist patriarchy has indoctrinated into us, and it's made us all sick and it's pushed us to the point where we're burning ourselves out. I want to live in the generous model. I want to live in the how can we nurture, how can we create, how can we take care of, how can we lift each other up, how can we make sure we all have what we need. That to me is much more interesting and it feels so much better than driving, the driving.

AFTERWORD

by

MARIA POPOVA

If we are not at least a little abashed
by the people we used to be,
the voyage of life has halted
in the windless bay of complacency.

This renders the interview a curious cultural artifact by design—a consensual homily of future abashment, etching into the common record who we were at a particular point in life, in a particular state of being, with particular enthusiasms animating our minds and particular sorrows gnawing at our hearts, with all the temporary totality of inspirations and indignations that we so often mistake for final destinations of personhood. An interview petrifies us in time then lives on forever, the thoughts of bygone selves quoted back to us across the eons of our personal evolution—a strange and discomposing taxidermy diorama of life that is no longer living.

But a great interview does something else too. A great interview is a fixity that hints at a fluidity and contours a continuity. To revisit a great interview across a span of time and change is not to enter an ossuary holding the remains of a long-outgrown self but to enter a reliquary holding those elementary particles of personhood that make us who we are—

the parts of which we ourselves so often lose sense and sight of as we coalesce around new projects, new enthusiasms, new life stages. A great interview touches the nucleus of being and potential, untouched by the forces of time and change.

Over the years, I have witnessed Debbie interview a kaleidoscope of visionaries—artists, writers, designers, scientists, philosophers, poets. I have witnessed the effusion of gladness and gratitude with which people—people who give a great deal of interviews—emerge from the soundproof reliquary of her amiable and penetrating intellect, her erudition, and her uncommon generosity as an interviewer. I have witnessed person after person leave her studio aglow with the ecstatic relief of feeling what we all ultimately wish to feel: deeply understood and appreciated, a little bit more in touch with ourselves beyond our selves, reminded of who and what we are in the hull of our being, in that place from which we make everything we make as we go on making ourselves.

EVERYONE WHO HAS EVER BEEN ON *DESIGN MATTERS*

(as of March 2021)

Marina Abramović
Michaela Abrams
Cey Adams
Sean Adams
Jonathan Adler
Justin Ahrens
Elizabeth Alexander
Keira Alexandra
Marc Alt
Elissa Altman
Chris Anderson
Gail Anderson
Kelli Anderson
Kurt Anderson
Laurie Anderson
Paola Antonelli
Philippe Apeloig
Michael Arad
Audrey Arbeeny
Heather B. Armstrong
Dana Arnett
Lawrence Azerrad
Catherine Bailey
Eric Baker
Marian Bantjes
David Barringer
Lynda Barry
Jake Barton
Caroline Baumann
Carlos Bayala
Alex Bec
Alison Bechdel
Jen Bekman
Scott Belsky
Ed Benguait
Susan Benjamin
Kate Betts
James Biber
Gail Bichler
John Bielenberg
Michael Bierut

Jen Bilik
Kate Bingaman-Burt
Mr. Bingo
Connie Birdsall
Gunnar Birkerts
Ayse Birsel
Debra Bishop
Sophie Blackall
Sara Blake
Nicholas Blechman
Barry Blitt
Alex Bogusky
Kate Bollick
Grace Bonney
Irma Boom
Layne Braunstein
Sheila Bridges
Noah Brier
Neville Brody
Brené Brown
Derren Brown
Tim Brown
Dominique Browning
Peter Buchanan-Smith
Stefan Bucher
Bo Burnham
Ron Burrage
Bisa Butler
David Byrne
Ralph Caplan
Ken Carbone
Matthew Carter
Alex Center
Art Chantry
Roz Chast
Josh Chen
Maurice Cherry
Ben Chestnut
Frank Chimero
Allan Chochinov
Scott Clemons

Jean-Louis Cohen
Brian Collins
Beth Comstock
Lisa Congdon
Rodrigo Corral
Patrick Coyne
Patricia Cronin
Moira Cullen
Hillman Curtis
Claire Danes
Brenda Danilowitz
Liz Danzico
Anil Dash
Alain de Botton
Roberto de Vicq de
 Cumptich
Barbara deWilde
Pamela DeCesare
Marion Deuchars
Emma Donoghue
Michael Donovan
Simon Doonan
Michael Dorf
Glennon Doyle
Stephen Doyle
Aaron Draplin
William Drentell
Alan Dye
Elliott Earls
Dave Eggers
Tina Roth Eisenberg
Marc English
Eve Ensler (aka V)
Rafael Esquer
Hartmut Esslinger
Ryan Essmaker
Tina Essmaker
Oded Ezer
Robert Fabrikant
Shepard Fairey
Ed Fella

Ray Fenwick
Tim Ferriss
Jack Ferver
Jonathan Fields
Louise Fili
Karen Finley
Elsie Fisher
Kenneth Fitzgerald
John Flansburgh
Dan Formosa
Lisa Francella
Ze Frank
Tobias Frere-Jones
Kenny Fries
Janet Froelich
Steve Frykholm
John Fulbrook
Hsinming Fung
Kathryn Gallagher
Cindy Gallop
Stephen Gates
Roxane Gay
Katherine Gehl
Tom Geismar
Andrew Geller
Alexander Gelman
Andrew Gibbs
Elizabeth Gilbert
Bob Gill
Anand Giridharadas
Joyce Gladwell
Malcolm Gladwell
Milton Glaser
Ira Glass
Jocelyn K. Glei
Seth Godin
Carin Goldberg
Thelma Golden
Tim Goodman
Bryony Gomez-Palacio
DeeDee Gordon

Jake Gorst
Lori Gottlieb
Minda Gralnek
Adam Grant
Bill Grant
Nancye Green
Maria Guidice
Jason Hackenwerth
Greg Hahn
Richard Haines
Stanley Hainsworth
Su Mathews Hale
Tosh Hall
Gabrielle Hamilton
Dawn Hancock
Adrian Hanft
Jonathan Harris
Sagi Haviv
Luke Hayman
Karl Heiselman
Jessica Helfand
Cheryl Heller
Steven Heller
Josh Higgins
Hrishikesh Hirway
Jessica Hische
John Hockenberry
Michael Hodgson
Jonathan Hoefler
Susan Hoffman
Joe Hollier
Kris Holmes
Bennett Holzworth
Eli Horowitz
Will Hudson
Gordon Hull
Randy Hunt
Gary Hustwit
Angus Hyland
Mirko Ilic
Natalia Ilyin

Alexander Isley
Michael R. Jackson
Rose Jaffe
Michael Jager
Randa Jarrar
Chase Jarvis
Oliver Jeffers
David Cay Johnston
Saeed Jones
Sarah Jones
Rick Joy
Miranda July
Thomas Kail
Maira Kalman
Masaaki Kanai
Eric Kandel
Robyn Kanner
Fritz Karch
Hjalti Karlsson
Deborah Kass
Hagit Kaufman
Sarah Kay
Joyce Rutter Kaye
Michael Ian Kaye
Aaron Kenedi
Jonathan Key
Jeffrey Keyton
Chip Kidd
Kaki King
Mark Kingsley
Jennifer Kinon
Austin Kleon
Maria Konnikova
Brian Koppelman
David Korins
Jason Kottke
Barbara Kruger
Cliff Kuang
Adam J. Kurtz
Anne Lamott
Alexandra Lange
Lewis Lapham
Julie Lasky
Nick Law
Catie Lazarus
Charlie Lazor
Tan Le
Ji Lee

Jake Lefebure
Pum Lefebure
Jonah Lehrer
Warren Lehrer
Scott Lerman
Josh Liberson
Elle Luna
William Lunderman
Giorgia Lupi
Ellen Lupton
Jenna Lyons
Carmen Maria Machado
Maggie MacNab
Wendy MacNaughton
John Maeda
Laurie Haycock Makela
Shirley Manson
Joe Marianek
Roman Mars
Bobby J. Martin Jr.
Shantell Martin
Ina Mayhew
Thomas Page McBee
Grant McCracken
Austin McGhie
Erin McKeown
Zoe Mendelson
Peter Mendelsund
Amanda Michel
Abbott Miller
Chanel Miller
Mike Mills
Marilyn Minter
Isaac Mizrahi
Sigi Moeslinger
Bill Moggridge
Clement Mok
Ryan Moore
Wael Morcos
Noreen Morioka
Jennifer Morla Morley
Kate Moross
Nico Muhly
Eileen Myles
Jamie Myrold
Ivan Navarro
Marty Neumeier
Chani Nicholas

Tucker Nichols
Christoph Niemann
Jacqueline Novogratz
Sukey Novogratz
Gemma O'Brien
Emily Oberman
Vaughan Oliver
Eddie Opara
Michael Ovitz
Amanda Palmer
Priya Parker
Caroline Paul
Pamela Paul
Chee Pearlman
Bennett Peji
Esther Perel
Robin Petravic
Dan Pink
Steven Pinker
Maria Popova
Mauro Porcini
Lana Z. Porter
Michael Porter
Virginia Postrel
Sam Potts
Doug Powell
Rick Poynor
Todd Pruzan
Rossi Ralenkotter
Rankin
Alice Rawsthorn
Robynne Raye
Brian Rea
Alberto Rigau
Mike Rigby
Petter Ringbom
Margaret Roach
Lucy Wainwright Roche
Michael Rock
Edel Rodriguez
Carolina Rogoll
Laurie Rosenwald
David Lee Roth
Gretchen Rubin
Stefan Sagmeister
Paul Sahre
Louise Sandhaus
Peter Saville

Magda Sayeg
Paula Scher
Edwin Schlossberg
Tatiana Schlossberg
Ruth Adler Schnee
Ben Schott
Ian Schrager
Jonathan Selikoff
Pierluigi Serraino
Seth
Dani Shapiro
Nathan Shedroff
Amy Sherald
Tiffany Shlain
Bonnie Siegler
Steve Sikora
Christopher Simmons
Simon Sinek
Brian Singer
Fanny Singer
Cliff Sloan
Felix Sockwell
Pete Souza
Aminatou Sow
David Spergel
Erik Spiekermann
Emily Spivack
Brandon Stanton
Jennifer Sterling
DJ Stout
Scott Stowell
Michael Straussberger
Cheryl Strayed
Michael Surtees
Rachel Sussman
Cheryl Swanson
Susan Szenasy
Gong Szeto
Lisa Taddeo
Lita Talorico
Amber Tamblyn
Terry Teachout
Jane Thompson
Philip Tiongson
Krista Tippett
Linda Tischler
Manuel Toscano
Christina Tosi

Gael Towey
Ethan Trask
Jakob Trollback
Dori Tunstall
Julia Turshen
Alice Twemlow
Masamichi Udagawa
Rochelle Udell
Tea Uglow
Mimi Valdes
Rick Valicenti
Martin Venezky
James Victore
Vivienne Vienne
Massimo Vignelli
Khoi Vinh
Armin Vit
Petrula Vrontikis
Alissa Walker
Rob Walker
Rob Wallace
Jessica Walsh
Aaron Walter
Abby Wambach
Chris Ware
Todd Waterbury
Albert Watson
Ben Watson
Steven Watson
Amy Webb
Lawrence Weiner
Lynda Weinman
Alina Wheeler
Jan Wilker
Ann Willoughby
Sam Winston
Laetitia Wolff
Robert Wong
Jacqueline Woodson
Thomas R. Wright
Richard Saul Wurman
Dustin Yellin
Doyald Young
John Zapolski
Jeffrey Zeldman
Eric Zimmer
Andrew Zolli

ACKNOWLEDGMENTS

This book took a village to create
and was made possible by the following people:

Goddess of Sunshine and all things Great in the World: Charlotte Sheedy

Design: Alex Kalman / What Studio?
Eternal thanks for coming in at the last minute and knocking the design out of the park.

Copy Editing: Jeremy Lehrer with David Sokol and Tess Thackara
Photo Editing and Research: Rivka Genesen
The team at HarperCollins, especially Elizabeth Sullivan and Lynne Yeamans

Special thanks to photographers Brent Taylor, John Keatley, Allan Amato,
and John Madere for beginning this journey with me.

Eternal gratitude to Roxane Gay, Timothy Ferriss, Maria Popova,
Steven Heller, and Zachary Petit for your beautiful essays.

This book could not exist without the contributions of the brilliant artists, writers,
thinkers, and makers I've had the extreme privilege of talking with over the last
sixteen years. Thank you for making the world a better place with your work.

Design Matters is part of the TED Audio Collective

Design Matters Media
Editor-in-Chief: Zachary Petit
Art director: Emily Weiland

Design Matters is produced by Curtis Fox Productions at the Masters in
Branding Program at the School of Visual Arts in New York City and the
generosity of President David Rhodes and Vice-President Anthony Rhodes

PHOTOGRAPHY

First published in 2021 by
Harper Design
An Imprint of HarperCollins*Publishers*
195 Broadway
New York, NY 10007
Tel: (212) 207-7000
Fax: (855) 746-6023

harperdesign@harpercollins.com
www.hc.com

Distributed throughout the world by
HarperCollins *Publishers*
195 Broadway
New York, NY 10007

ISBN 978-0-06-287296-8
Library of Congress Control Number: 2018965719

Book design by Alex Kalman & What Studio?
Printed in Thailand

First Printing, 2021

"In the end, I had to do the work. Inspiration didn't strike." MATTHEW CARTER

"To me, a line is the most beautiful thing in the world. It's all the humanity. It's pain, pleasure. It's beauty, it's not beauty. Those are all the things I see every day in humanity." RICHARD HAINES

"Ultimately, design is a future-facing act, and it's an optimistic act, because everything we create is going to live in the future." BRIAN COLLINS

"The book is maybe dead, but it's more alive than ever." IRMA BOOM

"I'd rather do work that half the people love and half the people hate than do work that everyone just finds okay." JESSICA WALSH

"People are going to have their opinions, but I'd rather do work that half the people

"I just wanted to fuck things up. I had a chip on my shoulder. I felt resentment that I was abandoned, and I wanted to do something to say, 'Hey, look. I'm alive. Look, I'm doing this. Look, I have an opinion, I can do things the way I want to do them.'" TIM GOODMAN

"Basically, my upbringing was like a nonstop Michaels." ADAM J. KURTZ